The American Architect
from the Colonial Era
to the Present

The American Architect from the Colonial Era to the Present

CECIL D. ELLIOTT

McFarland & Company, Inc., Publishers
Jefferson, North Carolina, and London

Library of Congress Cataloguing-in-Publication Data

Elliott, Cecil D.
The American architect from the colonial
era to the present / Cecil D. Elliott
p. cm.
Includes bibliography references and index.

ISBN 0-7864-1391-3 (softcover : 50# alkaline paper)

1. Architectural practice—United States—History.
2. Architecture—Vocational guidance—United States.
I. Title.
NA1995.E48 2003 720'.23'73—dc21 2002015001

British Library cataloguing data are available

On the front cover: Design and plasticene mold for a terra cotta
ornament for the Suffolk Title and Guaranty Co. Building,
Jamaica, Long Island by Dennison & Hirons, architects
(Pencil Points, January 1929)

Manufactured in the United States of America

McFarland & Company, Inc., Publishers
Box 611, Jefferson, North Carolina 28640
www.mcfarlandpub.com

Contents

Preface

Professions have most often in the past been viewed as well meaning and self-regulating activities, sufficiently controlled through arrangements made among colleagues as represented by the major professional organizations. But during the last several decades this view has been altered, and the activities that once were referred to as the "learned professions" have changed. Today scholars who observe and comment on such things are employing cumbersome terms such as "deprofessionalization" and "proletarianization" to describe changes that are occurring in the profession of architecture, as well as law, medicine, engineering, and other fields. These developments have involved an adjustment of legal and governmental attitudes and policies, but to some extent they also indicate popular opinion. Therefore, this may be a particularly pregnant time to consider the history of the architectural profession as it has developed in the United States.

This book began with my conviction that those active in architecture or interested in the subject might profit from learning about some of the things that have remained very much the same in the practice of the profession and other things that have changed appreciably and sometimes frequently. The sociological study of professions is a relatively small field and has largely focused its attention on the larger populations engaged in law and medicine, but architecture lies within ill-defined boundaries among related professions and occupations. Its development has seldom been considered from within the profession or from outside it.

The largest and the most influential architectural firms have been located in major centers of population, and it is their practices that have most frequently been studied and their documents most carefully preserved. In learning of other firms I have been greatly assisted by the historical societies and students of history who have researched and published information about their local architects and architectural firms. I am grateful to the scholars, historical societies, and academic programs that have given their attention to these architects who were not famous. Their publications gave me the information necessary to picture the scope of the architectural profession in realistic terms.

My debt to libraries and librarians is immense. The patience and skill of Deborah Sayler, Lorettax Mindt, and Wendy Gibson in the Inter–Library Loan Office of the North Dakota State University Library have been invaluable. Irene Askelson of the NDSU Architecture and Landscape Architecture Branch Library has ably answered many of those questions that suddenly arise during preparation of a manuscript.

Professor Ronald L. M. Ramsay has generously shared his research and his extensive knowledge of this subject and has

made useful comments on the manuscript; Frances Fisher advised me on research methods, reviewed a section of the manuscript, and provided encouragement; Dr. Joel B. Goldsteen has gone over portions of the manuscript and has provided indispensable advice; Cindy Urness and Mark Barnhouse assisted with parts of the text. I am deeply indebted to all of them, but I remain responsible for errors and misjudgments.

A Note to the Reader

This book is meant to provide architects, drafters, students, and those outside the architectural profession with a general view of the way in which that profession developed in the United States. While architecture is undeniably a form of art, matters of architectural style have been avoided in this study. There are already several excellent histories that trace the succession of architectural styles in America and many exceptional monographs on the heroes of the profession who adopted and advanced those styles.

Style and esthetic invention were obvious factors in the success of some architectural firms, but rarely did they directly influence the professional principles and operational management of architectural firms. Neo-Gothic designers and advocates of the "Roman Renaissance" discussed the professional problems they shared with little reference to their stylistic disputes, and the majority of architects—employing both of these modes of expression as well as others—learned that their professional problems were much the same.

Distinctions among architecture, building, and other related activities are difficult to make. Some sixty years ago, the noted architectural historian Nikolaus Pevsner drew the line somewhere between Lincoln Cathedral and a typical British bicycle shed, a differentiation that was somewhat illustrative but never useful. In the pages that follow, little effort has been made to distinguish among architects, technicians, carpenters, builders, designers, or businessmen engaged in architecture. The difficulties that have been encountered in formulating legal definitions for licensing architects attest to the futility of trying to decide exactly who was or is not entitled to be called an architect.

Part I

Before 1800: Colonial Origins

Establishing colonies was rough and heartbreaking work, to be undertaken only if its rewards were sufficiently great. In South and Central America gold and silver were enough to attract conquistadors to the New World, and few buildings were built except the mission churches required by the pope's demand that Spain convert the natives to Christianity. In the Caribbean and the southern portion of what would become the United States, well-to-do settlers were attracted by the possibility of developing large and lucrative plantations of sugar, tobacco, rice, or indigo. Colonists farther north were drawn by the availability of farmland, which had become a precious commodity in England and much of Europe. By felling trees and clearing rocks a colonist and his family might obtain their own farm on which to live in peace and independence. Life in the American colonies was dominantly agricultural. As the 18th century ended and the new republic began, 95 percent of the American population was rural and only about 1.5 percent lived in settlements having populations above 25,000. However, the dominance of agriculture varied according to local circumstances; in 1800 just over a third of Pennsylvanians were officially listed as "farmers."[1]

Wealthy Europeans, who might invest in the companies that sponsored colonists, rarely chose to subject themselves to the rigors and privations of colonial life, and the architects who stood ready to serve them had no reason to come to the colonies. The design of buildings was most commonly done by draftsmen and builders with significant assistance from the architectural books of the time, and the projects were relatively small and simple. Even a major city such as Boston, which in 1798 had only 4,500 male residents, had need for few buildings of size or pretension. In the colonies building craftsmen found themselves able to advance quickly. The traditional guild requirements of apprenticeship and training were of less concern on this side of the Atlantic, and their services were everywhere in demand. Since American taste in architecture was conservative, lagging behind European fashions, the dictates of style could be easily learned from books.

The Revolution itself had made some families destitute and other families rich, and there were examples of extreme wealth in the United States. John Adams, who favored setting up a powerful American aristocracy, believed that John Randolph of Virginia, owner of more than a thousand slaves, was in actuality more powerful than the Duke of Bedford, England's richest man. In the northern colonies the finest house may well have been that of William Bingham, a Philadelphia banker, which a British traveler described as "a magnificent house and gardens in the best English style, with elegant and even superb furni-

ture."[2] The inequality of wealth between rich and poor was even greater on the frontier than along the Atlantic seaboard, and because he might soon be moving farther west the frontier farmer was more likely to clear more fields than enlarge his house.

A Compelling Need for Buildings

The first settlers in the British colonies required few structures. Their colonial governments could function with no more than a scattering of customhouses, barracks, fortresses, and meeting halls; city merchants needed only the shops and the warehouses in which their goods were stored; and the townspeople built their houses, stables, barns, and churches. In 1626 New Amsterdam, where there were around two hundred residents, had only its crude defenses, a general store, and some thirty houses. The horse-driven mill that was under construction had been planned with a church hall above its work area. Boston had been capital of the Massachusetts Bay Colony for twenty-six years before the city built the Town House in 1658, providing space at ground level for a market beneath a meeting hall that would also serve as a courtroom. This impressive structure—sixty-six feet long and thirty-six feet wide—resembled the market halls of English towns, except that its walls were of clapboard and its roof of wood shingles. But trade and cities grew fast, and some twenty years later Boston had increased so much in population, commerce, and buildings that a fire was reported to have destroyed around seventy warehouses and eighty other buildings.[3]

The merchant organizations that sponsored bands of colonists were largely ignorant of actual conditions in the areas where settlements and trading posts were to be established, and in most cases the inescapable realities of colonial life overrode

any previous plans. Among the 144 colonists brought to establish a trading post at Jamestown in the spring of 1607 there was included a building crew of six carpenters, two bricklayers, and one stone mason, for whom the sponsors had advertised in England, but by the start of the settlement's second year only one carpenter was still alive. Because defense against the natives and food production were of paramount importance, the temporary shelter that could be provided by caves, huts, wigwams, dug-outs (like those later used in settling the western plains), and tents fashioned from ships' sails had to suffice until settlements were protected and enough land had been cleared for planting.

The fishermen living on Cape Ann were spared unfamiliar work when in 1624 the timber frame for a building was brought from England and assembled, and this structure was later taken apart so it could be reassembled in Salem. (After all, William the Conqueror had used prefabricated castle frames in his 1066 invasion of England.) The men of New Plymouth in 1633 "made a smale frame of a house ready, and ... stowed their frame in [the ship's] hold, & bords to cover & finishe it, having nayles & all othr provisions fitting for their use."[4] The materials were taken to a new trading post, where the colonists "clapt up their house quickly" and went about the work of extending trade and colonial rule. In many locations the colonists had tall trees at hand or stone for quarrying, but there was very little time that could be spared for building anything other than the rudest shelter. At New Amsterdam the colonists were so intent on launching a profitable Dutch fur trade that their more important buildings were put up by a small number of Englishmen in the settlement.[5]

Because the climates encountered in North America were unlike those of England and Holland, many traditional ways

of building in Europe were ill suited to conditions in the colonies. Most of those who worked as builders arrived with little experience, and shelter was so urgently needed that the first attempts to erect buildings often resulted in structures that were soon dilapidated beyond repair. Although it was only ten years old in 1638, it was reported that Mrs. Beggerly's house in Salem would be "falling to the ground, if something bee not done."[6] The first building at Harvard College, a clapboard structure, E-shaped in plan, was an ambitious project, and some people thought at the time that the building was "too gorgeous for a Wilderness, and yet too mean ... for a Colledg."[7] It was the largest structure that had been attempted in New England, but within two years of its completion the building had suffered "yearely decayes of the rooff, walls and foundation" that required attention.

About a century after these construction misjudgments in New England, the early phases of settlement in Georgia were underway. In about a decade that colony's population dropped from 6,000 to about 600, and the streets of Savannah were filled with the rotting ruins of houses that had been abandoned. For one thing, it was difficult in the southern colonies to find capable brick makers, and in 1755 an observer reported:

> I saw a brick house that is scarcely two years old and is about to collapse because the bricks are crumbling into dust on their own. However, I believe the ruin of these houses is greatly furthered by the slovenly workmanship of the carpenters and masons.[8]

In New Orleans the early buildings constructed under French control deteriorated quickly, because it was common practice there to set a building's frame on cypress timbers that rested directly on the soggy ground.

In the 17th century a Virginia plantation owner, responding to questions from a prospective colonist in England, wrote him that a house in Virginia would certainly cost three times as much as it would in London and would take at least three times as long to build. He recommended that his correspondent bring with him some indentured masons and carpenters so that, during the four or five years they would work in return for their passage to America, they could be profitably hired out to others when not required for work on his master's plantation house. Most ordinary farmers in Virginia were reluctant to invest any significant sum in housing, because tobacco crops so quickly drained fertility from the soil and forced them to move their families westward to fresh land.[9] Until the 18th century (and on the western frontier much later) buildings in New England could only be simple and practical. It was the extreme cost of construction, more than Puritan restraint, that led to the simplicity of early New England buildings.

In Europe the early architects came mostly from the master masons who had dominated medieval construction, and carpenters had been employed principally to frame floors, make the trusses that would span wide spaces, and construct the scaffolding needed by the masons. But America's wealth of trees contrasted strongly with the tragic deforestation of England, which had been recognized as a serious problem two centuries before the first British colonists came to America. In most of America it was the carpenter who dominated building construction in early times, with masons engaged for the construction of cellars and chimneys. With many areas lacking suitable building stone or clay for making bricks, the colonists built principally of wood. When the colonial cities suffered fires they quickly reacted by enacting regulations to limit the use of thatched roofs and wood construc-

tion. As early as 1631, after about a decade of New England settlement, a fire in Boston caused the governor to order that "noe man shall build his chimney with wood, nor cover his house with thatch." By 1700, it was boasted in Philadelphia that two-thirds of the city's seven hundred houses were built of brick, and local citizens thought it likely that there were more brick buildings in Philadelphia than in all the other colonies together. Still, a century later carpenters and others artisans who worked with wood outnumbered all the other building trades by more than four to one.[10]

If we assume that the colonists who arrived in New England included qualified carpenters, masons, and thatchers in about the same proportions that were usual in their homelands, there remained the fact that *all* of the colonists required housing upon arrival in their new homeland. By a very rough estimate, during the first decades of colonizing New England, about 24,000 people upon arriving would have required the construction of some 5,000 dwelling places. For this reason the Virginia Company did not allow the building artisans in their colony to engage in activities that might interfere with following their trades, forbidding them to "plant tobacco or corne or do any other worke in the ground."[11] As late as 1711 a North Carolinian wrote that "workmen are dear and scarce," and it was often advised that planters in that colony might do well to learn carpentry and other building skills. In North Carolina, where slaves did most of the building, visitors to a Moravian settlement were "surprised to find that white people had done so much work."[12]

Although few other public buildings were built in those early years, there was need for many small parish churches. In Virginia church-building ranked second only to the construction of large plantation houses for the gentry. In New En-

gland, where a minister's salary might be half a town's total budget, during the 17th century there were over two hundred meetinghouses erected. (New England colonists, most of them members of England's "dissenting" religious sects, at first avoided using the term "church.") In the 18th century more than two thousand meetinghouses were built in New England, and these primary structures of the colonial communities provided opportunities for their designers to display their skills.[13]

The demand for the services of builders capable of erecting, repairing, and enlarging structures was urgent and persistent, and there were so few competent craftsmen available that the wages of all building workmen soared. There was a tale that Nicholas Codd, a capable carpenter-designer, had been shanghaied from Ireland to build houses for two of the leading citizens of Damariscotta, Maine. Only farming outranked building in the New England economy before the influx of Pilgrims came to an end in the 1640s, and after that point it was only farming and the lumber trade, which supplied both house carpenters and ship carpenters.[14]

By this time, in most of Europe the building trades had become clearly separate activities, carpenters, masons, and the other craftsmen pursuing their recognized specialties. It might be possible for a Massachusetts villager or Maine parishioner to obtain the services of a fully qualified carpenter or mason from another town, but it was more likely that the work would be done by a farmer or miller who knew something, but relatively little, of the craft. Since there was seldom enough building activity in a village to assure a livelihood for a thatcher or a sawyer, a combination of building skills and another form of regular employment was usually necessary. In most of the colonies the handful of workmen available in any one township necessarily developed a wide range of skills, and

adaptation that led in time to the development of the diversity of abilities that characterized the "Yankee jack-of-all-trades." In colonial records one encounters such versatile men as Rev. Jonathan Fisher, clergyman, artist, essayist, farmer, and a maker of both clocks and furniture, who for the construction of his own house felled the timber, split the shingles, and quarried the stone.[15]

In Virginia the wages of carpenters and others in the building trades remained relatively stable, but this was not the case in New England. By the middle of the 17th century, building artisans of all kinds demanded and were paid inordinately high wages, the wages of skilled carpenters rising in some areas to a level so high that only the richest townsmen could afford their services. Officials in Boston increased the number of workmen there when in 1660 they altered the traditional apprenticeship regulations and allowed apprentices to end their training at the age of twenty-one rather than twenty-four, although a total of seven years was still required. In the 1690s New York went farther, lowering the period of apprentices' training to four years with no limitations regarding their age. The wages of "carpenters, joyners, brickelayers, sawers and thatchers" were so high that they were the principal targets of the regulations that colonies and towns formulated to fix wages, and "clapboard ryvers [splitters]" were soon added to the list. Rarely did these legal maneuvers achieve their goals, because the cities in which wages were highest were those expanding most rapidly.[16]

Builders and craftsmen who were newly arrived in America proudly advertised their abilities, emphasizing that they brought with them a knowledge of the latest European fashions in architecture. A Charleston carpenter, Dudley Inman, in 1751 advertised in the *South-Carolina Gazette*, proclaiming his ability to undertake "buildings of all kinds, with more convenience, strength and beauty, than those commonly erected in this province." Like most new arrivals Inman, whose advertisement emphasized that he was "lately arrived from London," played on the Southern colonists' fear of lagging too far behind London vogue by offering to design "houses, according to the modern taste," of which he declared there were "but few in or near this town, ... [having] all the conveniences and beautiful proportions of architecture."[17]

Peter Chassereau, a Charleston builder who was also "newly come from London," declared himself capable of drawing "Plans and Elevations of all kinds of buildings whatsoever, both Civil and Military" as well as offering to accommodate "young Gentlemen and ladies ... at their own Houses to be taught Drawing." In Boston at a later time, an architect advertised with considerable eloquence: "that he makes Plans, Sections, and Elevations, for town and country houses of every description, from the splendid mansion or elegant villa, to the simple cottage."[18] But the pious merchants of New England may have been less concerned about the latest fashions in London than were the plantation-owners of the South, where the latest in fashion was much admired and planters had adopted European nobility's habit of living in debt.

Carpenters, Builders, and Gentlemen

In studying the architects of this time it has been customary to divide the early designers of American buildings into three categories: (1) carpenters, (2) housewrights or master builders, and (3) dilettante designers. While these classifications are useful, they should always be loosely and cautiously interpreted. Some carpenters had also been trained to be joiners,

woodcarvers, and furniture-makers, crafts that might awaken and develop in them a sensitivity to form and detail. Carpenters, duly apprenticed and self-schooled with the handbooks of the period, were sometimes the true designers of works that are attributed to the builders and dilettantes who hired them. It was not difficult for a carpenter to become a housewright or master builder, if his reputation as a craftsman and his judgment as a businessman earned him the transformation. (The term "housewright" came into use in New England during the 1670s. "Master builder" was adopted in Philadelphia just before the Revolution, and in New York at the end of the 18th century. Both terms dropped from use around the middle of the nineteenth century.)[19]

However, there were significant risks in being a housewright or master builder. Large sums had to be spent by building contractors over an extended period of time, which meant that an unanticipated fluctuation in the prices of materials or other conditions might radically increase the cost of a project. The drawings and specifications with which construction commenced were usually sketchy and incomplete, but this could hardly explain building costs that were 50 to 100 percent above carefully prepared estimates of a familiar sort of work. Prices could fluctuate disastrously, and owners (who often dealt directly with many subcontractors) might order additions to a project without reckoning their cost. In some cases the master builder assumed a role that was similar to today's real-estate developer, bringing together the investors and contractors required in order to execute a project, but this was more frequently the role of wealthy gentlemen with an interest in building and the typical American weakness for speculation.

Men who engaged in any of the professions were commonly viewed with the traditional European association of competence with class, the assumption that knowledge and a breadth of outlook were to be found most often among gentlemen. Traditionally, to be considered a gentleman in England one should live on the rents received from family holdings of land, but in the colonies, where there were vast stretches of undeveloped land, this definition was of little use. Very few Englishmen who could be properly classed as gentlemen left their native places for the hardships and inconveniences of colonial life, and therefore there was ample room at the top of colonial society. Merchants, of whom only the richest would have been admitted to English society, could become the acknowledged leaders of American life, and the pursuit of a profession was often a way to rise in life as one moved from the trades of carpentry and building toward the profession of architecture.

As they prospered, local builders came to be admired as praiseworthy figures in village or town society, inevitably identified with the improvements that most visibly marked the growth and advancement of the community. Samuel McIntire, a woodcarver and house carpenter of great talent, became a local celebrity in Salem, Massachusetts, where he had the patronage of that port city's wealthiest families. McIntire's obituary declared that "all the improvements of Salem for nearly thirty years past have been done under his eye." Brother Micajah Burnett, who at eighteen (the lowest age permitted) joined the Shaker settlement at Pleasant Hill, Kentucky, revised that community's plan and an obituary referred to him as the "Architect of this Village—an accomplished Civil Engineer, a Masterly Mathematician, a competent Surveyor, a Mechanic & Machinist of the first order, a good Mill Wright, &c."[20]

Housewrights and master builders might well become outstanding citizens of their communities, particularly in the

northern colonies where the social strati-
fication was less rigid than in the South.
The famous Boston dilettante architect
Charles Bulfinch was to some degree a
protege of Col. Thomas Dawes, a builder
active in Massachusetts politics and at one
time the acting-governor of the colony.
Dawes built houses for two British admi-
rals stationed in Boston at the same time
that the attic of his home served as the
meeting place for some of the men who
would soon lead the Revolution.[21] How-
ever, Dawes' sentiments were so well known
around the city that the British troops
sacked his house as they withdrew from
Boston.

When a new governor arrived in
North Carolina in 1765, he brought with
him John Hawks, who held relatively high
positions in the colonial government while
he served as designer and builder for the
Governor's Palace in New Bern and other
buildings in the colony. Samuel Powell,
known around Philadelphia as "the Rich
Carpenter," was said to own some ninety
houses in the city. Samuel Rhoads, the de-
signer of the Pennsylvania Hospital and a
member of its governing board, had been
trained as a carpenter and for some time
worked at that trade. Rhoads was not only
a leader in the Carpenter's Company, an
influential Philadelphia guild of builders,
but he also became active in mercantile in-
vestments and speculations in real estate.
In 1774 Rhoads was both mayor of Phila-
delphia and a member of the Continental
Congress meeting there. Frederick Philipse
of Yonkers, New Jersey, who came to New
Amsterdam as a carpenter for the Dutch
West Indies Company, was known as Di-
rector-General Peter Stuyvesant's archi-
tect-builder. Soon Philipse extended his
activities into trade, stringing wampum
and gambling on the fluctuations of its
price, and enlarged his interests into land
speculation. (Some also included piracy
among his activities.) In the 1690s Philipse's

holdings extended for twenty-two miles
along the banks of the Hudson River, and
the British government officially recog-
nized him as Lord of the Manor of Philips-
borough.[22]

With open land always lying just to the
west and get-rich-quick speculations to be
found everywhere, land speculation was a
natural obsession among the colonists,
whether one dealt in thousands of acres to
the west or lots within a city. As early as
1645 a Puritan poet commented on a cur-
rent real-estate boom:

> Come buy my house, here you may
> have much medow at your dore
> 'Twill dearer be if you [wait] till the
> land be planted o'er....
> They build to sell, and sell to build, ...[23]

In flourishing young cities dealing in lots
and buildings came naturally to those who
were experienced in the building crafts
and whose finances permitted such busi-
ness ventures. Dilettante architects and
others with money to invest became real-
estate speculators, buying land and build-
ing on it with the assistance or partnership
of master builders. These adventurers in
real estate usually maintained their ties to
the businesses in which they had made
their start, be it merchandising, money
lending, or privateering. Master builders
who ventured into trade usually kept the
same versatility, maintaining their origi-
nal building activities as they experi-
mented with other profitable fields.

The dilettantes and dabblers had their
own properties and businesses, expecting
little profit from amusing themselves in
architecture, and builders usually engaged
in architecture as natural extensions of
their businesses. The 1786 Rule Book of
the Philadelphia Carpenters' Company
advised flexibility regarding its members
who provided architectural services: "Draw-
ing Designs, making out Bills of Scantling,
collecting Materials, and sticking up Stuff,

are to be charged by the Carpenter in proportion to the trouble."[24] It would have been difficult in colonial times to make one's living by architecture alone. One writer has pointed out that: "The few architects that there were [in colonial times] usually found it convenient to carry on some better paying if less aesthetic pursuit—such as painting or surveying—upon which they could fall back at odd or slack times."[25] In addition to the fluctuations of the economy, a shortage of money in the colonies and British policies restraining the development of colonial trade often meant that there were simply no buildings to be built in the small towns of the period. In itself the combination of a professional role with another business was not unusual, for in the 17th century there were few towns large enough to support a physician or lawyer who was not willing to be a school teacher, storekeeper, tavern owner, or merchant in addition. Even clergymen, members of the most respected profession of that time, might teach school or pursue some other sideline.

Most experienced workmen were able to fall back on cabinet-making and other related skills when work was scarce. Surveying was a particularly useful skill, not only because of the feverish speculation in large holdings of land, but also for the determination and subdivision of city lots. John McComb, Sr., a New York City mason-builder, was a city-surveyor for four years during the period of confusion that resulted from the city having been occupied by British troops. (A city-surveyor in this case was authorized to determine property boundaries, but was not a city employee.) Retail merchants in many cases served as bankers, and professional men found it wise to maintain their connection with whatever other skills they might possess. Only in the largest cities of America could professional men narrowly specialize.

Like proper English gentlemen, Southerners of distinction were often inclined to pursue an interest in architecture. In 1704 William Byrd II, who had spent much of his life in England, inherited about 26,000 acres of Virginia land and a position in trade, land speculation, and growing tobacco. Byrd's library included some thirty books on architecture. When the new governor, a professional soldier, came to Virginia he quickly became interested in the construction of Governor's Palace and other buildings in Williamsburg, and he wrote that he found himself "sufficiently amused with planting Orchards & Gardens, & with finishing a large House."[26]

The dilettante pursuit of architecture was perhaps interpreted as a cachet of success. Peter Harrison was a sea captain as well as being involved with his brother in trade in rum, molasses, and mahogany until 1786, when he left Newport, Rhode Island, to assume duties for the British colonial government as the Collector of Customs in New Haven. Harrison's architectural work was apparently a gentleman's avocation, for in 1760 he was given twenty-five lottery tickets "for the Trouble drawing Plans of Masons' Hall" in Newport, Rhode Island.[27] In Providence the four Brown brothers arranged the continent's first monopoly by controlling the supply of spermaceti oil from which the best candles were made, found remarkable success as importers of rum, and engaged in the slave trade, in which Rhode Island soon outranked New York. After Joseph Brown left the family business, he pursued his scientific studies as a professor of natural philosophy at Rhode Island College and designed two houses and three public buildings.

Charles Bulfinch, the descendant of wealthy Boston families, dabbled in designing buildings until the failure of a real-estate venture following the 1795 depression made it necessary for him to combine his architectural activities with a salaried

position as superintendent of the Boston police. Andrew Hamilton, lawyer in the famous trial of John Peter Zenger for seditious libel, prepared the design of Independence Hall in Philadelphia (one suspects, with ample assistance of a builder). Since this seems to have been his only architectural venture, Hamilton's participation may have been due more to his desire as Speaker of the State Assembly to expedite the project than to his having any keen interest in the art.

Richard Taliafero, a Virginia justice of the peace and sheriff, continued his legal practice and management of a nearby plantation at the same time that he acted as the designer and builder of several houses. He willed his own house in Williamsburg to his son-in-law, George Wythe, a signer of the Declaration of Independence. In South Carolina, where during the malaria season most rice planters fled the man-made swamps on their plantations and took refuge in Charleston, Gabriel Manigault designed buildings in the vicinity of the city and led in the conversion of rice fields to the cultivation of indigo. Though he may well have been the richest American at that time, Manigault's interest in architecture seems appropriate, since one of the Huguenot refugees who founded the family in America had worked as a carpenter, one grandfather was a prominent speculator in Charleston real estate, and the other grandfather had accumulated a distinguished collection of architectural books.

A contract was signed in 1767 for the design and construction of a palace at New Bern, North Carolina, for Governor William Tryon, who later became governor of New York. John Hawks, who had been trained under an architect in England, was perhaps the first American with professional training in architecture, and in the contract Hawks was charged with preparing "all necessary designs, plans, Elevations, proportions, drawings or directions, for carrying on the said Building and Offices, with all suitable elegance, and Strength."[28] For a salary about four times the earnings of a qualified carpenter, Hawks was also to act as both architect and builder, selecting the materials and superintending construction. About a month after the contract was signed, Hawks found a trip to Philadelphia necessary to recruit workmen, since skilled craftsmen could not be found in New Bern.

It was 1806 before the professional identification as "architect" would appear in the Boston city directory, and it would be more than a century before legal restrictions in the United States would attempt to define architects and regulate the use of the professional title. In the meantime the rest

One of the drawings John Hawks sent to officials in London in 1767. The titles read: "The Elevation of the Governors House at Newbern, North Carolina. The Extent of the North Front and Offices 223 Feet." The center-and-wings scheme was a favorite of English Palladianism and figured prominently in James Gibbs' pattern book, which had been published almost forty years earlier. (North Carolina Division of Archives and History, from the British Public Record Office.)

of the colonies probably shared Charleston's confusion about the distinction to be made between architects and others who took part in erecting buildings. At the end of the 18th century the minutes of a church vestry meeting, as printed in a Charleston newspaper, identified Edward McGrath and his partner as the congregation's architects and a third person as the builder. However, over a period of six years the Charleston city directories listed McGrath as a carpenter one year, then as an architect for two years, after which he was once more a carpenter.[29]

In many locations such distinctions obviously had little meaning. Housewrights and carpenters who contracted to construct a building might in addition provide the required drawings. Another Charlestonian, although principally a woodcarver, advertised thus:

> Ezra Waite, Civil Architect, House-builder in general, and Carver, from London, Has finished the Architecture, conducted the execution thereof, viz; in the joiner way, … and carved all the said work in the four principal rooms; and also calculated, adjusted, and draw'd at large for to work by, the Ionick entablature, and carved the same in the front and round the eaves, of Miles Brewton, Esquire's House…. He flatters himself to give satisfaction to any gentleman, either by plans, sections, elevations, or executions….[30]

Most woodcarvers and joiners had first been carpenters, and many of the men who provided architectural advice had once been builders. Even if one called himself an architect, in order to make a living it was almost always necessary that he also contract for the construction of buildings.

Apprenticeship and Education

According to tradition, training in a profitable trade or craft was the most valuable possession a father could bestow on his sons. Apprenticeship was in later times a system through which the traditional transfer of skills from a father to his sons was extended to include the sons of other families, who could be taken into an artisan's household to learn the trade, assist in the work to be done, and undergo moral instruction as provided by his master. (In that way apprenticeship permitted a father to give his son training in a field that might be more profitable than the father's.) The cost to the boy's parents varied considerably according to the master's reputation and his need for this kind of supplementary income. Usually seven years of apprenticeship began at the age of fifteen, although this could vary in different trades and locations. Under the system of pupilage, which dominated the training of English architects throughout the nineteenth century, young men living at home were taken into architects' offices for instruction without their master assuming the parental responsibilities that were involved in apprenticeship. Thus the manner of teaching architecture was changed to a system in which an architect's office became to some degree a professional school. Parents might pay for such instruction or a lad could be accepted as an unpaid worker, learning the elementary tasks of the drafting room through performance rather than lessons.

Formal schooling in architecture and the methods of drawing architecture were frequently announced to colonists by newspaper advertisements inviting laymen to attend classes conducted by a local craftsman or builder. Europeans arriving in the colonies with the necessary skills often found that teaching classes or offering private lessons in architecture and architectural drawing could fill the period of their adjustment to America. Their classes may have sometimes been attended by gentlemen who sought a modest know-

ledge of architecture as a part of their education, but it seems more likely that a young gentleman would make arrangements for private lessons and that an older gentleman would hire draftsmen to put his ideas on paper.

Amateurs who possessed a few architectural books may not have attended these classes, but ambitious carpenters came. One early advertisement announced afternoon classes and also broached the possibility of instruction "from 5 to 6 in the Morning," before carpenters began a workday that customarily lasted as long as there was daylight. In 1790 James Hoban, an Irish architect who later won the competition for design of the President's House in Washington, announced in the Charleston, South Carolina, *City Gazette* that he intended to "establish an EVENING SCHOOL, for the instruction of young men in Architecture." The program of a similar school is described eleven years later in an announcement published for the residents of Windsor, Vermont, by a young builder who would later become known as the author of manuals and handbooks:[31]

TO YOUNG CARPENTERS, JOINERS &
ALL OTHERS CONCERNED IN
THE ART OF BUILDING:—

The subscriber intends to open a School of Architecture at his house in Windsor, the 20th of February next—at which will be taught The Five Orders of Architecture, the Proportions of Doors, Windows and Chimneypieces, the construction of Stairs, with their ramp and twist, Rails, the method of framing timbers, length and backing of Hiprafters, the tracing of Groins to angle Brackets, circular soffits in circular Walls; Plans, Elevations and Sections of Houses with all their Ornaments.

The Art of drawing Plans and Elevations, or any other figure perspectively will also be taught if required by

ASHER BENJAMIN

In Philadelphia a member of the Carpenters' Company during the 1760s had offered private instruction in "the Art of Drawing Sundry Propositions in Architecture." Plans might easily be drawn by alert young workmen, but until the middle of the nineteenth century elevations having a bit of realism and views shown "perspectively" would be taken as an indication of one's familiarity with the higher realms of architecture.

Colonial Books and Libraries

So powerful was the American respect for books that in 1686, when only seven thousand people lived in Boston, the city had some seven bookstores.[32] Of the books Boston imported at that time about nine out of ten seem to have been either religious or instructional texts, but even a meager supply of architectural books exerted a powerful influence. In Charleston, South Carolina, a leading bookseller in the 1770s offered the city of about eleven thousand people (over half of them black slaves) at least nine carpenters' handbooks and four of the more elaborate pattern books for dilettantes, and the Charles Town Library Society owned a single handbook as well as four pattern books. Wherever organizations of carpenters and builders were founded, the development of a library was a crucial objective, because access to an extensive collection of architectural books was often beyond the means of even the most prosperous builders.

There were three kinds of books published to assist in the design and detailing of buildings. Handbooks demonstrated the classical orders of architecture, gave examples of doorways, mantelpieces, and other details, and they sometimes contained drawings of building designs and such technical matters as the trusses to span wide spaces and the construction of the spiral staircases that were so admired

in the colonies. Most handbooks were intended to be used by ambitious building artisans who wished to advance in their trade, as clearly indicated by the subtitle of one of Edward Shaw's handbooks, *Modern Architecture, Every Carpenter His Own Master*. Pattern books, on the other hand, were much more elegant and expensive, since they were principally aimed at conveying the latest architectural fashions and the most admired designs of the past. Drawings of specific building projects and their details, all clearly identified with the architects' names, occupied most of the pages in pattern books. A third sort of architectural book provided instruction in drawing, more often construction layouts than pictorial renderings, which could equip readers with the predictive skill required for carpenters and builders to demonstrate their ideas to clients, for owners to receive a confirmation of their desires, and for dilettantes to adapt designs or concoct combinations of forms. (A bit of elementary drawing instruction was included in some of the carpenters' handbooks.) For the ambitious carpenter this precious ability to depict designs opened the door to a higher economic and social status, making visible to all his skill and knowledge in matters of architecture.

Probably the largest and most select colonial library of architectural books was that of Peter Harrison, a collection that was part of the transformation of that Quaker sea captain into a merchant gentleman, staunchly Anglican and Tory. Harrison's library of over thirty volumes was almost evenly divided between small handbooks that would have cost two or three days of a good carpenter's wages and impressive pattern books that might well cost more than three times that amount.[33] Joseph Brown in Rhode Island may have had a modest collection of architectural pattern books in his personal library, but many were also listed in the records of

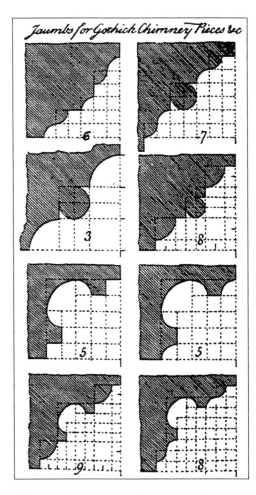

Above and on next page: Three pages illustrate the contents of Batty Langley's influential handbook, *The Builder's Director, or Bench-Mate* in its 1751 edition. By numbers and grids the proportions are shown in a manner that allows applications at different scales. 172.—"Jambs for Gothick Chimney Pieces &c." 29.—"The Ionick Capital and Entablature by Giacomo Barozzio of Vignola." (Here the dimensions are given in "36ths of the Diameter" of the columns.) 91.—"Sketches of Dorick Intercolumnations for Doors, Porticoes, Arcades, Colonades, &c."

Providence's library. Charles Bulfinch's grandfather and two uncles, all members of the wealthy Boston family of Apthorp, were interested in architecture and had acquired their own libraries.

Lists of books in their owners' wills and the inventories made in settling estates often provide records of the books

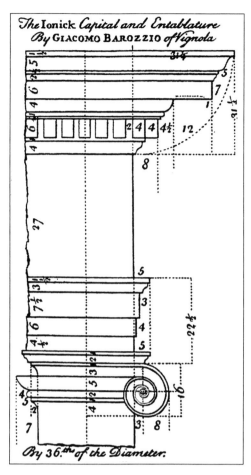

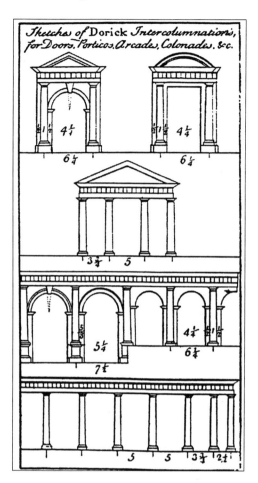

that were used in designing buildings at this time. Thomas Dawes, Bulfinch's mentor, seems to have had a library of at least the twelve architectural publications that are now in the library of the Boston Athenaeum. Included were the five volumes of Colin Campbell's pattern book, *Vitruvius Britannicus* (1715-17). In fact, Dawes' signed copy of the handbook, *The Builder's Dictionary and Architect's Companion*, somehow found its way into Bulfinch's library. In South Carolina the grandfather of Gabriel Manigault had acquired a distinguished collection of pattern books. Such books were printed in Europe, all but a few in England, and the first architectural book to be published in the United States was a 1775 Philadelphia reprint of Abraham Swan's *The British Ar-*

chitect, a carpenters' handbook that had been first published in London thirty years earlier. To sponsor the American publication of Swan's handbook, the publisher was able to secure almost two hundred subscribers, twice as many of them carpenters as master builders.

To understand the use of architectural books at this time we will consider two that seem to have been among the most popular and influential. Between 1726 and 1756 Batty Langley published more than twenty books in England. In one of these books he described himself and his qualifications as "architect, surveyor, builder, measurer." (In England and the American colonies "measurers" calculated the amount of brickwork put in place, the area of roofing laid, and made

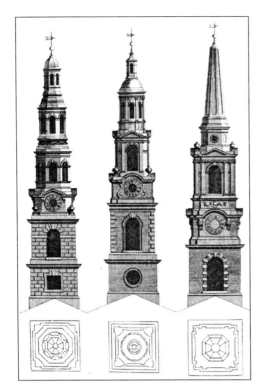

Above and on next page: Three pages from James Gibbs' patternbook. *A Book of Architecture Containing Designs of Buildings and Ornaments* (1728 edition). "Plate XXIX ... Draughts of Steeples made for St. *Martin's* Church, with their Plans." "Plate XCIV. [Eight of] Thirty-eight Designs of Chimney Pieces, done for several places." "Plate LVIII. A Design made for a Gentleman in *Dorsetshire.*"

other computations that would validate the figures a builder submitted to his client for payment.) Langley's *The Builder's Director or Bench-Mate,* very popular in America, was intended for the journeyman or master carpenter, not the novice. Small enough to be carried about in a workman's pocket, over half of its 184 pages are devoted to drawings of the orders "Tuscan, Dorick, Ionick, Corinthian, and Composite," their proportions, spacing, and applications. (The *Builder's Director* was first published in London in 1746, and this description is based on the 1751 edition.) Elements for the design of buildings, both exterior and interior, include fourteen examples of doorways and windows as well as twenty-one variations for fireplaces with twenty-four different profiles for the projections of mantels above them. No en-

tire buildings are illustrated in *The Builder's Director,* but some of Langley's later books, particularly those titled *Treasury of Designs,* were more like the pattern books that had become increasingly popular.

Of the English pattern books the most influential was James Gibbs' *A Book of Architecture, Containing Designs of Buildings and Ornaments* (1728), fine engravings of the works of a skilled English architect. Originally intended for country gentlemen living in the many parts of England where professional advice on architecture was not easily come by, this folio became "probably the most widely used architectural book of the century," valued in British colonies around the world and especially in America.[34] Six churches, including Gibbs' St. Martin in the Fields in

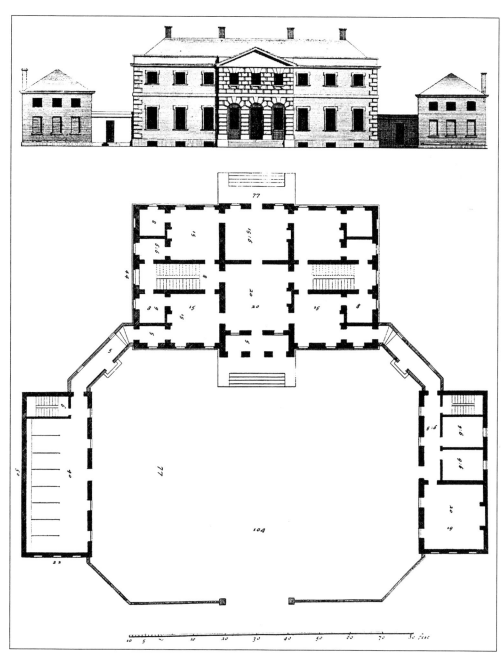

London, are shown with plans and elevations, but in addition a dozen steeples are presented to provide for the bells or clocks that might be placed on churches or other public buildings. For houses, there are twenty-five schemes displayed with both plans and elevations, the ground area they occupy varying from a modest 2,000 square feet to an impressive 30,000 square feet. Residential details show some fifty doors, windows, and niches as well as forty-four fireplace designs. Gateways, obelisks, monuments, sarcophagi, and decorative vases complete an assortment of architectural ornaments sufficient to satisfy the needs of craftsmen or stir the

imaginations of gentlemen who had architectural aspirations. But Gibbs' designs, which had been fashionable in the reign of George I, were clearly out of date in England at the end of the 18th century, during the reign of his great-grandson George III.

Westward Colonization

As the remainder of North America would be settled throughout the nineteenth century, the conditions of the colonial period were repeated as new regions were populated and made productive. The western territories were in a very real sense colonies of the East. Carpenters who moved to Indiana and Texas gained experience and became contractors, and as they headed farther west some contractors declared themselves architects. But with the advent of the railroad and mail service it became increasingly likely that the use of such local talents would be limited to designing residences and small public structures, while the officials charged with the construction of large churches and government buildings would engage one of the architectural firms of an Eastern city. During the colonial period English architects had not provided designs for buildings in the colonies, not even for the appropriate architectural symbols of British rule. But during this period of internal colonization, Eastern architects viewed the western territories as a fresh supply of clients, and the wealthy and influential leaders of western communities saw Eastern sources as essential to the advancement of frontier culture.

Part II

1800 to the Civil War: Formation of the Profession

In the years before the Civil War the United States went about the implementation of that great American invention, the Constitution of 1787. The land area of the fledgling nation in those years more than tripled, and it became occupied by around eight times as many people, rich and poor. Just before the Revolution the richest tenth of the American population had owned somewhat less than 50 percent of the country's assets; by the time that the Civil War began both commerce and industry had expanded and the richest tenth owned almost three-quarters of the assets.[1] This meant that there were eight times as many wealthy persons, having greater wealth on the average than at the beginning of the republic, all of them possible architectural clients who might, individually or in combination, wish to erect buildings for their own needs and pleasures or for their institutions and organizations.

The federal government at this time required few buildings, its non-military functions being limited on the whole to little more than legislation, the enforcement of laws, and the collection of taxes and tariffs. Although capital buildings were needed for some twenty new states, most of them were sparsely populated and preferred economy to ostentation. Such caution was wise since seats of government could be moved and often were.

During the first nine years of statehood the capital of Ohio was twice at Cincinnati and twice at Chillicothe before 1812 when the city of Columbus was founded for that purpose—new towns being a common geographical and political compromise.

Following the embargoes associated with the Napoleonic Wars and the War of 1812, the American economy advanced steadily, and by the 1820s the number of immigrants arriving from Europe increased sharply. Among the new arrivals were many ambitious architects and craftsmen who had been trained in their native lands. Their reasons for emigrating varied: all escaped the competition that resulted from an extraordinary increase in the population of Europe, and many were encouraged to emigrate to America by the depressions of the period and the unsuccessful uprisings of social protest that in 1848 took place throughout Europe. In 1836 eleven architects met in New York to form a professional organization meant to exemplify the qualifications that should be expected of architects, and of that number around half had been born in Europe. At a similar meeting in 1857 the ratio was about the same. Still, many immigrant architects stayed only a short time on the East Coast before pressing westward to make their names in frontier cities such as

St. Louis and Chicago or to join in the California Gold Rush.

The New Capital

The officers of the Philadelphia Library Company advertised in 1789 for designs of a library building, and the winner of the competition, Dr. William Thornton, was awarded one share of stock in the Library Company for submitting the design that most pleased the sponsors of the competition. Thornton, a physician who came from the British Virgin Islands, had no previous experience in architecture, and he explained his success in the simplest of terms: "[I had] never thought of architecture, but I got some books and worked a few days...."

The most significant and attractive competitions of this period were conducted a few years later. They sought suitable designs for the Capitol and the President's House to be built in the newly designated Federal District that after much political maneuvering in the first Congress had been located on the Potomac River. Aware that the French often used competitions to obtain designs for their public buildings, Secretary of State Thomas Jefferson suggested that method to determine the design of the first two buildings that would permanently establish the capital in the southern location that he had favored. Announcements of the competitions and their requirements were published in all the major newspapers of the time, and 15 July 1792 was set as the last date on which drawings could be submitted, although this date was not actually adhered to. As they were published, the requirements for the Capitol specified the size and function of most major spaces within the building, although a degree of imprecision resulted from the structure's being intended for a new and untried form of government. The description of the President's House was even vaguer: "The [purpose] of the building will point out to the Artist the number, size and distribution of the apartments." It was assumed that a knowledge of palaces and manor houses would provide adequate precedents for the competitors.

The composition of the architectural profession at the end of the 18th century and the start of the republic can be judged from those who participated in the competitions for the new capital city, opportunities that would have been certain to attract most of the architectural talents and ambitions of the time. Boston's gentleman architect, Charles Bulfinch, did not enter the competition, although it was conducted before a personal financial crisis forced him to engage in architecture more strenuously than he had before. English-trained John Hawks, who had come to North Carolina almost thirty years earlier with Governor Tryon, had died two years before the competition, and Benjamin Latrobe had not yet come to America.[2]

Seven submissions for the President's House and sixteen for the Capitol were received, and they were submitted by nineteen individuals since four participants sent designs for both buildings. Accurate records of the entries in the competition have not survived, and accounts of the event are usually based on the remaining drawings and the correspondence of the Commissioners who were in charge of the projects. Thirteen of the competitors can be identified as carpenters and builders by the submitted drawings that strongly suggest a craft background. Most of this group were residents of Maryland or Virginia, convenient to the Federal District. However, the best known of the builders entering the competition was Samuel McIntire, a New England woodcarver and housewright who had recently completed several public buildings. Four gentlemen designers prepared drawings: George

Turner, a personal friend of Washington who had been appointed judge for the Northwest Territory; Samuel Blodgett, Jr., a businessman and land speculator who several years later would prepare the designs for the Bank of the United States in Philadelphia; William Thornton, winner of the competition for the Philadelphia Library Company; and Thomas Jefferson, who anonymously submitted a design for the President's House.

Unlike the builders' submissions, the dilettante architects' designs showed a familiarity with some of the more recent buildings of Europe as they were depicted in the expensive pattern books of the period. Dr. Thornton was declared the winner of the competition, and work began on adapting his scheme for construction. Unfortunately, responsibility for the design of the Capitol, as it was developed and built, has always been a matter of debate, sometimes as bitterly contentious as were the relationships of those who at that time participated in the project.

In addition to the thirteen builders and four dilettantes in the capitol competition, there were two young men with architectural training. Both were at that time in their mid-thirties and had lived in the United States for about a decade. The winner of the prize for design of the President's House was James Hoban, an Irishman who had received professional training in Dublin before emigrating. Hoban had arrived in Philadelphia, then the colonies' largest city, where he would have become familiar with colonial fashions and materials that were available. Etienne (Stephen) Sulpice Hallett had been recognized in France as one of a select group of promising young architects. He came to the United States in connection with a network of academies that had been proposed by a prominent French educator, but when that project failed and the French Revolution began Hallett was

stranded. These were the only two participants in the Federal competition who had credible architectural training. Among those who competed, the number from the building trades was more than double the number of both dilettantes and professionals combined. This may suggest the extent of architectural services available in the coastal states, but there was probably a far greater proportion of builders actively engaged in the design of buildings.

After the competition for the national capitol and what is now called the White House, there was a competition for the design of a penitentiary in Richmond, Virginia, and another for a combined courthouse and city hall in New York City. The latter competition was announced 20 February 1802, and all competitors were required to submit their drawings, accompanied by calculations of the buildings' cost, not later than 1 April.

From the twenty-six drawings that were submitted the winner was the design submitted by Joseph Francois Mangin and John McComb, Jr. Benjamin Latrobe usually avoided competitions, because he found it

> ... extremely inconvenient and humiliating to devote a month's time to making a complete set of drawings and calculations, ... only for the *chance* of being preferred to the Amateur, and workman....[3]

Nevertheless, at the urging of Aaron Burr, a Republican leader, Latrobe had entered this competition, complaining when he lost that the winners were "a New York bricklayer and a St. Domingo Frenchman." There were suspicions about the Federalist city council's decision in favor of McComb (the "New York bricklayer"), who had strong political ties to an influential Federalist senator and Alexander Hamilton, the Federalists' leader.[4]

Defining the Profession

In the more populated parts of the United States there soon were organizations of tradesmen and merchants, some of them including builders. In smaller places artisans and merchants combined; in larger cities all the building trades might establish a single organization as they did in Albany, New York, in 1793 and in Augusta, Georgia, the following year. These were not meant to be representative bodies. Their membership usually included only the dominant builders or craftsmen, who hoped to thereby validate their pre-eminence and restrain their competitors. The Master Carpenters' and Joiners' Society of Cincinnati in 1819 had twenty-eight members, at a time when there were in the city about eighty masters of those crafts and some four hundred journeymen and apprentices. (Joiners are workmen qualified to execute finish carpentry, doors, stairs, and panelling.) In 1825 the Master Carpenters of Boston expressed in a newspaper their "surprise and regret" that the carpenters they hired had joined together to press for a ten-hour workday, instead of the traditional dawn-to-dusk hours of work.[5] In order to broaden the scope of work for which they might contract, builders increasingly hired helpers from related crafts. The Mobile *Daily Commercial Register* in 1835 contained an advertisement for bids on construction of the Government Street Presbyterian Church, in which the broadening of builders' activities was spelled out.

> The carpenter's proposals will embrace the covering of the roof, and all the carpenters, jointers, builders, glaziers and plumbers work. The mason's proposal will embrace the excavations for the foundations, and all the brick, plasterers and stone cutters work.[6]

Charles Bulfinch was probably the first American-born designer to assume the role of architect without first being qualified in one of the building trades. The son of two very prosperous Boston families, after young Bulfinch graduated from Harvard in 1781 there was little to occupy his time.

> I was placed in the counting room of Joseph Barrell, Esq., ... but unfortunately the unsettled state of the times prevented Mr. Barrell from engaging in any active business ... my time passed very idly and I was at leisure to cultivate a taste for Architecture, which was encouraged by my attending to [observing] Mr. Barrell's improvement of his estate.[7]

When an uncle died and left £200 to Bulfinch's parents, the money financed their twenty-two-year-old son's travel in Europe for about nineteen months, a tour assisted by letters of introduction from the Marquis de Lafayette and Thomas Jefferson.

For eight years after his return Bulfinch served as a dilettante arbiter of architectural taste in Boston, until the failure of a real-estate venture forced him into bankruptcy, consuming his entire fortune and that of his wife. A Boston newspaper recommended that some way be found to assist "Mr. B. [who] has sacrificed the best part of his time, nay, his interest also, in ornamenting and beautifying the town."[8] Architecture alone would not provide a livelihood, could only serve as a supplement to an income from some more dependable source. After Bulfinch failed in two attempts to be elected to a city office that would bring a regular salary, the staunch Federalist majority on the city's governing board bestowed on Bulfinch the honorific, but uncompensated, position of Chairman of the Board of Selectmen, and later compensated him as superintendent of the police. At the same time, in the words of Mrs. Bulfinch: "My husband ...

made Architecture his business, as it had been his pleasure."⁹ Bulfinch continued to combine his income as an architect and his salary as a public official for some eighteen years, until he was called to Washington in 1817 to succeed Benjamin Latrobe as architect of the national capitol.

When Bulfinch left Boston, there were only three people listed as "architects" in the city directory: Peter Banner, an Englishman who had been listed as "carpenter" and "master-builder" in the New York directories before changing in 1806 to "architect" in Boston; Asher Benjamin, a Vermont carpenter-builder who arrived in Boston in 1803 as a "housewright"; and Alexander Parris, a Maine carpenter and schoolmaster who was skilled in both architecture and engineering. By 1830 the number of architects in the Boston directory had grown to eight, as opposed to almost six hundred housewrights.¹⁰

Around the 1840s the architectural profession in Boston was led by a trio, all three having come there after being trained in New England towns as carpenters. Their cooperative relationship is indicated by the fact that Solomon Willard at one time lived in Alexander Parris's household, and Isaiah Rogers, who was about twenty years younger than the other two, named his first son after Willard. Such harmony was limited in Boston's architectural community. Edward C. Cabot recalled that when he began practice in 1847 there were only "half a dozen architects and several of these had been bred as engineers," but the Boston city directory showed that about twenty people classified themselves as architects. Cabot remembered a competitive spirit with "but little sympathy between them, their designs were carefully guarded from each other and their libraries kept locked."¹¹

At this time master builders or housewrights acted as intermediaries between clients and designers. The owners of stores, householders needing new houses, or the leaders of civic organizations were accustomed to dealing with a trustworthy builder to whom they explained their needs. This information was then conveyed by the builder to the draftsman-designer who would execute the drawings. In 1832 when James Gallier arrived in New York from Dublin he found that

> ... the majority of the people could with difficulty be made to understand what was meant by a professional architect ... the builders, that is, the carpenters and bricklayers, all called themselves architects, and were at that time the persons to whom owners of property applied when they required plans for building; the builder hired some poor draftsman, of whom there were some half a dozen in New York at that time, to make the plans, paying him a mere trifle for his services.... All this was soon changed, however, and architects began to be employed by proprietors before going to the builders;¹²

Apparently this use of New York draftsmen was customary, for a Rhode Island mason-builder working in Charleston, South Carolina, wrote his client: "I Shall want to send to N York to have you A regular Set of Drawings made." After Charles Reichardt's Charleston Hotel burned, the builder engaged in 1838 to rebuild it sent the framed drawings to a New York draftsman-architect, who provided a set of working drawings. In Philadelphia Thomas U. Walter, son of a builder but trained in an architect's office, did not totally escape the preparation of quickly-drawn plans and elevations. Between 1831 and 1851, well before he assumed responsibility for continuing work on the U.S. Capitol, Walter undertook 373 projects, but almost two-thirds of them involved the hurried completion of minimal drawings for five to ten dollars a sheet.¹³

The more prominent architects in early 19th-century New York had almost all started their careers in the building trades, Ithiel Town, Martin Thompson, and Minard Lafever having been trained as carpenters. Their senior, John Mc-Comb, Jr., was the son of a mason-builder and had toured Europe after working for his father. However, A. J. Davis, Ithiel Town's partner, had apprenticed with a printer and excelled at preparing engravings of the new buildings and the scenery of New York and Boston. Among the major New York architects of the 1840s were a number who had not entered the architectural profession through the traditional route of training in a building trade. Richard Upjohn had been a skilled carpenter and cabinetmaker in England, but after coming to America had studied architecture with Alexander Parris in Boston. Leopold Eidlitz had studied estate-management in Vienna and worked for Upjohn in New York. Frederick Diaper had completed training in the office of a London architect before coming to the United States. James Renwick, however, was the son of a well-known New York engineer and after graduating from Columbia College in 1836 had worked on railroad construction and the preparation of the reservoir at the present site of the New York Public Library.

In Boston there was a similar trend away from architects whose experience came from the building trades, although housewrights still dominated in numbers. Gridley J. F. Bryant left Quincy, Massachusetts, at the age of fifteen and went to Boston, where he studied under Parris. E. C. Cabot, scion of a prominent Boston family, was one of the first to enter architecture through an initial interest in painting. Ill health had caused him to spend time sheep-farming in Illinois and Vermont until at the age of twenty-nine he won the competition for the design of the Boston Athenaeum. Henry Greenough, two of whose brothers were sculptors, at eighteen studied painting in Italy and architecture in France before opening his Boston practice. In a sporadic partnership with his brother, Hammat Billings practiced architecture, although he was more widely known for his book illustrations. Billings' multiple activities may have been necessary after he teamed with a builder in 1847 to contract for construction of a Boston church that in the end cost more than double their contract figure.[14]

The Government as a Client

Benjamin Latrobe, who was at all times proud of the professionalism with which he conducted his practice, finished the national capitol and spent three years restoring it after it was burned by the British during the War of 1812. He described the experience of working in an atmosphere of political intrigue and bureaucratic manipulation by saying: "The service of a republic is always a slavery of the most inexorable kind under a mistress who does not even give to her hirelings civil language."[15] Latrobe had been brought to the District of Columbia by President Jefferson at a time when the government was crowded with functionaries from the Federalist party, the results of the twelve years of the Washington and Adams administrations. At all stages Latrobe's work was vociferously opposed by Dr. William Thornton, winner of the competition for the design of the Capitol and a staunch Federalist with close ties to that party's leadership in Congress.

The battle between Latrobe and Thornton, equally haughty in temperament, lasted from Latrobe's first days in Washington until his departure in 1817. Thornton responded angrily to all suggestions and criticisms made by others regarding changes that might make construction of his orig-

inal design feasible; and Latrobe, who referred to himself as both architect and civil engineer, viewed Thornton as a mere novice in architecture, ignorant of any practical considerations involved in designing or constructing buildings. (The absence of definitive drawings makes it impossible to adjudicate this dispute now.) Both Latrobe and Thornton wrote scathing documents for distribution to congressmen, tracts that seem to have been taken seriously according to whether the readers were Republicans or Federalists. After a letter by Thornton to the editor of the Washington *Federalist* newspaper was published, Latrobe sued Thornton for libel, and after five years of delays the case was decided in favor of Latrobe, who was awarded one cent and costs.

In spite of the problems that might materialize, the small number of government projects offered tempting chances for architects to undertake large works that might occupy them for a lengthy period. After the failure of some engineering projects with which he was involved, William Strickland went to Washington to seek government commissions. Arriving there, he discovered that there were others on the same mission, and wrote a friend, "there are a great many more *pigs* than *teats*."[16] Almost as soon as the federal government moved to Washington it became evident that architectural and governmental concerns were not entirely compatible.

In Europe much of governmental building was controlled by monarchies, in which kings were usually succeeded by princes who owed some degree of respect to their predecessors' projects. But the American system of government had been designed with a relatively great capacity for change and disruption. Even under the best of circumstances, planning and completing an important building in the 19th century might take many years, much

longer than the terms of representatives, presidents, and even senators. Even if one political party were to remain in power through two or three presidential terms, there was a strong possibility that a project's progress would be challenged by financial crises, charges of malfeasance, or the jealousies and ambitions of bureaucrats. Disagreement and debate were essential elements of political life, and rarely would a building be so important that the administration in power would take a political stand on its design or construction.

Even before recognition of the "spoils system," it was the custom for winning political parties to replace officials with appointees from their own ranks, and there was an understandable belief on the part of presidents, congressmen, and cabinet members that their political supporters and personal associates merited special consideration when decisions were made about the government buildings that were to be built and the contracts necessary for their construction. As early as 1857 the army engineer in charge of federal construction pointed out in a report that custom houses and post offices were being located where their revenues did not merit the expenditure and that in some government-operated marine hospitals the employees outnumbered the patients.[17] As the scope and requirements of government inevitably increased with the area and population of the United States these fundamental problems of governmental architecture were also abundantly evident in the governments of most states, territories, and cities.

Matters of Faith

There was confusion in Florida churches when control of the colony and its state-supported churches shifted in 1763 from Catholic Spain to Protestant England and reversed just twenty years

later. But this problem was not so inflammatory as the religious factionalism that developed in the first half of the 19th century and continued to the end of the century. It has been estimated that in 1800 nearly all the population of the United States was of Protestant Christian faiths. (One assumes that slaves and native Americans are not included in this estimate.) Around seven-eighths of all these Protestants were members of the three dominant denominations that were extensions of sects present in Great Britain: Congregationalists most commonly found in the Northern states, Episcopalians in the South, and Presbyterians along the frontier.

The majority of Protestants, particularly the highly influential members of the upper-class faiths, were confronted with two frightening conditions. They feared and firmly opposed the threats posed by immigration and the spread of Catholicism. At the same time, within American Protestantism there was the internal threat represented by the growth of evangelistic denominations and Unitarianism, the latter a belief denying that Jesus was the Son of God. The Unitarian church, which had in 1782 had been founded in Boston, was fundamentally Protestant but disavowed belief in the Holy Trinity, thereby shocking the clergy and congregations of the major Protestant faiths. To many Americans in 1782 the popularity of Unitarianism in the upper class was fully as alarming as the admission of foreigners who were not even Protestants.

In this environment of religious controversy architects who designed places of worship, as most did on occasion, were often forced to position themselves cautiously with regard to the fierce sentiments of their churchly clients, but a single denomination would seldom suffice for an architectural practice. In Rhode Island, where Baptists were the largest religious group,

the Baptist architect, Thomas A. Tefft, was architect for about as many churches for other Protestant sects.[18] Through the antebellum period Richard Upjohn in New York was the principal architect for the Protestant upper crust of Episcopalians, members of the American modification of the Church of England, and his work was published by those groups' journals in the United States and England as models of religious propriety in architecture. Upjohn seems to have designed over 130 churches, which constituted the main part, although not all, of his practice, and his church designs were spread from Maine to Florida and as far West as Texas and Iowa. Additional small churches were no doubt built from the drawings provided in *Upjohn's Rural Architecture* (1852).

The clumsy way in which Upjohn in 1846 refused a commission to design a new building for the Federal Street Church in Boston, a Unitarian congregation, became an embarrassment. Rather than simply declining the commission, Upjohn wrote the church officers that he could not design a building for worshipers who did not subscribe to Trinitarian belief.[19] The *Christian Register* promptly printed a satirical correspondence in which a fictitious architect refused to design a church because of disagreement on the matter of "baptism by immersion or sprinkling." In the final letter of this lampoon the imaginary architect wrote to the imaginary church:

Sir:—
I go for immersion, and can, of course, have no farther correspondence with you. Unchristian as you are, … you will be glad to know that my refusal to deal with unbelievers will give me ten contracts where they would have furnished one. Trusting that the bitter lesson which you have now learned will win you to the mild light of Christianity, I am with due respect,

S. Sly[20]

The Federal Street Church incident occurred at the very beginning of a decade in which Upjohn had the greatest influence and designed his largest number of churches, and so the satirist may indeed have been prophetic.

In Philadelphia the recognized specialist in churches of various Protestant faiths was John Notman, who had arrived as a carpenter in 1831 and a decade later listed himself as an architect. Notman also became a specialist in landscape design and the planning of cemeteries, which were then replacing churchyard burial grounds. Almost all of Notman's churches were Episcopalian or Presbyterian, although he took part in the building of the Roman Catholic Cathedral of St. Peter and St. Paul in Philadelphia. The Cathedral had been started by Napoleon LeBrun, son of a French diplomat, who had studied under Thomas U. Walter. LeBrun was replaced by Notman, but later resumed the work after Notman was discharged because he refused to reduce his fee below the 5 percent of his contract with the church officials. Relying on his professional skill at satisfying the needs and preferences of his clients, Notman took no part in church controversy. Though he was married in an Episcopal church, Notman was buried from his residence, and was not known to be a member of any congregation whatsoever.[21]

Much of the increased immigration that began in the 1840s, was made up of Catholic refugees from the Potato Famine in Ireland. Although Roman Catholics had been only about 1.3 percent of the population in 1800, the flood of Europeans—1.5 million in the 1840s, 2.5 million in the next decade—included many Catholics. Anti-Catholic and xenophobic feelings were so strong that, for example, in 1844 two riots in Philadelphia resulted in fifteen people being killed and three Catholic churches and forty houses being burned down in an Irish neighborhood.

Many Catholic churches were, of course, designed by the contractors who built them, perhaps with the assistance of a priest's picture of a church in his homeland. In the state of New York, Patrick C. Keeley, an Irish architect's son who came to Brooklyn in 1841, was said to be the architect of at least five hundred churches in the state of New York, not counting those in New York City. Keeley's designs included the Catholic cathedrals of five states in New England and extended from Montreal to New Orleans. The needs of Catholic parishes in St. Louis had the attention of Stuart Mathews and his nephews John F. Mitchell and Robert S. Mitchell, who were trained in Mathews' office. Mother Joseph Parizeau, a Sister of Charity of Providence and the daughter of a carpenter-builder in Montreal, in 1856 arrived in the Pacific Northwest, where her missionary efforts included designing and seeing to the construction of schools, hospitals, and other church-operated projects in what became the state of Washington.[22]

Available Knowledge

Builders and architects gradually came to have available a variety of publications that could assist them in their work. Measurers, who were usually also builders, were employed by the owners of buildings to verify another builders' charges by measuring the amount of work that had been completed and applying the prevalent prices for such work. For this purpose they used local "price books" that were prepared for major cities, listing materials, the grades available, and the price for the unit by which such work was customarily calculated. (Builders' bills often also included an item designated as "expenses of the evening," which recorded the cost of food and drink for the workmen's celebration upon completing a project.) The Philadelphia Carpenters' Company for years maintained

AMERICAN BUILDER'S

GENERAL

PRICE BOOK AND ESTIMATOR,

NOW FIRST PUBLISHED,

TO ELUCIDATE THE PRINCIPLES OF ASCERTAINING THE
CORRECT VALUE OF EVERY DESCRIPTION OF

ARTIFICERS' WORK

REQUIRED IN BUILDING,

FROM THE PRIME COST OF MATERIALS AND LABOUR

IN

ANY PART OF THE UNITED STATES,

DEDUCED FROM EXTENSIVE EXPERIENCE

IN

THE ART OF BUILDING,

TO WHICH ARE ADDED,

A VARIETY OF USEFUL TABLES,

Memorandums, &c.

BY

JAMES GALLIER,

ARCHITECT AND BUILDING SURVEYOR, NEW-YORK.

NEW YORK:

SOLD BY LAFEVER AND GALLIER, ARCHITECTS, CLINTON HALL;
STANLEY & CO., PUBLISHERS, 418, BROADWAY; and 50, CANAL-STREET;
And of all respectable Booksellers in New-York, Philadelphia, and Boston.

Above and on next page: Although this price book, published in 1833 by James Gallier, was based on prevalent New York prices for the materials and labor required for common construction, the title page insists that its information applies to "any part of the United States." In most instances, 20 percent was added for the contractor's profit and contingencies. A comparison to modern prices can be made by noting the laborer wage of $1.00 per day. (James Gallier, *The American Builder's General Price Book and Estimator*, 1833.)

PLASTERERS' WORK.

COST OF ONE HUNDRED AND FIFTY YARDS OF PLASTER; FLOAT, AND HARD FINISH ON BRICKWORK.

		$	cts.
8 casks of lime	at $1 50	12	00
11 loads of sand	0 50	5	50
6 bushels of hair	0 25	1	50
Plasterer 5 days	1 62½	8	12½
Labourer 5 days	1 00	5	00
		32	12½
20 per cent profit :		6	42½
		38	55

$ 38.55 per 150 yards = 25⅔ cents per yard.

COST OF ONE HUNDRED AND FIFTY YARDS OF LATH, PLASTER, FLOAT AND HARD FINISH.

		$	cts.
8 casks of lime	at $1 50	12	00
11 loads of sand . . .	0 50	5	50
6 bushels of hair . . .	0 50	1	50
3000 laths	2 00	6	00
30 lbs. of nails . . : .	0 07½	2	25
Plasterer 8 days . . .	1 62½	13	00
Labourer 5 days . . .	1 00	5	00
		45	25
20 per cent profit . .		9	05
		54	30

$ 54.30 for 150 yards = 36¹ cents per yard.

THE FOLLOWING LIST OF PRICES IS MADE FROM THE COST OF MATERIALS AS UNDER.

Thomaston lime per cask,	$ 1 50	Sand per load, . .	$ 0 50	
Hair per bushel, . . .	0 25	Laths per thousand,	2 00	
Nails per pound, . . .	0 7½	Plaster per bushel,	0 75	
Plasterer per day, . .	1 62½	Labourer per day,	1 00	

a price book for the use of its members, who signed a pledge of secrecy and paid a deposit when they received their copies. The price book was so valued by the Carpenters' Company that upon the death of a member his widow would be visited—some thought with unseemly promptness—by a representative of the Company who would return the deposit and regain custody of her husband's price book.

The Carpenters' Company was shocked in 1801 by the publication of a pirated edition of its price book, but about a decade later a national edition was brought out by the Carpenters' Company itself. This edition included instructions for local adjustment of the figures given, such as the advice that in Virginia, New Hampshire, Vermont, Massachusetts, Connecticut, and Rhode Island the costs should be reduced by 20 percent and in South Carolina and Georgia they should be multiplied by 28 and then divided by 45. After the Practical House Carpenters' Society was founded in Philadelphia in 1789, its price book competed with that of the Carpenters' Company. James Gallier, upon arriving from Ireland, found that in there was no price book available in New York, and he set about compiling the *American Builder's General Price Book and Estimator* (1833). The publication did not prove to be profitable, but it had been intended to attract people to a series of lectures that Gallier delivered in an effort to make his name known in New York.[23]

A broader influence came from workmen's handbooks, beginning with imported copies and the publication of American editions of the handbooks that were most popular in the British Isles. In addition to the orders of classical architecture and a few Gothic examples, typical handbooks included difficult construction details (such as the framing of spires and steeples), ornamental work (entrance doors and mantelpieces), and sometimes plans and elevations of relatively simple buildings. Handbooks became so essential to a carpenter's work that a Maryland judge in 1817 ruled that creditors could not compel a bankrupt builder-designer to sell his handbooks, because he would find it "hard to separate them from his chisels and plane."[24]

The first architectural handbook published in the United States was Abraham Swan's *The British Architect*, which was printed in Philadelphia in 1775, thirty years after being first issued in London. While Swan had been listed on the title page of the London edition as a "carpenter," he was identified in America as an "architect." William Pain's *The Practical Builder*, which had come out in London in 1774, was published in Boston in 1792, and in the next five years three other books by Pain appeared in the United States. Peter Nicholson's *The Carpenter's New Guide*, which saw its first American edition in 1818 and its sixteenth edition in 1871, was probably the most popular construction handbook in America.

The Country Builder's Assistant, the first architectural handbook to be written by an American, was published in 1797 by Asher Benjamin, a New England carpenter and housewright. In 1803 Benjamin left Windsor, Vermont, and set up practice in Boston. There Benjamin was listed in the city directory as "housewright" until 1810 when he declared himself "architect and builder," following the example of his English-trained competitor, Peter Banner. Benjamin's handbooks by 1856 totalled seven different titles, which were published with frequent revisions through a total of forty-seven editions. His fourth and most popular book, *The Practical House Carpenter*, was reprinted twenty-one times.

In *The American Builder's Companion* Benjamin explained the need for a handbook prepared by a knowledgeable American craftsman:

> Books on Architecture are already so numerous that adding to their number may be thought to require some apology; but ... not more than one third of the contents of the European publications on this subject are of any use to the American artist.... The style of building in this country differs very considerably from that of Great Britain and other countries of

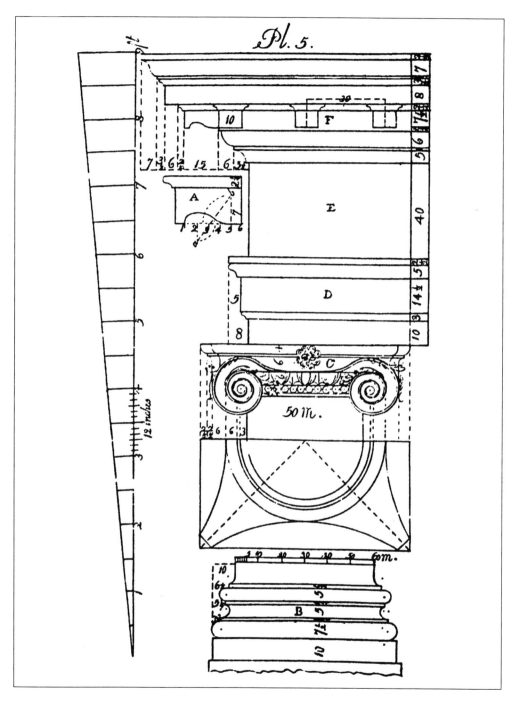

Above and on next two pages: Asher Benjamin's *Country Builder's Assistant* (1797) included much the same information that could be found in English handbooks, except that American handbooks tended to adapt details to the use of wood instead of stone. "Plate 5.—The Ionic Base, Capital, and Entablature, with all their Mouldings, figured for practice, in height and projection." "Plate 15.—On this Plate is the Tuscan, Doric, and Ionic Pedestal Mouldings, which may be drawn from the same scale, that you draw the orders from." "Plate 97.—The design for a small steepled church having an interior space about 50' by 60'."

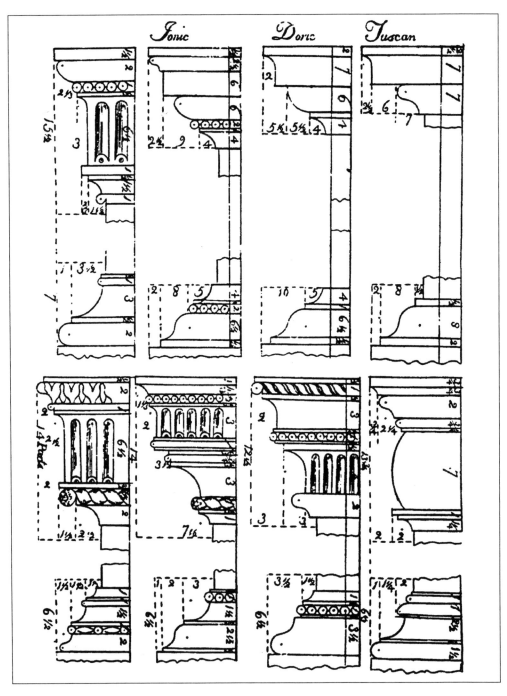

Europe, which is partly in conse-
quence of the more liberal appropri-
ations made for building in those
countries, and of the difference of
materials used, particularly in the ex-
ternal decoration.

In spite of these distinctions between
the methods of building appropriate for
English conditions and those of America—
and there were more than Benjamin ac-
knowledged—the author realized that craft
traditions were exceedingly slow to change.

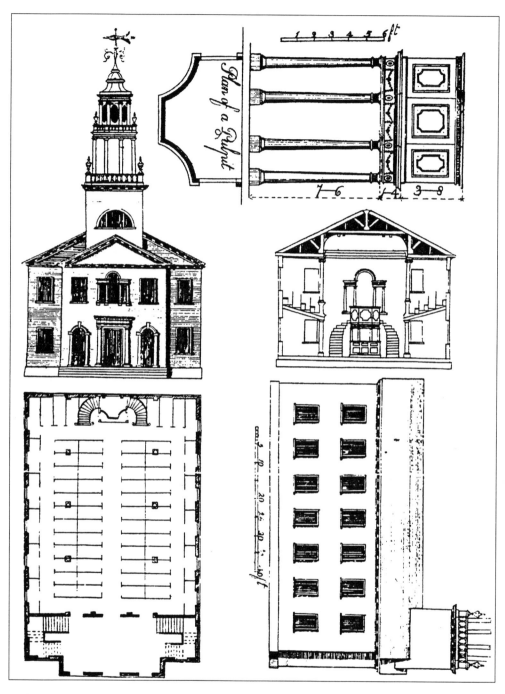

Referring to two of the sources that were frequently found in the libraries of American architectural dilettantes and housewrights, Benjamin warned his readers: "Old fashioned workmen, who have for many years followed the footsteps of Pal-ladio and Langley, will, no doubt, leave their old path with great reluctance."[25]

Owen Biddle, a Philadelphia "House Carpenter and teacher of architectural drawing," published *The Young Carpenter's Assistant* in 1805; and the following

year Stephen William Johnson produced *Rural Economy*, which in addition to the usual contents offered information on rammed earth construction, "the Culture of the Vine; and on turnpike roads." Just two years after he came to Philadelphia from England, John Haviland began publication of *The Builder's Assistant* in several volumes (1818–1824). Minard Lafever, a New York "carpenter and architect" as he was listed in the 1828 city directory, published five handbooks that had a total of fifteen editions between 1829 and 1856.

Although only one architectural book had been published in the 1790s, the demand increased until ninety-three were issued in the 1850s. Every builder had one or more handbooks on which he relied most. A Charleston mason-builder clarified his design by writing his client regarding his house's doors and windows:

> sliding and folding doors (as per plate No. 7 in Lafevers modern Architecture 1835 ... in the hall and dining room & Library to be finished as per plate 19 in Lafever ... [in] the second story to be finished as pr plate no 14 with no 19 cornice ... entrance to be as p/ plate no 13.[26]

(Some of the function of workmen's handbooks were continued by Ramsey and Sleeper's *Architectural Graphic Standards*, a handbook for architectural drafters first published in 1932 and in its tenth edition in 2000, having grown from 240 to 1,092 pages.)

The costly pattern books that contained exquisite engravings of buildings and details fulfilled much the same function, assisting in the practice of architecture by providing examples that could be agreed upon before the demanding processes of adaptation and drawing were required. The plates of pattern books provided ideas, and they also furnished justification for many design decisions. Almost a decade after he left the presidency,

Thomas Jefferson was invited to add his improvements to the drawings of another Virginia planter and amateur architect. Jefferson wrote back that this was impossible because he had sold all of his books to the Library of Congress. A Kentucky client of Gideon Shryock wrote his wife, describing the results of his meetings with the architect: "... we talked over a plan.... We have agreed already as to the front, which is to be taken from a plan of a country house in England which we selected from one of his books on architecture."[27] Obviously, clients' choices most often underwent difficult adjustment to fit their requirements and their budgets and to combine elements artfully that had been selected independently.

Professional Libraries

Some of the first professional libraries were established by organizations of builders. A group of Boston builders met at the Green Dragon Tavern in 1804 to organize the Associated Housewright Society, which would attempt to standardize the wages that members paid their workers and regulate other aspects of the business. The annual dues of the Society's members were principally used as emergency help for the families and apprentices of members who were sick or had died. The Society purchased a majority of the shares in the Boston Architectural Library that had been organized by two architects (Ithiel Town and Solomon Willard), two housewrights, and a stucco worker. In 1809 the Library consisted of fifty-five volumes, mostly handbooks and the English pattern books that might well be too expensive for builders to purchase individually. When hard times came in 1837 Alexander Parris became custodian of the Library, and made the collection available at his office.[28]

The Carpenter's Company of Phila-

delphia also began the development of a library, which in 1827 listed sixty titles in its catalog, but by 1858 the catalogue included just 109 architectural books, about evenly divided between British and American publications.[29] A large part of this increase was the result of the Company's purchasing from Thomas U. Walter twenty-three volumes on Egyptian architecture that were published after Napoleon's military campaign there in 1798-1799.

Architects of the time might make use of an organization's library, but those who wished to keep up to date also kept their own libraries. Fifty-two books on architecture comprised the New York professional library of John McComb, Jr. The personal professional library of Charles Bulfinch, which may have included some of his grandfather's and uncle's purchases, is said to have numbered around thirty volumes, over two-thirds of them published in London. Five or six were carpenter's handbooks, but most of the others were stylish pattern books.[30]

The largest architectural library of the period was that of Ithiel Town, who had profited from the royalties he received for use of a truss he designed around 1820. The Town lattice truss was a long horizontal rectangle of wood diagonals bounded by timbers. Popular from Newfoundland to the Carolinas for use in railroad construction and covered bridges, the truss helped finance Town's purchase of books that numbered some 10,000 near the end of his life, with architecture and engineering the subjects of about 2,000 volumes each.[31] In addition, Town's collection included about 170 paintings and over 200,000 engravings, many of architectural subjects. While most of the library was kept at his residence, the professional collections were housed at Town's architectural office, where the books were available to the public. Perhaps Town's library and Davis's graphic skills enhanced the partners' positions in the intellectual and artistic circles of New York. Richard Lathers, a young Southern merchant who studied drawing and architecture with Davis, recalled that at Davis's studio he met such New York cultural leaders as the writers Washington Irving, James Fenimore

In Ithiel Town's house in New Haven his library occupied all the upper level of the central building mass, more than a quarter of the house's floor area. Town's professional libraries on architecture and engineering, slightly less than half of his collection, were kept at his office. (From an engraving by A. J. Davis.)

Cooper, and A. J. Downing, as well as the painter-inventor Samuel F. B. Morse. Town and Davis, and other architects such as Martin Thompson, John Frazee, and James Renwick were active in art organizations sponsored by Morse and William Cullen Bryant. But not all of the upper class were so generous toward architects who assumed the status of gentlemen. After a brief conversational exchange with James Renwick—later architect of St. Patrick's Cathedral in New York, seventh generation of wealthy Dutch landowners, and son of a prosperous merchant who was also a professor of engineering—this entry was made in the diary of a conservative New York lawyer and investor:

> Nature cut him out for a boss carpenter, and the vanity and pretension that are endurable and excusable in an artist are not to be endured in a mechanic.[32]

Arrivals from Europe

The influx of architectural talent from the British Isles increased after the American Revolution ended. Peter Banner, who came to Boston early in the 19th century, listed himself in the city directory as "Architect and Builder" and was soon absorbed into the community of Boston professionals. But William Jay, in spite of having influential connections and sound English training, spent only about six years in Savannah before returning home penniless. Two years after arriving from Ireland, James Gallier headed from New York to Louisiana in the company of Charles Dakin, and, while waiting in Mobile, Alabama, for news that the New Orleans yellow fever epidemic had ended, they prepared plans for a town hall, a school, and a church. London-trained George I. Barnett, only twenty-four years old in 1839, headed for St. Louis, where he soon would become a major figure in the architectural profession. From the first Barnett attracted notice in St. Louis by executing a perspective—a type of drawing that few Americans had mastered at that time—for an architect who had won a competition with the customary plans and elevations.[33]

Some of the British émigré architects had completed their professional training before coming to the United States. Charles Duggin, who became a New York residential architect, had been a member of the Institute of British Architects. Frederick Diaper, another residential architect in New York, was trained in the office of Sir Robert Smirke, and both John Haviland and George Snell, though almost thirty years apart in age, studied with the Liverpool architect James Elmes. Shortly before the outbreak of the Civil War the profession in New York was joined by J. Wrey Mould, who in England had been an assistant to Owen Jones, the period's acknowledged master of ornament. In the United States Mould became known as "that ugly and uncouth J. Wrey Mould, architect and universal genius," the last term referring to Mould's musical interests: the songs he wrote, the translations of opera librettos he published, and the highly regarded musical soirees at his residence.[34]

Most architects of French background came to the United States as a result of events in the history of France. In 1685 Louis XIV revoked the Edict of Nantes, which had provided French Protestants with a degree of protection from persecution by the government and the Catholic church. Benjamin Latrobe, Minard Lafever, and the South Carolina plantation owner Gabriel Manigault were all descendants of Protestant Huguenot families who fled their homeland, although intervening generations may have diminished their personal associations with France. Lafever's family settled in Pennsylvania in the seventeenth century; Manigault's started as builders and planters in South Carolina.

Many Americans opposed the French revolution, and Benjamin Latrobe was viciously attacked by a Federalist newspaper in Philadelphia, in spite of the fact that his family had left France about a century earlier, his mother had come from Pennsylvania, and much of Latrobe's schooling had been provided by Moravian institutions in Germany. Nevertheless, the Federalists' hatred of everything French was so intense that the Philadelphia tabloid *Porcupine's Gazette* denounced Latrobe as "the son of an old seditious dissenter" and reported that "he is now employed in the erecting of a *Penitentiary House*, of which he is very likely to be the first *tenant*."[35]

The French Revolution caused royalist architects to emigrate, and some of those who were connected with revolutionary movements left their homeland when their factions were out of favor. In many cases these émigrés stayed in the United States only so long as internal conditions in their own country prevented their return. Maximilian Godefroy, a royalist who had been a captain in Louis XVI's Royal Engineers, came to the United States in 1805 and served as an instructor at St. Mary's College in Baltimore, where he taught "architecture, drawing and fortification." At the same time Godefroy practiced architecture and became a friend and occasional collaborator of Latrobe before returning to Europe in 1819.[36] Marc Isambard Brunel remained in the United States for about five years, designing and building a New York theater in collaboration with the Mangin brothers and engaging in many engineering projects before going to England, where Brunel became one of the most brilliant of the early engineers.

Joseph Jacques Ramée had been one of the Jacobins, idealistic radicals of the early French Revolution, but due to the Reign of Terror he spent about sixteen years in Germany and Denmark before coming to the United States in 1812. As an experienced architect almost fifty years old, Ramée was soon involved in the preparation of fortifications for the War of 1812. When he left for Belgium after four years, Ramée was best known in the United States for planning Union College in Schenectady, New York. Pierre Charles L'Enfant and Stephen Hallett, both royalists and both heavily involved in the disorganized activity of founding the District of Columbia, chose to remain in the United States, living in relative obscurity after being discharged from their work for the government. Barthélemy Lafon at the start of the French Revolution escaped France to Louisiana, where he was known as a surveyor, builder, architect, and theatrical producer. It is said that Lafon laid out the stronghold of the pirate Jean Lafitte and was made a major when he and the pirate throng assisted Andrew Jackson in his defense of New Orleans.[37]

A third historical factor that brought French architects and dilettantes to the United States was the 1791 rebellion of some 400,000 black slaves against the French plantation owners in Santo Domingo (the island of Hispaniola, now Haiti and the Dominican Republic). Roughly 10,000 refugees from the island appeared in New Orleans, attracted by the city's French heritage. Making the most of their talents while they waited to regain their land and property in the West Indies, two of them, Arsène Lacarrière Latour and Hyacinthe Laclotte, advertised drawing lessons in a New Orleans newspaper, assuring its readers that they were in addition skilled at the "distribution, ornamenting, and furnishing of apartments in the newest taste, and according to the principles adopted in the Paris Academy of Fine Arts, of which they are both pupils."[38] They continued their practice in New Orleans and in 1815 were made majors in the U. S. forces defending the city, Latour being one of two engineers who played major roles in General Jackson's tactics.[39]

The three royalist brothers De Mun had fled France for Santo Domingo only to be forced to flee that island in turn. In Philadelphia they were at various times employed by Benjamin Latrobe, Louis De Mun becoming the architect's chief draftsman before leaving to join his brothers in Havana. Four Santo Domingans came to Charleston in the 1790s, and at different times presented themselves as architects. The Marquis de Grasse advertised his willingness to teach architecture and fortification, but during his short stay in South Carolina more students seem to have been interested in his other offerings, fencing and the use of the broad sword. The first architect in St. Louis was probably Gabriel Paul, a Santo Domingan refugee who spent some years in Baltimore before he came to Missouri in 1817. Paul's architectural activities in the end may have been very much those of a dilettante after his marriage into the wealthy and influential Chouteau family of fur-traders.[40]

Alfred Piquenard came to the United States in 1848 as a member of an Icarian group of sixty-nine idealistic Frenchmen who intended to establish a Utopian communistic settlement in America. After the failure of their community on leased land in Texas failed, the Icarians bought Nauvoo, Illinois, from the Mormons. Piquenard, whose father had been a builder, had studied in Paris at the *Ecole Centrale des Arts et Manufactures*, so when he left the Icarians he entered architectural work in St. Louis, including a brief partnership with George I. Barnett.[41] After service with the Missouri militia during the Civil War, Piquenard at the age of twenty-seven found employment and later partnership with a Chicago architect, John C. Cochrane, for whom he did much of the design work that won competitions for the capitol buildings of Illinois and Iowa.

The unsuccessful 1848 revolutionary uprisings of workers across most of Europe may have been a major factor leading to the arrival in New York of Dietlef Lienau, a German who had studied in both Munich and Paris. Known principally for decorative work and interiors, much of Lienau's architectural commissions came from a circle of Frenchmen in New York: houses for his brother and a French banker, as well as a warehouse for the French and Belgian Plate Glass Company. From Germany came young Oswald J. Heinrich and Albert Fink, who after taking part in the German uprisings left for America, where their German technical training helped them make their way. Fink combined architecture with railroad engineering, inventing a form of truss, and Heinrich in the end taught mining. It is likely that the workers' uprisings that took place in most European countries at that time were more often responsible for the emigration of families whose sons became architects.[42]

The major influx of German architects would come later in the 19th century, but by 1801 there were already enough German-born immigrants for those in the city of Charleston to construct a German Friendly Society Hall from plans provided by John Horlbeck, Jr. and Henry Horlbeck, two builder-architects who had been trained in Germany. Charles Frederick Zimpel, who apparently had some military background in his homeland, in 1830 came to New Orleans, where he worked as an architect and engineer. Zimpel became involved in real-estate speculation and after his losses from the crash in 1837 returned to Europe. There were several German builders and architects in New Orleans, most working for clients within the city's growing German colony, but Edward Gottheil, who arrived there in 1849, provided architectural services for a cross-section of the New Orleans population. Unfortunately after abandoning architecture to devote all his attention to business, Gottheil was bankrupt and left New Orleans.[43]

The Southern Frontier

The tradition of gentleman dilettantes continued in the southern states, that role being defined by the example of Thomas Jefferson. Visitors observed that Monticello seemed always to be in some phase of construction, and Jefferson confessed: "Architecture is my delight, and putting up and pulling down one of my favorite amusements."[44] The architectural activity of Gabriel Manigault, the rich Charleston dabbler, was reduced after he moved to Philadelphia in 1804, but Henry Izard, Manigault's brother-in-law, experimented in the use of odd geometries in buildings.

At most times there was a shortage of adequately trained craftsmen in the southern states, although records indicate that during the late 18th and early 19th centuries it was not uncommon for free black builders to sign contracts for construction. In the 1820s William Nichols, then working on the Mississippi state capitol, thought it wise to advertise for artisans in newspapers as far north as Pittsburgh and New York. James Gallier complained that in New Orleans he was himself compelled to direct craftsmen in their work and act as "foreman mechanic in each of the trades engaged in the building." Because the Episcopal bishop was afraid that local masons might not be capable of properly executing Christ Church's facade, Richard Upjohn in 1846 sent a New York mason to Raleigh, North Carolina.[45]

In the first decades of the 19th century a number of carpenters, most of them in their twenties, moved from small New England towns to southern cities, particularly Savannah, instead of gravitating to the major northern cities. Transfer southward permitted them to become builders in their own right, instead of spending years working for the builders in Boston and Providence. (Some of them still found it desirable to return to their hometowns in the North during the sweltering summer months.) The 1850 scheme for the Alabama capitol was prepared by Daniel Pratt, a former carpenter-builder from New Hampshire, although seventeen years earlier he had shifted his attention to the management of a company that manufactured cotton gin equipment. As late as the 1870s a New Jersey carpenter-builder who had become an architect in North Carolina made his advance in station known to all who read his advertisement:

> G.S.H. Appleget, Architect. Having had twenty years experience as a builder in New York, Philadelphia, and other large cities has concluded to devote his whole time to ARCHITECTURE. Designs and specifications, also Detail drawings (Fullsize) for buildings of any description, prepared at short notice WILL ALSO SUPERINTEND THE ERECTION OF BUILDINGS, WHEN DESIRED, BUT DO NOT TAKE CONTRACTS NOR EMPLOY HANDS.[46]

The southern colonies had developed later and more slowly than northern settlements, and it was well into the 19th century before the Gulf states came under U.S. control. The Louisiana Purchase of 1803 almost doubled the area of the United States, and the new land came with its own system of transportation, the network of the Mississippi and Missouri Rivers and their tributaries, which provided a system for bringing to market the products of the newly-acquired territory. In 1812 the first steam-powered boat heralded the new era as it left Pittsburgh, travelling down the Ohio River to meet the Mississippi and go on to New Orleans. By the 1830s New Orleans became a busy port, second only to New York. The population of Memphis, Tennessee, grew tenfold between 1830 and 1870, and became larger than the older Southern cities of Charleston and Savannah. Mobile, Alabama, through which the

cotton bales from the valleys of the Al-
abama and Tombigbee Rivers were shipped,
in the 1830s ranked third of all U.S. ports.

The growth of trade in key cities of
the South, particularly those on the Gulf
coast, resulted in an influx of businessmen
from the North, who rapidly became lead-
ers of their communities and clients of
local architectural talent or the architects
who followed them south. In his twenties,
Levi Weeks practiced in New York with
his brother, but after being acquitted of
murdering his paramour Weeks moved in
succession to Massachusetts, Ohio, and
Kentucky. After six years of roaming,
Weeks settled in Natchez, Mississippi, a
city that only about a decade earlier the
United States had taken over from Spain.
In the country home of a lawyer and plan-
tation owner from Massachusetts who had
recently come to Natchez, Weeks in 1809
introduced to the South the style of build-
ing that had been popular when he had
started in New York.[47]

The career of William Nichols fol-
lowed the westward development across
the Gulf states, starting in North Carolina
when he was in his early twenties and
following the needs of states for capitols,
university buildings, and the other archi-
tectural evidence of improvement and ad-
vancement. Nichols had been born in the
fashionable English resort of Bath, a mem-
ber of a family of builders. He arrived in
New Bern, North Carolina, in 1800, moved
up coast to Edenton after six years, and in-
land to Fayetteville twelve years later. Dur-
ing the time that Nichols spent in Fayet-
teville he was officially designated as State
Architect of North Carolina, responsible
for improvements to the existing state
capitol in Raleigh. From 1827 to 1833
Nichols was State Architect in Alabama
where he was responsible for the state
capitol in Tuscaloosa and buildings at the
University of Alabama. Later his applica-
tion for the position of State Architect in

Mississippi was passed over, and Nichols
appeared in Louisiana around 1834 as As-
sistant State Engineer. Two years later
Nichols was made State Architect of Mis-
sissippi, where he was responsible for the
state capitol, the governor's house, and a
penitentiary. When the position of State
Architect of Mississippi was abolished in
1848, Nichols retired to Yazoo, Missis-
sippi, where he died three years later at the
age of seventy-one after almost a half cen-
tury of professional practice in the south-
ern states.[48]

A similar westbound movement across
the southern states was made by Abner
Cook. Once Cook had completed his ap-
prenticeship as a carpenter in North Car-
olina, his westward path fell inland to
Georgia and over the Great Smoky Moun-
tains to Nashville, Tennessee. It was only
two years before Cook, then twenty-five
years old, left Tennessee for the Republic
of Texas. Cook spent the remainder of his
life in Austin, except for two years during
which he superintended construction of
the Texas state prison at Huntsville, a pro-
ject in which the workmen were to be dis-
missed as soon as enough construction
was completed to house prisoners to take
over the work.[49]

At the start of the Civil War, many of
the Yankee builders who had come to the
South returned to their Northern homes.
Will Parkins, a native of New York who
had come to Columbia, South Carolina,
and married, spent eighteen months mak-
ing his way through Confederate lines and
escaping conscription. However, after the
war ended Parkins returned, and for a
time was the only architect practicing in
Atlanta and active in the reconstruction of
the city that General Sherman had burned.[50]

A Professional Community

The *New York Evening Post* in 1803
published an announcement addressed to

the "Noble Architects" of the "Brethren of the Workshop of Vitruvius" that cancelled a meeting "in consequence of the prevailing Epidemic." A few months later an advertisement made it known that "a meeting of the Order will be held on Friday next, ... at the usual place."[51] The use of the name Vitruvius suggests that this organization was in some way related to architecture, but it seems instead to have been a lodge that for some obscure reason had chosen to identify itself with that ancient Roman architect. At that time just four men were listed as architects in the New York city directory: Levi Weeks listed as an architect only, Joseph Baird and Edward Probyn as both architects and builders, and Samuel Clark as combining the roles of architect and grocer. (Clark's brother was listed in the directory as builder and grocer.)

There were still few who pursued the profession of architecture without some other means of livelihood. One builder in New York offered to erect structures and stated that "Plans and Elevations will be drawn suitable to the applicant," for which services "one quarter of contract money will be taken in Dry Goods or Groceries."[52] A Philadelphia advertisement in 1804 made it known that William Bridges, "Engineer, Architect, and Land Surveyor" could "furnish plans, estimates, and minute specifications," and that his wife offered an "assortment of millinery and also ladies' morning dresses...."[53] When Jonathan Goldsmith came to Ohio from New Haven in 1811 opportunities for work as a builder-carpenter soon dwindled, forcing him to begin working as a cobbler. But seizing upon opportunities was common in even the most settled parts of America. Between 1810 and 1840 almost a fifth of the college-educated lawyers in Massachusetts and Maine left the general practice of law for positions in banks, railroad companies, and new industries.[54]

Among the professions there were three groups that were generally recognized in the early 19th century: the clergy, law, and medicine. Clergymen had their own system of recognition as established by the many religious denominations, but both doctors and lawyers sought to clarify their status through governmental recognition. By 1800 three-quarters of the sixteen states had passed laws for the licensing of lawyers, and by 1830 twenty-one of the twenty-four states had the same for doctors. However, the democratization that began with the election of Andrew Jackson brought growing distrust of the professions and the gentlemanly status that they affected. This change in the public perception of professions was consistent with the egalitarian spirit of the time, but it was also a response to monopolistic attitudes within those professions. By 1860 only a quarter of the thirty-three states still required licenses for lawyers, and some of those had eliminated all punishments for practicing law without a license. Almost no states retained licensing for physicians.[55] Only after the Civil War would a growing respect for education and a waning enthusiasm for democratization result in restoring licensing legislation. Among architects, professional organizations and legislative approval would become indicators of the profession's advancement.

The idea of establishing a national professional organization may have been suggested by the meetings of English architects, principally those in London, between 1834 and 1837, meetings that led to the founding of the Institute of British Architects. (The term "Royal" was added in 1866 with the permission of Queen Victoria.) The Architectural Association, which was formed in London in 1842, tended to have younger members and a more liberal point of view. In France the *Société Centrale des Architectes* was organized in 1843, although there had previously been a few

local organizations in the major provincial cities. The *Architektenverein zu Berlin* (Architects' Society of Berlin) was founded in 1824, and provincial organizations that were established in the 1850s and 1860s were amalgamated into the *Verband deutscher Architekten- und Engenieur-Vereine* (Union of German Architects' and Engineers' Societies) following national unification in 1871. In the United States the American Society of Civil Engineers and Architects was founded in 1852, and it was 1869 before the words "and Architects" were dropped from the organization's name.[56]

Eleven architects met in early December 1836 at New York's Astor House hotel to form the American Institution of Architects. Attending were: William C. Cramp, A. J. Davis, Charles F. Reichardt, Isaiah Rogers, F. Schmid, Thomas Thomas, Thomas Thomas, Jr., all residents of New York; John Haviland, William Strickland, Thomas U. Walter of Philadelphia; and Richard Bond of Boston. The organization was intended to represent all the United States, as indicated by the fact that invitations to the first meeting had also gone to architects as far away as Ammi B. Young in Vermont and James H. Dakin in New Orleans. William Strickland was elected president and Thomas U. Walter secretary, both from Philadelphia.[57] When the organization met in Philadelphia in the spring of the following year, its roster included twenty-three architects (their average age in the mid-forties), two associate members, and twenty-five honorary members. At about the same time that the American Institution of Architects was organized, the New York building boom, which had begun in 1834, suddenly collapsed. One of the founding members, Charles F. Reichardt soon left New York for Charleston, South Carolina, and other New York architects looked to the thriving Southern states for clients. Although little is known of its activities, the Institution continued for about ten years, being defunct by the early 1850s.

In February 1857 thirteen New York architects attended a meeting Richard Upjohn hosted in his office. Those attending were: Charles Babcock (Upjohn's assistant and son-in-law), H. W. Cleaveland, Henry C. Dudley, Leopold Eidlitz, Edward Gardiner, Richard Morris Hunt, J. Wrey Mould, Frederick A. Petersen, J. M. Priest, Richard Upjohn, Richard M. Upjohn (their host's son), John Welch, and Joseph C. Wells. Six of the twelve who were invited had been associated with Upjohn's office. Upjohn, then in his fifties, and Petersen, a German émigré, were senior in the group. Upjohn felt that the number present was sufficient to start the organization, but Petersen considered it imperative to contact other architects so that the organization would not appear to be a New York clique. Petersen's view prevailed, and an additional twelve were invited to membership. Of this second group six had received their early training in England before coming to the United States; three had offices in Boston, and one in Philadelphia. At this time the median age of members was almost ten years below that of the 1836 organization.

At the first meeting the new organization was named the New York Society of Architects, but that designation was changed to American Institute of Architects (AIA) in order to indicate the founders' broader plans. (The first meeting was actually held on 23 February, but it was decided that it would officially be recorded as 22 February, perhaps to coincide with the birthday of George Washington.) Continuity was provided when Thomas U. Walter, secretary of the 1836 Institution, turned its records over to the new Institute. The following year a meeting of the AIA had twenty-eight New York architects present. From the first there were plans for

the presentation of papers by members, but there seems to have been difficulty in accomplishing that goal. Annual conventions were held in cities other than New York, even so far west as Chicago. A modest library was acquired by the Institute, but when the Civil War began the organization vacated its small meeting room in New York and shifted its library to Upjohn's office for safekeeping.[58]

Architects' Fees

Like many of those who came to America after having begun professional work in Europe, Latrobe was inclined to make disparaging remarks about American clients and architects. Latrobe had been confronted early in his American career by members of the powerful Carpenters' Company of Philadelphia whose members sometimes declined projects if the detailing and supervision of the work were not placed entirely in their hands. Latrobe said, "I have had to break the ice for my successors, & what was more difficult to destroy the prejudices the villainous Quacks … had raised against me." Of the Philadelphia carpenter-housewrights he grumbled: "They have done me the honor to copy and to disgrace by their application almost all my designs…." Nevertheless, Latrobe recognized that the builders were but a natural part of America's architectural development. In 1806 he wrote his former student and assistant Robert Mills:

> The building artisans, especially the Carpenters have been sufficiently informed [skilled] to … supply the orders of a young country. Out of this state of infancy we are now emerging, — & it is necessary that those who have devoted their best Years & a very considerable expenditure to the attainment of that variety of knowledge which an Architect ought to possess, —should take their legitimate rank….[59]

An early seal of the American Institute of Architects combined medieval motifs, particularly appropriate during the eighteen years that church-architect Richard Upjohn was president.

Although Latrobe warned Mills, "Do Nothing Gratuitously!", he sometimes disobeyed that rule himself. There was always in Latrobe's discussions of the architectural profession a conflict between hardheaded business behavior and the generosity and public concern that were a part of the architect's status as a gentleman. Regarding the percentage fee common in Europe, Latrobe insisted that it was "just as much as is charged by a Merchant for the transaction of business, expedited often in a few minutes by the labor of a Clerk."[60]

Professional fees of architects would always be a subject of debate. In 1798 Latrobe, who firmly believed in the need for professional standards, wrote state officials in Virginia regarding the questionable logic of charging a percentage of the total cost of a project:

I never was of opinion that the charge of a regular sum prCent upon all buildings was a fair mode of recompence. Upon very small works of taste it is much too little, upon very extensive ones, it is often too much. It is however difficult to contrive any other more eligible method, and compared with the charge of merchants for their negotiations, it is in all instances very reasonable.[61]

Latrobe added that in France, Germany, and England the usual fee for full professional services was 5 percent of the total cost of the building, half for the design and preparation of drawings and the other half for supervision of its construction.[62] In addition, if the site were at some distance from the architect's place of residence it was customary to pay all travel expenses and a daily fee for any trips to the site that might prove necessary.

Still, percentage fees were not always the customary method of determining architects' reimbursement. In many cases payment was much like the sale of drawings. In 1848 the "designs without superintendence or working drawings," plans and elevations, for a small cottage costing $1,000 were listed by A. J. Davis at $50 (which equalled a fee of 5 percent), but the price for drawings of a $20,000 cottage was increased to only $150 (0.75 percent). By 1850 Davis had changed his method of charging and listed "full professional services" at 5 percent and a set of drawings and specifications as 1 percent.[63] Russell Warren, who practiced in Rhode Island, charged $100 for the specifications and simple drawings required for a residence or church.[64] In frontier areas the early practices of selling drawings persisted. In Indiana John Elder charged Henry Ward Beecher $15 for the plan, specifications, timber list, and price estimate for a house. It must have been a large house, for the same services with respect to a building that would be occupied by two stores re-

quired a fee of $12 and a three-story hospital with a modest dome merited a fee of $100.

In this period it is often difficult to distinguish between architects' payment by clients and the kickbacks some architects obtained from contractors and the suppliers of materials. In a meeting of the revived AIA, Charles Babcock urged determination of a schedule of charges in order to combat competitors "who please their employers by charging a very low price for their plans, and cheat them of three times the amount by connivance with the contractors."[65] The Constitution of the Boston Society of Architects, as adopted in 1867, contained a passage that forbade its members' accepting "direct or indirect compensation for services rendered in the practice of his profession other than the fees received from his clients," a phrasing that acknowledges a common practice of architects receiving kickbacks from contractors or suppliers.[66]

A full discussion of architects' fees, as they were viewed in 1861, is provided by the detailed reports in the *Architects' and Mechanics' Journal* regarding the lawsuit of Richard Morris against Dr. Parmly, a New York City dentist who was active in real-estate speculation. At issue was payment of the fee for preparing drawings and supervising construction of a house, the design having begun in France and becoming Hunt's first architectural commission after he returned from the *Ecole des Beaux-Arts*. No written client-architect agreement had been executed for Hunt's architectural services, and Parmly alleged that he had hired a builder to replace Hunt's expensive plans and had made other arrangements for supervision of the work. In addition to the lack of a contract, there were complications due to the client's frequent change of the functions to be served by the building and errors Hunt had made in technical matters. However,

the heart of the lawsuit lay in Parmly's expectations of buying drawings in the manner that had long been tradition in New York and Hunt's intentions of rendering full professional services, as he had observed them in France.

The jury's decision was a compromise, allowing Hunt only the fee for preparing drawings.[67] However, the testimony of such respected practitioners as Richard Upjohn, Frederick A. Petersen, J. Wrey Mould, and others did much to establish the fees due architects. Upjohn testified in court that:

> Five percent on the cost of the house; that has been the customary charge for ten or twelve years, if not longer … many architects in this city … will do it [make drawings] for anything; if they can't get $10 they will take $5; they are men who are half way between builders and architects; they are not architects.[68]

Eleven Chicago architects in the 1850s combined to publish their schedule of fees on a percentage basis, ranging from 3 percent to 5 percent for full architectural services including the preparation of plans, specifications, and working drawings as well as the supervision of construction. The lowest fee was listed for simple projects, such as "Plain Wholesale Stores and Warehouses," and the highest fee was for "Gothic, Norman, or Romanesque" courthouses or schoolhouses, which merited 1 percent more in fee than the same kinds of buildings executed in the "Grecian or Italian style."[69]

It was not uncommon for building committees to seize on superintendents, clerks-of-works, or draftsmen to continue an architect's work, invariably at a lower cost. In this manner business inexperience and ambition were exploited as a means of saving public funds, which was always laudable in political circles. Construction of the capitol for North Carolina had hardly begun when the Commissioners voided their agreement with the New York firm of Town & Davis and put the clerk-of-works, David Paton, in charge of the project. Paton, whom Ithiel Town had sent to Raleigh several months earlier, had been trained by his father, an architect in Scotland, where Greek Revival architecture was at its peak. Repeatedly Paton was promised salary increases, which kept him on the job until the building was completed and he was summarily discharged. In Paton's petition to the North Carolina legislature for recompense, an Edinburgh architect attested to the quality of 229 drawings that Paton had made for the capitol, but after the building had been completed the drawings did not provide leverage, and Paton was never paid.[70]

Even when fees were clearly stated the abstract nature of professional services could be the basis for nonpayment of architects; buying drawings was a forthright exchange, but advice and supervision were less tangible. Ithiel Town sued a client in 1815 in a last-ditch effort to get payment for his services. After a panel of three arbitrators had agreed that he had submitted "a just and reasonable Bill," Town wrote his recalcitrant client:

> I have taken every method that I am capable of … for settling my accounts with you, amicably, fairly & according to the most simple & undeniable principles of Justice & equity;—but no one of those methods seems to meet your approbation.[71]

Town even proposed that he use part of the money—if it were paid to him—to purchase books for the new medical school's library in New Haven. Nevertheless, the client insisted on taking his case to court, where Town won. In 1793 the University of North Carolina engaged a relatively inexperienced builder to design and erect the institution's first building. During the disagreements that ensued the builder wrote the University's committee:

When I undertook this building I thought I had to Do with a Set [of] gentlemen that would Not Quible about triffles.... I have been Keppt out of the Second Payment Nearly three Months after it was Due.... And Now when finished for several months No payment Can be had.... To be Kept out of this Last Payment so Long ... not only Hurts my Credit but my feelings.[72]

Without construction contracts that spelled out terms for penalties, owners usually believed that delays, cost overruns, and other variables of the construction phase entitled them to penalties that would reduce their final payments to the architect or builder, who was usually reluctant to battle publicly the complaints of the community's outstanding citizens. When Gideon Shryock was denied his final payment by Morrison College in Lexington, Kentucky, he wrote the university officials that by making impossible for him to settle outstanding debts in connection with the work saying that they were "alienating me from my friends, destroying my credit, agitating my mind and disqualifying me for all the purposes for which my genius and talents have fitted me." Ten years after he left the Town & Davis office, two churches failed to pay John Stirewalt for his work, a delay that may have been due to a depression that had begun in 1837. Before abandoning his profession Stirewalt wrote A. J. Davis in despair: "I have made up my mind that if I continue longer as an architect I shall certainly *starve*."[73]

In earlier days the design of churches had often been a generous gesture by a parishioner who was a gentleman dilettante architect or merely an additional element of the contracted work of a builder-architect. As churches grew larger in size and required the services of architects, it became customary for church officials to insist on a reduction of the customary architectural fees. A church building committee seems to have insisted on special considerations when dealing with John Notman, who in 1848 acceded cautiously and informed the church officials that "my charge is 5 percent and travelling expenses, ... at the same time I will make a donation to the Seminary (as I promised Mr. Phillips) when the Committee pay me the balance."[74] A Baltimore Presbyterian congregation seems to have driven a hard bargain with Robert Cary Long, Jr., who agreed to provide his professional services "at the usual rate of 5 pr cent upon the cost of the building deducting one fourth of his Commission in consideration of its being a Church." When Long's lawyer presented the bill, the church building committee complained that the church had cost "much more than expected" and blamed Long for that fact. At last the committee offered to give Long a document acknowledging their indebtedness, but the architect accepted that solution only after the debt had been personally guaranteed by one of the church officers.[75]

Documents and Contracts

Some builders and architects employed models to demonstrate their designs to clients. John Holden Greene of Providence, Rhode Island, advertised in 1835 that thereby "every angle, brake, projection, and curve may be delineated and placed in full view which cannot be done on paper."[76] Nevertheless, the most common method of design development was drawing, since most of the devices, both functional and ornamental, were familiar. Plans, elevations, and sections were the mainstays of architects until perspective drawings were introduced.

Early drawings for building construction were simple. For construction of the Trinity College Library at Cambridge University during the last part of the seventeenth century, Sir Christopher Wren

F. GLEASON, { CORNER OF BROMFIELD AND TREMONT STREETS. — BOSTON, SATURDAY, MAY 14, 1853. — $3 PER ANNUM. 6 CTS. SINGLE. } VOL. IV. NO. 20.—WHOLE No. 98

MCLEAN ASYLUM, SOMERVILLE, MASS.

The McLean Asylum for the Insane, situated in the town of Somerville, a suburb of Boston, is well known all over this country as being one of the most excellent institutions of the character in this land, and probably in the world. Under the control of intelligent and liberal men, officered by persons of both sexes, chosen, as well for their humane dispositions and proper temperaments, as for their other professional qualifications, the institution has gradually come to share the entire confidence of the public, and especially of those who have been obliged to resort to its means in behalf of suffering friends. The faithful representation which we present below of the institution and the grounds attached, will be at once recognized by a majority of our New England readers, or any of the more distant ones who may have chanced to visit Boston, and seen the points of interest in its environs. The asylum is under the immediate charge of Dr. Bell, one of the most successful physicians that has ever attempted the treatment of the insane. Dr. Bell's report shows that there have been three hundred and sixty-six patients in the asylum

during the last year. Of these, one hundred and thirty-five have been discharged; more than one half of whom—seventy-two—have been restored to reason. The average number of patients has been exactly two hundred. The number of deaths, fifteen, has been unusually small for such an institution. Nothing of unusual incident has occurred in the asylum during the year. Dr. Bell advises us at length, of a necessity, the approach of which has for some time been apprehended, viz., the provision of further accommodations for the class of patients resorting to the asylum. Not more than one half of those for whom application has been made have been admitted during the last year—the refusal being occasioned solely on account of want of adequate room. Other hospitals in this region of the country are similarly crowded. Dr. Bell estimates that the fair extent of accommodation at the asylum, even after the completion of the Appleton Wards, will not exceed that for one hundred and sixty,—looking to the higher order of arrangements—although the number of patients has, at times, amounted even to two hundred and ten. The main buildings remain, in external dimensions, as they were

in 1837, when the household consisted of less than half of the present number, and the excess has, in a considerable degree, been provided for by interior alterations, encroaching even upon the proper quarters of those having official charge. These alterations have made the interior of the present asylum irregular and inconvenient, so far as those sections are concerned which have been fitted up at various times to meet pressing emergencies. The hope, which was cherished, that such alterations or enlargements would be no longer needed, after the many and large proposed New England establishments for the insane, has proved entirely illusive. Indeed, it is ascertained that there are as many insane patients, in this region of country, for whom accommodations cannot be obtained in an institution like this, as there were at the period of the establishment of the asylum. Dr. Bell is of opinion, for reasons which he gives, that it is true policy to establish another similar asylum, separated, in point of location, from the present one, but bearing similar relations to the General Hospital. He also believes that there would be advantages resulting from having entirely separate asylums for the two sexes.

VIEW OF THE MCLEAN ASYLUM FOR THE INSANE, IN SOMERVILLE, MASSACHUSETTS.

Before there were American journals for the architectural profession, popular magazines kept the profession and the public informed about the building projects in major U.S. cities. *Gleason's Pictorial Drawing-Room Companion*, published weekly in Boston from 1851 to 1854, on its masthead pictured the city's church spires, the dome of the State House (1795-98), and Bunker Hill Monument (1825-43). The magazine's issues often featured new buildings such as McLean's Asylum for the Insane which in the spring of 1853 had just been completed in a Boston suburb.

had prepared eight drawings, including two half-plans, a full elevation, a half elevation with half section, and a transverse section.[77] At that time much of the detail would have been determined as the work progressed by drawings produced by the architect or by decisions of the builder according to his experience. Details were often determined by reference to standard designs that were already known to the workmen or available in handbooks, or by referring to existing buildings in the region, particularly earlier works by the same architect.

In the 1820s Robert Mills' inked documents for a very small South Carolina church consisted of a plan, front elevation, side elevation, two cross-sections, and a lateral section, all at the unusual scale of ⅛"= 1'. Mills' drawings, on sheets of paper only 8½" by 11", were accompanied by several pages of handwritten specifications. About thirty years later A. J. Davis prepared a booklet measuring 10" by 13", which contained all the necessary architectural documents for a house on Long Island and consisted of eleven sheets of specifications and nine sheets of drawings that included plans, elevations, and sections.[78]

For small buildings architects often relied heavily on the experience and judgment of the builder who would execute the project. A dormer or stairway might at a small scale might be sufficiently indicated as a typical design, or perhaps a note would adequately clarify the designer's deviation from the examples shown in the standard construction handbooks that were in use at the time. For many buildings constructed under arrangements made with master carpenters and housewrights there was little need for drawings. In 1813 a Boston builder contracted to erect a building "exactly like the building next to the cooper shop; on said wharf and to be as good as that building outside and in every respect," a specification that may have actually been more precise than a limited set of documents. A less demanding contract arranged for a house "similar to Mr. Briggs' situated on said street."[79]

James Gallier, upon arriving in New York, had quickly discovered the customary procedure of residential clients in that city:

> When they wanted a house built, they looked about for one already finished, which they thought suitable for their purpose; and then bargained with a builder to erect for them such another....[80]

In other cases this technique could become much more detailed. The contract between Ithiel Town and the officers of New Haven's Trinity Church stipulated some of the materials to be used, facade details, and interior furnishings:

> ... good Middletown stone equal to those used in the New Meeting House for the First Society in New Haven ... Gothic Architraves to terminate with a finial similar and equal to the Providence church but the jambs of them are to be plastered.... The Pulpit and Reading Desk to be like or equal to that in the Providence church with a suitable canopy or sounding board.... The pews and aisles [with] book boards and kneeling boards as is common in the churches in New York.[81]

There was much confusion and dispute about the ownership of an architect's drawings. To clients it often seemed that, having paid for the preparation of drawings, the design became the client's property as would the portrait for which a painter had been paid. It seemed reasonable, under that logic, that the client as owner of the drawings might use them again or lend them to friends. (Architects' discussions of the ownership of drawings fail to mention the architect's possible reuse of designs.) The *Evening Post* com-

plained, "No layman is free from the liability of having a neighbor erect a dwelling-house precisely like his own."[82] When officials of the new University of Arkansas decided that they liked a building they had seen at the Illinois Industrial University (later University of Illinois), they asked the Chicago architect, John Van Osdel, for a copy of the plans. The drawings had been destroyed in the Chicago fire of 1871, but Van Osdel reproduced them and made changes the University desired for $1,000, less than 1 percent of the $136,246 construction cost.[83] A client's rights to drawings would be supported later when the British government successfully sued the heirs of Sir Charles Barry for the drawings employed in rebuilding the Houses of Parliament. In the United States it proved simpler to have the ownership of drawings stipulated in the architect-client contract, if such a document existed.

As a witness in *Hunt v. Parmly*, Upjohn had only been able to state that a contract regarding the architect's services was "not unusual," and that in his own practice he only occasionally entered into written contracts with his clients. Frederick A. Petersen stated at the trial: "It is very rarely that anybody asks me beforehand what I am going to charge ... to avoid such a question I have a tariff of prices fixed in my office right over my desk." (A half-century later Detroit architect Wells Butterfield would have his fees printed on the reverse of his business card.) Detlef Lienau testified at the *Hunt v. Parmly* trial, "It is most common for an architect not to have his compensation fixed: ... I do not very often make a bargain beforehand." Such reluctance to engage in hard-headed business and negotiate contracts was probably caused by established architects being anxious to maintain the "gentlemanly" aspect of the architectural profession and lesser architects being afraid to risk offending their clients. (In 1927 *The Architect's Hand-book of Professional Practice*, a publication of the AIA, would comment on: "The strange timidity that architects display in informing clients of their charges, and their willingness to go forward without any understanding whatever....")[84]

State Capitols

Around thirty state capitol buildings and hundreds of county courthouses were constructed in the United States between the Revolution and the Civil War. Some states used courthouses, theaters, lodge halls, and churches as temporary capitols, although the last of these solutions usually required making special arrangements regarding cursing and spittoons. Over a thirty year period, Vermont's legislature met forty-seven times in thirteen different towns before a capitol building was begun in the 1830s.[85] Some projects of the states and counties replaced structures that burned or became too small or dilapidated to satisfy the needs of a growing population and a faster-growing government; others marked the settlement of new territories, the admission of sparsely populated western territories into statehood, or the subdivision of a county or a state (Massachusetts to make Maine and Virginia to make West Virginia). In some cases the geographic redistribution of population and political power led to the purchase of undeveloped land for the establishment of new cities to serve as state capitols, cities located as geographical compromises between different socio-political factions.

The location of a state's capital city was usually a bitterly contested political decision, and it was usually feared that any delay in the construction of a capitol building might encourage the introduction of legislation to transfer the state's seat of government to a competing town. (Similar maneuvers had occurred during

the construction of the national capitol in the District of Columbia. When the U.S. Capitol was burned by the British during the War of 1812, Federalist congressmen promptly proposed that Washington be abandoned and the government returned to a northern location.) During the years of constructing a capitol building newly-elected governors and legislatures, who often had campaigned with accusations of corruption and promises of reform, were inclined to launch investigations of their predecessors before the inaugural ball had ended. Construction of Ohio's capitol took about twenty years, including a hiatus of six years (1840-1846) during which the legislature debated removing the capital from Columbus.

An architectural competition for the design of the Ohio capitol was advertised nationally, and resulted in the submission of over fifty designs. First prize was awarded to Henry Walter, a Cincinnati house-builder; second prize to Martin Thompson, previously Ithiel Town's partner in New York; and third to Thomas Cole, a painter who founded what is called the Hudson River school of landscape painting. (Among architects Cole is probably best known for his painting of "The Architect's Dream" in which a seated man gazes over a melange of buildings illustrating all architectural styles.) However, the building commissioners reported, rather disingenuously, that they were unable to select one of the three winners' designs as the building to be erected. This indecision may well have been related to one commissioner's long-standing friendship with Cole, who had been assisted by a nephew who had worked for Town & Davis in New York.[86]

The commission began excavation and construction of the building's basement, using dimensions that they believed to be satisfactory for any of the three winning designs. Meanwhile, two members of

the commission traveled to Philadelphia, where they discussed their problems with Thomas U. Walter, and then to New York, where A. J. Davis for $140 prepared a drawing meant to combine aspects of the three winning designs. Davis's proposal proved to be much too expensive in the opinion of Columbus builders, and the Cole scheme was revised with Henry Walter chosen to supervise construction. It was at that point that the Ohio legislature repealed the act that had initially authorized the construction of a capitol in Columbus, and it was six years before a new act authorized resumption of the work. All of the men put in charge of construction were subjected to fierce political attacks, and it was 1860 before the Ohio capitol was completed and occupied, having survived four boards of commissioners, five architects officially designated, twelve governors, and two state constitutions.

Architects on such projects usually found the legislatures and the building committees that were charged with constructing capitals to be stubbornly tight-fisted. Latrobe had explained this characteristic in a letter to his former student Robert Mills:

> Individuals, responsible only to themselves…, are often generous…; but a number of the same individuals, meeting as guardians of the public money, feel in the first place, the necessity of pleasing their constituents, and in the second involving themselves in no unnecessary responsibility.[87]

One of the most obvious ways to save money and gain the admiration of voters was the reduction or elimination of the architect's fee, more easily done in the construction phase of the project than during the preparation of drawings. In most instances this action was supported by the fact that an out-of-state architect might be

replaced with a builder who was well connected in the local network of politics.

The designs of four capitol buildings in this period came from competitions. A building so important in its state was an irresistible professional challenge for architects who aspired to large projects and the design of domes and multicolumn facades, and the boards and committees in charge of building the capitols were anxious to fulfill their charge with distinction. When the state of Tennessee in 1843 fixed on Nashville as its capital, the state's building committee was specifically instructed to select an architect *without* conducting a competition, although some members of the building committee would have preferred that method. Perhaps the Tennessee legislators knew of the problems that had been part of the state capitol competitions in Ohio and Pennsylvania, problems that were typical of many architectural competitions conducted during the 19th century. In Pennsylvania the committee had been discussing the project with an English-born builder-architect, A. Stephen Hills, but in 1816—four years after the capital moved from Lancaster to Harrisburg —an architectural competition was conducted. Wrangling began immediately among architects and among the politicians, false rumors were planted and empty charges made. Another competition was conducted, and Hills' design was chosen from the seventeen designs received.

The Tennessee committee began by dealing with Gideon Shryock, architect of a capitol building for Kentucky. However, the committee was informed that William Strickland, the Philadelphia architect under whom Shryock had studied for a year, might be available. Like many other architects, Strickland had few commissions during and after the Panic of 1837, a depression that lasted several years, and he gladly accepted the offer tendered by the Tennessee committee. Strickland moved

his family to Nashville, living and practicing architecture there the remainder of his life, and with the permission of the state's legislature he was buried in a tomb set within the walls of the capitol building.

The state capitols built after the Civil War were on the whole larger than their early counterparts and tended toward imitation of the national capitol as it had developed through the first half of the century. Competitions were conducted in more than half of the cases, although it was invariably unclear whether the purpose of such a competition was to select a design or select an architect. The competitions became somewhat more orderly, gradually coming to include advisory architects who prepared clear statements of the state's functional requirements and participated in evaluation of the designs that were submitted. Still, there were often disturbing irregularities that arose from the political environment in which the competitions took place.

Courthouses were smaller than state capitols but much more plentiful. The sixteen states that were part of the United States in 1800 now have over 845 counties, and the additional states that were admitted before the Civil War now have almost 1500 counties. Of course, many of these present-day counties were created later in the 19th century through subdivision of existing counties in order to satisfy warring political factions, but at all times replacements of dilapidated or burned structures increased the number of courthouses that had to be built. Designing the courthouses needed for these smaller governmental units was often a specialization of local and regional builders and architects. At first, the elementary needs of a county could be satisfied by frame structures, even log courthouses, of which at least sixty are known to have been constructed in Tennessee.[88] More pretentious structures were produced by builders referring to their

handbooks for the design of columned porticoes and cupolas. As part of South Carolina's program of improvements in the 1820s, Robert Mills designed sixteen courthouses and twelve jails, another essential of local government. When Indiana became a state in 1816, the legislators solved their immediate problem by providing half the funds needed for a courthouse in Marion County, where the state capital, Indianapolis, was to be located. In 1833 John Elder, a builder from Pennsylvania, arrived in Indianapolis, and before he left for California in 1850 Elder had designed and built four Indiana courthouses. Another courthouse, which had been designed by Elder, was constructed by Edwin May, who was heir to the specialization. May went on to serve as architect of some six other courthouses in Indiana, and shortly before his death May's design for an Indiana state capitol was accepted.[89]

Westward Movement

Roving frontiersmen, engaged in trapping or mining, required only simple structures that they could build themselves or with the help of someone having an elementary knowledge of carpentry; the farmers and hunters who followed needed little more. But as a third wave of settlement came into parts of the west to establish towns, build roads and railroads, and set up the governmental apparatus that would be required, there was need for larger, more permanent architecture. This stage of development was characterized by enthusiasm and forthright boosterism. Each building added to a town was hailed as a giant step in the advancement and growth of the community. A hotel invited comparison with those in competing cities and indicated the prospect of untold numbers of visiting tradesmen; a college was always seen as a stabilizing influence that would attract upstanding citizens to the town.

Courthouses, railroad stations, churches, schoolhouses, theaters, and all the other new structures were tangible evidence of the vigor of the growing city. For these architectural talent was desirable. Moving west often meant that a carpenter or builder found his professional status to be relative, and judging himself the most skilled builder of his new town a carpenter might well announce himself to be an architect. Two years after he was listed in the Baltimore directory as a carpenter and builder, Francis Costigan left Maryland in 1837 because of the financial crisis of that year. In Madison, Indiana, he became the town's leading architect and builder. Hezekiah Eldredge, a carpenter and builder in Rochester, New York, in 1833 sent out his eighteen-year-old son, who was trained as a joiner, to discover what opportunities lay in Cleveland, Ohio. After a year of his son's favorable reports about the River City, Eldredge moved west and in 1837 listed himself as an architect in Cleveland's first city directory.[90] Like their colonial predecessors, frontier architects needed other activities to tide them over the frequent periods during which there were no building projects at hand. In Indiana both John Elder and Francis Costigan tried operating inns, and Edwin May opened a loan office. A. B. Cross, who seems to have acquired architectural training in St. Louis, moved to Kansas City in 1858 and simultaneously opened his architectural office and the A. B. Cross Lumber Company.[91]

So far west as Milwaukee an 1848 city directory listed only two architects, one of whom advertised that he had come west after twenty years of building experience in New York. However, the distinction between builder and architect may not always have been meaningful in frontier towns. It was 1857 before Victor Schulte's listing in the Milwaukee city directory changed from builder to architect, but ten

years prior to that he had been trusted with the design and construction of St. John's Cathedral.[92] In Kansas, "Bloody Kansas" where settlers from the North and the South engaged in the preliminaries to the Civil War, the Bishop of Indian Territory in 1864 began replacing the small wooden cathedral in Leavenworth, Kansas, with a brick structure for which plans were prepared by Father Francis Xavier De Coe, a Jesuit missionary who had designed a similar church in Kentucky. Around the same time Kansas Episcopalians built two churches with drawings that came from Upjohn's New York office, where it was the practice to prepare each year one set of church plans without charge.[93]

Every year a fresh valley or a new forest opened to settlement and development as the American people expanded westward. In addition to the gradual progress across the plains and mountains the discovery of gold in California brought a rush of settlers by sea around South America and along the trails that crossed the plains. The architects who came to California in the early years of the Gold Rush were in some ways typical of the entire influx of adventurers. About three-quarters of the settlers as a whole and of the architects coming to California were young and American-born, and before settling down to their practices most spent a few years in pursuit of a big strike.[94]

While just about half of the gold rushers were from the northeastern states, at least 85 percent of the gold-rush architects were from New England, New York, and Pennsylvania. Among the builders and architects who came to California there were some with professional training. Reuben Clark, a carpenter from Maine, who had moved south to work on the Mississippi state capitol, was a builder in New Orleans before coming west. A. A. Bennett was trained three years in a New York architect's office and worked three years in Alabama and New Orleans before making his way to San Francisco by crossing the isthmus of Panama on foot. Before heading west Albert Snyder, who came from Virginia, had spent several years studying architecture and painting in Europe. English-born Matthew Teed settled into an architectural practice in Stockton, California, but he still could not resist the periodic attraction of lesser gold strikes in New Mexico, Pike's Peak, and Elk City, Washington.[95]

Not all of the buildings in San Francisco were the work of local designers or craftsmen. Iron frames for buildings and corrugated iron sheets to cover them were shipped from England. Twenty-five wooden houses that had been built in Boston and divided into sections were put aboard sailing ships headed for California. Presbyterians in San Francisco met in the city hall until the arrival of a church that had been "planned and sawed and planed and chiselled in the East, and shipped by sailing vessel around Cape Horn."[96]

Part III

From the Civil War to World War I: Strengthening the Profession

Largely due to immigration the population of the United States more than doubled during this period, growing from about forty million in the 1870 census to some ninety-two million in the census taken forty years later just before the start of World War I. And at the end of the period there were over eight times as many architects, one for every 5,536 people in the country. Until 1950 this ratio remained about one architect for six thousand people, suggesting that by the turn of the century a practical level of architectural services had been determined. Urbanization was a major factor in this sharp increase in the number of architects. At the same time that portion of the population living in towns of more than 10,000 population grew from 19 percent to 39 percent. With the increase in population this meant that five times as many Americans lived in cities where architectural services might be available and where the assistance of architects might be need for building projects.

After the Civil War, businessmen discovered the great benefits of size, combining companies so it would become possible to trade nationally over the newly-built network of railroads and to utilize the many advantages, economic and political, that were available to a very large business. Manufacturers and merchants that served only local and regional markets began to disappear; in 1904 it was found that 319 industrial trusts had developed by gobbling up about 5,300 small independent companies.[1] The formation of corporations permitted investing in business concerns and reaping profits without the investor being liable for any debts beyond his own investment. As the size of businesses increased so did the size of fortunes. There had been only a handful of millionaires in the United States before the Civil War, but by 1892 there were over four thousand.[2] The biographies of only a few tycoons resembled the "rags-to-riches" novels of the period's popular fiction; most came from affluent families. Early in the 20th century the richest 1 percent of the American population held almost 88 percent of the nation's wealth. (Recently the top 1 percent has held about half.) Living in what now seems grotesque luxury, most "robber barons" concluded that engaging in philanthropy would be a sensible protective measure.

Among the popular subjects of philanthropy were college buildings, music halls, libraries, galleries, museums, and hospitals, all of them associated with or

parallel to the new responsibilities that were being assumed by the various levels of government. Some were functions that in Europe had once been assigned to official government religions, and therefore indirectly funded by the governments; others arose from the interests and concerns of a growing middle class. State legislation expanded the public schools and required attendance; with the assistance of building funds from the philanthropy of Andrew Carnegie public libraries became customary; imposing and ornate structures held the treasures of galleries and museums. Small and large, such projects attracted the attention of architects and provided them with opportunities for lavish architectural treatments equaled only by government buildings.

Immigration

Only about two-thirds of the architects counted in the 1870 U.S. census were native-born. Roughly 13 percent came from Germany, 11 percent from England and Ireland.[3] ("Designers, draftsmen," a much smaller census category that was not limited to architectural activities, showed a somewhat larger proportion of the foreign-born.) By the last half of the 19th century, the Irish in the northeastern states had become active in building trades such as carpentry and bricklaying, and many second-generation Irish-Americans established themselves as builders and contractors. The flood of new Americans from Germany had started with those who came principally for personal and financial reasons, but there was a period of reduced immigration due to the U.S. depression of 1857 and the Civil War. The rising numbers of German immigrants included many whose beliefs were radical to some Americans, refugees who had manned the barricades in 1848 during the revolutionary turmoil that spread among European

workers. Soon half the population of Chicago was foreign-born, and German immigrants were the largest segment of that group.

In New York the German-American population had their own banks, hospitals, and newspapers, and men could even enlist in their own regiments of the National Guard. The firms of Werner & Windolph and Albert F. D'Oench were among the architects most favored by New York's many prosperous German businessmen. In Davenport, Iowa, over a quarter of the people were of German origin, most of them from Schleswig-Holstein, and German immigrants made up a ninth of the population of New Orleans, where they were concentrated in an area known as "Little Saxony." In Mobile, Alabama, Rudolf Benz provided architectural services for the city's German population and at the same time was co-owner of the Walhalla Lager Beer and Concert Hall.[4] The German population was sufficient in Washington, D.C., to support publication of a German language newspaper, and German immigrants in Chicago supported at least six German-language newspapers through the 1890s. Capable German architects and draftsmen could be found throughout Chicago's architectural firms.

The German architects of Chicago were especially admired for their contributions to the technical knowledge of the profession. Dankmar Adler, who had been born in Germany and came to the United States in his teens, referred to Frederick Baumann's "checkered career, sometimes as architect, sometimes as contractor," but this description does not adequately recognize Baumann's vital contributions to the science of constructing tall buildings on the treacherous soil of Chicago.[5] Upon arriving in the United States those immigrant architects who had received the technical education provided in German schools were often able to find jobs immediately in

fields that required engineering knowledge as well as architectural ability. Employment could often be found in the drafting rooms maintained by the railroad companies and brewery designers. Around Chicago and in other areas the predominance of German architects in the construction of factories, warehouses, and grain elevators was also influenced by the large number of German merchants and manufacturers who became their clients.

Among the immigrants from Germany and Central European countries were many young Jews who would become architects in the United States. Leopold Eidlitz, who was probably the country's first Jewish architect of note, had become interested in architecture while training in Vienna for estate management. In New York Eidlitz was trained in the office of Richard Upjohn, the fountainhead of neo-medieval church architecture in America. (Leopold's brother, Marc Eidlitz, became one of the most respected builders in New York.) Eidlitz had left Upjohn's office more than a decade before Upjohn arranged the initial meeting of the American Institute of Architects (AIA) in 1857, and Eidlitz' invitation shows that Upjohn ranked him as a respected colleague.

Two years later a rabbi from Germany arrived in the United States, and his son Dankmar Adler would become one of the most respected and influential architects among Chicago professionals. Adler's opinion was sought by other architects on professional practices and technical matters, and he was from the first a leader of the Western Association of Architects. At that time most German Jews found assimilation and acceptance much easier than did the Jews of Eastern Europe who would come later to America, and the profession's acceptance of Eidlitz and Adler suggest that there was not a strong anti-Semitic attitude within the practice of architecture.

Publications

Before collegiate training in architecture became available in the United States in the last half of the 19th century, beginners learned from their employers the techniques of designing and executing buildings, but from magazines and books they learned about the newest fashions in design and the latest developments in the technologies related to building. Even after training in Europe or study at an American college, it was essential that the young architect keep informed. Publications made it possible for the newest architectural office to learn about factory-planning or steam-heat, and an architect in Wyoming could become somewhat familiar with the latest Boston buildings.

One of the first periodicals dealing with architecture was *Crayon*, which included all the arts in its pages. *Crayon* was generous in its attention to the architectural profession, reporting on the revival of the AIA and supporting efforts to advance the profession. The *Architects' & Mechanics' Journal* was also a resolute advocate of the architectural profession, giving detailed accounts of Richard Morris Hunt's lawsuit against Dr. Parmly, in which the testimony of prominent New York architects did much to establish accepted levels of fees for architectural services. But each of these magazines lasted only about five years, discontinuing publication as the Civil War began.

Building activity in the United States remained listless through the Civil War, Reconstruction, and the four years of depression that followed the Panic of 1873. In the 1870s two architectural magazines appeared in Philadelphia, but they both ceased after only a year or two. Magazines aimed at satisfying the interests of both builders and architects were attempted during those years, but most of them also failed. The first magazine to flourish was

The building of Eban P. Jordan in Boston (Winslow & Wetherell, architects). **This drawing was the work of English-trained David Gregg, who for about thirty years was one of the staff delineators for the *American Architect*. Around the time he executed this drawing, Gregg left the magazine for freelance work and a teaching position at Harvard. (*American Architect*, 7 June 1890.)**

the *American Architect & Building News*, which began publication in Boston in 1876 and continued until 1938, through those years becoming a strong influence on American architecture. The magazine was issued weekly and therefore avoided long articles, and a typical issue of some sixteen pages devoted roughly half of the space to text and about a quarter each to illustrations and advertisements. Through the years three more expensive versions of *American Architect* were added, the *Gelatin*, *Imperial*, and *International* editions, each in turn containing more of the large illustrations for which the magazine was noted. The *American Architect* soon became the semi-official organ of the AIA, and it shared some of that organization's problems of elitism and geographical isolation. Editors of the magazine were on the whole products of fine Boston families, graduates of Harvard, and connected in some way with the architectural program of study at the Massachusetts Institute of Technology; and the buildings that were published in the *American Architect* were predomi-

nantly the works of the more prominent architectural firms of Boston and New York.

After 1883 states west of the Appalachians were served by the *Inland Architect & News Record*, a Chicago publication that was the official organ of the Western Association of Architects (WAA) when that organization challenged the AIA's representation of the profession. By the time American building activity peaked in 1890 there was a full range of other journals related in different ways to architecture and building, a large part of them introduced in the 1880s. At the same time there were periodicals such as *Building*, aimed at contractors and printing practical articles on such matters as the installation of heating systems and the application of new building materials. (The latter part of some architectural periodicals' names indicated that they included such functions, as in *American Architect & Building News* and *Inland Architect & News Record*.) For builders there were also lists of companies and institutions that

were contemplating construction and notices of fires that would probably lead to reconstruction of buildings. The news sections of the *American Architect & Building News* in 1877 included items of interest to architects, builders, subcontractors, and salesmen:[6]

> Anderson, Ind.—Ed. May's design was accepted for the county poor asylum, near Anderson, Ind.
>
> Arcade, N. Y.—A new Congregational church has just begun to be built from the plans of Mr. M. E. Beebe of Buffalo, N. Y. It is to cost about $7,000.
>
> Deadwood, D[akota] T[erritory]. —It is proposed to build a $20,000 court-house.
>
> Joliet, Ill.—St. Mary's Roman Catholic church is to be of stone, 86' × 138', with a tower 190' high. Mr. Keily [Keeley?] of Brooklyn, N.Y. is the architect.
>
> Burlington, Vt.—Walter Dickson of Albany, N.Y., is the architect of the new building for the Vermont Life Insurance Company.

These brief notices allowed architects to offer their services to potential clients, informed contractors of projects on which they might wish to bid, and provided valuable information to salesmen of building materials and equipment.

By the middle of the 19th century the publication of workmen's handbooks had almost ceased, except for new editions of Asher Benjamin's books and other constant favorites of that genre. Many of the handbooks had contained plans and other drawings of specific designs for houses or churches, but these were secondary to instructional material for workmen. In the 1840s publishers had begun to produce books in which the designs were meant to assist an owner in making decisions. Some of these planbooks were essentially the catalogs of architectural firms from which working drawings, simple specifications, and lists of materials might be ordered.

Others were meant to provide enough information to be shown to an obliging builder, just as a lady of the period might show an illustration from *Godey's Lady's Book* to her dressmaker.

Since building in cities was usually restricted by standard lot dimensions and limited by local regulations, planbooks most often focused on "village and country" designs, related to the movement to the suburbs. One booklet by George L. Catlin bore the title *Suburban Houses for City Business Men* and was published by the Erie Railway & Northern Railroad in hopes of increasing commuter traffic in the "rich valleys of the Hackensack and Passaic." Concentration on rural villages, where architectural services might not be available, called for examples of small stores, banks, and churches, as well as small residences, which in this period were usually classed as "cottages." More challenging were the frontier conditions considered by C. P. Dyer, who in the 1870s published *The Homestead Builder* (in some versions *The Immigrant Builder*), its subtitle announcing that it contained instructions on "How to Plan and Construct Dwellings in the Bush, on the Prairie, or Elsewhere, Cheaply and Well with Wood, Earth or Gravel."[7]

At least nineteen architectural books were published in 1890, the year building construction peaked. The output of planbooks had stabilized earlier and the increase in the number of architectural books was largely due to the production of more specialized professional books that illustrated historical detail, such as J. Buhlmann's *Architecture of the Classic Ages and Renaissance*, Edouard Bajot's *French Styles in Furniture and Architecture*, and W. D. Goforth's *Old Colonial Architectural Details*—the kind of folios that had previously been imported.

With building activity high in 1891, two new magazines were started: *Brick-*

builder, which in 1917 became the *Architectural Forum*, and the *Architectural Record*, which began publication with the backing of a New York weekly, the *Real Estate Record & Builders' Guide*. The same year F.W. Dodge instituted an information service for the builders and architects of the Boston area. After a few years Dodge expanded his service to New York, becoming a partner of Clinton W. Sweet, publisher of the *Architectural Record* and the *Real Estate Record and Builders' Guide*.

Most architectural journals had advertisements isolated from text and illustrations so that those pages could be stripped from an issue before it was placed in an architect's files. This did not solve the problems arising from the flyers, booklets, catalogs, and price lists that architectural firms received from manufacturers of building materials and equipment, information so useful that new architectural firms customarily inserted small notices in the professional journals in order to be added to the mailing lists of manufacturers and salesmen. The issue of *Architectural Record* for February 1905 contained over three pages that purported to be a letter received from an architect furious about the jumble of catalogs he received from manufacturers of building materials and equipment. "Most of our manufacturers today are simply distributing printed matter from the press to the waste paper basket." Obviously, the *Architectural Record* was preparing groundwork for its publication of *Sweet's Indexed Catalogue of Building Construction*, of which the first annual issue would be published in the following year. According to its editors *Sweet's Catalog* was introduced "under a 'mandate' from the profession," and this may well have been true after architects had contended for years with filing the different sizes of manufacturers' catalogs. "Everything was tried, arrangements of shelves, bookcases, pasteboard boxes, filing

cases, patent binders, filing cabinets, cases of drawers, indexing schemes....."[8]

The design libraries maintained in architectural offices were the source of most stylistic ideas in the eclectic practices of the 19th century. Henry Van Brunt recalled that he and other apprentices "often looked with eager and unsatisfied eyes through the glass of their master's locked bookcases." When the pressure of work required stricter organization at H. H. Richardson's home-office in a Boston suburb, the draftsmen were "no longer allowed to seek relief among the treasures of the study." At the time of Richardson's death his collection of 308 volumes on architecture and art was evaluated at a value of $4,000, almost a fourth of his belongings. (He owned no real estate.[9])

Former employees at the offices of McKim Mead & White later remembered the hours that Charles McKim spent thumbing through books that contained drawings of Roman architecture, a process McKim referred to as "going fishing." According to one former employee, McKim "had his assistants spend hours and hours looking up data for him, particularly in Letarouilly, which was a kind of office bible—if you saw it in Letarouilly it was *so!*" (Paul-Marie Letarouilly's *Edifices de Rome Moderne*, the first volume published in 1840, contained views of Renaissance structures in Rome.) When a college building or a private residence required an English precedent for wood panelling or a fireplace, the design personnel at McKim Mead & White consulted "a collection of rotogravures, which we called the 'English book'." Charles Adams Platt, a painter who began architectural practice at the age of fifty-five, had a professional library of only about two hundred volumes, a small number for a practice focused on the design of country estates and their gardens. Architects who specialized in churches, country estates, or other fields in which

historical precedents were crucial might have appropriately specialized collections of books. It was common practice to borrow freely from all publications of designs, old or new. H. Van Buren Magonigle remembered his days in the office of Charles Coolidge Haight: "Like everyone else he cribbed freely and when the original source of one of his designs was discovered the men would say, 'Too bad! The old man has been anticipated again!'"[10]

Learning in Europe

At the midpoint of the 19th century, young Americans who had chosen a career in architecture most often found their training in architects' offices where they might acquire much practical knowledge, but little of the esthetic training that was so important in eclectic practice. This followed the practice in England and some European countries, where students were accepted by practicing architects as paying pupils, unpaid workers, or very junior employees. The exact status and the money involved depended largely on the reputation of the architect, the wealth of the parents, and the ability of the student. The amount that students might learn varied according to the interest of their master, as we can judge by Charles Dickens' *Martin Chuzzlewit* in which we read of Architect Pecksniff's apprentices endlessly drawing elevations of Salisbury Cathedral. Travel in Europe, sketchbook in hand, was an accepted supplement to work experience, and the increasing numbers of well-to-do Americans who toured Europe by steamer and train, visiting cathedrals and palaces, might well expect their architect also to have that background.

At the end of the 18th century Germany had founded the *Berliner Bau-Akademie* (Berlin Academy of Building), the first of many technical schools that would be established as Germany unified and industrialized. These German institutions were principally meant to train government architects and building inspectors, since through most of the 19th century fewer than half of German architects were engaged in private practice. Most German schools required at least one year of work in an architect's office before a student entered their programs in architecture. After four years of study one could choose to enter government service or receive a diploma. Little beyond the engineering aspects of architecture were included in the German curriculums, and design projects were executed with much attention to construction. The more serious students of architecture would be advised to attend art academies, travel in Italy, or study in Paris after they had completed study in Germany. Many American-born students of German extraction went to Germany for all their architectural education or pursued professional studies there after attending an American university. Young architects with no Teutonic heritage probably learned of these polytechnic schools from the German immigrants—draftsmen, architects, engineers—who were employed in American architectural offices.[11]

Russell Sturgis, one of the earliest Americans to seek European education, studied during the Civil War at the Academy of Fine Arts and Sciences in Munich after having worked a year in the New York architectural office of Leopold Eidlitz, who had studied in Austria. Some Americans followed the strong technical courses of study available in Germany with a more artistic experience at France's national school of architecture, the *Ecole des Beaux-Arts* in Paris. Nathan Ricker, between graduating from the University of Illinois and assuming direction of the University's new program in architecture, spent six months in Europe. Half of that time he was at the *Berliner Bau-Akademie*, which may have given a Germanic tone to

the early years of the University of Illinois' program.

In the 1870s Richard Morris Hunt, architect to the Vanderbilts and Astors, and Henry Hobson Richardson, who developed a very popular style somewhat related to the Romanesque, were two of the most talked-about architects in America, and young architects and students were well aware that both Hunt and Richardson had been trained in Paris at the *Ecole des Beaux-Arts*. Hunt, the first American to study at the *Ecole*, had lived in Europe since the age of fifteen, when his widowed mother took her five children to Europe where living expenses were low and cultural opportunities plentiful. After training in a Swiss architect's office, Hunt studied at the *Ecole* and before he returned to the United States in 1855 served as inspector of construction for part of the extension of the Louvre. Richardson attended the *Ecole* during the Civil War, working in the offices of Paris architects when wartime conditions reduced the funds that his New Orleans family could send him. (Between Hunt and Richardson two other American students attended the *Ecole des Beaux-Arts*, Arthur Dexter and Francis Peabody, neither of whom attracted attention in his practice.) In the same period that Hunt and Richardson studied at the *Ecole des Beaux-Arts*, there was an American architecture student at the Paris *Ecole Centrale des Arts et Manufactures*, William LeBaron Jenney, who later played a key role in the development of the Chicago skyscraper.

France's Royal Academy of Architecture had been established in 1671 by Colbert, Louis XIV's finance minister, and, except for four years after the Revolution, its *Ecole des Beaux Arts* continued until 1863, when the school's operation was separated from the Academy. The *Ecole* also included programs of study in painting and sculpture, neither of which were popular in the late 19th century, since most students of those arts believed better instruction was available in privately-operated *ateliers* in Paris. Many devout American families were reluctant to send their sons to "naughty" Paris. According to their son, the conservative Presbyterian parents of William A. Delano gave their consent only after they had been reassured by Thomas Hastings, the architect son of New York City's leading Presbyterian minister. After entering the *Ecole* at the age of twenty-three, Raymond Hood, who had been reared as a staunch Rhode Island Baptist, for some time refused to venture inside the "Catholic" cathedral of Notre Dame.[12]

Hunt and Richardson were the first of a stream of American architectural students passing through the *ateliers* of Paris, a stream that continued into the 20th century. Well over five hundred young architects studied at the *Ecole des Beaux-Arts* before World War II, but most of them were in Paris during just two decades, 1890 to 1910. Admission to the *Ecole* was a problem for most Americans, as most Frenchmen. Twice a year entrance examinations were given to several hundred applicants from whom sixty new students were to be selected. Fifteen of those entering the *Ecole* could be foreigners, but no foreigners could be admitted with scores lower than those of the lowest-ranking Frenchman to be admitted. Upon arriving in Paris most American students planned to begin their stay in the care of tutors who would help them prepare for the entrance examinations of the *Ecole*. In fact, by the time Louis Sullivan arrived in Paris in the early 1870s, personnel at the American embassy were prepared to suggest textbooks and tutors who specialized in preparing American applicants for the examinations. Architectural design, drawing, and modelling skills could be honed at the same time that chemistry, physics, and mathematics were

The students of the Atelier Pascal in 1905. Pascal, who was the fifth director since the atelier was founded in 1800, was credited with four grand prizes and fifteen second prizes after becoming *patron* in 1872. (E. Delaire, *Les Architectes Elèves de l'Ecole des Beaux-Arts*, 1907.)

reviewed, and lessons in the French language were usually included in the preparation, because high-school French was inadequate for the oral portion of the mathematics test.

The section of the entrance examination dealing with design was weighted as more than a third of the total score, and—in addition to the *ateliers* in which one studied design after admission to the *Ecole*—there were in Paris several *ateliers préparatoires* that specialized in training applicants in the rapid completion of designs for monuments, gateways, fountains, mausoleums, and the other subjects that were typical of the entrance examinations in design. Two or three times a week twelve-hour design projects would be issued by the master of an *atelier préparatoire* and students' work criticized. An applicant who took the examinations in 1903 explained:

> There was a certain technique to be learned that was almost essential; one had to become accustomed to the pace—inured to the nervous strain. This last did not, as a rule, affect the French contestants. If they did not get in this time they might the next, or perhaps succeed the time after that.

For those from the United States, however, it was often, for financial reasons, a case of now or never.[13]

Once a student had gained admission to the *Ecole*, there was no charge for its modest program of lectures on art history, construction, mathematics, and descriptive geometry. For instruction in design, a student might choose to attend free *ateliers* within the *Ecole* or make his own arrangements with one of the *patrons* who operated *ateliers* in connection with the *Ecole*. These architects were in most cases winners of the *Grand Prix de Rome*, which had provided two years of study in Rome and marked them as that year's outstanding newcomer in French architecture. Upon returning from Rome, winners of the *Grand Prix* were usually retained as official architects for agencies of the French government. At the turn of the century three free *ateliers* operated within the *Ecole*, and about sixteen others were situated in the top floors of buildings scattered around the Left Bank, the traditional student district of Paris. All *ateliers* pursued a schedule of architectural design projects that were prepared and issued by the *Ecole des Beaux-Arts* and the students' work was

The larger Beaux-Arts drawings were usually required only for the projects of the more advanced students. This well-dressed student, working with the assistance of candlelight, was not typical. One American recalled his first appearance at his *atelier* as finding himself "an object of critical regard by about thirty young men who have on long yellow gowns exceedingly dirty." These smocks were symbols of study in Paris, and at reunions of American *ateliers* they were sometimes worn by those who had gone on to the *Ecole*. (Ernest Flagg, "The Ecole des Beaux-Arts," *Architectural Record*, April/June 1894.)

evaluated by professional juries arranged by the *Ecole*.

The *patron* in charge of an *atelier* might appear there no more than one or two afternoons a week, mostly to criticize the work of advanced students. The beginning levels of instruction, which were a majority of the students, were largely entrusted to the advanced students, whose attention could be earned by a beginner's performing routine and menial work that assisted in the completion of the advanced students' drawings. This system was known to the Americans as "niggering" from a French term *negrifier* for doing the lowly tasks required in a workshop. Having "niggered" for someone who won a major prize of the *Ecole* was considered a significant enhancement of one's education.

The different *ateliers* were fiercely competitive. In the 1920s one former student spoke of the Atelier Laloux: "André, the most competent teacher of the past generation, … had a high record of seven *Prix de Rome*, and it was Laloux's life ambition to do better…. To-day he totals eleven *Grand Prix* [*de Rome*] and twenty-three First Seconds." Management of an *atelier* was largely the responsibility of the students, and tasks were assigned according to seniority. Beginners swept floors and tended stoves, while the most advanced of the students maintained discipline, instructed beginners, and collected the fees due the *patron*.

After admission to the *Ecole* the studies in architecture were divided into two levels, and completion of each level depended on a student's accumulating points from his successes in a schedule of competitions that varied from twelve-hour sketches to the development of grander designs that were allotted a month or more. Exercises began with students receiving written programs that summarized a building's purpose, the required spaces, and the site. For the longer exercises each student prepared a small rough sketch of his solution while sequestered for twelve hours in a small cubicle at the *Ecole* itself. (Strict isolation made it difficult for the highly competitive *patrons* to assist their students.) Larger and more detailed drawings would present the student's final solution, as it had been developed through subsequent weeks of study and dozens of drawings, but it was required that the design shown in the final drawings correspond to the rough sketch submitted at the beginning.

When drawings were due at the *Ecole*, two-wheeled carts from the different *ateliers* rushed through the streets of the Latin Quarter, accompanied by noisy bands of students who had just completed work on the drawings. It was "a time of wild disorder, shouting, tense tempers and confusion until, about five minutes before the gates of the school were closed, the still wet drawings would be loaded into the *charrettes* and the wild rush through the streets would begin."[14] Tourists sometimes came to the Left Bank to witness the carts rushing over cobblestones to reach the *Ecole* before its clock chimed. Rarely did students actually complete last-minute work as the carts rolled to the *Ecole*, but there persisted a romantic picture of desperately drawing as the cart moved along. Working *en charrette* came to represent the entire drama of scrambling to meet a deadline.

Later the drawings, perhaps a hundred of them at a time, would be judged by a jury made up of *patrons* and Paris architects. Different levels of awards were assigned, many designs were judged unsatisfactory, and others might disqualified because they did not adequately conform to the written requirements or deviated from the vague sketch the student had made weeks before. This experience in designing competitively and drawing rapidly was often an advantage for *Ecole* students

A Boston architect who had been a 1900 student in Paris wrote of the days when students' drawings were due and the streets near the Ecole "were alive with *charrettes* and crazy Frenchmen ... all rushing headlong" from their *ateliers* to the offices of the *Ecole des Beaux-Arts*. "No Frenchman could work except under pressure, and they delighted in spending thirty hours at a stretch over the last part of their drawings." (Charles Collens, "The Beaux-Arts in 1900," *Journal of the American Institute of Architects*, February 1947.)

when they returned to the United States, where many of the choice architectural commissions, from office buildings to churches, would be determined by competitions.

Americans who studied architecture at the *Ecole des Beaux Arts* were on the average around twenty-three years old when they entered, having either attended a university to study engineering or architecture or spent some years of training in an American architectural firm. A few went to Paris as young as seventeen, but all had to leave the *Ecole* when they reached the age of thirty, because students were not permitted to continue beyond that age. Walter Cook had completed both A.B. and M.A. degrees at Harvard University and enrolled in the *Ecole des Beaux-Arts* in 1874 at the age of twenty-seven. Upon reaching thirty, Cook shifted to Munich where he studied for a time at the Royal Polytechnic. Ernest Flagg, who believed that "the important thing is to get into the *Beaux-*

Arts just for the prestige it gives one," simply falsified documents to show his date of birth as 1860 instead of 1857.[15]

Data suggest that only about half the students at the *Ecole*, French or foreign, ever qualified to advance into the upper level of instruction, which would have required, on the average, two or three years. Although the full program to earn the *Ecole*'s diploma usually required six years, about three years seems to have been the average spent by Americans, many of whom seem to have agreed with a Boston architect who went from Yale to Paris in 1900:

> The whole value of the School to us Americans was to learn how to study a problem, and in being associated with men who were rendering great [projects] ... and thus learn to be afraid of nothing, no matter how big. Two years was ample time for that. A man was liable to become Frenchified or theoretical in his attitude toward his work, to become too dilettante, to

A small city hall was the subject of a typical exercise of the *Ecole des Beaux-Arts* around the turn of the century. (John F. Harbeson, *The Study of Architectural Design*, 1926.)

lose his perspective of the value of real business methods in his profession, and to waste in pleasurable study the years in his life when he should have been acquiring American habits of office practice.[16]

In the last half of the 19th century, Paris was the international center of fashion, pace-setter for the western world, and all foreign study, particularly that in Paris at the *Ecole des Beaux-Arts*, was a mark of distinction when young architects returned to the United States. A few Americans came to Paris by winning scholarships, but many had scrimped while working as draftsmen, saving for their European adventure. Rarely could such students afford to stay at the *Ecole* longer than one or two years. There were exceptions: J. J. B. Benedict, who later inspected his Denver building sites wearing spats and carrying a cane, had a valet through his four years at the *Ecole*.[17]

The abilities and attitudes imparted by the *Ecole* must have been powerful. Louis Sullivan said it was there that he "first grasped the concrete value of logical thinking," although he stayed in Paris less than seven months after completing the examinations required for admission to the *Ecole*.[18] Those with family funding for a long stay in Paris often seem to have pursued the *Ecole*'s program irregularly, with excursions to Italy, Greece, and England scheduled by skipping one of the *Ecole*'s longer assignments. Some broadened their interests and abilities by participating in sculpture and painting *ateliers*, gaining from them a more artistic point of view than they had experienced in the drafting rooms of American architects or American colleges.

Most Americans were impressed by any European credentials, but some were skeptical. Ralph Adams Cram, a leading medievalist eclectic, complained that the students of the *Ecole* produced drawings that were more pictorial than practical, drawings "that would have made a charming figure in a formal wall paper, but it would hardly have commended itself to a building committee." The *Ecole*'s obsession with the magnificent and monumental seemed odd to many. Bernard Maybeck remembered that on one occasion Julien Guadet, the *Ecole*'s highly respected lecturer on theory, was applauded as he walked to the classroom lectern, and the applause continued as all the students filed out of the classroom—this a respectful protest against Guadet having written a program calling for them to design a factory, an assignment that offended the students. But to most of those who had attended the *Ecole*, derogatory comments were merely "the sentiments of a small clique of malcontents." Some architects who clamored for

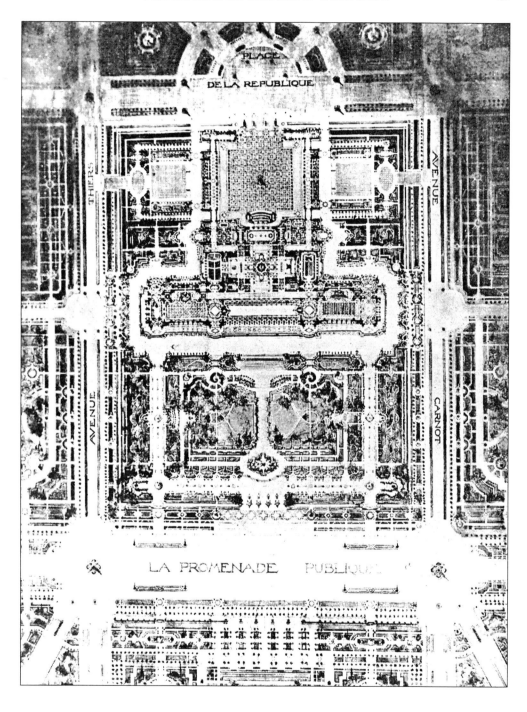

Designs for the *Grand Prix de Rome* of the *Ecole des Beaux-Arts* usually involved large monumental buildings, surrounded by vast areas of gardens, walks, and fountains and filled with mosaic patterns for the floors. This plan for a presidential palace in the capital of a republic sets the building in terraces and broad carriageways. Such drawings were usually several feet in dimension so that the student lay across the drawing board to paint details at the top. (John F. Harbeson, *The Study of Architectural Drawing*, 1926.)

the development of a "native style" in America opposed the teachings of the *Ecole des Beaux-Arts*, but Paul Cret, who had come to teach in the United States after his training in France, realistically pointed out, "It was of their own free will that hundreds of Americans went to Paris and that thousands more took their inspiration from the ideas they brought back."[19]

Learning in the United States

In the fall of 1858, three years after his return to the United States, Richard Morris Hunt accepted three young men into his new office in New York, not as apprentice worker-trainees but as students in Hunt's version of a Paris *atelier* of the *Ecole des Beaux-Arts*. The first group were: George B. Post, a graduate in civil engineering who became a major New York architect; Charles D. Gambrill, later a partner of H. H. Richardson; and Henry Van Brunt, who practiced in Boston and Kansas City. A few months later another four students were added: William R. Ware, who established the school of architecture at the Massachusetts Institute of Technology; Frank Furness, an influential Philadelphia architect; Edmund Quincy; and E. L. Hyde. (Neither of the last two continued in the field of architecture, Quincy turning to painting and Hyde to the ministry.) Hunt was thirty years old when he began this educational experiment, and his students were in their early twenties. Most spent about two years working on projects Hunt assigned and criticized aggressively, his speech sprinkled with bits of French and profanity. The students were allowed access to Hunt's collection of around 2,000 architectural books, at that time probably one of the largest professional libraries in the United States.

The Polytechnic College of the State of Pennsylvania, which operated in Phila-delphia from 1853 to 1890, offered architectural courses within its department of civil engineering. With an admirable record in engineering education, the Polytechnic in 1860 introduced a separate program in architecture, a two-year curriculum (later changed to three) consisting mostly of engineering courses.[20] Progress at the Polytechnic College was handicapped by the Civil War, and when Congress passed the Morrill Land-Grant Act in 1862, giving federal land for every state to sell in order to finance the development of colleges that would offer instruction in the "agricultural and mechanical arts," the state conferred this support instead on Pennsylvania State College.

Ten years after the AIA was revived in 1857, the professional organization proposed a national school of architecture. The institution, to be located "in the upper part of Manhattan Island, or upon the banks of the Hudson in Westchester County," was to have an initial program of two years in which drawing and general subjects would be emphasized and an advanced program of three years in which there would be lectures on the history of art and architecture, as well as "practical solution of problems." Preliminary planning had fixed on $500,000 as the sum needed to initiate the Polytechnic School, including the construction of a building, preparation of a library and equipment, and a "permanent fund." A faculty of thirty professors were to be paid from the tuition of 1,800 students, an optimistic estimate since the 1870 U.S. Census could find only 2,038 architects in the entire country. A national university had been talked about since the federal government first moved from Philadelphia to the District of Columbia, but the proposal of a national school of architecture suggests the influence of the *Ecole des Beaux-Arts*. The idea indicates the influence of Richard Morris Hunt, of the six Americans who

had studied at the Paris school before 1867, the only one who was active in the AIA. The proposal of "an American school of architecture, modeled after the *Ecole des Beaux-Arts*" persisted at least until the 1890s when it appeared as a goal of the Society of Beaux-Arts Architects.[21]

Land-grant legislation not only provided means for founding institutions in young states, it also supported many existing colleges at a critical time in their development. For the Massachusetts Institute of Technology (MIT) land-grant funds permitted an expansion of programs that included addition of a curriculum in architecture. By 1870 thirty-seven states had accepted the Morrill grants of land, and many of these colleges in their departments of civil engineering offered occasional classes presenting a few basic principles of architecture and architectural drawing, but before America could establish its own system of architectural education suited to its colleges European examples would be examined, adapted, and combined.

For this task MIT chose a young architect, William Robert Ware, a native of Cambridge and the son of a prominent local Unitarian minister. Ware had graduated from Harvard University, studied civil engineering at Harvard's Lawrence Scientific School, worked in the Boston architectural office of Edward C. Cabot, and during 1859 studied for several months in the studio of Richard Morris Hunt. The following year Ware had established an architectural practice in Boston, later entering into a partnership with a fellow student at Hunt's *atelier*, Henry Van Brunt, a Bostonian just returned from Navy service in the Civil War. The firm of Ware & Van Brunt, the latter assuming most design responsibility, took students into an *atelier* modelled after Hunt's. Ware was in 1865 appointed professor at MIT and director of what would become the most prominent among the early collegiate schools of architecture in the United States.

Before opening the new program Ware spent almost a year traveling in Europe, investigating foreign systems of instruction in architecture and purchasing books, photographs, and plaster casts. As he summarized them, Ware's conclusions were: "The French courses of study are mainly artistic, and the German scientific, and the English practical, they all, from this very fact, fail to furnish the model we should wish to follow."[22] In 1868 the MIT Department of Architecture opened with four students and its one professor. Ten years later there were thirty-two students, but only ten of them were following the Department's full curriculum. It was difficult to implement a satisfactory program for the regular students. At first engineering courses occupied all the first three years of MIT's regular curriculum, and it was 1874—the year after the program's first degree was granted—before architecture courses were allowed to become part of the second year of study. The majority of MIT students were enrolled in a "special course," of two years for those who had spent some years working in architects' offices or studying the fields of engineering that related to architecture.

Other universities soon followed MIT's lead. The University of Illinois awarded its first college degree in architecture to Nathan Ricker three months before MIT graduated its first architecture student. This was made possible by Ricker's serving as the program's sole instructor at the same time that he was a student in its classes. After having been in the program two years, Ricker left the University through the spring and summer of 1872 to work for an architect during the frenzy of rebuilding that followed the Chicago fire. When the instructor they had engaged failed to appear at the start of the fall term, college officials persuaded Ricker, a serious man

The Architectural Society of the Massachusetts Institute of Technology in 1887-1888, six years after Prof. Ware had left for Columbia University. Seated at the center is Eugène Létang, the first French instructor to come to an American school of architecture. On his near left is C. Howard Walker, who four years before had returned from an archaeological expedition in Asia Minor. To Walker's far left is Theodore Minot Clark, who would soon leave the MIT faculty to become editor of the *American Architect* for more than twenty years. (*Federal Architect*, April-June 1942.)

of twenty-nine, to undertake instruction of himself and three fellow students of architecture. For a dozen years Ricker taught all the architecture courses usually with an enrollment of about eight students. Because textbooks were few, Ricker wrote and translated a number of books on structures and also translated several major works of the time from Viollet-le-Duc's *Diction-naire Raisonée de l'Architecture Française* (1854) to Otto Wagner's *Moderne Arkitek-tur* (1896). Cornell University initiated a program in architecture in 1871; Syracuse University followed two years later. The University of Michigan started an architecture program in 1876 under the guidance of the influential Chicago architect William LeBaron Jenney, who commuted from Chicago, but the state legislature closed the program the following year.

Columbia University's program in architecture began in 1881 with one or two students being taught by William R. Ware,

who had been lured from MIT. At Columbia the university administration promised Ware a free hand, but it was over twenty years before Ware saw the Columbia Department of Architecture moved out of Columbia's engineering division, the School of Mines, where an overload of engineering courses were required. It was a standard explanation at Columbia that architecture's being placed in the School of Mines (later named the Faculty of Applied Sciences) was "simply a matter of administrative convenience." However, according to his assistant A.D.F. Hamlin, Ware frequently complained of the "tyranny of mathematics." "With great patience and perseverance he [Ware] labored year after year to persuade the faculty of the School of Mines to disburden the courses in the department of these irrelevant and hampering studies."[23]

By the end of the century there were eight additional schools of architecture in

American colleges: University of Pennsylvania, Pennsylvania State College, George Washington University, Tulane University, Harvard University, Armour Institute of Technology, Notre Dame University, and Ohio State University. Of the thirteen U. S. schools of architecture at that time, all but one were located in the northeast quarter of the nation. In many other universities various elementary architecture courses continued to be taught, usually in a department of civil engineering, with varying degrees of intensity.

In many of the schools of architecture adequate enrollments largely depended on the number of students enrolled in abbreviated programs of instruction. In the 1890s at Columbia, Ware reported that there were about ten times as many students in the "short course" as "college men," but he felt that the presence of two-year short course students brought a useful realism to the classes. While the directors of programs usually represented those students as seasoned veterans of architectural drafting rooms, data suggest that the short course was often employed as a method of rapidly accumulating credentials. Cass Gilbert seems to have worked briefly as a helper and draftsman for a carpenter before one year at MIT and several months touring Europe, and Thomas R. Kimball, son of an Omaha railroad magnate, began the MIT two-year program at the age of twenty-three after two years at the University of Nebraska and five years in Boston, two attending an art school and three being tutored for MIT's entrance requirements. At Cornell, Frederic Hall's place in the special program seems to have been based on summer work in an architect's office.

To counter university fears that these special students might pass themselves off as having completed the Columbia's full program in architecture, Ware pointed out that "a student who takes only part of our work is really no more dangerous to our

reputation than ... the incompetent and unsuccessful regulars, comprising about two-thirds of all that enter, who fail to complete the course." According to numbers reported to an AIA convention in 1898, short-term students were then almost half the enrollment at MIT, over a third at Harvard and the University of Pennsylvania, but only about an eighth at most other schools, a majority of which had the advantage of being state-financed.[24] In 1905 about half the students entering the architecture program at Columbia came for the short course leading to a "Certification of Proficiency," and as late as 1913, the architectural press contained advertisements in which the Universities of Pennsylvania, Michigan, Syracuse, Washington University in St. Louis, and other schools stressed the "special courses" that were available at their institutions.

At Columbia University the balance of technical and design courses was a concern, and Ware also tried to diminish the emphasis on competitions and competition juries that had already become so much a part of architectural education. In the spring of 1902 Prof. Ware resigned his post at Columbia. He was seventy years old and failing in health, but two other factors are sometimes related to Ware's retirement: First, he had assisted in preparation of material for a correspondence school and recommended that students entering Columbia be given some credit for correspondence study; second, Charles McKim, whose firm was designing the university's new campus at Morningside Heights, had complained about the program's essay requirements and its lack of direct application to professional needs as McKim saw them. Professional services for buildings at Columbia University occupied McKim Mead & White through the decade of low building activity after the depression of 1893. A large part of the opposition to Ware resulted from his failure

to hew to the Beaux-Arts style of the 1893 World's Columbian Exposition in Chicago and the "Roman Renaissance." A writer in the *Architectural Record* accused Ware of giving "attention to other styles—thus, from the start, committing the scheme to confusion." As director of the architecture school at Columbia, William R. Ware was consulted by university officials, but Mc-Kim—having the ear of his clients, the Columbia trustees—campaigned to make sure that Ware did not interfere with his firm's "Roman Renaissance" style which McKim was convinced should be the exclusive national expression of American architecture.[25]

The changes at Columbia made immediately after Ware's retirement brought greater resemblance to the *Ecole des Beaux-Arts* in Paris. Three *ateliers* were established: one at the new University campus and two downtown, the downtown *ateliers* bearing the names of McKim and Thomas Hastings, although their assistants did almost all of the instruction. Advanced students might also choose to work in one of the five *ateliers* then operating in the city under the auspices of the Society of Beaux-Arts Architects.[26]

In 1872 Ware had brought to MIT a French design critic, Eugène Létang. For many years Létang taught all the architectural design classes, which were limited to the third and fourth years of the curriculum. In 1880 this meant providing instruction for twenty-eight "special program" students and only five full-time students. When Létang died in 1892 he was followed by Constant Désiré Despradelle, winner of the *Grand Prix de Rome* a few years before, who arrived in Boston at the age of thirty-one and stayed until his death in 1912. Soon all American schools felt the need for a French critic, who could be backed up by one or more *Ecole*-trained Americans. Between the year of Létang's arrival at MIT and 1920, almost fifty years, about twenty

young French architects—some of them winners of the principal prizes at the *Ecole des Beaux-Arts*—took positions in American universities, all in the northeast quarter of the country, except for the University of Minnesota and Oklahoma Agricultural & Mechanical College.[27]

At the AIA convention in 1918, D. Everett Waid, eight years a member of the New York registration board, declared, "If there is one thing that will give a registration board a sinking feeling, it is the statement that a candidate got his architectural training in a correspondence school."[28] In the late-19th century, the nation's largest cities usually had "mechanics' institutes" that offered night courses to develop the skills and knowledge of ambitious young workers. But for many young people, who could not attend a college for reasons of location or cost, the architectural courses of the International Correspondence Schools (ICS) of Scranton, Pennsylvania, founded in 1891, and the American School of Correspondence in Boston (later associated with Armour Institute in Chicago), were a godsend.

William Allen, an English-born mason-contractor in Davis County, Utah, began ICS architectural study in 1895 when he was forty-five years old, but he did not continue beyond the nineteenth of the twenty-five courses in the program. William C. Bunce of Chicago pursued the ICS course of study, qualified to enter the *Ecole des Beaux-Arts*, and became a mainstay of Albert Kahn's office in Detroit; Joseph H. Casey studied with ICS at the same time that he worked as a draftsman in Buffalo. In Huron, South Dakota, F.C.W. Kuehn at the age of twenty began almost three years' work on the ICS program in architecture, mailing his last drawing to Scranton late in 1908. In California Hazel Wood Waterman, widowed at the age of 38, followed a correspondence course of study and after two years began work for Irving Gill. And

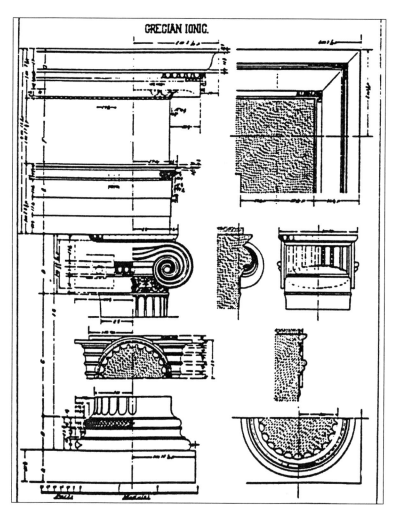

These drawings were prepared by F. W. C. Kuehn as part of his study with the International Correspondence School. At the time (1907-1908) twenty-three-year-old Kuehn was employed by the only architect in Huron, South Dakota. (Jeanette Kinyon, *Prairie Architect*, 1984.)

it is likely that John A. Lankford, who established the first professional architectural office headed by an African-American, referred to ICS training when his business card listed "a course in architectural and mechanical drawing at Scranton, Pa.," completed when he was twenty-three.[29]

The correspondence school programs that were available could at least provide the basic abilities that might qualify one for a beginning-level position as a draftsman in an architect's office. In the 1920s O'Neil Ford completed the ICS architecture course and found his first architectural employment with a Texas architect who had himself sampled several of the ICS courses of study.[30] Ford would later refer to his college yell as: "To hell with Harvard, to hell with Yale! We get our learning through the mail."

The Government's Own Architects

Through the first half of the 19th century a succession of able architects—Benjamin Latrobe, Charles Bulfinch, Robert Mills, and Thomas U. Walter—had been appointed by presidents to accomplish the design and construction of the U.S. Capitol and other government buildings in Washington. The federal government at that time had few buildings outside the District of Columbia, and their construction had usually been placed in the hands of committees of the most prominent and influential citizens of the cities in which the buildings were to be located. A competition was sometimes conducted for the design of such projects, and the winning architect might be employed to supervise construction. Construction inspectors were provided by the government, and they were "paid out of the several appropriations according to the time given to each work…. No system of keeping or rendering accounts of the respective works at

the buildings or in the Department had been adopted."[31] ("Supervising" construction usually means the general and periodic oversight of the work by an architect to make sure that plans are followed and major problems are solved; "superintending" denotes the day-by-day direction of the work and workmen by the contractor.)

By 1853 the federal government had built or bought outside the District of Columbia only twenty-three custom-houses and eighteen marine hospitals for the care and quarantine of seamen, a total of forty-one non-military buildings, for which repair and maintenance were the responsibility of the Treasury Department. Custom-houses were a major source of government revenue, and marine hospitals were supported by a fund from the wages of navy and merchant seamen. To oversee construction activities the Secretary of the Treasury requested that the Secretary of War provide "a scientific and practical engineer to be placed in charge of the construction." Thereupon Capt. Alexander H. Bowman assumed responsibility for the "Construction Branch of the Treasury Department," and at the same time a respected New England architect in his fifties, Ammi B. Young, assumed the role of Treasury architect under Bowman's direction.[32] The Treasury's architectural staff consisted then of eight people, plus a small and variable number of draftsmen who were paid from Congressional appropriations for individual projects.

Young and the administrator were both dismissed in 1862, and the role of "Supervising Architect" was assumed by Isaiah Rogers. (At the same time that Rogers served as "Supervising Architect," Thomas U. Walter, who was engaged principally on the U.S. Capitol building, served as "Architect of Public Buildings.") Then in his sixties, Rogers had through three decades of practice set up offices in Boston, New York, Cincinnati, and Nashville, prin-

cipally in connection with his thriving practice as the foremost hotel architect. His tenure as Supervising Architect was limited to two years, which were principally occupied with completing buildings that had been planned several years before he came to the office. Alfred Mullett, who four years before had briefly been a partner of Rogers in Cincinnati, was made Rogers' assistant in 1863, largely through the influence of Secretary of the Treasury, Salmon P. Chase, also from Cincinnati. Shortly before Rogers resigned as Supervising Architect, he charged Mullett with incompetence.[33] When Mullett succeeded Rogers as Supervising Architect, he was thirty-two years old and seems to have had no architectural training beyond the two or three years he spent with Rogers in Cincinnati. The beginning of Mullett's tenure as Supervising Architect fell during the aftermath of the Civil War when funds for new construction were extremely limited, and the last six years were during the administration of President Ulysses Grant, when pork-barrel appropriations kept Congress busy and anyone holding office could inadvertently become entangled in the widespread corruption of the period. In Grant's second term the dishonesty that had been apparent in his first term came to its sordid maturity, encompassing graft related to a variety of tax evasions, bribery of officials and congressmen, and the outright sale of government appointments. The government's busy construction program was not exempt from scandal inside or outside Washington. For instance, a group of dishonest quarry owners, called the "Granite Ring," had sufficient power to arrange that simple brick walls in the basement of Philadelphia's Post Office would be replaced by finely dressed granite.[34] Under Mullett the Supervising Architect's Office was responsible for a total of some fifty million dollars worth of construction, building large customhouses and post

offices located in the fastest-growing cities of the nation. (It is difficult to compare amounts of money at different times, but today a bricklayer is paid about fifty times the hourly rate in the 1870s.) By the 1870s the Supervising Architect's Office had a staff of about seventeen, plus a large number paid from appropriations.

Mullet's tenure as Supervising Architect, almost a decade, was the basis for decades of antagonism between the architectural profession and the federal government. Shortly after Mullett became Supervising Architect, it was decided to construct a new post office in New York City. The AIA had been inactive through the Civil War, but its revived New York Chapter promptly wrote the project's Board of Commissioners, recommending strongly that an architect be chosen by competition.[35] The letter, bearing about twenty-five signatures of individual architects or firms, recommended that $20,000 be divided among those who ranked highest in the competition and that the winner be engaged as architect. Fifty-two competitive designs were received, and after a delay of seven months the Board announced five winners among whom it was unable to choose a single outstanding design. Each of the five finalists was awarded $2,000, and all five were engaged to develop together a single design combining characteristics of all their designs.

Responsibility for the New York Post Office fell to the Treasury Department, where Supervising Architect Mullett reported that the compromise design was both unsound in structure and inefficient in arrangement. Mullett clearly implied that only he was capable of designing and constructing a building so large as the Post Office. In response to architects' protests, Mullet disingenuously declared that if he had not expressed his opinions he would have been "either dishonest or incompetent."[36] The architects who had collabo-

rated on the compromise design, leaders of the profession, justifiably believed they had been duped by the government and insulted by its Supervising Architect. The debate extended beyond the profession of architecture, and Mullett became a popular political target. The *New York Sun* awarded Mullett an extraordinary accolade: "the most arrogant, pretentious, and preposterous little humbug in the United States."[37] Architects had, of course, come to eye the many government buildings of this period as potential professional commissions that could be highly profitable; however, Mullett's invective had brought a new and more aggressive tone to an approaching battle between the architectural profession and governmental agencies.

The AIA Revived and Challenged

Throughout the Civil War the AIA had been dormant. In 1867 the organization's members, then about thirty in number, set about changing its bylaws. The designation for the senior category of membership was changed from Professional Members to Fellows. Below that in rank there remained Associate Members, who might eventually become Fellows, but in the meantime were not permitted to vote on issues that came before the organization and could not hold offices. Although the AIA had been firmly centered in New York, it recognized that a substructure of local organizations within other states and cities was needed to deal with professional matters that were of regional concern. These Chapters could also harbor architects who in the eyes of the AIA's Fellows were not yet qualified for membership.

From time to time various qualifications and examinations were suggested for each level of the organization, leading a British journal to comment:

An American architect is expected to belong to at least three societies. There is a local body, a territorial body, and an American Institute. If they all insist on tests the members who go through the ordeal will resemble refined gold.[38]

The need for local societies had already been felt in some cities. The Pennsylvania Institute of Architects was formed in 1861, and it was followed in 1869 by the Philadelphia Chapter of the AIA, which included members who were not architects because it wished to have "as much as possible of the character of an art society, rather than … a trades union." The Boston Society of Architects was established in 1867 but cautiously waited several years before going "under a yoke with those New York men." By 1887 there were a dozen Chapters of the AIA, all but one (Rhode Island) representing a major city. Because there were few local Chapters in the South, an illusory Southern Chapter took in candidates from any Southern state that did not have a Chapter.[39]

During the 19th century the status of professions was elevated, largely through the activities of professional organizations. The prestige of the clergy had declined and lawyers had become the most respected professionals, only to be outranked by physicians by the end of the century. While professional organizations ostensibly represented their professions, the desire to improve and advance their professions inevitably involved exclusiveness. The American Bar Association, founded in 1878 at exclusive Saratoga Springs, New York, for years excluded corporate lawyers, members of the new multi-partner firms, and Jews, and at the turn of the century only about 1 percent of American lawyers were members.[40] The American Medical Association, which was about thirty years older, was always plagued by the existence of "snake-oil" vendors and influential

blocs of homeopaths, osteopaths, and other sectarian groups. Architects were often frustrated in their efforts of professionalization by the closely related activities of civil engineers and builders (respectively, three and ten times as great in number).

The original constitution of the AIA had required that the names of applicants for membership be posted for thirty days at the office of the organization. (It was then essentially a New York City organization.) If three or more votes were cast against an applicant, membership would be denied and the action would not be recorded. In 1891 this was changed to five or more votes. An Irish architect, reporting on his two years in the United States, stated in 1875 that apparently the only American architect who had become wealthy was "the late John Kellum, whom, as I am informed, this Institute would not admit to its membership." Kellum, who had done many stores with cast-iron work around their ground-level showcases and employed that material for A. T. Stewart's New York department store, applied twice for membership in the AIA and was rejected both times. Nevertheless, Kellum's practice thrived with a clientele of New York's leading retailers.[41]

Understandably, there was resentment among architects who were denied membership in the AIA or its adjunct organizations. A twenty-eight-year-old Texan, J. Riely Gordon angrily wrote Dankmar Adler, then Secretary of the AIA, that "a few of my brother architects ... stoop to league themselves together to stab me in the back, under the cover of secrecy." A few years later another Texan was convinced that he knew who was blackballing him: "I would have no trouble in getting the signatures of the entire Southern Chapter of the AIA except Mr. Clayton."[42]

The AIA's image of itself was that of a select group of architects, artistically talented, ethically spotless, and thus obligated both to judge and represent the remainder of the profession. But that was not the view of many architects who were younger or who came from other backgrounds. One Boston architect recalled that in the 1880s the AIA seemed "a very small New York society of elderly dilettante architects who looked with distrust on any young man who proposed to draw with anything softer than a 6H [extremely hard] pencil." In Washington, D.C. "the older architects of the city ... jealously guarded its membership ... [and] thought the Chapter was their private club." The image of the AIA as a stodgy club of old-timers was certainly not contradicted by Richard Upjohn's tenure of eighteen years as the organization's president, although illness had prevented his attending several annual conventions. Upjohn was replaced as president only after Charles Babcock in 1876 persuaded the annual convention that his father-in-law sincerely wished to be replaced. Thereupon, Thomas U. Walter was elected president and served eleven years in that office before his death.[43]

In 1884 the Western Association of Architects (WAA) was organized, largely through the influence of the *Inland Architect*, a Chicago magazine that had just begun publication. Unlike the AIA, the WAA designated all its members as Fellows, and there was no junior level of membership. As chairman of a WAA committee on membership, Louis Sullivan expressed that organization's view that membership should be:

> ... broad and democratic; that it should not set up factitious barriers against those who ask for admission; that [it] wishes to count amongst its members every thoughtful, earnest, ambitious man in the profession; that it desires its strength and stability to be derived from the standing and capacity of the average man; that it welcomes the fervor of youth; that it cherishes the honorable record of old age....[44]

When the Western Association of Architects met in St. Louis in 1885 with Daniel Burnham presiding as president, Burnham called in his opening address for the preparation of an official seal for the organization, only to be assured that this seal had already been designed and approved. (*Inland Architect and Builder*, November 1885.)

State Associations of Architects were the subdivisions of the WAA, and in order to simplify changing allegiances the WAA had no initiation fees for "members of State Associations of the American Institute of Architects."[45] Though its stronghold was the lightly populated center of the country, by its fourth year of existence the membership of the WAA exceeded that of the AIA. Almost two-thirds of WAA members were in Illinois, Ohio, and Missouri. In St. Louis nearly all the members of the Missouri Chapter of the AIA switched to the Missouri Association of Architects, the local affiliate of the WAA.

The WAA's conventions, as recorded in the *Inland Architect*, displayed a consistent courtesy toward the AIA, suggesting that they recognized that a merger of the two organizations might soon become wise. Many architects, including the WAA's first president John Wellborn Root, were members of both organizations, but there was a fundamental difference between the AIA and the WAA. The Institute viewed

its Fellows as a select group having the highest qualifications and professional status in the profession, and in 1870 the number of fellows was limited to seventy who were to be selected by the organization's Board of Trustees.[46] At the same time that it practiced such elitism the AIA insisted that it represented the profession as a whole, the seventy Fellows speaking for over two thousand American architects, many of whom practiced in conditions drastically different from those of the urban East. Since the limited number of Fellows in the AIA were selected by their own number, there was an inescapable suggestion of European aristocracy, an aura too strong to be ignored by democrats of the West. At the same time, without licensing legislation to identify architects, even the most avid democrats were sometimes concerned about grifters and "yesterday's carpenters" who might become members of their professional organization.

The consolidation of the AIA and WAA, while inevitable, was not easily accomplished. Since the sticking point would predictably be their standards for the admission of members, the two organizations had a tacit agreement to admit no new members during the year of negotiations. One representative of the AIA complained: "We don't know who are in the Western Association.... Let them come in as associate members of the old American Institute of Architects, and let us not take any organization in as a whole." To this Dankmar Adler responded that the WAA was not applying for membership in the AIA.

> The Western Association of Architects was requested by resolution of the American Institute to appoint a Committee to act with a similar Committee of the American Institute to devise ways and means for the unification of the different architectural associations....[47]

Richard Morris Hunt, president of the AIA, relinquished the chair at a meeting and spoke fervently against the AIA taking in the entire WAA, reluctant to recognize that by continuing its elitist control the AIA would sacrifice its claim of representing the profession. However, the maneuver that had been planned involved the two organizations merging. The amalgamation would then assume the name American Institute of Architects, principally because legal counsel advised continuing the name that had through the years appeared in legal decisions and other documents. The consolidation was accomplished at a Cincinnati convention late in 1889, but it would be another ten years before the organization's headquarters would be moved from New York to Washington, D.C.

Women Architects

At the 1885 convention of the WAA in St. Louis a roster of 110 screened applicants had been presented and voted into membership. A separate issue was made of the application of Louisa Blanchard Bethune, who had been trained in a Buffalo, New York, architectural office and practiced there with her husband. The Board of Directors raised the "broad question of admitting women," and in answer to a question from the floor of the convention President Burnham expressed the Board's views as being "very much in favor of it." Bethune was admitted by a unanimous vote and was thus taken into the AIA when the WAA and AIA consolidated. (It was 1898 before Ethel M. Charles was admitted to the Royal Institute of British Architects after heated debate.) Bethune strongly opposed the competition among women architects for the design of a Woman's Building at the Columbian Exposition of 1893, convinced that a separate building for women implied "inferiority."

In her opinion the prize offered was insulting because it was less than a third of the percentage that male architects were paid for designing other exhibition buildings. She also ridiculed the idea that a suitable niche for women lay in residential architecture, "the most pottering and worst paid work."[48]

Two young women were taken as students in 1882 by the Philadelphia firm of George Champlin Mason and his son, who wrote that other firms had "previously attempted this." The experiment was termed "fairly successful" by the younger Mason, although after five years both women left the office for other pursuits. According to Louise Bethune, who had chosen office training instead of a university program, by 1891 there were no more than twelve women graduates of architecture schools, and most of them had "renounced ambition with the attainment of a degree." In 1882 the office of the Treasury Department's Supervising Architect listed at least five women in its drafting room, and shortly before World War I the firm of Purcell and Elmslie had two women in its drafting room, each of whom stayed with the office for about seven years.[49]

Few women entered architectural practice, and that few got their start in much the same way as did their male counterparts. Houses were designed for college friends, social connections, and relatives, and any ties with clubs and other organizations could bring in clients. Successful campaigns for the settlement house movement, improvement of tenements, women's suffrage, and prohibition had given women's organizations strength and confidence, and for the buildings of women's organizations it seemed natural that a woman architect might be considered and perhaps even preferred. Minerva Parker (Nichols) at the age of twenty-seven took over the practice of the Philadelphia architect under whom she had studied and worked. Although her

practice was for the most part residential, she also executed two women's clubs and other non-residential buildings.[50] Theodate Pope (Riddle) began developing her reputation for the design of boarding schools, first one for a close friend and another in the 1920s that grew to include some eighteen buildings. Daughter of a wealthy Cleveland family, Pope devoted much of her time to campaigns for social reform, women's suffrage, and the Socialist party, and she participated in planning the progressive curriculums of the schools she designed.[51] Julia Morgan, who opened her San Francisco practice in 1907, began with residential commissions from her sister and some sorority sisters and a library for a women's college. For Morgan's studies at the *Ecole* in Paris financial assistance had been provided by Phoebe Hearst, who later helped Morgan obtain the commission for the first of at least eleven buildings she designed for the Young Women's Christian Association. After more than a decade of practice, Morgan began many years of design for her patron's son, the publisher William Randolph Hearst.

The competition for design of a Woman's Building for the 1893 Columbian Exposition, which was limited to women designers, received thirteen entries. The competition was won by Sophia Hayden, the first female graduate from MIT's four-year program. When Hayden fell ill the *American Architect & Building News'* editors believed that the problem had not been the general public criticism of her design, but that Hayden had instead been "victimized by her fellow-women [the committee in charge of preparing the building] to such an extent that her health has been seriously ... impaired," implying that an uncontrollable committee of women was responsible. Minerva Parker, who was in her fourth year of practice in Philadelphia, wrote to blame Hayden's condition on the nature of the competi-

tion, which had allowed her to undertake a project for which she was "unprepared through lack of experience."[52]

Registration

The preparation of a model statute for professional registration had been discussed in 1885 with enthusiasm at the WAA's second convention in St. Louis, and in May 1889 an issue of the *Inland Architect* triumphantly announced that an architectural licensing law had been passed by the Texas legislature: "The Texas State Association [of Architects] deserves the commendation of every association in the country for thus establishing a precedent that will doubtless be followed by the legislatures of the other states...."[53] Texas architects had prepared and lobbied for a bill that called for an appointed board of three members to administer licensing by examination. Unfortunately in the hectic last days of the legislative session the architects' bill had not come to a vote, and it would be 1937 before such a bill would be passed in Texas.

Under U.S. law licensing is a function of state, not national, government, and state licensing of various activities became popular in the 1890s. At the end of the decade the Supreme Court upheld West Virginia's law requiring the licensing of physicians. However, in 1901 an Illinois court decided that the drive for licensure had been excessive and voided a law to "Insure the Better Education of Practitioners of Horse-shoeing, and to Regulate the Practice of Horse-shoeing."[54]

In 1897 the Illinois legislature passed the first law requiring registration of architects after an intense campaign by the state's architects, led by the Chicago Architects' Business Association, an organization that had been created for that purpose. Two years earlier a licensing bill had failed in the Illinois legislature, but at their

second attempt one of the elected members of the legislature was Charles W. Nothnagel, a Chicago architect specializing in apartment houses. The Illinois architects also had "the powerful political influence of the trade unions," because of

> ... a very serious building accident, which was due to the incompetence of a young architect in supervising his work, [which] incited a very large and well-organized trade union of mechanics to suggest that such a law be passed. They were very insistent in the matter....[55]

New York had already attempted twice and Ohio once to have such a law passed, but neither would succeed until their fourth tries in 1915 and 1935 respectively. New Jersey and California were the first to follow Illinois, but in California applicants could satisfy licensing requirements by presenting a letter of recommendation from a professor or a practicing architect.[56] In 1918, D. Everett Waid, surveyed the conditions of architectural registration at a time when fourteen states had enacted laws for that purpose:

> Only five states out of fourteen mention any requirements for the general education of an architect. One of these five accepts "primary school work," two required a high-school course, and two go further.... Some states require only a "good moral character," while others demand two or three years of practical experience in an architect's office before taking the technical examination. In some states, graduates of architectural schools are permitted to practice without experience.[57]

Most states included in their laws a "grandfather clause" requiring or permitting that a license be given to anyone able to present proof that he had practiced architecture prior to passage of the law. The Illinois law gave its licensing board discretionary power in such cases, and in 1904

the board denied a reciprocal license (a license given by one state because the individual has been previously licensed in another state) on the grounds that the New Jersey board had not had the authority to refuse a license. Most boards were also inclined to deny reciprocal licenses when the original license had been obtained through a "grandfather clause." Michigan, where a three-day examination was required, denied the transfer of a license that had been obtained by taking an examination of only two days.[58]

An architectural registration bill was passed by the State Assembly of New York in 1892, only to be vetoed by the Governor. Opponents of the bill reasoned that for protection of buildings' occupants it was more important to enact and enforce "building laws" stipulating satisfactory standards of construction. It was also pointed out by opponents of the measure that "no laws requiring the licensing of architects exist in any country in the world, while in every large city, abroad and at home, building laws conserve the public interests." Actually, at that time Spain and Russia required diplomas from their schools of architecture and satisfactory completion of an examination, and Germany, Hungary, and Greece required diplomas for architects entering government employment. In the first years of the new century the influential New York and Boston chapters of the AIA firmly opposed licensing laws for architects, and the Cincinnati chapter believed that such legislation was "not desirable or expedient," arguing that licensing would only serve "to shelter a favored few from the competition of men as able." A New England architect commented in the architectural press that New Jersey's passage of a licensing law had not appreciably improved the quality of architecture in that state. A leading Cincinnati architect, Samuel Hannaford, spoke out in 1899 against passage

of such laws, citing the fact that in a London meeting of the Royal Institute of British Architects almost three-quarters had opposed registration legislation.[59]

In the eyes of the law at this time an architectural firm's contract with its client was a personal obligation. One court decision stated that when dealing with a partnership a client "contracted for the special knowledge, skill and taste, the professional pride of achievement, the wisdom of the counsel, and the personal probity of both" partners.[60] In 1907 the building committee for St. John the Divine in New York seized on the death of George L. Heins to discharge the firm of Heins & Lafarge, the firm that had won the competition for design of the church over twenty years earlier. A change in taste after the death of H. H. Richardson had deserted neo–Romanesque church architecture for full-blown neo–Gothic. This seems to have been the principal reason for the board's action, since only one church trustee from the time of the competition remained on the board and according to legal precedent at the time the death of one partner made a partnership's contracts void.

Matters of ethics were always under discussion in the meetings of the state registration boards and of AIA. (It is often pointed out that much of professional "codes of ethics" are concerned with etiquette among rival members of the profession, rather than behavior in actually practicing the profession.) Seldom did firm decisions result from such discussions, because before state registration laws the only punishment for infractions of a code of ethics was exclusion from the AIA, and the most blatant offenders were most usually not members of that organization.

A perennial ethical dilemma was advertising by architectural firms. Around 1860 such prominent New York architects as Upjohn and Renwick had placed advertisements in the *Architect's & Mechanic's Journal*, discreet notices that resembled a business card. In Utah the oversized business cards distributed by William Allen included on their face several exhortations: "Successful business men always get plans from an Architect before they build, because that is the most business like manner. It's false economy to try to build from a builder's rough sketch."[61] (There were in the 1890s protests by contractors and materials suppliers regarding the aggressive salesmanship of agents selling advertising in the brochures of individual architectural firms.) Opinion vacillated on the matter of displaying the architect's name at a construction site, and there was a wide range of opinion regarding the inclusion of the architect's name with a photograph or drawing that appeared in the advertisement of a contractor or supplier of building materials. In 1892 during construction of the Boston Public Library, a Boston newspaper reported that on the building's facade among the panels bearing the names of famous people, one panel had "a cheap advertising acrostic," consisting of names of famous men in which the initial letters spelled out the name of the building's architects, McKim Mead & White. (Moses, Cicero, Kalidasa, Isocrates, Milton, Mozart, Euclid, Aeschylus, Dante, Wren, Herrick, Irving, Titian, Erasmus.) This drafting-room prank was quickly removed, but not before the firm had suffered considerable embarrassment. During World War I the AIA's code of ethics removed most restrictions on advertising, and a St. Louis architect commented: "While many forms of advertising still in use are extremely vulgar, the same criticism may be made of much of our national architecture."[62]

Competitions

A British observer in 1875 reported that among the architects of the United

States "the frantic and disgraceful struggles called architectural competitions are neither so numerous nor yet so humiliating as in England."[63] Nevertheless Cass Gilbert in 1899 wrote his wife:

This whole competition system is wrong—and I'm sick of it. It is too much to ask a man to spend months of study and work and thousands of dollars all on *chance* and then to have [to] work by political methods to hold what you may have won fairly by merit.... I can't understand why McKim and other men of equal merit submit to it.[64]

However, once his firm participated in a competition, Gilbert was sure to do his utmost.

Early in his career, before he transferred his practice from St. Paul, Minnesota, to New York, Gilbert had artfully maneuvered himself into the meetings of the board in charge of the competition for design of the Minnesota state capitol. When a competition for Washington University in St. Louis was underway, Gilbert went there and invited university officials to view a display of drawings and photographs of his firm's work that he had installed in his hotel suite. As soon as an open competition commenced or he received an invitation to participate in a closed competition, Gilbert recruited "Beaux-Arts men" around New York and set them to work preparing a dazzling entry.

For the competition on the New York Custom House, Gilbert brought Ernest-Michel Hébrard from France and after the competition had been won kept him occupied with revisions of the elevations.[65] Charles McKim around the end of the 19th century both expressed his disapproval of competitions and confessed their importance when he wrote Daniel Burnham: "The ambition of this office is to keep out of competitions and so long as

we can make our bread and butter otherwise, I think it most unlikely that we shall go into competitions...." A year after Stanford White was murdered, McKim was reluctant to enter the closed competition for the New York Municipal building, but four young architects who had recently been promoted to the status of junior partners argued in favor of competing.[66]

There was an undeniable excitement that came from participating in competitions, in one architect's phrase, "what alcohol is to a drunkard." The exhilaration of intense rivalry lay at the heart of the training that young architects received at the *Ecole des Beaux-Arts* in France or gained through participating in the U.S. competitions organized by the Society of Beaux-Arts Architects. (The competitive problem-jury system stubbornly persisted in American architectural education, with exceedingly rare departures from it.) One "Beaux-Arts man" described the attraction in this way:

I had happened to meet on a street here in New York, a former [student] of the Paris school, and he asked me: 'Want to work on a competition?' I accepted with alacrity. Such an invitation to a young man fresh from the Ecole was like a dinner invitation to a hungry tramp.[67]

Thomas Hastings stated an obvious parallel when he extolled the advantages of "a centralized and co-ordinated system of competition or comparison between our schools and colleges, similar to what obtains physically in the intercollegiate games."[68] (By 1902 college football was so firmly entrenched that there were already cries for its reform.) Team spirit was expressed in the way "Beaux-Arts men" boasted of the record of their *ateliers* and of having "niggered" for advanced students who won the major prizes of the *Ecole*. The "Beaux-Arts men" boasted of

the past victories and traditions of their *atelier*, and most *ateliers* had annual banquets in Paris as reunions of former students. Although most architects complained bitterly of the professional competitions required of them, such challenges lay at the core of their training and long remained an essential part of their rivalry.

The horrors of American architectural competitions—whether for governmental, institutional, or private clients—were certain to be discussed whenever American architects met. At the 1885 convention of the WAA, the organization's Committee on Competitions reported its findings, which was that "in spite of confessions of architects generally, that competition, so-called, is full of evil; still it flourishes, and your committee is convinced that it cannot be abolished." The committee had gathered architects' complaints, grouped and combined them. Typical were :

> I was beaten by showy drawings.
> The jury did not call for drawings in good faith.
> The committee 'cribbed' from my design, though it was rejected in the competition.
> A poor design was chosen through favoritism.[69]

In many of the remarks the committees conducting competitions were accused of stupidity, mismanagement, and dishonesty, but most of the grievances could also be read as sour grapes, efforts to save face by explaining away a professional inadequacy.

Evaluation of competition entries had usually been a matter of selection by the laymen who constituted a building committee or commissioners in charge of a project, who were sometimes advised by architects in making their decisions. The code suggested for closed competitions by the WAA committee stipulated that the jury should consist of three architects, one chosen by the owner or building committee, one by the architects invited to participate, and a third selected by the other two jurors. In addition to detailed instructions regarding the systematic handling of drawings and documentation, the WAA code specified that the jury should "not allow any personal conferences with any competitors."[70] Although the proposed code specified that the winner of the competition be engaged as architect of the project, it did not contain any references to compensation of the losers for the expense of preparing the drawings they had been asked to submit.

Building committees that had procrastinated could be driven to bursts of activity in order to meet the deadlines imposed by politics. Officials in Media, Pennsylvania, allowed competitors only one month to prepare designs for their courthouse, in hopes that a show of activity toward construction of a building would thwart efforts to return the county seat to the city of Chester. After the commissioners for the Texas state capitol allowed only two months for the preparation of competition drawings, it was rumored that certain architects had received advance information. Fifteen months before the competition began the Austin *Daily Statesman* quoted a letter in which an unnamed architect claimed to have information that "the architect and contractors are already staked out."[71] The Texas competition received eleven designs from only eight architectural firms. (Architects sometimes submitted more than one design; for state capitols the most common reason was the opportunity to present both a classical domed design and a medieval or Second Empire tower.)

It was said that some of the drawings submitted in Texas had been entered in previous capitol competitions, but the requirements of different capitals or court-

houses were so much alike and the stipu-
lations given to competitors were usually
so vague that the re-use of competition
drawings was probably inescapable. A
draftsman in the office of George R. Mann
recalled being assigned the task of ex-
punging a row of columns from a per-
spective of a state capitol so that a some-
what different arrangement might be
painted in for a current competition. Mann
himself wrote of a competition entry being
"the refinement of floor plans that I put in
for four State Capitol competitions."[72]

John M. Carrère, whose firm did well
in competitions, quoted a building com-
mittee member justifying the cost of a
closed competition, "We have ten [in-
vited] competitors. We can only select one
architect but we expect to get at least $500-
worth of 'ideas' out of each one of the oth-
ers."[73] In many cases competitions for
public buildings seem to have been orga-
nized from the first as exploratory inves-
tigations. If a client or a committee were
uncertain of their preferences and lacked
confidence in their taste, a competition let
them explore a range of ideas at little cost.

Some insisted that competitions were
meant to assist in selecting an architect.
However, in closed competitions in which
only a small number of architects were in-
vited to participate the competitors' pre-
vious works and previous clients could
provide much more reliable evidence. Ob-
viously, most competitions were actually
intended to call up a variety of building
designs at small cost, all prepared without
their architects having had any opportu-
nity to discuss with the clients their de-
sires and needs. As late as 1905 thirteen de-
signs for a city-county building in Chicago
were received by a jury with William R.
Ware as its professional advisor. (Carrère
& Hastings, George B. Post, and D. H.
Burnham & Co. had withdrawn because
of their objections to the conditions of the
competition.) The jury arrived at an imag-

inative decision. A first and second prize
were awarded, and the second-prize win-
ner and another designer were com-
mended by the jury for their interior plan-
ning. However, it was decided by the jury
that for the project the architect of still an-
other design should collaborate with one
of those commended for planning, leav-
ing the winning firm without the com-
mission as architect for the project.[74]

Committees usually consisted of
politicians accustomed to reach decisions
through compromise. A Texas newspaper
reported in 1852 that after receiving com-
petitive submissions for the design of its
state capitol building, the committee in
charge "rejected all the plans submitted,
borrowing enough from each to enable
them to draft one of their own."[75] In a
competition that was restricted to local ar-
chitects, a blanket rejection of all entries
also had the advantage of equally offend-
ing all who had submitted drawings. After
refusing to name any winners it was pos-
sible to have drawings prepared by the
contractor, combining all the ideas and
avoiding the fee that an architect would
expect.

After receiving architects' drawings,
commissioners often allowed the com-
petitors to appear before them and pro-
vide explanations of their submissions.
When drawings were put on public dis-
play for weeks before the commissioners
arrived at their decision, local newspapers
usually became active in a public debate
about the merits of the different designs.
In the squabble over design of the Con-
necticut capitol, the selected contractor set
about publicly ridiculing the design of the
architect Richard M. Upjohn (son of the
founder of the AIA, Richard Upjohn.),
who had won the competition over a year
before. James G. Batterson, a quarry-
owner who had remarkable influence in
the Connecticut legislature, for some rea-
son concluded that he should be the leader,

the dominant spirit, the builder, and also the designer of his state's most important building. Relying on the talents of his quarry draftsman, he maneuvered himself onto the list among the distinguished architectural firms that were invited to participate in the initial competition. Upon losing in the competition, Batterson entered a low bid and was engaged as contractor for the project, after which he instituted a newspaper campaign opposing the Upjohn design. Batterson was supported aggressively in newspapers by two architects and a bishop who praised Batterson's design and described Upjohn's scheme as "dreary, misbegotten." The legislature appointed a new Commission, which sought plans from Upjohn, Batterson, and two other firms. In the end it was still Upjohn who was to be the architect and Batterson the contractor.[76]

At the end of the century a similar zealot appeared in Arkansas. There had been no competition for the building in Little Rock, and George W. Donaghey, a contractor who was a member of the Commission, was chosen to represent it during construction. Before the architect had completed foundation plans, Donaghey started excavation and construction of the basement. For ten years Donaghey battled with the architect, George R. Mann, argued against the contractor, ignored governors, questioned the judgment of the consultants that were brought in, and rejoiced when it was charged that legislators had taken bribes in connection with the capitol project. At last Donaghey, having been himself elected governor of Arkansas, was able to fire Mann and bring in Cass Gilbert to complete the work.

Although Elijah Myers was the architect of other types of buildings, competitions for state capitols were a major part of his thirty-year professional career. In 1872 he wangled an invitation to participate in the second Connecticut competition, but

submitted no entry. The following year Myers won the competition for the Michigan capitol, and construction on the project proceeded so smoothly that it became a principal advertisement for the services of "E. E. Myers, Architect and Superintendent." Twenty-four architectural firms competed in 1878 on the Indiana capitol, but although Myers—always an aggressive competitor—had persuaded the Commission to visit his Michigan project the design of an Indianapolis architect was chosen. Soon a suit was brought charging the Commissioners with accepting bribes, and Myers joined in by suing them for fraud on the grounds that the Commission's draftsman had been instructed to copy portions of the scheme submitted by Myers. One of the Commission's architectural advisors testified that he had been instructed by the Commissioners to add certain features from losing entries to the winning design although "I thought it was not exactly the proper thing to do."[77]

The Colorado competition, which began with twenty-one drawings submitted, soon came down to three designs among which the commissioners could not make up their minds. Myers was asked to combine the three and his compromise design was accepted. However, after two years of constant arguments with the superintendent of construction and many threats of lawsuits, Myers was discharged. In 1884 Myers entered the competition for the Georgia capitol and did not win. After Myers won a competition for the territorial capitol of Idaho, construction was delayed by injunctions obtained by the competing town of Hailey. In Wyoming only three designs were submitted, and Myers claimed that the winner had been secretly sent photographs of Myers' drawings. On the whole, Myers' record is probably better than that of most architects who entered competitions for state capitols. In nine tries he had four winners, but the

burden of tending to construction in several scattered states was detrimental to Myers' health and the solvency of his practice.

The Boston Society of Architects in 1897 tried to devise some standards for the conduct of architectural competitions. They proposed that each firm invited to participate in a closed competition should be paid for the costs incurred in preparing their entry and that in open competitions prizes totaling 0.5 percent of the building's estimated cost (that would be $5,000 for each million dollars) should be divided among at least five competitors, the winner to continue as architect for the project.[78] The Bostonians recommended that these standards go into effect only after being signed by three-quarters of the members of the chapters of the AIA in Boston, Illinois, New York, and Philadelphia, a cautious method of ratification. After the Boston Society signed the document, other groups dawdled, and in the end the effort failed.

Later eighteen of the major New York firms, including McKim Mead & White, Carrère & Hastings, Richard Morris Hunt, George B. Post, Babb Cook & Willard, and Bruce Price, arrived at a policy for closed competitions that required that the winner's employment should include supervision of the construction and that the fee be at least 5 percent. In 1910 the AIA enacted a code for the conduct of competitions, making it unethical in the eyes of the organization for architects to participate in competitions that had not received AIA approval. This code favored closed competitions with payment to participants and opposed open competitions with their "promiscuous submission of sketches." However, six years later the AIA confessed that "we shall always have members who are unwilling to make these sacrifices."[79]

There was a fundamental problem that outweighed all the faults that could be easily found in the operation of competitions. A book on law as it related to the practice of architecture spelled it out clearly:

> If architects choose to enter contests in which no definite promises are made to them by responsible parties, the law will not supply the promises: and judges are quite ready to believe, from their own observation, that architects are willing to do a good deal of work without them....[80]

When the state of Missouri in 1912 began the process of replacing the Jefferson City capitol that had burned, the Commission, on the advice of the state attorney general and in spite of discussion with the state's architects, organized a competition that did not conform to the AIA code. After the local and national officials of the AIA had reviewed the competition documents, the St. Louis and Kansas City chapters announced that for any member to enter the competition would be considered both unprofessional and unethical. At this point the governor instructed the Commission to meet with representatives of the architects, and a satisfactory solution was found.

Although they changed often in form, the AIA's recommended standards for competitions gradually came to be accepted. Disagreement continued, but the comments of the editors of the *American Architect* probably furnish the most realistic summary of the situation:

> ... the "Competition Evil" will, and can, never cease, simply because it is impossible for the profession to agree upon just what the evil is ... the same men at short intervals will reverse their lines of reasoning and argue against conditions which a short while before they had warmly supported, ... the young man who once argued so strenuously for open competitions argues as convincingly for limited competitions when his hair

has grown white ... we have never met the architect who at all times held the same opinions on the competition evil—the men who come nearest ... are those who make it a rule never to enter a competition.[81]

Unfortunate Political Involvements

The committees appointed to build government buildings, churches, or other structures could sometimes be pressed into reckless decisions by constituents clamoring for immediate results, but that was not always the case. Revision of the copyright law in 1870 required that two copies of all copyrighted material be deposited in the Library of Congress, which changed it from a legislative collection to the official national library. An architectural competition for a building to house these functions was organized in 1873 by a committee consisting of the Librarian and two senators. From more than twenty-five entries the winning design was that of John L. Smithmeyer and Paul J. Pelz, both of whom had come to Washington after the Civil War. Smithmeyer, born in Vienna and trained in Chicago and Indianapolis, was at the time employed as superintendent for construction of government buildings in the South. Pelz, a German immigrant trained in New York, was an architect for the U.S. Lighthouse Board.

A year after the competition for the Library of Congress had ended Senator Timothy Howe, chairman of the committee, toured Europe and upon returning instructed the architects to produce a scheme for a library about 70 percent larger than the competition had required and designed in "Victoria Gothic." Congress made the reopening of the competition official, and Smithmeyer & Pelz once again were the architects chosen. Debate continued over the site of the structure, the size of the building, and its style. At a meeting of the American Library Association in 1881 the Librarian of Congress referred to eight years of "no less than four special commissioners and half-a-dozen joint committees," and heated debate among librarians began regarding the degree of departmentalization that might be desirable.[82]

Through more than a decade the project encountered both bureaucratic indecision and legislative squabbling, but a large problem was stylistic disagreement. After the "Italian Renaissance" design that had won the 1873 competition and the 1875 switch to "Victoria Gothic," Smithmeyer & Pelz executed drawings, at the committee's request, for "French Renaissance" in 1877, then "Romanesque," followed by "German Renaissance" in 1879, again "Italian Renaissance" in 1880, a return to "Gothic" in 1882, and final attempts at "Italian Renaissance" in both 1885 and 1886. (These changes requested by the congressmen were itemized in a U.S. Supreme Court decision that considered the claims of Smithmeyer & Pelz for remuneration.) In addition to these variations of architectural style there were also changes in the building's site and its interior provisions.[83]

Trying to sustain their tenuous professional connection with the project, Smithmeyer and Pelz agreed in 1886 to take annual government salaries of $5,000 and $3,000 respectively. In 1886 Smithmeyer was made architect on the construction of the Library of Congress, and the next two years were filled with librarians' arguments about the plan, congressmen's complaints about the cost, interference by an architect who had been placed on the committee, and complete estrangement of the partners, Smithmeyer & Pelz. Probably only Pelz had been occupied with design decisions and preparation of drawings, since Smithmeyer

appears to have been more active in promoting new work than in executing it.. (During the furor, the *Nation* magazine called Smithmeyer a lobbyist, and the Speaker of the House of Representatives called him a liar.) In 1888 the construction of the Library was put in the hands of General Thomas L. Casey, Chief of the Army Engineers, popular after his having completed the Washington Monument. About three years later Pelz was discharged, and the completion of the building's interiors was put in the hands of twenty-eight-year-old Edward Pearce Casey, the general's son who had just returned from study at the *Ecole des Beaux-Arts.*

In 1889 Smithmeyer and Pelz sued the federal government for a 3 percent fee on the Library of Congress. (The usual fee for design and drawings would have been 2½ percent, and an additional ½ percent was added for the project's delay and its interference with their obtaining other commissions.) The case made its way to the Supreme Court, where in 1893 the architects were awarded part of their claim, an amount that was never paid to them in spite of the architects' repeated petitions to Congress. Smithmeyer, who had been president of the Washington Chapter of the AIA in 1887, was barred from the Library in 1899 after a watchman found him loading a revolver in the gallery of the Reading Room.[84]

Construction of a large government building, usually a matter of many years at this time, could mean that its architect might become inescapably associated with the political powers that controlled the project, and in the last half of the 19th century conditions in the federal government and many state and city governments might well require dealing with corrupt political machines and powerful bosses. Few city bosses were as powerful as Boss William Marcy Tweed, whose rule in New York City soon extended to the entire

state. The state government of New York had outgrown its capitol building before the Civil War, and once the war ended the state legislature occupied itself briefly with debate about moving the capital to a location other than Albany.

Advertisement of a New York state capitol competition in 1863 drew only three responses from architects, but after a legislative act was passed in 1865 the Governor appointed a three-member commission, which again advertised its requirements and received thirty submissions. The winning design was the work of Thomas Fuller and Augustus Laver, Canadian architects recently moved to New York City, who some five years before had won the competition for design of Canada's Parliament Building in Ottawa. Ground was broken in Albany, but work slowed after quicksand was found in the excavation, and it was three years before the cornerstone was laid. During much of that period "Boss" Tweed of New York City controlled the legislature, and in 1869 one of his henchmen became governor of New York. Hence, almost all operations of the state government, certainly including the construction of the capitol building, took place with adept skimming by Boss Tweed's notorious Tammany Hall gang, and construction of a large building provided the Tweed Ring with an almost irresistible opportunity for graft. After Tweed was sent to jail in 1872 construction of the capitol was investigated under Governor Samuel Tilden, who had been a key reformer during Tweed's downfall.

As part of ridding the state government of graft, Tilden appointed his lieutenant-governor, William Edward Dorsheimer, as chairman of a new Commission that would assume responsibility for the completion of the capitol. To advise them regarding the project the Commission appointed an Advisory Board of experts, consisting of Leopold Eidlitz, who had

been practicing architecture in New York City for about thirty years; H. H. Richardson, in his tenth year of architectural practice; and Frederick Law Olmsted, whose reputation as a landscape architect had been established by Central Park in New York City and Prospect Park in Brooklyn. Richardson at the time was thirty-eight years old; Eidlitz and Olmsted in their mid-fifties. (Apparently Richardson was greatly impressed by having been included, and that year his sixth child was named Frederick Leopold William after his father's collaborators and the lieutenant governor.) Some eight years earlier Dorsheimer, one of the founders of Buffalo's Academy of Fine Arts, had built a house designed by Richardson.

The Advisory Board's report to the Commission praised the structural soundness of the capitol but found nothing to be admired or even tolerated in the architectural style of the prize-winning design of Fuller and Laver. A few months after the report was completed Fuller & Laver was discharged as architect on the basis of the report and unsupported allegations of responsibility for construction funds having been involved in the graft that was rampant in Albany. The authors of the report were quickly made the new architects for the capitol building. Since it had been specifically requested that the Advisory Board's report include new drawings, this outcome could have surprised no one. Augustus Laver had already gone to San Francisco, where their firm had been engaged as architects for a new city hall, and after a few years Thomas Fuller returned to Canada, where he served for fifteen years as the dominion's official architect.

For the capitol project only, the Advisory Board rapidly transformed itself into the firm of Eidlitz, Richardson and Company, at a time when it was unlikely that any of the partners were overburdened with work because of the severe

worldwide depression that had begun in 1873 and continued through 1877. Although the capitol building had already been under way for more than five years and construction had reached the third floor employing Fuller's style, usually spoken of as "Italian Renaissance," Dorsheimer seems to have been more inclined toward medieval precedents. Eidlitz usually favored the Gothic style, although he seasoned it with bits of Moorish and other Middle Eastern details; Richardson had only recently begun experimenting with the weighty Romanesque forms that would become his style; and before landscape development began Olmsted's role was simply that of treasurer and skilled spokesman for the one-job firm.

The imposition of quasi-medievalism on an "Italian Renaissance" base was hotly discussed in the architectural press and in Eastern professional circles, where historical and stylistic consistency could sometimes be taken very seriously. There were also arguments within the profession about the ethics of the incident. Should an architect be ousted on the basis of evaluations made by consultants whose opinions might well have been determined by their plans to take his place? The *American Architect & Building News* commented: "We doubt if any occurrence in this generation has done more to weaken the general confidence in architects...."[85] The new architects proceeded in their work without much attention to a comprehensive view of the design—which would have been difficult with so much of the construction already completed. Eidlitz and Richardson simply divided up the work territorially. Certain rooms and facades were assigned to each of them, with a degree of accommodation at boundaries that fell between their jurisdictions.

Concerned about lavish expenditures on the work, one new governor vetoed an appropriation until it was cut in half, and

in doing so he referred to the project as "a great public calamity … without a parallel for extravagance and folly." Occasionally legislators worried about the mounting cost of the building, but in 1879 a governor concluded that the capitol building was "so far advanced that there seems to be no rational course left but to provide for its completion in the most advantageous manner possible." When most of the building was at last opened to the public, twelve years after ground was broken, the governor refused to attend the festivities. Grover Cleveland during his tenure as governor viewed the project with resignation: "The building should be finished as quickly as practicable, and the delays, errors and expense attending its construction, if possible, forgotten." But it was 1899 before the "Million-Dollar Staircase" was finished and the New York state capitol could be declared completed.[86] (The actual cost was closer to $1,500,000 in 1900 dollars.)

Early in the next century the architect of a new Pennsylvania capitol building became enmeshed in a similar movement of political reform. A 1901 competition was won by Joseph Huston, a thirty-five-year-old Philadelphia architect, well-connected socially and principally known for his designs of fashionable residences. Only residents of the state were permitted to enter the competition, and both Philadelphia's T-Square Club and the Philadelphia Chapter of the AIA had declared the competition off-limits for their members. Six years after his triumph in the competition, Huston told a reporter: "It was my first public building and, please God, it will be my last." Construction of the capitol was in the hands of a Building Commission and so seemed adequately protected from the outrageous activities of the state political boss Matthew Quay. However, a separate Board of Commissioners of Public Grounds and Buildings was appointed, and it gained control over the "furnishing" of the building. It was through this Board and the desks, spittoons, and chandeliers that the henchmen of Boss Quay, then a U.S. senator, found their graft. The State Treasurer informed the public that the project had cost around three times the amount officially announced, and this led to hearings that were held for three and a half months with 3,500 pages of testimony taken. In the end Huston and the Philadelphia decorator who provided furniture, lamps, and fixtures for the building were tried and convicted.[87] After all the trials had ended, Huston was the only one who lived to serve his sentence, six months and twenty days before he was paroled in 1911. The Quay machine had collapsed seven years before, when Matthew Quay died.

Practices and Partnerships

When he was seventy-one years old, Leopold Eidlitz commented on changes in the conduct of architectural practice, but his comments may have applied more to his New York colleagues than architects in small cities:

> Like the modern politician, the architect of fashion has no convictions, but follows adroitly in the wake of public opinion. His aim is not to be a great architect, but to do a big architectural business....
> The old method of spending weeks and months in designing in the seclusion of one's library is utterly impracticable with the modern business habits of the architect of fashion. Two or three hours in the morning must suffice for office work, which consists mainly in receiving prospective clients, in brief and rapid interviews with clerks of the works, in signing certificates for payments to builders and dictating a few letters.... The afternoons and evenings are devoted to social intercourse with probable clients who are visited at their offices, met … in banks and insurance build-

ings, and later at clubs, receptions
and public meetings.... Architecture
has ceased to be an art and has be-
come a business, a fashionable busi-
ness carried on by business methods
on business principles.[88]

Eidlitz perhaps exaggerated when he wrote
that an architect might have little time for
designing, and his words may have been
less often true in partnerships where indi-
viduals' abilities varied.

The New York firm of Town & Davis
is usually cited as the first architectural
partnership in the United States. There
had been a brief earlier partnership (1827–
1829) of Town and Martin Thompson at a
time when Davis was practicing alone. The
young Irish architect James Gallier found
that in New York there were "some half a
dozen" draftsmen engaged in the "horse-
in-a-mill routine of grinding out drawings
for the builders," and the only architect's
office in the city—in his opinion—was the
partnership of Town & Davis.

> Town had been a carpenter, but was
> no draftsman; he had obtained a
> patent for a wooden bridge ... and
> had made some money by it; ...
> Davis, his partner, was no mechanic,
> but was a good draftsman, and pos-
> sessed much taste as an artist....[89]

The trips Town took to promote the use of
his wooden lattice truss provided oppor-
tunities for the architectural firm through-
out the seaboard states. The partnership
was consequently a well-chosen balance of
abilities between men about twenty years
apart in age.

One writer described typical archi-
tectural firms of the 1920s as being "com-
posed of men of varying talents and abili-
ties; a designer (often hired), a constructor
(sometimes hired), a business man, and a
business promoter."[90] (It should be noted
that the last two positions in this archetyp-
ical firm were not to be "hired.") Aspiring
architects who lacked certain qualifications

might arrange a partnership that would
solve their problem. Kirtland Cutter, from
a wealthy Cleveland family and Europe-
trained in painting, had limited success in
Spokane, Washington, though he was a
nephew of the city's leading banker. How-
ever, his practice thrived once Cutter in
1889 took as his partner John C. Poetz,
who had seven years of education and ex-
perience in architecture. Charles A. Platt,
who pursued a career in art until he was
fifty-five years old, explained his practice
of architecture by saying, "...it was a great
relief to me to employ 1st class men...."
Shortly before World War I the Philadel-
phia firm of Mellor Meigs & Howe was
formed. Mellor had graduated in archi-
tecture from the University of Pennsylva-
nia and worked two years for an architect,
Meigs had no professional preparation so
far as is known, and Howe had three years
of experience in an undistinguished firm.
In practice Meigs and Howe designed,
each doing the projects he had himself
brought into the office, and Mellors, the
architectural graduate, supervised man-
agement of the firm.[91]

Probably the most common form of
professional partnership was the tradi-
tional association of father and child, the
father teaching his child the basics of the
family trade. (Father-and-son partner-
ships were commonplace, but in Detroit
from 1915 to 1936 the firm of Butterfield &
Butterfield consisted of Wells D. But-
terfield and his daughter Emily, a 1907 ar-
chitecture graduate of Syracuse Univer-
sity.) Not all sons had either the interest or
talent needed to equal their parent's pro-
fessional performance, but they sometimes
had the judgment to hire carefully, finding
employees to compensate for their own in-
adequacies. In some cases the transition
from father to son clearly reflected changes
in the profession. After years as a respected
mason, contractor, and dabbler in real es-
tate, Jonathan Preston, born in Boston at

the start of the 19th century, adopted the title "Architect and Builder" in 1850 and moved his office to the Court Square district, the architectural profession's center.[92] Ten years later, Jonathan's new status was acknowledged by his being one of six architects invited to compete for the Boston City Hall. In the same year, his son William G. Preston graduated from the engineering program at Harvard's Lawrence Scientific School and left for study in Paris, one of the earliest Americans to study at the *Ecole.* William returned to practice with his father, who retired at the age of seventy-five.

There might well be more than a single generation involved. The Snook family's prominent New York practice began in 1837 when Jonathan B. Snook opened an office at the age of twenty-two. Jonathan's son Samuel, his grandson Thomas, and a great-grandson Thomas Jr. followed. Three generations, all named John Stevens, practiced in Portland, Maine, and many other firms were passed on to grandsons. The Smiths (Mortimer, Sheldon, and Fred) practiced in Detroit from 1855 to 1941 through family partnerships and incorporation. While a fourth generation (Fred L. Smith, Jr.) left the firm of Smith Hinchman & Grylls after some six years as an architect-specification writer, the Smith family retained a significant amount of stock in the firm. Continuous operation of a practice was not possible for the Upjohns. Richard's son, Richard M. became a partner after six years of training in his father's office, but Richard M.'s son was only fourteen years old when his father retired from practice. In spite of that interval, when Hobart Upjohn opened his office in 1905, he was soon selected as architectural advisor to the New York parish of Trinity Church, which his grandfather had designed about seventy years before.

Brothers might band together, but this had varying results. Harvey Ellis, known principally as a delineator, practiced briefly in Rochester, New York, with two brothers who had no particular architectural qualifications; Charles acting as salesman, Frank as bookkeeper.[93] In the Rapp family of Carbondale, Illinois, five of the seven sons of a builder-architect became architects. The older two, Isaac and William worked together in Trinidad, Colorado, and New Mexico, where they were influential in the development of the "Santa Fe style" in the first decades of the twentieth century; and during the same period two younger Rapps settled in Chicago, where their firm designed more than four hundred movie houses.

When Willis Polk's family joined him in San Francisco in 1892, he organized a firm based on their skills: the father was familiar with construction, brother Daniel was a talented draftsman, and Willis was designer. But after four years the father retired, Daniel left for a career playing banjo in vaudeville, and Willis was left to practice alone.[94] George I. Barnett in St. Louis trained three sons, one of whom moved to California. At one time the succeeding firm, Barnett Haynes & Barnett included Tom Barnett, his brother-in-law John Haynes, and his brother George Dennis Barnett, whose son and grandson also followed careers in architecture. The partnerships of brothers-in-law were more tenuous. When his sister divorced Charles McKim after one year of marriage, William Bigelow felt obliged to leave the firm of McKim Mead & Bigelow, opening a vacancy for Stanford White.

Another source of partnerships was the office in which an ageing architect worked with a faithful younger draftsman or perhaps chief draftsman who supervised the office staff. The St. Louis firm of Grable Weber & Groves provides an example of changes in the profession.[95] Sixty-three-year-old Alfred Grable, who had been a carpenter and builder before

the Civil War, formed a partnership in 1888 with thirty-one-year-old Auguste Weber, who had joined Grable three years earlier after eleven years of experience with another architect. Albert Groves was employed by the firm after he graduated from Cornell University, and three years later he was taken in as a partner in 1894. At that time the ages of the firm's partners were sixty-nine, thirty-seven, and twenty-eight.

Employers who were late in recognizing the contribution of a useful designer or draftsman were often surprised when informed that their dependable employee was leaving to open his own office or join an employer who might be more appreciative. Such crises could be avoided by making key personnel "junior partners" who customarily shared in profits but were not included in the firm title. Occasionally such a partnership was declined, because the employee was unwilling to assume a minor role or preferred to continue with a specific income rather than a percentage of unpredictable profits.

In 1889, seventeen years after he joined the firm of McKim Mead & White, Joseph Wells declined the firm's offer of a junior partnership. Highly admired by the firm's staff, Wells was an extremely gifted detailer and designer, but he declined the partnership saying that he did not wish to have his name connected with "so much damned bad work." Five years later the partners of McKim Mead & White felt that they should do something for the men who had been working there for several years. They offered key personnel a choice between an increase of pay from $35 per week to $50 or a partnership with a small percentage of the firm's profits. Henry Bacon chose the increase in pay and later commented that the others got nothing but "their names on the door and a key to the bosses' toilet."[96]

The sickness or death of an architect practicing without partners usually led to the office staff completing the work in hand before closing the office. Sometimes this situation encouraged the staff to establish a continuing firm of their own. In 1886 H. H. Richardson died at the peak of his popularity with about twenty-five commissions in his office, varying from contracts under negotiation to construction projects near completion. This work was assumed by a successor firm of (1) George Foster Shepley, who had been with the Richardson office for four years and soon would marry Richardson's daughter, (2) Charles Allerton Coolidge, a Richardson draftsman for three years who would soon marry Shepley's sister, and (3) Charles H. Rutan, an employee for seventeen years who had come to be relied on for engineering and technical matters.[97]

Both Shepley and Coolidge had come to the Richardson office upon finishing the two-year "special course" at MIT, both had family connections and upbringing that would assist in securing clients, and both were in their twenties. Obviously Rutan, almost a decade senior in age and experience, was needed to balance the partnership. Among the other firms that came from the demise of the Richardson office were Longfellow Alden & Harlow, Andrews Jacques & Rantoul, and Warren Smith & Biscoe. In each case all of the partners were in their twenties, and the first partner listed came from the famous Richardson office. But death did not necessarily end an architect's practice. The Philadelphia firm of Cope & Stewardson did not end until 1912, continuing under Emlyn Stewardson after partner John Stewardson died in 1896 and Walter Cope died in 1902.

Many partnerships were made of coworkers who discovered each other's capabilities while employed in the same architectural office. John M. Carrère and Thomas Hastings met only once while

both were studying in Paris, because Hastings thought Carrère, who had been educated in Europe, was a Frenchman. While they both were employed at McKim Mead & White in New York they shared responsibility for a house in Baltimore, Hastings doing the drawings and Carrère supervising construction. In 1885 they formed a partnership, but Hastings did not recall there being a written partnership agreement before 1900. In their practice Carrère continued to take care of construction and Hastings the design, although H. Van Buren Magonigle remembered that Carrère once told him "that he was 'tired of being thought the plumber' and had resolved never again to write or speak on anything but the esthetic side of architecture."[98]

The partnership of York & Sawyer also began at the offices of McKim Mead & White, where the future partners had little contact until

> Yorkie came into my alcove [and] asked if he might look at some competition drawings which I had made for a Plainfield, New Jersey, High School ... and asked if he might take it in his alcove to look over.... Presently Yorkie came back. "Would you be willing to let me use these drawings in a competition and if we should win, to go into it with me fifty-fifty?[99]

After a few small adjustments to the drawings were made, they won the competition for a building at Vassar College. A similar relationship between Daniel Burnham and John Root was succinctly described by a Chicago rival: "Burnham got the jobs. Root did them."[100]

Partnership did not necessarily signify a close working relationship among a firm's partners. Just before the Civil War, Albert Diettel, who had left Dresden after the revolutionary outbreak in 1849, was a partner in the New Orleans office of an Irishman, Henry Howard. In the spring and summer Howard spent his time on riverboats, traveling the Mississippi to inspect construction of the firm's projects and to solicit other commissions. John Hubbard Sturgis, who had studied in England and traveled through much of the world, returned to work in Boston from 1861 until 1866, when he established a partnership with Charles Brigham. Brigham tended to matters in Boston while Sturgis spent the next four years in England and afterwards went there annually for extended visits with semi-monthly letters coming from Brigham to inform him of happenings in their firm.[101]

In the office of McKim Mead & White both McKim and White designed projects and solicited business, Charles McKim being known for the eloquence with which he charmed institutional and business clients and Stanford White for his influence with clients' wives and members of the countless clubs to which he belonged. Many of those who worked there remembered the office as having been two different teams, almost independent, one occupied with McKim's projects, the other with White's. The design judgment of Mead, the third partner, was respected by both of his partners, but he was principally charged with managing the staff, and he explained his role as preventing his partners from "making damn fools of themselves."[102] The 1911 revision of the partnership agreement for Cram, Goodhue & Ferguson shows that more than distance separated two of the partners:

> The final decision in all matters of design in work carried on in the New York office shall rest in BERTRAM G. GOODHUE. The final decision in all matters of design in work carried on in the Boston office shall rest in RALPH A. CRAM. The final decision in all matters of engineering and construction in work carried on in both offices shall rest in FRANK W. FERGUSON.[103]

The following year Goodhue asked a friend in England to listen carefully to Cram's speech before the Royal Institute of British Architects and inform him if Cram took credit for any of the work done in New York.

In Chicago the partnership of Adler & Sullivan brought together Sullivan's extraordinary design talent and Adler's broad technical knowledge, both being— for very different reasons—profoundly respected by their professional colleagues. With this kind of division of labor one of the partners might actually design all projects undertaken by a firm, however as the number of projects grew it became increasingly likely that projects, particularly small projects, could receive little attention from anyone listed on the firm's letterhead. Although one must conclude he was being disingenuous, Louis Sullivan wrote in his autobiography of discovering some time in the 1870s that works of architecture were not always the designs of those who received credit for them.

> Louis learned incidentally that the Portland Block [attributed to William LeBaron Jenney] had in fact been designed by a clever draftsman named [Adolph] Cudell. This gave him a shock. For he had supposed that all architects made buildings out of their own heads, not out of the heads of others. His experience in the office of Furness & Hewitt, in Philadelphia, it seems, had given him an erroneous idea. Yet the new knowledge cheered him in this hope: That he might some day make buildings out of his head for architects who did not have any heads of their own for such purpose.[104]

The architects listed on an office door could usually be assumed to have at least an indirect or supervisory relationship with a design produced by the firm, but this might be little more than their judgment in hiring employees that were capable of furthering the firm's stylistic and technical development. George B. Post's office had been in operation only about two years in the 1860s before he began a system of assigning projects to individual designers on the staff.[105]

Extending Practices

The thinly-settled West provided a vast experimental field in which young architects from the East could quickly rise to positions of responsibility and sample a variety of training. Henry C. Trost in 1880 left Toledo where he had gained a little experience, and in the next twenty-three years he engaged in architectural work in Denver, Pueblo (Colorado's "Pittsburgh of the West"), Dallas, Fort Worth, Galveston, Dodge City, Chicago, Colorado Springs, and Tucson. At the age of forty-three Trost settled down in El Paso, Texas. Willis Polk, starting in Kansas City in his early twenties, worked for five architects and moved from coast to coast three and a half times before settling in San Francisco. Samuel E. Patton practiced as architect and builder in Phoenix, Flagstaff, Prescott, Roswell, and El Paso, promoting, constructing, and operating opera houses in most of those cities. (Western opera houses presented many sorts of entertainment, but rarely opera.)[106]

When clients had complained to Benjamin Latrobe about his being absent from a construction site, the architect replied that he necessarily assumed simultaneous commissions at different locations: "… in countries infinitely more populous no Architect or Engineer of any reputation could ever remain long in one place." Even in the most populated areas of the northeastern United States it was often necessary for architects to range over long distances in search of a steady supply of clients. As firms grew in size it was often necessary to take on work in distant areas in order to sustain the specialized work-

force that had been assembled. After the Civil War the major architectural firms in the United States became national in their practices. At first (1873-1892) the Chicago firm Burnham & Root had only around a tenth of its buildings outside Illinois and the adjacent states of Indiana and Wisconsin. After John Root's death and the Columbian Exposition (1893-1904) almost a third of the succeeding D. H. Burnham & Company's work was located outside that three-state area, and by the final eight years of that firm (1904-1912) the proportion rose above two-thirds, the most distant projects being Selfridge's department store in London and the planning of Manila in the Philippine Islands.[107]

Frequently the architectural firm that had completed design and construction drawings for a project would not be employed to supervise construction. For public buildings it was likely that supervision would be arranged with a member of the building committee who was somewhat familiar with construction or that a politically advantageous choice could be made. The end of a competition left many things to be determined:

> ... once a design is selected, the architect has to enter on a series of discussions as to what further he is to do in reference to it; whether he is only to furnish the plans, or whether he is also to superintend, and in what way, and at what rates; if there is to be a superintendent besides the architect, and if so, whether he is to act over or under the architect.[108]

If the architectural firm provided supervision, a traditional clerk-of-the-works could be situated on the construction site to prepare additional drawings when needed and explain the plans to the foremen. The position of clerk-of-the-works, never so common in the United States as in England, originally involved responsibility for keeping accounts of the materials and labor employed in the project and seeing that the drawings were followed, for which he was paid by the owner although supervised by the architect.

In the 1870s Glenn Brown, an architect in the District of Columbia, had acted as clerk-of-the-works on a building designed by H. H. Richardson and constructed by O. W. Norcross. Brown's description of the clerk-of-the-works' duties go somewhat beyond those traditionally associated with that position:

> Of the architect's drawings he made full sized shop drawings, with patterns for stone work and details of carpenter's and mill work. The office was in reality a working branch of the architect's office. In addition ... he delivered and explained the drawings to the foremen of the different trades.[109]

For large projects at a distance from the architectural firm's office it was often necessary to make other arrangements for the long construction period. Supervisory services could be contracted with an architectural firm, builder, or engineer in the vicinity of the site, and employees of the firm who specialized in job-site supervision might be periodically dispatched to the site.

A frequent solution was the assignment of one of the office's draftsmen who was familiar with the project's details, the firm's intentions in the design, and the firm's experience in the construction of other buildings. Usually this meant an unmarried draftsman who had participated in the preparation of drawings for the project. After such a representative had spent several years in a western city as the representative of a distinguished East Coast or Chicago firm, he would have acquired useful professional, social, and perhaps political connections with which to start his own practice. Richard Morris Hunt in 1890 sent Richard Sharp Smith to Asheville,

North Carolina, where Smith saw to the construction of the Vanderbilt's Biltmore estate for six years and later became a leader among the state's architects. The two young men McKim Mead & White sent to Oregon to supervise construction of the Portland Hotel became the firm of Whidden & Lewis two years later. Charles H. Bebb, with European education and South African experience in engineering, was sent to Seattle by Adler & Sullivan, but after the Seattle Opera House project was abandoned he supervised construction for Seattle architects before opening his own architectural practice. The Philadelphia firm of Cope & Stewardson, recognized as specialists in college architecture, in 1900 won the competition for buildings at Washington University, St. Louis, and placed one of its draftsmen, James F. Jamieson, in charge of a branch office there. When the firm of Cope & Stewardson was dissolved, Jamieson was chosen to succeed as architect for Washington University.[110]

The Boston firm of Shepley Rutan & Coolidge, the partnership formed by his senior staff after H. H. Richardson's death, had a tendency toward far-flung activities. Shortly before he died, Richardson had sent one of his draftsmen, twenty-five-year-old Frederick A. Russell, to supervise construction of the Allegheny County Court House and Jail in Pittsburgh for which the firm had won the competition in 1884. Continuing Richardson's work, Shepley Rutan & Coolidge, sent Frank E. Rutan (brother of a partner) to join Russell in Pittsburgh, and after the completion of the Court House, the firm of Rutan & Russell opened practice in Pittsburgh. One of the Shepley Rutan & Coolidge partners, Charles Allerton Coolidge, seems to have liked traveling, and the initial terms of the partnership permitted him to travel at his own expense, participating in the firm's profits from those jobs that re-

sulted from his travels.[111] Coolidge's penchant for travel resulted in the firm in 1888 obtaining the commission for the design of Stanford University in Palo Alto, California, a railroad magnate's memorial to his son. The firm's Boston office sent Charles E. Hodges west, where he represented it from 1893 to 1900, and himself served as architect for Stanford University from 1900 to 1907.

Shepley Rutan & Coolidge had won the competition for design of the Chicago Public Library in 1892, and this was soon followed by the commission for the Chicago Art Institute. (Their good fortune was resented by many Chicago firms, where the Boston office was occasionally referred to as "Simply Rotten & Foolish.") Chicago became the firm's western outpost, usually having a partner in residence and responsible for work that might be scheduled in the western two-thirds of the nation. Among those sent from the Boston office to Chicago: George S. Dean, who later established a Chicago office that specialized in industrial construction, and Alfred H. Granger, who opened his own Chicago practice in 1894 and with various partners designed many railroad stations. John Lawrence Mauran and E. J. Russell were in charge of the Shepley Rutan & Coolidge branch office in St. Louis, where they later formed the firm of Mauran Russell & Garden—the last having been a draftsman in the branch office.[112]

Drawings and Specifications

For relatively simple structures in the first half of the 19th century, such as the church by Robert Mills and the house by A. J. Davis that have been mentioned before, fewer than a dozen drawings were required when construction started. The numbers of drawings that had to be prepared and reproduced would multiply remarkably through the 19th century, and

the size of projects and the amount of detail that was needed for contractors bidding the work greatly increased the amount of information that was expected in the drawings. Workmen were not familiar with the multitude of details and embellishments that different architects employed and were, some said, less skilled in their crafts.

Toward the end of the century more and more of the elements that made up buildings were selected from the catalogs that manufacturers published, instead of being fabricated on the building site in accordance with drawings supplied by the architect or a clerk-of-the-works. Because much larger projects were being built more quickly, greater demands were made on the predictive powers of architects, their draftsmen, and those who supervised construction. Once a designer might have been able to look at the roughly-finished volume of a room, judging the quality of light and the actual space, before details of the mantel and panelling were prepared. That became impossible, and the spirit of the details depended increasingly on the designer's ability to foretell conditions and the adoption of accepted standards of design.

To receive a client's final approval of their work and obtain contractors' bids or estimates, architectural firms in the last half of the 19th century prepared sheets of floor plans, elevations, critical sections, and those details that were most important. These basic drawings were usually laid out at the scale of ⅛" = 1'. Conventions varied from office to office, but most architects prepared those essential drawings on large "stretched" sheets of white paper. For this purpose it was the accepted standard to use hot-press (smooth surface), double elephant (27 by 40 inches) watercolor paper, as manufactured in England by Whatman. On all four edges of a sheet of this paper a margin of a half-inch or

more was turned up before the paper was sponged with water. Glue was applied to those margins in order to secure the paper to a drawing board, and the margins were pressed down firmly to force out any excess glue. As the paper dried it shrank to become as tight as a drumhead. After a drawing was completed and cut from the drawing board, it was necessary for office boys to soak and scrape the glued margins from the board, preparing it for the next "stretch."

The basic drawings would be kept in the architect's office throughout the long process of construction, so they were customarily backed with cloth by a local bookbinder's shop. Copies of these basic drawings would be prepared for the use of contractors during construction. Before the introduction of manufactured tracing paper, fine-pointed "prickers" were used to make tiny punctures through key points of the drawings and through fresh sheets of paper that had been placed beneath. These holes, barely discernible, served as guides for the construction of duplicate drawings.

Pencils of graphite in cedar wood had originated in the late 17th century, and by the middle of the 19th century hexagonal pencils were available in standardized degrees of softness.[113] (Since the term "pencil" had originally meant a small thin brush, they were at first called "dry pencils.") Pencils were marked with "B" for "black," "F" indicating "firm," and "H" for "hard," and numbers were added to these designations to denote the degree of blackness or hardness. The pencil lines of a drawing were drawn over with ink in two-pronged ruling pens. Ink was made by rubbing sticks of India or Chinese ink with water in small dishes of slate or soapstone, a tedious chore for office boys until bottled ink was introduced in the 1880s. Before erasers of India rubber were available, pencil drawings were usually cleaned with

wadded chunks of stale bread, and errors in inking were corrected by scraping the lines with a sharp knife blade and then rubbing the area with emery powder. After lettering and dimensions had been added, the inked plans and sections were tinted with watercolor to indicate the materials to be used. (Wood in ocher, brick in light

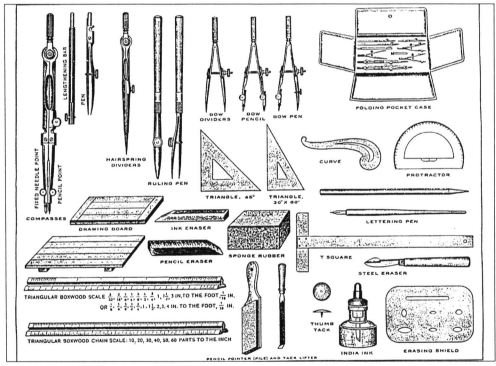

Top: Even after manufactured India ink became available, the clear, rich black of Chinese ink was preferred for preparing shaded monochromatic wash drawings. The glossy black sticks of ink (three to five inches long) were rubbed with water in the well of a dish of slate or soapstone. Graininess in the ink thus prepared could be eliminated by siphoning it into another container through a strip of cloth. (*Catalogue and Price List of Eugene Dietzgen Co.*, 1902-1903.)

Bottom: An elementary set of equipment for an architectural draftsman. Ink from an extension of the bottle cap was fed between the prongs of the ruling pen, which could be adjusted to increase or diminish the width of the line that would be drawn. The points of dividers were used to transfer a dimension from one drawing to another or to mark off repeated dimensions as for brick courses or stair treads. (A. Benton Greenberg, *Architectural Drawing*, 1913.)

red, and iron in blue.) Shadows were often added to elevations in the drawings that were to be given to the architect's client or exhibited in the architect's office. For this purpose it became customary late in the 19th century to use a 45°/45° (diagonal of a cube) direction of light, a system that originated in France.

Before commercial production began, a kind of tracing paper could be made by coating thin sheets of paper with a mixture that was primarily turpentine with the addition of small amounts of resin and nut oil, but most draftsmen considered this paper's odor insufferable. As manufactured tracing paper and tracing linen, a thin cloth heavily coated on one side, became available during the middle of the 19th century, an increasing number of copies were made from drawings by office boys who had been accepted for training as draftsmen or by young men with high school training in "mechanical drawing." It seems often to have been convenient for drafting-room personnel to blame any errors on the "stupidity and carelessness of tracing-boys."[114]

The Chicago office of Burnham & Root around 1890 was known for its use of a hektographic system that involved drawings made with aniline inks or pencils of various colors, which were transferred to a slab of gelatin or a glue-glycerine mixture from which copies could be made. Purcell says that on the roof of the Tacoma Building in Chicago hektographic prints were made on "large moist clay table tops."[115] The "indelible" inks used were so powerful that they could not be erased, and errors had to be cut out and redrawn on an inserted piece of paper. Different colors of hektograph inks indicated materials, corresponding to the colors used in watercolor; red was used for dimensions and dimension lines. With the development of photolithographic techniques a few architectural offices, notably the Su-

pervising Architect of the Department of the Treasury, began reproducing drawings by those methods.

By the 1880s blueprinting became common, eliminating the copying that had required so many tracing-boys. The process had been discovered in the 1840s by the astronomer Sir John Herschel as part of his studies of light and photography. Although other methods were developed, Herschel's basic process continued to be the one most commonly used by architects and engineers "on account of its simplicity, and because it requires the least skill and experience."[116] In its early form blueprinting involved mixing solutions of citrate of iron and red prussiate of potash (ferric ammonium citrate and potassium ferri-cyanide in today's terminology) and sponging the solution onto the paper on which a print was to be made. After drying in a dark drawer, the paper would be a deep yellow. The frame for making blueprints in the sun consisted of a padded board and a sheet of plate glass. Between the padding and the glass were inserted a sheet of the treated paper and a drawing on tracing paper or cloth. The frame had to be exposed to sunlight for thirty to forty-five minutes on clear sunny days or twice as long on cloudy days. If slips of prepared paper and a small tracing were inserted at the edge of the frame, pulling the slips out would determine when the print had received enough light.

After exposure to the sun the print was a bronze color with dark brown lines from the drawing, but when thoroughly washed in cold water the prints showed white lines against a deep blue background. An office boy assigned to prepare paper for blueprinting and wash the prints with cold water could be easily identified by his chapped and blue-stained hands. When blueprint paper began to be available commercially, most architects in the Eastern states preferred to use a paper that

Top: At prices ranging from $35 to $70 an architect was able to buy a blueprinting frame for mounting in a window. The frame was turned over for insertion of the drawings and blueprint paper. It could then be rolled through the window and tilted so that the glass side would be aimed at the sun. Other models also swiveled horizontally for additional adjustment to the sun's position. (*Catalogue and Price List of Eugene Dietzgen Co.,* 1902-1903.)

Bottom: The introduction of arc lamps made blueprinting more efficient and convenient. Cylindrical machines, in which arc lamps were lowered inside a glass cylinder around which drawings were strapped, were introduced at the end of the 19th century and remained popular for several decades. In the later continuous copiers electric motors drew a wide belt over curved glass. (*Catalogue and Price List of Eugene Dietzgen Co.,* 1902-1903. B. J. Hall, *Blue Printing and Modern Plan Copying,* 1921.)

sunlight in the two regions.[117] With the introduction of blueprinting, color could no longer be used to identify the materials shown in drawings, and it was necessary to develop a system of hachures, patterns of lines and dots, to identify the materials shown in drawings.

The New York office of Charles Coolidge Haight in the 1880s had a blueprinting frame "that ran in and out of a window on a track." In 1894 McKim Mead & White built a shed for blueprinting and model-making on the roof of the Fifth Avenue building that held their offices. When F. C. W. Kuehn moved to an office above the City National Bank in Huron, South Dakota, he installed a bracket outside the south window of his office to hold his blueprinting frame. However, in the 1930s Kuehn bought from another architect one of the blueprinting machines that had been introduced, a glass cylinder around which tracings and print paper were held in place by a canvas girdle as an arc lamp was lowered inside the cylinder. Although sturdy frames could be bought and easily installed in a sunny office window, William G. Purcell recalled that at the age of twenty-two, fresh from Cornell, one of his duties in the office of an Oak Park, Illinois, architect was a trip at Saturday noon to take the entire week's production of tracings to downtown Chicago, where they would be "sunprinted" on the roof of the Tacoma Building.[118]

was quicker and produced a slightly lighter shade of blue than was popular in the Western states, but this choice may have been influenced by different qualities of

For Christ Church (1846) in Raleigh, North Carolina, Richard Upjohn provided ten drawings of plans, elevations and sections; a large-scale section of the roof; sixteen sections and details; twenty-five full-size details; and a model to explain the roof construction—all of this for $500. By the time that the Union Station in St. Louis was completed in 1894, its construction required about 165 drawings—working drawings, presentation perspectives, and details, most of them executed in India ink on tracing linen. At the end of the 19th century, the Philadelphia firm of Cope & Stewardson prepared twenty-six sheets of drawings as their initial documents to accompany the specifications for the Law School Building at the University of Pennsylvania. However, during construction those initial drawings were supplemented by 321 drawings of details, the majority of which were drawn full-size.

The custom of drawing the plan and other basic drawings for a large project at a scale of ⅛" = 1' was abandoned by the New York firm of Tracy & Swartwout after their drawings for the Denver Post Office and Court Building (1900-1914) had to be executed on sheets about 4' by 5' and those for the Missouri State Capitol (1912-1916) around 5' by 7'. For the latter project the contractor found it efficient to move the complete set of seventy sheets of drawings (including structural and mechanical layouts) around the construction site in a wheelbarrow. However, there were reports that workmen often simply tore off the portion of a blueprint that they needed. After that experience the architects began using a more diagrammatic plan at 1⁄16" = 1' for large projects.[119]

Before the introduction of blueprinting every architectural office provided a "contractors' room," where estimators came to study the drawings for the building on which they were to figure their firm's bid. Placement of the contractors'

room required reasonable proximity to the firm's specification writer and separation from draftsmen, designers, and visiting clients. While contractors were preparing their calculations, work began on detail drawings for the project. Full-size drawings were drawn in soft pencil or crayon on detail paper, white or manila, which came in rolls of 100 yards, either 36" or 55" wide. The roll was usually hung on a drafting-room wall, where draftsmen could easily tear off the length of paper required for their work. On these drawings a water color outline defined the materials for workmen, who received the originals while tracings of them, often drawn freehand, were kept in the architect's office. Since a vertical wall-section for a large building might occupy several yards of paper, detail drawings were folded for storage. Tracings of the details made in George B. Post's office were "folded to 8 × 10 inches and put in portfolios." As late as 1918 Albert Kahn's office in Detroit included storage for "boxes for the folded, full-size details."[120] Drawings at a scale of ¾"=1" were sometimes used for designers to study portions of the building that could not be adequately considered at the small scale of the major drawings.

Until the typewriter came into use, the specifications that stipulated materials, equipment, and the methods of installing them were written in longhand, and some firms included "many free-hand pen and ink sketches to clearly interpret the meaning" in the wide margins of their specifications. H. Van Buren Magonigle, a prominent New York architect around the time of World War I, recalled after fifty years the tedium of copying specifications from his employer's illegible script and making copies, all because at the age of fourteen his penmanship was clear and precise.

> With all other right-minded office boys I loathed that job at the close of day just when we wanted to cut away

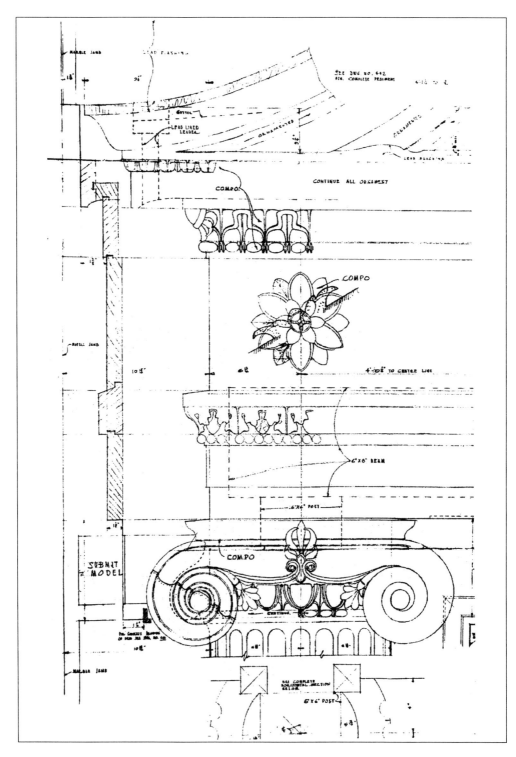

Above and next page: This full-sized drawing (split in the middle) for the City Hall in Burlington, Vermont (McKim Mead & White, architects), was drawn on a single sheet of detail paper about three feet wide and over eight feet high. (***Pencil Points,*** July 1928.)

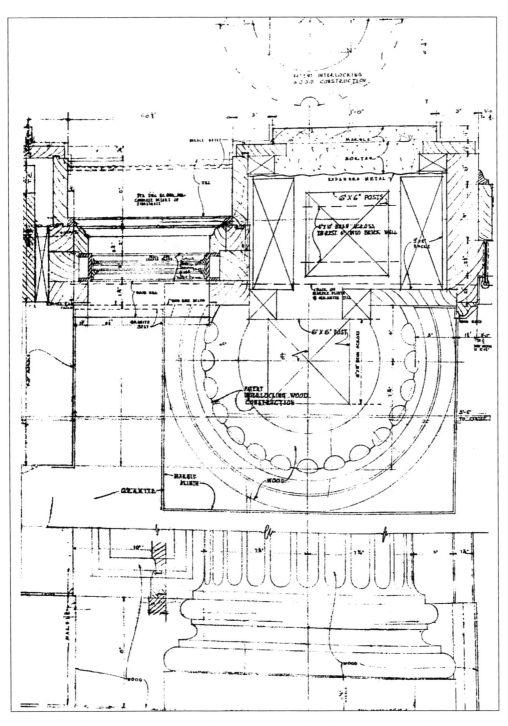

home…. But when I [showed] up with my clear schoolboy script, extra hand-written specifications, especially for clients' use, were saddled on me…. My handwriting straightway declined in quality, but bad as it speedily became (with a dim idea that Mr. Radford might sense the mute and tacit protest) it was still so much better than his that I couldn't shake the job.[121]

An ornament to be executed in colored terra cotta for the Suffolk Title and Guaranty Co. Building, Jamaica, Long Island (Dennison & Hirons, architects), was roughed out by a designer and then passed to the modeler, Rènè Chambellan, who completed the design in plasticene, from which a mold could be made by the terra cotta company. Modelers might work independently or be employees of the companies that manufactured terra cotta or cast metal ornamentation. (*Pencil Points*, January 1929.)

All of this was changed, of course, when typewriters were introduced, and young women were hired to operate them.

In many offices the specification writers became a separate division of the firm's staff. At McKim Mead & White they worked in a special room that had two layers of fabric panels hung on spring rollers around three walls. Blueprints were attached to the fabric so that one set of panels could be rolled up to reveal the blueprints behind it. It was said that the specifications writers sat at desks in the center of the room and looked at the blueprints on the walls through opera glasses.[122]

Staff

The custom of architects taking students and apprentices is in part explained by R. Clipston Sturgis's description of the kind of English setting in which he had been trained, where the students were "apprenticed for two or three years … paying a hundred guineas a year for the privilege.… They generally outnumbered the paid draughtsmen and consequently the payroll of a good office was almost negligible." Some British architects later regretted the passing of "the old system of pupilage which the rush of modern practice had made almost impossible." In Atlanta, Georgia, during the 1870s the personnel in a typical architect's office

> … did not consist exactly of the principals and draftsmen but almost always included a little group of architectural students—young architects in the making. The office, of course, was a workshop; the practical business of the day was always uppermost, but never-the-less in a way it took on the character of a studio.[123]

The careers of some young draftsmen are illustrated by the story of one employee in the office of George B. Post who was first hired at the age of fifteen as an office boy, of which most offices had several before the installation of telephones reduced the number required. After two years his salary had doubled to $30 per week. While he was being trained to be a draftsman his salary was lowered to $25, but once he was declared a qualified draftsman his salary returned to what he had made as an experienced office boy.[124]

It was common for a young draftsman to be taken on for a period of some months before he received payment for his work. In 1871 the Philadelphia architect Frank Furness expressed his willingness to hire a draftsman who already had experience: "We will take him therefore, paying

him nothing while he is learning our ways and as soon as he becomes useful to us we should of course expect to pay him." Regarding fifteen-year-old Bertram Goodhue, the New York firm of Renwick Aspinwall & Russell wrote, "...it is not our custom to pay anything to pupils, and in many offices it is the custom to charge them...." At one time McKim Mead & White routinely required that a new draftsman work without pay for as much as six months to prove his worth. In 1854 a prominent Episcopal bishop wrote Richard Upjohn asking how his son was performing in Upjohn's office and inquiring about when his son might "become entitled to some compensation for his services."[125]

Most architects were quite willing to add young men of influential families to their staffs. Early in the 20th century, after young Joseph Hudnut, later dean of Harvard's School of Design, repeatedly applied for a position in the office of "a great architect," he was informed by a secretary that the architect "only takes on the boys who can bring in clients." Hudnut contacted a family friend, a bishop who could provide the commission for a small church, only to have the project scorned by the architect, who said, "My dear boy, I am not looking for pigwidgeons." During a five-year period in which Frank Furness himself designed all other work coming from his office, the draftsman that Frank Furness had so reluctantly employed was responsible for the design of a grammar school building and five large houses commissioned by various branches of his family.[126]

Most architectural offices had their drafting rooms divided into cubicles in each of which one or two designers or draftsmen worked. In the office that H. H. Richardson built onto his home in the Boston suburb of Brookline in 1878 there were nine cubicles for individual drafts-

men in addition to space where tables might be placed when more draftsmen were needed. A special room was reserved for the concentrated study that was required to prepare the firm's competition entries. Richardson's staff brought their lunches so that at the noon hour they might have a "delightful ramble through the wooded lanes and roads of the neighborhood" or play tennis on the court.[127] Unfortunately, around 1884 the work in Richardson's office had increased so much that he limited the noon break to one hour. When in 1913 the architectural firm of McKim Mead & White, then probably the largest architectural firm in the country, moved its offices to 160 Fifth Avenue, the new drafting room was clear of all partitions except for six alcoves at windows for the most senior personnel, and smoking was not allowed in the drafting room because of the risk of fire. Opinions about the arrangement of work areas differed, and in the Chicago office of Burnham & Root, which at times might have employed as many as sixty draftsmen, there were nine cubicles. Each usually contained two or more draftsmen, because of "experience showing that more and better work is done in this way ... than under the old system of having all the work done in one large room" Burnham & Root's office also included a small gymnasium and bath because of the firm's belief that "men work better and more efficiently if they are encouraged to take recreation in physical exercise during their spare moments."[128] Sometimes Burnham appeared and gave employees lessons in fencing.

Around 1850 Richard Upjohn executed his work, by that time almost exclusively the design of churches, with his son and a staff of four. George B. Post's firm, a solid organization that businessmen liked, started in the 1870s with about a dozen workers and grew to about sixty by the end of the century. The Chicago firm of Burn-

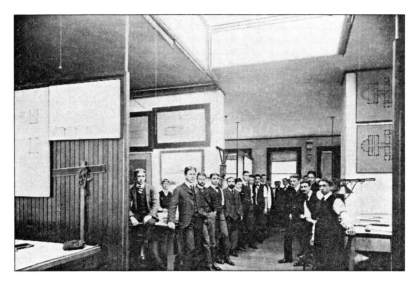

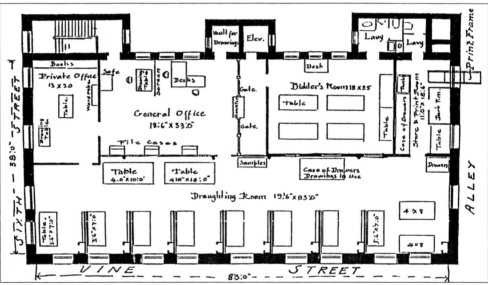

Top: The drafting room cubicles in Ernest Flagg's Wall Street office in 1901. Architects often occupied the top floor of office buildings, which permitted skylights to augment the light provided by windows. A top floor office also made it possible to avoid shadows that would interfere with blueprinting at one of the office windows—if the roof were available for that purpose. ("Where Our Architects Work, No. 3," *Architectural Record,* January 1901.)

 Bottom: The new office of Samuel Hannaford & Sons, Cincinnati, in 1890. A blueprinting frame extended into the alley on the south side of the building. A generous but isolated space was designated the "Bidder's Room," where representatives of contractors could take quantities from the drawings. However, at that time it was customary in Chicago for contractors to take the necessary drawings overnight. (*Engineering and Building Record,* 23 August 1890.)

ham & Root had started in the 1880s with about eighteen draftsmen and an additional number of specialists who dealt with construction and technical matters, but at certain times the number might briefly rise to around sixty. McKim Mead & White in its early years had only a small number working in their drafting room—four in

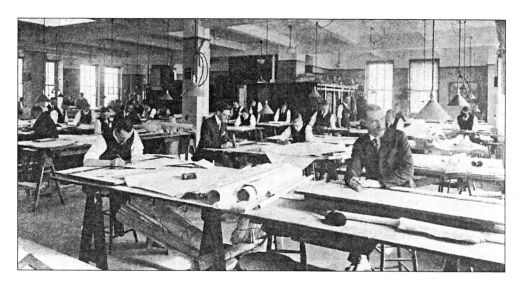

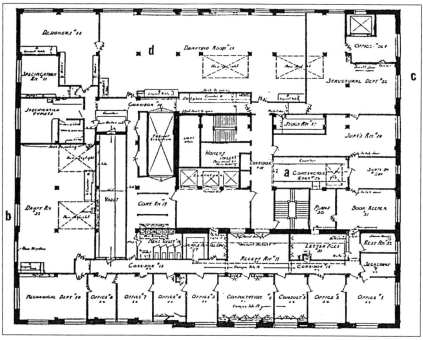

Top: The drafting room of McKim Mead & White in 1913. After the deaths of White and McKim the firm moved to the Architect's Building, which was built by a stock company of fifteen architects and seven engineers. With two draftsmen at each of the long tables the drafting room accommodated forty-eight, but more could easily be added. (D. Everett Waid, "The Business Side of an Architect's Office," *Brickbuilder*, December 1913.)

Bottom: The offices of Albert Kahn in Detroit occupied the top floor of a building that had originally been a power plant. A contractors' room (a) is provided near the office of the construction supervisors. There is clear evidence that technological requirements were stressed in Kahn's firm, which designed many of the early automobile factories. The firm's departmentalization had led to a division of drafting staff into a group adjacent to the mechanical engineering department (b), another group in the structural department (c), and an architectural group next to the designers (d). (George C. Baldwin, "The Offices of Albert Kahn, Detroit, Michigan," *Architectural Forum*, 1918.)

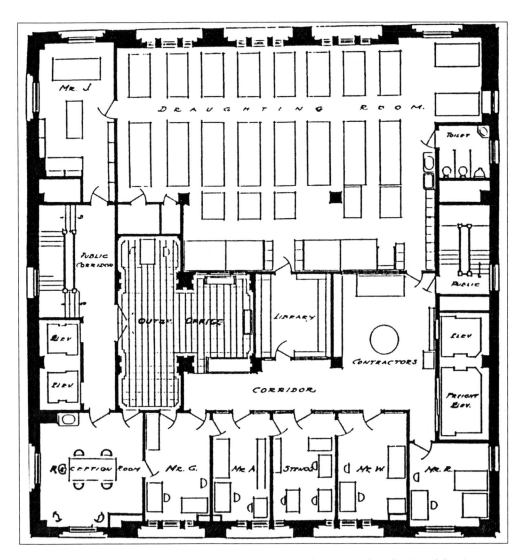

Cass Gilbert's office in 1911 was located on Madison Square in New York, a district of the city popular for architectural firms. The space labeled "Contractors'" was rarely occupied by bidders, and instead it was used to store samples of materials. In other offices the contractors' rooms might be converted for filing drawings, mailing and receiving packages, or as offices for the staff employed to supervise construction of the firm's projects, an increasingly important part of the office staff. (D. Everett Waid, "How Architects Work," *Brickbuilder*, December 1911.)

1879—but the number increased steadily until there were around 120. Financial conditions could very quickly affect architectural firms. After the depositors' rush to withdraw their money from banks at the start of the panic of 1873, it was only two months before Frank Furness found it necessary to drop Louis Sullivan from the staff of his Philadelphia office.[129] During the de-

pression years in the 1890s the work force at McKim Mead & White was reduced to about eighty. Goldwin Goldsmith, who at eighteen had been a stenographer at McKim Mead & White, in 1897 returned from architectural school and a year in Europe only to be told by Mead that "Last week I let twenty men go. I am letting twenty more go this week." At one point

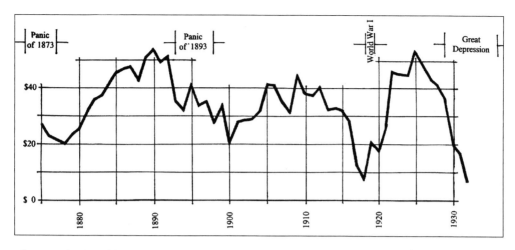

The annual value of building permits per capita in major U.S. cities, 1875-1932, converted to 1913 dollars. After 1900 these data include fifty-two cities; before that date the number varies. Note that the negative effects of the Panics of 1873 and 1893 reach approximately the same level, and the building booms of 1890 and 1925 are also similar. Data do not include government-financed construction for World War I. (Information from John P. Riggleman, "Building Cycles in the United States, 1875-1932," *American Statistical Association. Journal*, June 1933.)

Bruce Price's staff in New York consisted only of an office boy, and Price said the year's income from his office was $750, but Price had the advantage of a wealthy wife. In Chicago the staff of Holabird & Roche had dropped from forty to three by 1896, and the partners thought it a good time for them to travel in Europe. By the end of the century Burnham's staff probably averaged around a hundred, and after Burnham's death in 1912 a successor firm that included his son, Graham Burnham & Company, had as many as 120 in their drafting room and additional numbers at branch offices in New York and San Francisco.[130]

There was a roving class of "journeyman draftsmen," as William Gray Purcell called them. Skilled and experienced in their craft, they moved from city to city, office to office, able to adapt quickly to the procedures and stylistic habits of any architectural firm. They were in Purcell's words:

> ... a jolly crowd, more often than not hard drinkers, drifting from one office to the next in a restless quest for romance and adventure, carrying with them the gossip of the building world and a homely philosophy of life which reached their architectural work only indirectly. Traditional draftsmen they were, but the tradition was a working influence and habit within themselves ... with scant intellectual bent and no especial scholarly interest.[131]

The most skilled of these transient workers would be sought out when an architectural competition was approaching. Seldom were they leaders in the matters of architectural style, but they knew the latest fashions that were attracting the jurors of competitions and could often predict the characteristics of the designs that would be submitted by major rivals. The names of these designer-delineators seldom appeared in the architectural press, but if their design won a competition they might stay in that firm's drafting room until working drawings were well advanced.

Many delineators free-lanced, coming to an architect's office when needed to prepare the renderings that would be shown to a client or entered in a competi-

tion. Others continued as employees in offices, working on both renderings and ornamentation. However, E. A. Sargent, a renderer frequently employed by the office of George B. Post, was never officially listed as one of the office's regular employees. Otto Eggers, in addition to his renderings, was in charge of all design in the office of John Russell Pope. In that capacity he continued projects after Pope had considered the requirements of the client sufficiently "to outline his ideas orally." Rockwell Kent, who had studied architecture at Columbia, continued executing distinctive renderings while he became famous as a painter and lithographer. F. W. Fitzpatrick—whose claim that he was "winner of more competitions for public buildings than any other architect" may well have been true—mailed to architects who might be interested an elegant brochure in which were included lists of Fitzpatrick's clients and examples of the winning competition drawings he had executed for them.[132]

Many architects believed that alcohol

was "the curse of the profession," but that might well have been said at that time about most other lines of work. The office manager of one architectural firm recalled:

> Three-quarters of the pay checks came back from bar-rooms and such places. Often I would note the disappearance of many tee-squares; a dollar sent to the nearest bar would redeem them.

Harvey Ellis, a mythic figure among draftsmen, was the subject of many stories. A young draftsman reported that Ellis "did some of his best work when drunk and not too nervous," and a friend recalled:

> I do not know how many of the strong-nerved young draughtsmen of the Middle West nicked the edges of their T-squares in the vain effort to reproduce his 'crinkled' pen-line (the product, had they only known it, of nerves unstrung)....

Ellis's friend Oscar Enders, who had begun as a magician with a small circus, worked for many years in the St. Louis office of Isaac Taylor, who credited Enders with designing much of the office's work. One delineator had fourteen *signed* drawings (he may have done others) published in the *American Architect* over a period of eight months. Because the drawings were prepared for eight architectural firms located in four different cities, it is likely that this delineator worked in that periodical's stable of delineators who were made available by mail to architects throughout the country.[133]

The larger number of drawings re-

Eight years after his death the *Western Architect*, a Minneapolis-based magazine, published a collection of drawings Harvey Ellis had done for the architectural firm of L. S. Buffington. The caption for this drawing advised aspiring delineators that "The trees on right should be examined with a [magnifying] glass." (*Western Architect*, June 1912.)

quired for construction meant that more draftsmen were needed in architectural offices. The U.S. Census shows that between 1880 and 1900 the number of architects and contractors roughly tripled, while the number identifying themselves as belonging to the category "designers, draftsmen, and inventors" increased at twice that rate. (Because state licensing laws for architects were few the definition of architect was vague, and it must be assumed that many draftsmen considered and reported themselves architects.)

Except for specification writers and construction supervisors an employee's status within a sizeable architectural office usually related inversely to the amount of drawing done. Draftsmen, especially the junior draftsmen, were occupied with very little other than drawing. Proficiency in preparing details and the other routine drawings required for architectural projects was always a skill respected by other draftsmen and employers, but beginners were quite accurately convinced that the ability to create the ink or watercolor perspectives that wooed clients, won competitions, and might even be published in the architectural journals was the quicker path to advancement. Stanford White was offered a place with McKim & Mead after McKim had reported that White could "draw like a house afire."

The partners in a large firm made few drawings, and those were often incomplete sketches meant to convey an idea to the assistants who would continue the work. Stories were told of the scruffy sketches that H. H. Richardson handed to his staff, Stanford White's drawings on envelopes that were left at his assistants' drafting tables without instructions, and—much later—Addison Mizner's summoning a draftsman to a Florida beach to copy a plan he had scratched in the sand while talking with a wealthy client. John Russell Pope made loose sketches on gridded paper, but

as work on a project progressed he seems more often to have conveyed his design ideas through oral criticism of his staff's decisions. Pope is said to have sometimes conveyed design concepts over the telephone.[134]

The design mannerisms of most architectural offices became so predictable that in 1903 a book on country houses pointed out that

> All of the larger offices have developed more or less distinctive office styles, … these big offices generally have more buildings on their boards than the members of the firm have the time themselves to design—the tendency is to have this office style somewhat mechanically reproduced.[135]

In an 1894 competition the jury's final selection had been influenced by their detecting in a drawing certain design hallmarks of McKim Mead & White, only to discover after the final selection that these devices had been adopted by the office of Bruce Price.[136] Design by habit could become a powerful force, even within relatively small office. Before the firm of Trost & Trost was commissioned in 1917 as architects for a new Texas State School of Mines and Metallurgy outside El Paso, the artistic wife of the school's administrator obtained a decision that the architecture should be Bhutanese, as shown in the photographs of a *National Geographic* article on that Himalayan country. But the administrator, on seeing the architects' first sketches, commented "when they got through with it, it was not Bhutanese nor much of anything else, it was strictly Trost & Trost."[137]

In the 1880s Charles Rutan was engineer enough for the busy office of H. H. Richardson, although his only training had come in the office where he had started as an office boy. (On much of Richardson's work the contractor was O. W. Norcross, a very knowledgeable and capable builder

who traveled on trains with Trautwine's *Civil Engineers' Pocket-Book* as his casual reading.) By 1870 about half the membership of the AIA had some higher education. Of that number about a third had studied in a school of architecture, a quarter in a technical or engineering school, and the remainder in general studies or some other specialization.[138] (It seems safe to assume that the educational levels of AIA members were higher than those for the entire profession.)

In large cities basic engineering instruction was available through night classes, and technical topics were popular in the lectures scheduled by draftsmen's sketch clubs. Young men who wished to become architects could find engineering education, because in 1910 there were five times as many engineers and, more specifically, three times as many civil engineers as there were architects. In many cases the principals or key employees of architectural firms had completed curriculums in civil engineering before learning about architecture as a draftsman or had completed two years at Harvard's Lawrence Scientific School before spending two years in the "special course" in architecture at MIT or at the *Ecole des Beaux-Arts*.

Often civil engineering, which was taught at all of the land-grant colleges, was a sensible approach to the architectural profession. There also seems to have sometimes been a youthful choice of the engineering profession, perhaps influenced by parents, that later changed. At Rensselaer Polytechnic Institute, Joseph Don Carlos Young, one of Brigham Young's twenty-six sons, graduated in engineering in 1879, but he was official church architect of the Latter Day Saints for fifty years and operated an architectural office in Salt Lake City.[139] Charles C. Wilson, a leading South Carolina architect early in the twentieth century, studied both mechanical and civil engineering, and after years of work on ar-

chitectural projects left for study at the *Ecole des Beaux-Arts* in Paris. William W. Renwick, nephew of James Renwick, graduated in mechanical engineering before becoming an architectural draftsman and studying art for several years in Europe. His office was known particularly for church designs, especially their ornamental and mural decoration.

Philip Sawyer (York & Sawyer) studied civil engineering and worked some years for the U.S. Geological Survey before enrolling in architecture at Columbia University. After education as an electrical engineer, young Peirce Anderson sought advice from Daniel Burnham, who inspired him to study at the *Ecole*. Anderson later was chief designer for Burnham's Chicago firm. Julia Morgan was in her last year of studying civil engineering at the University of California, Berkeley, when she encountered Professor Bernard Maybeck, in whose architectural office she worked for a year before going to Paris, where in 1898 she would be the first woman admitted to the architectural program of the *Ecole des Beaux-Arts*.

Structural engineers or architects who filled that role became standard participants in the larger architectural firms, although independent engineering consultants might be contracted to work on a firm's larger or more complex projects. After trusses collapsed during construction of the Midland Hotel in Kansas City, Burnham & Root brought in an engineer to design the steelwork in their buildings, and soon Holabird & Roche and other architects began to hire trained and experienced engineers to superintend construction of their projects. Chicago industrial specialists and brewery architects advertised themselves as "Architect and Engineer" or sometimes "Engineer and Architect." In Detroit by 1903 Fred L. Smith had combined with a firm of engineers to form the precursor of Smith Hinchman &

Grylls, and Albert Kahn had brought into his firm his brother Julius, a talented and innovative engineer. Nevertheless, in 1904 an engineer charged that the 850 practicing architects in New York City made use of only 17 consulting engineers, and that the engineer of a prominent firm "they took out of an engine room."[140]

The details of heating systems and other mechanical equipment were not always determined by the architect, although the technological advances were rapid and constant. A Boston architect explained that in 1890s:

> It was out of the range of even the best offices to make the plans and specification for [heating] systems, and the owners refused to pay for the employment of engineers. It became common even for reputable architects to get a friendly heating man to assist them, which he was always glad to do without cost. The reason came to light. The friendly man reported to his competitors the time he had spent in such service and each agreed to figure as usual and then add to his bid the value of the services rendered, say $500.[141]

In many cases manufacturers' engineers advised architectural offices on the provisions required for the equipment they sold. Manufacturers of elevators gladly sent their representatives to assist in drafting rooms; manufacturers of boilers and steam radiators prepared layouts of heating systems; and steel companies published handbooks that greatly simplified the selection of structural members. Mechanical engineers were far less common than structural engineers, and many architectural firms agreed with a 1905 convention speaker who envisioned a general technical capability: "The constructive engineer is generally capable of dealing with the mechanical problems of heating and ventilation, power plants, and electrical installations."[142]

Architectural firms tended to plan for secondary features of buildings as the need arose during construction, which might occupy several years. "Rarely was a building designed complete, and working drawings and specifications finished for all trades so that it could be let as a single contract, or as a number of contemporary contracts." One convincing reason for the change to a single contract including all trades was: "Nowadays, a building is expected to be finished in a certain space of time, at a cost not to exceed a certain limit, and the building must be equipped for its uses with a great many conveniences and appliances formerly unknown and unheard of." Another factor was the increasing use of borrowed money for construction purposes. For a speculative building a banker or other lender usually insisted on knowing specifics of the project, and delays in completion meant an extended period during which interest would be paid without receiving rents.[143]

The traditional method of contracting for construction of a project had required negotiation with individual crafts, coordination of their work being the responsibility of the architect. A Boston architect recalled that in the 1880s a house in the city might require ten to twenty different contracts, listing several minor areas, such as "bells and speaking-tubes" and five different categories of work in masonry. Near the end of the century, one book listed forty-four different crafts or activities that might be involved in the construction of a building, ranging from the preparation of foundations for the structure to the installation of special clocks for night watchmen. In the 1920s Bertram Goodhue at one point prepared twenty-seven separate specifications for the state capitol of Nebraska, one for each trade involved. However, there was not unanimity among architects regarding the desirability of single contract procedures

in which a general contractor negotiated the entire construction process and himself engaged subcontractors for each of the necessary subdivisions of the work.[144]

An early step toward the recognition of the single, general contract was the construction of the Pontiac Building in Chicago for which a single contractor received the contracts for excavation, foundations, masonry, and steel and iron portion of the construction, which included all the major parts of the work to be done. For excavation and masonry this contractor was to get 10 percent of the cost of the work, and 5 percent for the steel and iron work. This can be compared with the 4 percent of the architectural firm's contract for the project.[145]

As late as 1906 an AIA convention adopted a committee report that was "strongly condemnatory of the system of General Contracts, although that system had been in use by some architectural firms for several decades." The following year sentiment ran the same way, although Cass Gilbert spoke humorously of arrangements with a general contractor that could permit an architect to avoid "the difficulty of telling your client that you were not omniscient and omnipresent" and general contractors who "went to the structural steel concerns and got drawings of trusses or beams that you had not the time or the opportunity or the inclination to prepare yourself."

Schedules of architectural fees do not indicate any changes due to the transfer of the responsibility for the coordination of trades and synchronization of work from the architect to the general contractor. But, architects opposing single-contract operations often spoke of the danger of architects losing contact with the artisans who did the actual execution of building designs and of the general contractor's dangerous intrusion between architects and their clients.[146]

The First African-American Architects

Among the slaves and freedmen of the South there had been capable craftsmen who in their own localities became trusted master builders, but it was almost the end of the 19th century before African-Americans received specific training to enter the professional practice of architecture. In 1892 Robert R. Taylor graduated from the architecture program at MIT and soon accepted a position teaching at the Tuskegee Normal and Industrial Institute in Alabama, where Booker T. Washington eleven years before had established a school for young African-Americans. Taylor taught at Tuskegee for forty-one years, becoming vice-president of the Institute, and training many of the first black architects.

One of Taylor's early graduates, John A. Lankford, after briefly teaching at Shaw University in North Carolina, in 1899 set up practice in Jacksonville, Florida, probably the first black-operated architectural firm. Lankford in 1902 moved to Washington, D.C., where that city's large and relatively prosperous African-American population became his clientele. In addition to his architectural practice Lankford engaged in construction and real-estate dealings, and at one time he spoke with justifiable pride of employing "about one hundred and seventy-five men at work as mechanics, five as superintendents of construction, two as architects, one engineer, one stenographer, one bookkeeper and clerk." Sidney Pittman studied five years at Tuskegee before attending Drexel Institute in Philadelphia, where he graduated in 1900. After teaching several years at Tuskegee, Pittman moved to Washington and worked for Lankford before opening his own office with significant help in getting commissions provided by his father-in-law, Booker T. Washington. Before he

transferred his practice to Texas, Pittman won a competition for the design of the Negro Exposition Building at the Jamestown Tricentennial Exposition in 1907. The black architects in Washington had widespread practices, providing architectural services for the churches and institutional buildings built by African-American groups throughout the country.[147]

Vertner A. Tandy, a 1909 graduate of Cornell University, taught at Tuskegee before developing a thriving New York practice in Harlem. George A. Ferguson went from Washington's Armstrong Manual Training School to the University of Illinois, and after graduating in 1917 he returned to combine teaching at the Armstrong School with a Washington practice.[148] But, as the focus of education for black architects shifted from the segregated institutions for training in manual skills to university schools of architecture, it remained difficult for young African-Americans after graduation to find positions in architectural firms where they could gain experience. On the whole, white-operated architectural firms were unwilling to employ blacks, and black-operated firms were limited in size, because most of them depended on African-American churches, institutions, and businesses as their clients. While most African-American architects had practices within the black community, Julian Abele, the first black architecture graduate of the University of Pennsylvania, became chief designer for the prominent firm of Horace Trumbauer & Associates in Philadelphia. In that firm Abele was responsible for the design of some seventeen of the university buildings that resulted when Trinity College in Durham, North Carolina, became Duke University.

Specialization

Many of the most famous buildings of the late 19th century were produced by the most famous architects of the time to symbolize the gifts of industrialists who combined their activities as "robber barons" with their roles as philanthropists. Libraries, museums, hospitals, and university buildings were designed principally to extol this philanthropy. The Low Library at Columbia University, centerpiece of McKim's campus scheme, was undeniably impressive, but later the University was forced to construct another building which could function as a library.[149] The architects who received such lavish commissions were relatively few, and most American architects were occupied with buildings that were mandated by changes in the nature of American life and demographics.

Between 1850 and 1890 the population of the United States almost tripled, but the number of millionaires rose from only a handful to about four thousand. With a wealth of resources within its boundaries, the United States was a splendid setting for capitalistic development. Once the frontier had been conquered, commercial consolidation began. Small businesses merged, large companies bought lesser companies, and frequently resulted in very profitable monopolies, having the advantages of price-fixing. By the end of the 19th century large corporations fabricated two-thirds of all the U.S. manufactured products. Not only did the railroads provide transportation for this economic consolidation, the railroad companies served as models of corporate organization.

Railroad companies of this period provided specialization for a few architects because one architectural firm was usually retained to provide architectural services for buildings needed at locations along a company's entire network of tracks, a reliable income for an architectural firm. After being named in 1876 as architect of the New York, Lake Erie & Western Railroad at the age of twenty-three, Bradford

Gilbert became consulting architect for several other railway companies. The construction of a bridge across the Missouri River brought fresh prosperity to Kansas City, and in 1885 the firm of Van Brunt & Howe moved there from Boston. Kansas City was a convenient location where Van Brunt & Howe could establish a general architectural practice as it served the Union Pacific railroad line, an assignment given the firm by Charles Francis Adams, a Boston investor and president of the railroad company. Kansas City was later the location of Louis Curtiss, who around 1910 designed seven hotels and sixteen stations for the Santa Fe Railroad, some being combinations of the two functions. The historic "Harvey Houses," hotels and restaurants along the Santa Fe line, also operated shops that sold Indian crafts and artifacts, and those buildings were designed by Mary Colter, an art teacher who had experience with an architectural firm and an understanding of Indian crafts. Final drawings for Colter's designs were prepared by railroad draftsmen.[150]

By the start of the 20th century "union" stations combining facilities for several railroad lines became the preference, and their design was dominated by the firms of Frost & Granger in Chicago and Reed & Stem in New York. When Grand Central Station was to be built in New York around 1910, the firm of Reed & Stem was engaged because of its experience in designing stations. But, because the station would be a prestigious monument in the city, Reed & Stem were to collaborate with Warren & Wetmore. Whitney Warren was a prominent figure among the *Beaux-Arts* architects in New York and a cousin of the Vanderbilts, who controlled the New York Central Railroad. (This selection of separate firms for function and fashion would again become common toward the end of the 20th century.) Warren & Wetmore also built several hotels in the vicinity of Grand Central Station, for at that time hotels were usually built adjacent to railway stations and were often financed by railroad investors.

The first wave of hotel construction in America—as distinguished from the primitive roadside inns and rooms above taverns that had served stagecoach passengers—had been led by Isaiah Rogers, whose work began with the design for the Tremont House hotel in Boston (1828) and ended with the Maxwell House in Nashville on which construction began just before the Civil War. In these three decades Rogers was foremost among the architects who established a standard for the American "first-class" hotel. These buildings, sometimes referred to as "Palaces of the People," were so important to the business and social life of cities that many were financed by organizations of a city's most prominent businessmen, anxious to demonstrate their community's enterprise and willing to invest in hotels that anticipated the city's growth.

A second surge of hotel-building came after the Civil War, spurred by the westward extension of railroads and the elevated values of urban land in the vicinity of railroad stations. Small stations and freight warehouses were usually laid out in standardized forms by railroad draftsmen, but the hotels constructed by the railroads serving western cities might well be the work of architects in Chicago and Kansas City or the Rapp brothers in Trinidad, Colorado. Railroad service also made possible the development of resorts such as Harbor Springs, Michigan, where moneyed families from Chicago, Cincinnati, and St. Louis vacationed in some of about a hundred houses, large and small, that Earl H. Mead designed.[151] On a larger scale, the Philadelphia firm of Price & McLanahan in the first decade of the new century designed several of the hotels that

established Atlantic City, N.J., as a resort for New Yorkers.

The New York firm of Carrère & Hastings was born in 1885 when Henry Flagler, a partner in John D. Rockefeller's development of the Standard Oil Company, a member of the Presbyterian congregation led by Hastings' father, and also the organizer of the Florida East Coast Railroad from New York to Florida. John Mervin Carrère and Thomas Hastings, then in their middle twenties, had just returned from study in Paris and opened their practice after briefly working for McKim Mead & White. Flagler asked the firm to prepare "a picture" of a hotel for construction by two St. Augustine builders. The drawings that Hastings hurriedly prepared while the partners traveled south in Flagler's private railroad car were accepted, and the client insisted on having the firm's exclusive attention until the project was completed.

In the same period Robert W. Young became the leader in hotel design for the Los Angeles area to which the Southern Pacific Railroad one year brought an average of over 300 passengers a day and the Santa Fe line brought about as many. Because of the client's knowledge of their work in Evansville, Indiana, the Reid brothers were invited to San Diego in 1888 to design the Coronado Hotel, although they had little experience in designing hotels.[152] Henry J. Hardenbergh, already recognized for his apartment buildings, designed the Plaza and Waldorf Hotels in New York, as well as major hotels in other cities.

The offices of manufacturers and merchants, which had previously been located near their factories and warehouses, started to shift downtown, where financial dealings could be more easily conducted, and office buildings became a favored investment of speculators and insurance companies. The technological advances of elevators and steel construction encouraged tall buildings, a more profitable utilization of valuable land in the central areas of cities. It often required ingenious maneuvers to skirt state laws, but trusts were formed through which investors could participate in the profits to be gained by constructing tall buildings on downtown lots. The architects who became familiar with the techniques of designing tall urban structures could easily apply that knowledge to hotels, apartment buildings, or office buildings.

It is not surprising that those architects with engineering backgrounds were the early leaders in designing tall buildings. George B. Post had studied civil engineering before entering Richard M. Hunt's *atelier*. Shortly after returning from a brief period of service in the Civil War, Post was employed as consulting architect on the Equitable Building in New York, 130 feet high. His revision of the building's structural system significantly reduced the construction cost and brought Post recognition as an architect of tall buildings. Other architects prominent in the early phases of tall construction were: Otto Matz with German education and railroad experience in Chicago; William LeBaron Jenney, who had studied architecture at a Paris technical school; Bradford Gilbert, architect for a railroad company; John Wellborn Root (Burnham & Root) who had studied engineering and had worked under James Renwick, an accomplished engineer. Though it is doubtful that such architects actually did the calculations for construction of their firms' tall buildings, their technical knowledge encouraged them to hire competent engineers and following their advice.

The ability to construct taller buildings on the valuable land in dense cities also led to changes in housing. Newlyweds of the upper classes in New York had for years avoided the cost of servants by living

in hotels, a popular solution although it was considered morally questionable. When apartments were first introduced (then called "French flats") they were believed to be equally wicked because of their being a French tradition. Edith Wharton in her novel *Age of Innocence* (1920) wrote of "architectural incentives to immorality such as simple Americans had never dreamed of." (Multi-family residential buildings, "tenements," long having been available for tenants at the lowest economic levels, were a different matter.) Although a New York ordinance in 1885 limited the height of apartment buildings to seventy feet on streets and eighty feet on avenues, these regulations were easily evaded by an apartment building being classified as an "apartment hotel."[153]

Henry J. Hardenbergh in 1884 designed the Dakota apartments as an investment for an heir of the Singer sewing machine fortune who believed that there was "hardly any limit to the rate of expenditure and style of social splendor to which the apartment house might not easily be adapted."[154] Apartments in the Dakota, varying from four to twenty rooms, were sold during construction, plans being constantly altered to satisfy the wishes of purchasers. Philip G. Hubert, son of a French architect, introduced cooperative apartments in the 1880s through organizations called Hubert Home Clubs or Hubert Home Cooperative Associations. The Chelsea Apartments was typical of Hubert schemes: ninety apartments of which sixty were occupied by the investors and thirty were rented, that rent paying for financing expenses and the operation and maintenance of the project. Such schemes proved a sound investment, but only for those wealthy enough to afford the initial outlay. Some of the early apartment buildings had large ballrooms that tenants could rent for special occasions; in the summer the roof garden of one building was used for open-

air concerts; and the soundproofing of apartments in the Ansonia attracted musical and theatrical figures in addition to those who were simply rich.

Some of the most popular architects for luxury apartments at the turn of the century had gained earlier experience by planning tenements. George F. Pelham at one time provided typical drawings for tenements (twenty-four apartments in six stories on a lot twenty-five feet wide) for $25 a set. In an eight-year period, 1909-1917, the tenement experience of Goldstone & Rouse led to their designing some forty-seven apartment buildings, most of them nine to twelve stories high, which were around a third of the office's projects. In the 1920s the New York apartment designs of Pelham and J. Edwin R. Carpenter largely determined the character of Park Avenue and Fifth Avenue around 90th Street, where Carpenter is said to have built fifty apartment buildings. Samuel N. Crowen was a leading apartment architect in Chicago until he changed his specialization to industrial projects.[155]

At the same time that apartments were introduced for the rich, unsanitary tenements were being built for the poor. The 19th-century flood of immigrants meant that most urban housing was unsafe, unhealthy, and inadequate. The architecture curriculum at Columbia University had been initiated by a concerned trustee who insisted that "hereafter architects should be Sanitary Engineers," and Professor Ware had begun his work there with the title "Professor of Architecture and Sanitary Engineering." Architects were active in many of the charitable organizations that took part in efforts, usually inadequate, to improve housing conditions. George B. Post was a member of a committee that concentrated on the passage of legislation to improve housing conditions. Edward T. Potter, whose specialization was church design, retired from

active practice at the age of forty-six to de-vote his time to inventions, musical com-position, and his scheme for improved tenement design, the "System of Concen-trated Residence." I. N. Phelps Stokes—his grandfather a founder of the New York Association for Improving the Condition of the Poor and two aunts active in dis-tributing the family wealth through a va-riety of philanthropies—was a frequent participant or advisor for competitions aimed at improving tenement design in the districts of New York City where most immigrants lived.[156]

In Chicago, Dwight Perkins, whose mother had been a social worker with Jane Addams in the slums of the stockyard dis-trict, was active in the movement to im-prove and enlarge the city's parks and playgrounds. The Pond brothers, Irving and Allen, were actively associated with most of the charitable and progressive ac-tivities in Chicago. They were architects for Jane Addams' Hull House and Chicago Commons, the two leading settlement houses that provided assistance for needy immigrants, and much of the Ponds' pri-vate work was done for the families of well-to-do young ladies who were volun-teers in the settlement houses or other Chicago charities. Ernest Flagg, a Beaux-Arts architect who had grown up in slum areas of Manhattan, said: "It is almost im-possible for one, not a tenement dweller himself, to see the matter from the ten-ants' standpoint." After obtaining a site as a gift from one of his clients, Flagg was ar-chitect on an experimental project, the Model Tenements, sponsored by munici-pal authorities and the Suburban Homes Company, which was comprised of mem-bers of several of the principal housing re-form organizations.[157]

Of the architects who in their prac-tices developed and pursued expertise in a specific type of building, data suggest that slightly more than half were "church ar-chitects," a term that often included de-signing the schools, hospitals, and other structures that were operated by religious denominations. Between 1840 and 1860 the population of the United States had al-most doubled. In addition to the normal growth of families, this increase of popu-lation included about four million Euro-pean immigrants, many of whom were Roman Catholic. By the 1880 census the number of Roman Catholics in the United States almost equaled the total member-ship of the seven largest Protestant de-nominations, and American Catholicism, unlike its counterpart in Europe, mostly consisted of the working class. It was the policy of the Roman Catholic church to build separate churches for each of the ethnic groups living in an area. In one Chicago neighborhood, roughly three square miles, there were four English-speaking churches (principally for the Irish), two Polish, two German, one Lithuanian, one Italian, one Bohemian, and one Croatian. Along with the churches came rectories, parish halls, boys' schools, girls' schools, convents and sometimes hospitals. In Minnesota a Pole of Italian lineage, Victor Cordella, designed around twenty churches for Ukrainian, Slovak, Polish, and other immigrant groups from European regions that were not yet polit-ically independent, employing regional precedents of style based on the churches of Greek Catholic, Russian Orthodox, German Roman Catholic, and other faiths. Among the Protestant denominations, the complexes of religious buildings were smaller, but among American Protestants the myriad sectarian subdivisions required many buildings.[158]

Specialization in church architecture could take many forms. As a "high church" Episcopalian architect, Richard Upjohn might refuse a commission because of the congregation's liturgical practices. After his training under Upjohn, Leopold Eidlitz

became known for his design of Gothic churches as well as synagogues for his own faith, although the cruciform plan of one synagogue drew comment. Henry Congdon was the son of a founder of the Ecclesiologist Society, a strict and divisive group within Episcopalianism, and his churches were largely restricted to areas of the East Coast where those liturgical distinctions were of moment. The Potter brothers, (actually half-brothers) Edward T. and William A., practiced separately with churches the principal building type of both offices, a situation certainly assisted by their being sons of the Episcopal bishop of Pennsylvania and related to three other bishops and one college president.[159]

William W. Renwick, educated as a mechanical engineer, seems to have given attention in his architectural practice to churches exclusively. Solon Beman repeated the low-domed classicism of his Merchant Tailors' Building at Chicago's Columbian Exposition, occasionally for libraries and often for Christian Science churches, becoming something of an official architect for that denomination.[160] One of Beman's draftsmen, George F. Dunham, in 1908 moved to Portland, Oregon, where he designed Christian Science churches for congregations as far away as St. Louis.

There was also rapid growth in the need for public school buildings, as the number of school-age children grew and they were required to attend school longer. From 1876 to 1900 the number of students in public elementary schools in the United States shot up from 9,000,000 to 15,000,000, and there were almost five times as many graduates of public high schools. By 1900 thirty-one of the states and territories had passed laws that made school attendance compulsory. Boards of Education in many cities selected their own architects to design all the new school buildings that were needed and supervise the maintenance of

existing buildings. A Detroit group in 1919 studied the methods employed by eight large cities for building school buildings. In half the cities (Chicago, Cleveland, New York, and Philadelphia) city departments designed and supervised construction of new schools; in two (Boston and Pittsburgh) private architects designed buildings and a city department supervised construction; and in two (Baltimore and Cincinnati) private architects both designed and supervised. In many cities the chosen architect was permitted to serve clients other than the Board of Education; but some Boards insisted that their architects devote all their time to the city's schools. In St. Louis at a time when an exclusive obligation brought a salary of just $3,000 per year, architects still competed for the position. After years as Architect of the Board of Education an architect would usually have completed enough school buildings to qualify him as an expert. William B. Ittner was employed by the St. Louis Board of Education for about nineteen years and became a consultant nationwide. His firm was said to have done over 500 schools in 115 cities and 29 states.[161]

Dwight Perkins in 1905 assumed the duties of architect for the Chicago Board of Education, coming in as part of a reform movement in city government. The position involved supervision of fifty or more workers in the Board's drafting office, design of new school buildings, and maintenance of over 250 schools. Perkins held a distinctly progressive view of the Board's responsibility:

> Boards of education have, generally speaking, a responsibility only for the education of normal children under eighteen years of age, but ... boards will [in the future] ... be charged with responsibility for the education of the entire community, regardless of age or previous training....[162]

After five years as designated architect

Perkins was challenged by a political faction that had gained control of the Board of Education. After about a month of hearings in which he was charged with "incompetency, extravagance and insubordination," Perkins was removed from office in spite of receiving the fervent support of such diverse organizations as the City Club of ultra-conservative businessmen, the Winslow Park Women's Club, and the *Daily Socialist* newspaper.[163] Nevertheless, the quality of Perkins' work led to his becoming recognized as an expert on school design, which was from that time a large part of his practice.

Battling the Government

Chicago's 1893 fair, officially the World's Columbian Exposition, celebrated the four-hundredth anniversary of Christopher Columbus's discovery of the New World, and it proved to be a powerful advertisement for the American architectural profession. Unlike some expositions of the 19th century, in which the temporary structures seemed more like railroad sheds than buildings, the fair structures in Chicago—though mostly made of a concoction of plaster and fiber—had the appearance of actually being imposing monumental buildings. The city of Chicago had burned in 1871, and extensive reconstruction was delayed through the financial panic beginning in 1873. The architectural office of Burnham & Root, which had opened during the period of reconstruction, was well established by 1890, and the committee in charge of the Exposition selected Daniel Burnham as "chief of construction" and John Root as "consulting architect."[164]

The Exposition was national as well as local, so a National Commission, with representatives for each state and territory, shared authority with the Chicago officials. The list of the architectural firms that

would design the most significant elements of the Fair was divided, five from Chicago and five from other cities (three from New York and one each from Boston and Kansas City). All of the non–Chicago architects had either studied at the *Ecole des Beaux-Arts* in Paris or studied with Hunt shortly after he returned from the *Ecole*. Among the Chicago architects William LeBaron Jenney had studied in Paris (but at the *Ecole Centrale*), and Louis Sullivan had been at the *Ecole* briefly. (On an average the Chicago architects were about a dozen years younger than the non–Chicago architects.)

The first decisions made by the group of architects who were assigned major buildings in the Exposition were that the buildings in the central portion of the plan should all be classical in style and a uniform cornice level should be maintained, and later it was decided that all the plaster facades of the temporary buildings would be painted white. These decisions established the dramatic architectural display, the "White City," that accounted for over 21,000,000 paid admissions in spite of a cholera scare and the deepest depression between the Civil War and World War I. Banks closed and soup kitchens opened to serve long lines of the unemployed. The building permits issued in the largest U.S. cities began to drop in dollar value from the all-time peak of 1890; by 1894 permits had dropped by almost half, and in 1900 they were about one-third of the peak of ten years before. The number of architects in Denver plummeted from forty-seven to twenty-three in the first four years of the 1893 depression, and did not begin to rise significantly until 1902.[165] Nevertheless, the image of the White City was powerful.

After Daniel Burnham's heroic success in completing construction of the Columbian Exposition in Chicago, he was elected president of the AIA in 1893 and 1894. Obviously, the popular success of the

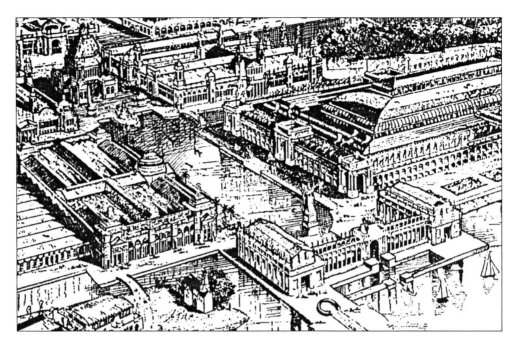

The bird's-eye view provided in a guidebook for Chicago's Columbian Exposition illustrates the impressive architecture of the Fair. With the additional example of Haussmann's improvements in Paris, it was inevitable that some architects' attention would be drawn to the increased building activity in Washington, D.C. (From a drawing in Hubert Howe Bancroft, *The Book of the Fair*, 1894.)

Fair at some point suggested that the nation's capitol and other federal buildings might well follow the example of the "White City." In a letter to the Secretary of the Treasury, Daniel Burnham expressed his opinion that "The people are no longer ignorant regarding architectural matters. They have been awakened through the display of the World's Columbian Exposition...."[166]

Through the 1870s and 1880s unsuccessful attempts had been made to secure the passage of legislation that would make it possible for private architects to participate in the government's rapidly expanding building program. (Lobbying by the AIA was difficult since its offices remained in New York.) In 1893, as hard times approached, a law had been passed, directing that "the Secretary of the Treasury be, and he is hereby, authorized in his discretion to obtain" designs by competitions in which "not less than five architects shall be invited." Called the Tarsney Act after

the Missouri congressman who introduced the bill, it also specified that "general supervision" of construction would continue to be provided by the Treasury Department.

The Tarsney Act was passed less than a month before John C. Carlisle, a former senator from Kentucky, was appointed Secretary of Treasury. A delegation from the AIA was invited to meet with the Secretary, who seems to have promised to introduce implementation of the Tarsney Act with the planning of a new federal building for Buffalo, New York. But about a year later a design for that building was published, as prepared by Supervising Architect Jeremiah O'Rourke. After he received a letter of complaint from the Buffalo Chapter, the secretary of the AIA wrote Secretary Carlisle protesting the poor quality of the design proposed for Buffalo. A reply came from O'Rourke, who was responsible for the design, and he

complained that the AIA's letter was "at variance with professional courtesy and good breeding." As president of the AIA, Daniel Burnham wrote Secretary Carlisle, objecting to O'Rourke's rudeness and insisting "that to make the present design [for the building in Buffalo] satisfactory would involve changes so extensive as really to produce a new design." (Some claimed that Secretary Carlisle could hardly spare time for the matter, because of the serious economic crisis and his involvement in the gold-standard and free-silver controversies of that period.)

Burnham wrote Secretary Carlisle:

> The obstacles [mentioned in Carlisle's letters] are not real ones, and never were, and after carefully looking over the ground I can see no others, ... You now inform us, in effect, that the law must be amended before you will act under it. I can see but one amendment which is needed to insure the satisfactory working of this measure, *i.e.*, the introduction of a clause ordering the Secretary of the Treasury to carry out its plain intent and purpose, and not leaving it to his discretion.

Carlisle replied to Burnham's complaint:

> Your very offensive and ungentlemanly letter ... is just received, and you are informed that this Department will have no further correspondence with you upon the subject to which it related, or any other subject.[167]

With the advantage of hindsight Dankmar Adler summarized: "...they proceeded to bombard the shying Kentuckian [Carlisle] with Olympian fulminations about the duty of the Government to the cause of art and all sorts of other things unintelligible and terrifying to the spoils politician."[168] (Carlisle served during the second term of Grover Cleveland, who had been governor of New York during the last two years of construction of that state's capitol.) An

impasse had been reached until the election of William McKinley three years later.

President McKinley appointed Lyman Gage, a prominent Chicago banker, as his Secretary of the Treasury. Gage, who had been president of the Board of Directors for the 1893 Columbian Exposition, was accustomed to working with the country's most prominent architects and probably shared their pride in the success of the "White City." With the advice of the AIA, James Knox Taylor, a former partner of Cass Gilbert, was installed as Supervising Architect. Taylor had already served for two years as a senior architect in the office of the Supervising Architect, having come there during the 1893 depression.

The Custom House in Norfolk, Virginia, was the first government building to use the services of a private architect under the Tarsney Act. The fourth was the New York Custom House for which Cass Gilbert won the competition. There was much wrangling on the latter project, largely because New York politicians were not certain that the architect, who had recently arrived from Minnesota, would cooperate in their customary rewards to political supporters. At first the architectural firms invited to participate in the competitions under the Tarsney Act were chosen with half of them picked for ability and the other half for "political expediency," but after many competitions had found no winners among the political group the Secretary changed to selecting completely on merit. Under the Tarsney Act competitions were at first limited to major projects in the largest cities, but in 1903 competitions for smaller projects were initiated with the Federal Building for Kankakee, Illinois.[169]

For the 1900 competition for the Baltimore Federal Building, since the appropriation did not provide for any payment other than a first prize, the official program suggested that out of his fee the win-

ner pay $500 to each of the losers. Although the competing firms agreed, the four architects on the competition jury objected, resigned, and were quickly replaced by another jury.[170] The Tarsney Act continued in effect during the McKinley, Roosevelt, and Taft administrations (1897-1913), but nevertheless by 1911 the Supervising Architect's office had about 160 draftsmen employed on the lesser projects under its jurisdiction.

For fifteen years (1897-1912) Taylor served as Supervising Architect, implementing the Tarsney Act by arranging competitions among private architects. There were sometimes controversies, and periodically architects, bureaucrats, and politicians victoriously announced new calculations proving that the employment of private architects was or was not more expensive than using the services of the Supervising Architect's office. Most architects seemed to consider the Tarsney Act "eminently successful, and if incapable builders could be eliminated, there would be no reason for criticism."[171]

Repeal of the Tarsney Act in 1913 came as a surprise to the AIA. The Secretary of the Treasury opposed the repeal, writing the congressional Committee on Public Building and Ground that the cost of architectural services on new buildings, combining the costs of private architects and the Supervising Architect's office, was merely 6.02 percent of total costs.[172] The repeal was considered by Congress as one of 289 amendments that had been attached to a major appropriation bill, a maneuver that did not require its being voted on directly. At about the same time Taylor was forced out of his position as Supervising Architect.

It was reported that only about a quarter of the competitions conducted under the Tarsney act had been won by architects who were not members of the AIA, but at that time AIA membership was probably around 5 percent of the number of people who told the census-takers that they were architects. In Washington many congressmen and civil servants looked on the AIA as a trade union and its fee schedule as price-fixing. They agreed with the Wisconsin officeholder who, it was reported to an AIA convention, gave "the public to understand that he has saved their funds from the grasp of the 'architects' trust'."[173]

Part IV

World War I to the Present: Adaptation to Extremes

The first half of the 20th century was dominated by armed conflict in size and scope that surpassed all of the hostilities of the previous century, World Wars that foretold the global influences that would become stronger as the years passed. For more than thirty years, 1914 to 1945, American life was largely controlled by war and postwar recovery and a severe worldwide economic crisis, the Great Depression. During such periods of stress privately financed construction declined, and public construction only rose significantly in response to preparation for World War II. The brief interwar respite that was later called the Roaring Twenties, a boom in building activity that led to advances in the techniques of constructing tall buildings, particularly office buildings and apartments, and increased the ties between the practice of architecture and the field of real-estate development.

The term "Golden Age" is sometimes applied to the second half of the century, during which general affluence and an expansion of governmental responsibilities increased the number of buildings built. Commercial and industrial structures were erected to house the thriving enterprises of the period, and public construction scrambled to keep up with the growing social and cultural role of government.

World War I

Almost three years passed between the assassination of the heir to the throne of Austria-Hungary by a Serbian patriot and the United States' entry into World War I. During that time American industry and banking interests assisted the Allies by providing armaments and loans without official governmental participation in the conflict. Once war was declared and the U.S. population was marshaled for war, the federal government acted quickly, but architects found themselves left out of the plans that were being rapidly formulated.

The editors of the *Architectural Forum* voiced the profession's indignation at this "humiliating snub" of architectural practitioners, who had

> ... complacently regarded themselves as useful members of society and worthy of at least reasonable consideration in any time of emergency. But how these innocent ideas have gone glimmering in the past nine months! Although scores of architects of the highest standing offered their office organizations and personal services ... to the Government in the early stages of the war when the great National Army cantonments were being projected, not one offer was accepted, and the construction of these buildings was entrusted to hastily gathered

organizations of engineers and land-scape architects, working under or with the general direction of the Quartermaster Generals' Office...."[1]

When a federal representative visited St. Louis to get information about candidates qualified to superintend the construction of military projects, the city's architects heard of the visit only after he had re-turned to Washington.[2] As if exclusion were not enough, the profession "was given another jolt by the President's amaz-ing request that all construction work be abandoned until the close of the war." Lit-tle comfort was to be found in the Red Cross's appeal for architectural firms to save drawings made on tracing linen, so that volunteer laundries could prepare the fabric for use by volunteers preparing bandages.

When planning for the construction of the World War I military training camps began, both the National Conference on City Planning and the American Society of Landscape Architects offered their ser-vices for the selection and planning of sites. This offer may have been effective because it was made by F. L. Olmsted, prominent in both organizations and also the son of Frederick Law Olmsted, who had been respected for his work on many government projects. Decisions regarding the location and layout of the Army's training facilities in the United States were made by committees consisting of a city planner, a water and sewer engineer, and an officer of the Quartermaster's Corps. Construction of all sixteen camps, each housing between 30,000 and 50,000 sol-diers, got underway almost immediately, and each required only about two months for completion of its essential elements.[3] The Government's reluctance to include architects in the planning phases of the projects may have been to some degree en-couraged by the decades of debate about the use of private architects for govern-ment buildings and the architects' obvious interest in the monumental and decorative buildings of the federal government. The AIA's campaign to obtain government commissions had led it to biting criticism of Congress. At an AIA convention two years before the delegates had laughed heartily at "Washington Pie or the Public Buildings of Medicine Hat," a skit satiriz-ing Congress's pork-barrel building ap-propriations. Such criticism could not have endeared the architectural profession to members of Congress, the only group that might have intervened in the archi-tects' behalf.

Although the services that had been volunteered by the most famous U.S. ar-chitectural firms were declined, individual architects proved to be extremely useful in several kinds of wartime construction. For more than two years before the United States joined the Allies in the war Charles Butler, a New York architect, had assisted the Rockefeller Institute for Medical Re-search in developing a War Demonstra-tion Hospital, working through the Amer-ican Relief Clearing-House in Paris. A hospital of prefabricated wood-frame con-struction was built in New York on the grounds of the Rockefeller Institute, de-signed after Butler had studied installa-tions that were already in service in the battle zones. France and Britain had each completed hospitals totaling more than 500,000 beds before the United States began planning its own program of hospi-tal construction. The Army's program was placed in the hands of Butler, whose work for the Rockefeller Institute served as the basis for design, and Edward F. Stevens, senior partner in a Boston architectural firm that specialized in hospital design.[4]

Architects also volunteered for work with the service organizations that were an integral part of the war effort. Since the army could not spare personnel for such purposes, appropriate tasks were assigned

to the American Red Cross, Young Men's Christian Association (YMCA), Knights of Columbus, Salvation Army, Jewish Welfare Board, and the American Library Association. In most situations these organizations had to provide their own equipment and buildings, and therefore needed architectural counsel. Because it operated the recreational programs and canteen facilities for all American troops, the YMCA in France initiated an extensive and urgent construction program in the face of extreme shortages of builders and materials. There were soon "Y huts" being built in France at a rate of a hundred a month, and in the United States 538 "Y huts" were quickly put in service at training cantonments.[5]

Plans for these buildings were derived from the Army barracks used a few years earlier during the Mexican border engagements, which adapted standard wood framing to panel prefabrication. A New York specialist in library architecture, E. L. Tilton, gave assistance with the internal arrangements of the standard buildings that would be adapted for use as camp libraries. Some of the "Hostess Houses" provided at many of the U.S. training centers as lodging for women visitors were the work of Julia Morgan in California or Katherine Budd on the east coast. The erection and adjustment of standard plans for "Y huts" was the work of architects who had volunteered to work in France, some of whom had retained a useful language skill from their study at the *Ecole des Beaux-Arts*. Three volunteer architects mentioned in the Paris diary of the YMCA's director of construction are probably typical: Cyrus Wood Thomas of Omaha, Nebraska, (who later lectured on city planning at the AEF University program at Bellevue) and John W. Chandler of Los Gatos, California, who were about thirty years old; and Edwin Hawley Hewitt of Minneapolis, Minnesota, in his mid-forties.[6]

In its indignant editorial the *Architectural Forum* had suggested that architects might well engage themselves in "great operations [that] are proposed for

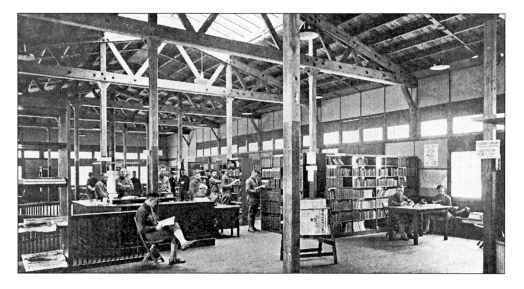

The standardized construction employed in buildings for more than thirty-two army training posts became camp libraries with little adjustment other than a rearrangement of fenestration. Books for the camp libraries were furnished by the American Library Association. (*Architectural Forum*, July 1918.)

housing the workers at the shipyards and munition plants." By June 1918 the Housing Department of the Shipping Board had thirteen housing projects ($25,500,000) underway. The Shipping Board seemed ready to erect housing for workers' families in the vicinity of five ship-building plants, all together a total of about 7,500 houses, but almost immediately the projects were redefined to consist primarily of "bunk-houses and barracks." Houses that were erected in a project at Groton, Connecticut, had to be under construction two weeks after the project was authorized. An architect was added temporarily to the Emergency Fleet Corporation's Branch of Design in its Division of Transportation and Housing "to design the houses in relation to a plan which had been completely projected though not developed." The layout of the community and the plans of the houses had already been determined.[7]

Before legally entering the war the United States was shipping war supplies to the Allies, and consequently the number of workers at Bethlehem Steel had tripled. The U. S. Housing Corporation, which was the federal government's first venture into housing, prepared plans for around fifty workers' towns in all, of which over half were under construction by the end of the war. Burt Fenner, who had inherited Mead's management role at McKim Mead & White, acted as general manager of the Housing Corporation, and John W. Cross, of the real-estate-oriented architectural firm of Cross & Cross, was the chief architect. In projects that ranged from 15 dwelling units to 1,200, plans were prepared for a total of some 114,000 occupants. By 1918 housing plans for Bethlehem, Pennsylvania, had been increased from 1,000 units to over 2,000 with the additional construction of community facilities and seventeen barracks for the munitions workers. Once the war ended construction immediately ceased, and many of the houses at Bethlehem were left incomplete, although only a roof might be lacking. Other projects seem to have provided more productive roles for the fifty-two architects that were engaged and their staff, a total of around 450. With deadlines a primary concern, the procedures of architectural practice at the time may not have readily adapted to the pressures of the frantic nineteen months of U.S. participation in World War I. The Boston firm of Kilham & Hopkins had only three weeks to complete drawings for Atlanta Heights, which included 300 houses and dormitories for 400 men.[8]

In the state of Washington the respected Seattle architectural firm of Bebb & Gould, already experienced in designing logging towns in the forests of the Northwest, was hired by the engineering firm charged with building a railroad and mill to provide Washington spruce for the manufacture of military aircraft. A town for 3,000 people was to be built, including a transient hotel, a family hotel, dormitories, houses, and the necessary community facilities, and it was hoped that by eliminating the horrid conditions that had long been typical of isolated logging camps it might be possible to avoid the frequent and bitter strikes that persisted in the industry. With the urgency of wartime Bebb & Gould produced over a hundred drawings in less than three months, including in them many changes and additions that were made during that time.[9] In late October 1918 the firm was fired by the engineering firm in charge of the project, but it was only seventeen days until an Armistice was declared, the war ended, and the project was abandoned.

The Small House Movement

A postwar depression delayed the resumption of construction in the United States. The housing shortage in the United

States and Canada had reached unprecedented levels, but residential construction was hampered by the high cost of both building materials and labor—about three times their prewar levels. The prices of single-family residences skyrocketed to almost double those of just five years earlier. In all sections of the country real-estate speculators were busy buying apartment houses for rapid and highly profitable resale. Apartment projects were so popular in 1923 that only the category "public buildings and schools" had a larger share of the expenditure on building construction, and the construction of single-family "dwellings" involved only about three-quarters as much money as was spent on apartments. House-building once again became possible after building costs dropped rapidly through 1921 and 1922, and in a group of fifty-two U.S. cities the building permits filed in 1925 exceeded in dollar value those of 1890, the previous boom year of building construction in the United States.[10]

Through these years architects and many of the public were shocked by the jerry-building that seemed an inescapable part of the period's hectic construction of housing, and architects were concerned about the social and economic ramifications of a residential building boom that was for the most part outside their professional domain. Four Minnesota architects confessed to being

> ... appalled at the vicious architecture of small houses ... [which were] being determined by a large extent in the service rooms of lumber dealers, by contractors or by carpenters. The architect, under a situation for which perhaps he was not responsible, had allowed himself to be eliminated. Building material dealers had evolved the custom of supplying blueprints free with the sale of a bill of goods; contractors anxious to secure clients were supplying free plans ... [which

were] extremely meager and incomplete.[11]

These architects in 1919 founded "The Architects' Small House Service Bureau of Minnesota," the last phrase of the title changing to "of the United States" when the organization gained the support of the AIA and became national in scope.

Members of the group contributed sketches of house designs, and for those selected the necessary working drawings, specifications, and materials lists were prepared. The designs and drawings were then made available to the public through catalogs, pamphlets, and features that were published by over forty magazines and almost two hundred newspapers. The Bureau made changes in drawings for a charge depending on "the amount of time required by the draftsman," and offered other help: "During the building of your home the Bureau stands by to help you. Any questions you ask by mail about materials and methods will be answered promptly without bias, fear, or favor."[12]

Publishing architects' house-plans was nothing new in American architecture. Shortly before he began his work on the dome of the U.S. capitol, Thomas U. Walter had joined John Jay Smith in the publication of *Two Hundred Designs for Cottages and Villas* (1846). The residential designs of Samuel Sloan appeared frequently in *Godey's Lady's Book* and several volumes titled *The Model Architect* that were issued between 1852 and 1873. Many other publications by less distinguished designers had provided the house-building public with plans and elevations that were adequate guidance if a reasonably experienced builder were employed. George Palliser published twenty-two architectural plan books between 1876 and 1893. The majority of Palliser's books were devoted to houses, but he also published volumes that supplied appropriate designs for

schools, courthouses, town halls, as well as "memorials and headstones." Around 1910 Seattle even had two plan-book publishers: E. Ellsworth Green circulated the *Practical Plan Book* in competition with Victor W. Voorhees' *Western Home Builder*, both charging $25 for a set of plans and specifications. Such entrepreneurs were not necessarily renegade architects. Henry Hudson Holly, who was known for his books *Country Seats* (1863) and *Church Architecture* (1871), also maintained a general practice and was active in the affairs of the New York Chapter of the AIA.[13]

Mail-order plans could be obtained later from architect W. J. Keith in Minneapolis, the Radford Company in Chicago, and the architectural firm of Daverman & Son in Grand Rapids, which at one time was said to have fifty drafters busy filling the orders they received. George Barber of Knoxville, Tennessee, informed his customers: "Write to us concerning any changes wanted in the plans, and keep writing till you get what you want. Don't be afraid of writing too often. We are not easily offended."[14] For such service Barber maintained a staff of about twenty secretaries and thirty drafters. Early in the century Aladdin Homes in Bay City, Michigan, the Pease Woodwork Company in Hamilton, Ohio, the Redwood Manufacturing Company in Pittsburg, California, and several other concerns were selling sectional, precut, and other forms of prefabrication. Montgomery-Ward and Sears-Roebuck, the two giants of mail order retailing also sold houses. Sears led in the business of unassembled houses, and by 1920 the company was selling some 125 houses every month. Loans were available from Sears, plans and instructions were provided, and a freight car could bring in all the precut lumber and other materials needed down to the nails. One customer was clearly elated when he wrote Sears in 1918: "Having the house on the train with

us, we were able to have it up and move into it two days after we reached Powell [Wyoming]."[15]

In the Architects' Small House Service Bureau the price of a share, available only to architects, was set at $100, and dividends on the investment were limited to 8 percent, a fact that led to much favorable press coverage alluding to its "$8-a-year architects." The AIA approved the Bureau, and Edwin H. Brown, who had given space in his firm's office for the Minnesota group, was made chairman of an AIA Committee on Small Homes. Working drawings and specifications for the Bureau's designs cost five dollars for each principal room in the scheme, but a six-room house was the largest available from the Bureau.

Within three years seven other geographical districts had joined the Northwestern division (which included the original group in Minnesota), and were in action against the housing problems of their regions. The Mountain District (Denver) published a book of fifty-two house plans, some as small as three rooms. In 1926, after six years of operation, plans for more than four thousand houses had been sold, but it is impossible to estimate the number of houses that may have been built from the minuscule drawings published in newspapers and the Bureau's catalogs without sending for working drawings. Data on sales by the Bureau show that the majority of plans were sent to seven states grouped in an area extending from New York and Pennsylvania westward to Wisconsin.[16]

The work of the Small Home Bureau did not proceed without criticism. To those who supported the Bureau, its altruism and the professional public relations were related to the fact that the design of small houses was so rarely an architect's work that any loss of those fees would not be noticed. Against such arguments the opponents of the Bureau insisted that "the

"COLONIAL" BROUGHT UP TO DATE

Copyright 1927—The Architects' Small House Service Bureau of the United States, Inc. Plan No. 6-G-2.

PEOPLE are beginning to weary of stage scenery houses. It seems that we can stand just about so much wild architecture and then we come back with a rush to the things which are substantial and sound and which have withstood the trials of generations. This design, 6-G-2, is such a house. The style is a rather free version of early seventeenth century Colonial, with the slightly projecting upper story characteristic of the time.

Practical double hung windows have displaced the casements of that earlier period, but the walls are covered with narrow clapboards and corner boards as many of the old houses were. The molded drops under the projecting story were a characteristic detail of these houses.

The walls, together with sash and all interior finish should be painted white. Blinds and doors should be a cheerful shade of green. The chimney of common brick should be painted white with a black band at the top. An acceptable alternative for the wall covering would be shingles which might be stained gray, or large hand split cypress shingles oiled or left to weather.

The plan is an extremely complete one, generous as to the sizes of rooms and as to the equipment and accommodations offered. There is a completely enclosed stair hall, a living room with fireplace, built in bookcases, and offering a vista through French doors to the porch which should make it an extremely impressive and pleasant room.

In the kitchen there is the usual array of equipment properly arranged for convenience and in addition an unusually commodious pantry with built-in cupboards and a separate entry to the back porch. In the entry is provided space for the refrigerator.

Upstairs there are three excellent bedrooms, two of them with wall space sufficient to accommodate twin beds. Each of these rooms has two closets. The third bedroom is of good size and, of course, has its closet. Additional closets are found in the bath room, two of them in the interior hall, and a third in the stair hall.

Construction: Wood frame, exterior finish siding or shingles, roof of shingles.

Lot size: Approximately 40 feet if the porch is omitted or placed at the rear, 55 or 60 feet if the porch is built as shown.

Complete working plans may be obtained for this and other designs shown in this series. For further information see editor's note below plans.

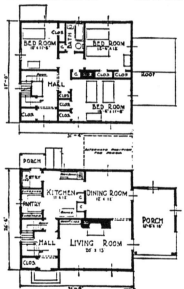

EDITOR'S NOTE: Building plans for the house shown above may be secured through the Home Building Editor of this paper. This service is presented to our readers through co-operation with The Architects' Small House Service Bureau, an organization of practising architects from leading architectural offices throughout the country. This bureau is controlled by the American Institute of Architects, and has the indorsement of the United States Department of Commerce. Its purpose is to provide, at moderate cost, plans and service for small homes of high architectural quality. Address the Home Building Editor of this paper for further information regarding this service. Questions from our readers regarding home building will be answered at no charge by the technical department of The Architects' Small House Service Bureau. Enclose a stamped, addressed envelope.

The Architects' Small House Service Bureau provided prospective owners with three sets of blueprints, specifications, material lists, and two contract forms, all for a charge of $6.00 for each "principal room." In the Bureau's *Scrapbook of Homes* (1928) this design was explained as "a rather free version of early seventeenth century Colonial."

majority of the architects in the country are doing small houses and make a living thereby." Furthermore, they said, small houses should be kept as entry opportunities through which young architects might moonlight to gain experience and initiate their own practices. Through the years the opposition to the Small Homes Bureau centered in New Jersey: the New Jersey Chapter of the AIA, the Architects' League of Northern New Jersey, and the New Jersey Society of Architects. Twelve years after the founding of the Bureau, the *Journal of the AIA* included a comment that "when the New Jerseyites … pack for the annual trip to the [AIA] convention it is as natural for them to include a briefcase full of arguments against the Bureau as it is to include their socks and ties."[17]

After 1926 the Bureau's sales declined, and by 1934 the Great Depression led to withdrawal of the AIA's support. Eight years later the Small House Bureau was officially closed. From the heyday of the Roaring Twenties to the depths of the Great Depression economic conditions had altered, but as late as 1936, toward the end of the depression, the "Small House" spirit seems to have continued. The *New York Times* announced that about twenty members, "either firms or individuals," had formed the Small House Associates to provide services to those who wished to build houses that would cost between $3,500 and $8,000. The director of the Federal Housing Authority (FHA) in Tennessee encouraged architect J. Frazer Smith, who formed the Memphis Small House Construction Bureau, and within a year 95 percent of the plans submitted to the FHA for financial assistance were architect designed.[18]

Estates and Mansions

The economy of the 1920s and the pro-business policies of the federal gov-

ernment brought great wealth to an extremely small segment of the U.S. population. Of architect's residential work the most publicized were the lavish suburban homes of the period's moguls, commissions that gave architects "an opportunity for being a little more elaborate, extravagant, and even fastidious than is usually the case in the matter of those refinements which are their pleasure and their delight."

Unlike the low-cost houses that had the attention of the Architects' Small House Bureau, figures published in the *Architectural Forum* showed that about 95 percent of houses costing more than $50,000 were designed by architects.[19] At the time this was far less than 1 percent of all the houses being built. Continuing the traditions of tycoons during the late 19th century, some rich families of the 1920s demonstrated their wealth and position through philanthropy, but at the same time ostentatious country houses had their appeal. Suburban railways made commuting possible, and some tycoons living on Long Island found it better to go to their Manhattan offices by yacht—or seaplanes for the young and daring. Almost half of the projects for which the firm of Delano & Aldrich became known were large suburban estates in and around New York, at least thirty-two on Long Island. The children of those wealthy families could also be found in the buildings that Delano & Aldrich designed for the more exclusive finishing schools, prep schools, and universities. Working to provide the areas around New York with rural mansions and country clubs, Roger H. Bullard's office started with estates for three clients who had been his fraternity brothers at Columbia University.[20]

The leading families of Chicago relied on Howard Van Doren Shaw, whose projects also included a housing complex for a steel plant, and David Adler, who through his decades of practice seems to have done

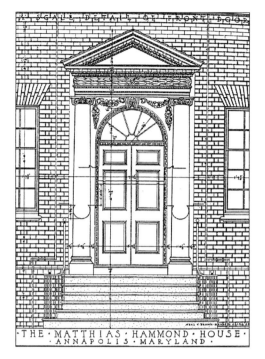

During the heyday of so-called "Colonial" residential design, the extremely popular *White Pine Series of Architectural Monographs* was published bimonthly by producers of white pine from 1915 to 1924. Publication continued in *Pencil Points* from 1925 through 1940. Typical presentations paired photographs and measured drawings as in this doorway included with other details from Annapolis, Maryland. (*The Monograph Series*, v. 15, no. 4.)

only housing for the rich, whether in the city or the country. J. J. B. Benedict was a favored designer for rich clients in Denver until, according to one comment, his practice "began to interfere with his social obligations." Nationwide, almost every sizeable city had at least one fashionable architect whose residential practice relied largely on college chums, in-laws, social connections, club acquaintances, and a flexible familiarity with a variety of styles. Some architects were known for their development of interiors. As Richard Morris Hunt and Stanford White had done in the 19th century, Addison Mizner made trips to Europe in order to collect furnishings and decorations for the houses in Florida he designed, and Charles A. Platt used the services of an Italian agent who took care of the necessary dickering after Platt had made his choices of furnishings.[21]

Wealthy clients could be demanding. Around the turn of the century Stanford White, as architect for the country estate of a Cleveland steel tycoon, weathered the unusual experience of a degree of collaboration with his client's thirty-year-old unmarried daughter, Theodate Pope (later Riddle). The Olmsted Brothers, landscape architects, submitted over two hundred plans to their clients for the grounds of one estate, more than had been required for a major park in Boston. Julia Morgan, who presided over William Randolph Hearst's assembly of his estate San Simeon, must have been pleased to receive a letter from her client: "I make a lot of suggestions and if any of them are impracticable or imperfect from an architectural point of view, please discard them and substitute whatever you think is better."[22]

For appropriate settings the larger

country houses might require the purchase of three or four small farms. The prospective owners of two adjacent estates on Long Island together bought four hundred acres and "destroyed the village of Lattingtown to get the view we wanted."[23] Thomas Hastings recommended that his clients set aside as much for construction of outbuildings as for the house. Power plants, water towers, staff cottages, stables, and garages were essential, but to these were usually added indoor pools and courts for various sports, greenhouses (fifteen for L. C. Tiffany), and other structures suitable for the rural life. Arthur Rubloff, a Chicago real-estate developer, had an estate in Wisconsin with a stable for sixty horses and a garage for thirteen cars. Alfred Hopkins, a specialist in the design of agricultural complexes, could be engaged to plan the stables and farm settings for the largest estates, the country houses usually being designed by other architects. His work included at least fifteen estates in the environs of New York before his specialization changed to prison design.[24]

In the boom-or-bust years of the 1920s many architects were tempted to extend their interests into real-estate ventures, assuming that a knowledge of buildings would certainly be an advantage in that form of financial adventure. In the firm of Cross & Cross, brothers from a prominent New York family, John W. Cross saw to the firm's architectural practice, and Eliot B. Cross dealt in real estate, particularly the development of the powerful firm of Webb & Knapp in which the Crosses at one time participated with two partners. Early New York luxury apartment buildings had been largely the investments of distinguished families and designed by socially accepted architects, but in the 1920s—especially after the city responded to the housing shortage by exempting residential construction from real-estate taxes for ten years—speculation

in the finer apartment buildings was dominated by immigrants or the sons of immigrants. Emory Roth designed apartment buildings for developers, including the law firm of Bing & Bing and builder-developer Sam Minskoff, who had started as a plumber; Rosario Candela designed for several builder-developers, such as Gaetano Ajello, Anthony Campagna, and Michael Paterno. Architects and developers of East-European Jewish and Italian extraction had taken over New York's construction of luxury apartments, a situation resented by many old-guard architects.[25] Roth was barred from membership in the AIA until the fashionable New York architect, Thomas Hastings, who had collaborated with Roth on an apartment project, intervened in his behalf. The architectural firm of Fuller & Dick had an advantage in the fact that Adolph Dick's father was a prominent figure in New York finance and real estate and his sisters had married into the wealthy households of Macy and Havemeyer. In Chicago John A. Nyden fared so well in his investments, particularly in hotels, that in 1927 he almost completely abandoned the practice of architecture and became a banker before being wiped out by the Crash of 1929.[26]

One of the most dramatic of architects' leaps into real estate was the Florida building boom in which a prominent role was played by Addison Mizner, whose father had gone to California during the Gold Rush and made his fortune in real estate rather than gold. With the funds provided by an heir to the Singer sewing machine fortune, Mizner built Palm Beach's fashionable Worth Avenue on land that just months before had been Joe's Alligator Farm. From 1925 to 1927 the Palm Beach scene was also enhanced by the architectural work of Joseph Urban, a Viennese who designed sets for the Metropolitan Opera and the Broadway shows of Ziegfeld. Mizner and his brother Wilson in

1925 pooled their talents to plan a 6,000-acre venture they named Boca Raton. The first day of business their contracts for the purchase of lots in the future Boca Raton were said to total over $11,000,000, but the Florida bubble soon burst. The collapse not only finished the Boca Raton project, it also brought an end to Mizner's architectural practice which had been primarily based on designing palatial residences for wealthy clients, projects that were usually scheduled for completion by the time their owners returned to Florida for the next winter season.[27]

Women in Architecture

Young women interested in architecture usually found it difficult to obtain the education and training that they needed. Private colleges, many of which had been founded for the education of clergymen, were reluctant to make exceptions to their all-male status, but state-operated land-grant colleges were, on the whole, proudly permissive. An experiment in architectural education began in the fall of 1915 when Katharine Brooks Norcross, a graduate of Radcliffe College, asked to be admitted to a Harvard University class in architectural drawing. Her request was denied, but the head of Harvard's architecture department asked one of the instructors, Henry Atherton Frost, if he would tutor Norcross. By the following February, Frost and a landscape architecture instructor with whom he shared a small professional office had six women students in their drafting room, the beginning of the Cambridge School of Architectural and Landscape Design for Women. Most of the women were studying landscape architecture, a field in which women had been more accepted than in architecture, and the "Little School" was known for its integration of those two fields of design. In 1938 the "Little School" was in need of a college

affiliation and arranged an association with Smith College, a women's school almost eighty miles away in Northhampton, Massachusetts. But in four years a change in the administration of Smith brought about the end of the Cambridge School. Through some twenty-six years of service "The Little School" graduated students, most of them studying landscape architecture, and in 1930 it was reported that 83 percent of its graduates were engaged in some form of professional work.[28]

Well into the 20th century many people still thought it inappropriate for a woman to seek a place in the architectural profession. The first woman architecture graduate at Washington University, St. Louis, looked back on the period after her graduation in 1916: "The excuses offered me for not hiring a woman architect!"[29] Ten years after graduating from the MIT short course Lois Howe, who had won second place in the competition for the Woman's Building at the 1893 Chicago Columbian Exposition, opened an architectural office in Boston in 1900. Most women practiced alone, but through the years two women graduates of MIT, around twenty years younger than Howe, were added as partners: Eleanor Manning in 1913 and Mary Almy in 1926. The firm was best known for Manning's interests in low-income housing, which she continued after the firm closed during the Great Depression. In Waltham, Massachusetts, the office of Florence Luscomb and Ida Annah Ryan, both MIT graduates, lasted from 1909 to the start of World War I. Nelle Peters, who came from Storm Lake, Iowa, found employment in a Sioux City architectural firm in 1903 and at the same time studied architecture through a correspondence course. She was sent to her employers' branch office in Kansas City, Missouri, and it was there she established her own practice in 1910. Through work for a local builder-developer, Peters became recog-

nized locally as a designer of apartment buildings and hotels.[30]

On the West Coast, the commission for a residential club for Jewish girls working in San Francisco was brought to Julia Morgan's office by her employee Dorothy Wormser, an architecture graduate of the University of California who had connections in the local Jewish community. In response to the complaints of the city's male Jewish architects, Morgan listed Wormser on the project drawings as "associate architect." Lilian Jenette Rice, another architecture graduate of the University of California, in 1922 was assigned by her employers in San Diego to take charge of the design of the Rancho Santa Fe development on land that the Santa Fe Railroad had originally bought for growing eucalyptus trees to use for railroad ties. Residential designs were the principal practice of Verna Cook Salomonsky, a Columbia University graduate who had also studied in France; Elizabeth Coit, daughter of a Boston architect and graduate of MIT; and Eleanor Raymond, who graduated from the Cambridge School and was partner of Henry A. Frost before opening her own office in 1928.[31]

The *Architectural Record* in 1948 contacted over a thousand women who had studied architecture and found 108 in practice. Of the ten for whom works were illustrated and biographical data given, most were principally engaged in commercial and residential projects, three had European training, two practiced with their husbands, and only one worked in a large firm. But women architects were not necessarily small-office architects or residential specialists. After joining the firm in 1944, Natalie de Blois became a senior designer in the New York office of Skidmore Owings & Merrill, and shifted to the firm's Chicago office in 1962. Chloethiel Woodward Smith opened her practice in the District of Columbia in 1945 and was

principally recognized for planning large housing schemes. Maglet Myhrum was a designer with Bertram Goldberg Associates in Chicago, while her husband, also an architect, practiced independently in residential work. Many other women were filling key roles in architectural firms, although at mid-century feminine names were still seldom seen in the names of firms.[32]

The American Beaux-Arts

American architecture students studying in the different Paris *ateliers* associated with the *Ecole des Beaux-Arts* were accustomed to relaxing together at the tables of the sidewalk cafés situated along *Boul' Mich'* (Boulevard St. Michel), delighting in Parisian life and the excitement of being part of it. On Thanksgiving Day 1890 about eighteen young American architectural students, enjoying a holiday dinner they had arranged at Café D'Orsay, pledged to continue their relationship after they returned to America. (Some say it was the Café Voltaire, but such variations are to be found in most stories of study at the *Ecole des Beaux-Arts*.) Three years passed before a dinner was arranged in New York for veterans of the *Ecole*, and at that gathering an organization was established under the name of Society of Beaux-Arts Architects. The Society stated its purpose as:

> Preserving among ourselves the principles of taste acquired at the *Ecole des Beaux-Arts*; by endeavoring to propagate these principles among the rising generation of architects and the public in general; by setting our faces steadfastly against the vagaries and abuses of architecture as it is too generally practised in the United States … by enlisting in our ranks, as fast as they return, young men who have had the advantages of such an education and by working together for ul-

timate formation of an American school of architecture, modeled after the *Ecole des Beaux-Arts.*[33]

Obviously, the group still felt their training at the *Ecole* to be an extraordinary advantage and believed that the style and method of the *Ecole* should be the future architecture of America. In some cases those convictions were the result of a thorough familiarization with the *Ecole des Beaux-Arts.* However, Ernest Flagg, a very vocal participant in the Society of Beaux-Arts Architects, seems to have studied at the *Ecole* only about six months during the two years he spent in Europe, study that was funded by his cousin's husband, Cornelius Vanderbilt II.

The idea of a single national academy of architecture had been discussed for almost a century, but as the population of the United States spread westward, local and regional notions of independence grew, and public education had become recognized as an essential function of state governments. By the time of the Thanksgiving dinner in Paris, there had been at least five collegiate programs established in U.S. universities and the program at MIT had operated—though at times faltering—for a quarter of a century. However, within the framework of the Society of Beaux-Arts Architects there came to be established a national system of instruction in which postal service from an office in New York to participants throughout the United States took the place of communications between the *Ecole des Beaux-Arts* and the Paris *ateliers* near it. In the United States the program requirements for student competitions, brief documents that provided a description of the internal provisions and the site for which a building was to be designed, were prepared in New York and mailed to university departments of architecture, *ateliers* sponsored by architects, and architectural sketch clubs. Members of local sketch clubs asked

architects, usually "Beaux-Arts men," to give occasional instruction and criticism for those entering the competitions. For the longer design projects, the students' initial twelve-hour sketches were mailed to New York, to be followed several weeks later by the students' finished drawings of the designs they had developed.

The first competition, "A Small Theatre for Cantatas," was held in September 1894, and forty drawings were received from six universities, three sketch clubs, and the students of individual members of the Society.[34] By the 1910s the awards given by the New York juries that were organized by the Society of Beaux-Arts Architects were almost evenly divided between college students and the non-academic competitors who were affiliated with architects' *ateliers* or architectural clubs. Of some two hundred awards made to students in the 1914-1915 season, over 80 percent went to universities in the northeastern section of the United States, the region with the largest and oldest schools of architecture. The awards won by students in *ateliers* and clubs were more widely distributed geographically, only half being in the northeast and some going to such distant groups as the San Francisco Architectural Club and the New Orleans *atelier* of C. A. Favrot.

In 1916 the Society of Beaux-Arts Architects obtained a charter for the Beaux-Arts Institute of Design (BAID), which would operate its educational activities. Almost 800 completed drawings for full-length projects in the 1914-1915 year were received in New York and almost 500 sketch problems, which usually were allowed only twelve hours for completion. Final drawings were received from far less than half the students who submitted the twelve-hour preliminary sketches that showed the idea they would develop. Drafters working a six-day week might easily lose heart, college students could be

Students' drawings from across the country were exhibited for jurying at the Beaux-Arts Institute of Design headquarters in New York. Small sketches that had been arrived at in the first twelve hours of the assignment were fastened to the bottom of the drawings that showed the later development of those ideas. As part of the jury process the sketches were checked with the completed drawings. (John F. Harbeson, *The Study of Architectural Design*, 1926.)

advised by their professors to abandon a project on which they had submitted a poor preliminary sketch—which had been the practice at the *Ecole*—or a professor might withhold botched designs in order to improve his university's record. Sketch clubs usually set aside *atelier* space in their club rooms, but the independent *ateliers* could be uncomfortable places to work. One *atelier* of the 1920s was described as the "top floor of a four story walk-up in New York's Greenwich Village. The ceiling was low, ... and it was hot in summer and bitter cold in winter." However, that resembles many descriptions of *ateliers* in Paris.

In the 1928-1929 season, just before the stock market crashed, the BAID received almost five times as many drawings as it had in 1914-1915, the number of architecture schools participating having increased with the growth of architecture schools at state universities. *Ateliers* and clubs received about the same number of awards as they had in past years, but that was just an eighth of the total. Participa-

tion in BAID competitions reached its highest level in 1929-1930 with more than 9,500 drawings submitted, but by 1948-1950 the number had fallen to about 6,000.[35]

In a school year the BAID might judge over 6,000 drawings, and an average jury of over twenty architects could be confronted with almost 200 drawings as their evening's work. Some juries at the peak of participation in BAID probably evaluated more than twice that number of drawings. A common complaint, which had also been leveled against the French *Beaux-Arts* system, was that with so many designs to consider in an evening the architect-jurors were attracted more by the superficial pattern of plans and the dramatic effects of elevations than by the practicality of the arrangements and the development of rational structural schemes. Even the consideration of facades may have been distorted by a peculiar preference for elevations rather than three-dimensional perspective views of buildings, a prejudice of the French *Ecole des Beaux-*

Drawings for the Beaux-Arts Institute of Design equaled the drama of their French counterparts, although American conditions might alter details. In 1914 this design for a city hall, in a distinctly American setting, won Harry Sternfeld a scholarship for study at the *Ecole* in Paris. (*Winning Designs 1904-1927, Paris Prize in Architecture,* 1928.)

Arts. In the French style, drawings had foreboding skies looming behind elevations, and plans were filled with rich patterns of mosaic floors. One architect, speaking of BAID juries, recalled seeing "many plans so filled with the bright colors of an oriental rug that the inadequate solution of the fundamental requirements of the building passed unnoticed. The Jury was too human. It reached out for the pretty picture."[36]

The subjects of BAID competitions varied, but they were principally public and institutional buildings or small-scale decorative studies. Among subjects for the projects allotted a longer period of study in 1914-1915 were: "Treatment of the Banks of a River Flanking a Natural Fall" and "A College Dining-Hall in English Collegiate Gothic." The twelve-hour sketch problems included: "A Life-Saving Station," "A Door to a Burial Vault," and "A Corner Pavilion in a Public Building." (Prof. James W. Fitzgibbon of Washington University, St. Louis, satirized BAID problem statements with an imagined introductory sentence: "A young man has inherited an island in the Potomac River and four antique columns.") Several weeks

after drawings were mailed to New York, they were judged, and roughly half of them received awards. The drawings were returned to the schools, *ateliers,* and clubs, with markings to indicate their ranking: "M" for an award, "½M" for a lesser award, "X" for no award, and "HC" (*hors concours*) for those that did not conform to the stated requirements or follow the student's initial sketch. In American universities it was difficult to follow the French pattern of instruction. Students in the French *Beaux-Arts* system advanced from lower to upper levels of the program only after they had acquired a certain number of awards for their work, and in the Paris *ateliers* most students' contact with their instructor was occasional, almost ceremonial with the principal assistance and criticism coming from upperclassmen. Both the *Ecole*'s method of advancing students and its approach to instruction obviously conflicted with the operating spirit of the typical U.S. university—the semesters, scheduled classes, and grading that were already immutable elements of American university life. At the University of Louisville, where a former stable was assigned as the School of Ar-

chitecture, about twenty students pursued the BAID program at night and on weekends without interrupting their full-time employment as drafters. (After horses were replaced by automobiles, stables often housed architectural classes and American *ateliers*, because they provided open space.) After twelve years the University of Louisville administration discontinued the architecture program in 1926, one of its reasons being the fact that the School of Architecture seemed more affiliated with the BAID than with the University.[37]

There were 9 schools of architecture in 1899, 20 in 1911, and 53 in 1930, most of this increase resulting from the development of architectural programs within the engineering divisions of land-grant colleges throughout the country. As in many professional curriculums, about 30 percent of the students who entered architecture programs graduated. In 1930 almost half of the schools required five years to complete their programs in architecture, but about half also offered four-year programs in architectural engineering, which accounted for more than a fifth of the total number of students enrolled in all kinds of architecture programs. After the introduction of accreditation for architectural programs, which recognized only programs of five or more years, some state architectural licensing boards continued to accept the four-year architectural engineering degrees from their own state's institutions.[38]

By the 1930s BAID exercises had begun to shift from eclectic solutions to more modern styles. The arrival of emigré

By the 1930s projects of the Beaux-Arts Institute of Design had changed both stylistically and functionally, as indicated by this premiated design by F. S. McNeill of the University of Notre Dame. (*BAID Bulletin*, February 1936.)

teachers who had been associated with the Weimar Bauhaus—particularly Walter Gropius at Harvard and László Moholy-Nagy at the Institute of Design, Chicago—encouraged this shift. The universities' architectural curriculums were updated by replacing introductory courses of drawing the classical orders with courses in abstract composition, generally known as "basic design" and attributed to the influence of the Bauhaus. Elementary geometric forms were arranged and combined as a preliminary to students being admitted to architectural design courses. Otherwise the curriculums remained as hybrid combinations of the Beaux-Arts methods and the customary requirements of the American university system.

After World War II interest in the exercises of the BAID dwindled. Schools of architecture were swamped with returning veterans, many living with wives and children in drafty Quonset huts and barracks at the edges of campuses. The BAID programs were updated, students being allowed to use real sites in their own locales, and such functions as "A Merchandise Display Center" and "A Commercial Laundry and Dry-Cleaning Establishment" appeared among the subjects assigned. Nevertheless, participation shrank and by 1956 the organization's title was again changed, becoming the National Institute of Architectural Education, which would be principally concerned with competitions related to scholarships that had been endowed in memory of "Beaux-Arts men" who had been active in the organization that had dominated American architectural education for about a half-century.

Sketch Clubs

In spite of their frequent financial problems, architectural clubs (often titled "sketch clubs" because they emphasized graphic skills), made significant contributions to the profession. Through the summer months the St. Louis Architectural Club, successor in 1894 to the local draftsmen's Base Ball Society, conducted a Saturday sketching class and awarded a prize for the season's outstanding portfolio of drawings. The Club offered architectural instruction for almost a decade before Washington University brought a university program of architectural studies to St. Louis, and for another decade the University's evening classes in architecture were held at the quarters of the Club, which paid both overhead and the teachers' salaries.[39]

Philadelphia's T-Square Club in 1913 had 224 members, which enabled the club to construct a clubhouse that would replace the three-story stable it had occupied since 1897. With only thirty-five young members during World War I, the T-Square Club, like most of the other clubs, was virtually dormant, but quickly revived after the Armistice. The Pittsburgh Architectural Club in 1923 proudly exhibited drawings that had been sent them by over thirty prominent New York architects, and it sometimes leavened its busy educational schedule with one-hour sketch problems on topics such as "A Gondola Suspended from a Balloon for Ten Flappers."[40]

Sketch clubs gave employers a way to sponsor the self-improvement of their staff and often provided an opportunity to spot and hire new talent. There callow drafters might meet the most distinguished architects of the city and the stars of their drafting rooms. Young architects who had just completed study in Paris or in a prominent New York *atelier* assumed the roles of advanced students or *patrons*, guiding younger men in the BAID competitions. Ambitious drafters, whose social contacts in the city might be limited to their coworkers, found companionship, advancement, and amusement in architectural clubhouses. Every

architectural club endeavored to rent or buy a location that could be the venue of its scheduled activities and could always serve as a casual gathering place for its members. For a while the St. Louis club owned a stable, and also operated a cooperative boarding house for some of its members. In 1922 the *atelier* of the San Francisco Architectural Club included about 30 of the 140 members who were drafters.

June 1920 saw the emergence of a new architectural journal, *Pencil Points*, a name taken from a leaflet published for a year and a half by the *Architectural Review*. The new publication's masthead carried a forthright declaration of its mission:

> *Pencil Points, An Illustrated Monthly Journal for the Drafting Room*—not meant for the architect owners of the firms, but instead catering to the interests and needs of drafters, specification writers, and the others who produced the documents for building construction.

The first issue of *Pencil Points* included many examples of building details (mostly decorative), the first in a series of articles on methods of constructing perspectives, many drawings of buildings, and some travel sketches by young architects. The second issue introduced a few pages that would be of interest to specifications writers. Drafters were, of course, interested in practical information that could be applied in the preparation of working drawings. *Don Graf's Data Sheets*, information on material and

details that could be cut out of the magazine and filed in a loose-leaf binder, continued in *Pencil Points* from 1932 through 1942, and frequently features in the magazine explained the techniques used in drafting for landscape work and other special requirements.

But every young drafter worth his salt dreamed of winning awards for competition designs at the local sketch club and imagined himself as one the delineators and free-lance designer-drafters who were the monarchs of the drafting rooms. Arti-

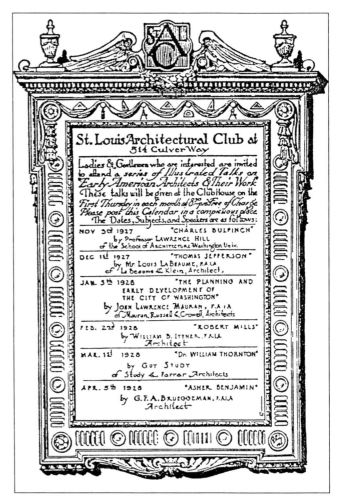

For the 1927-1928 season the St. Louis Architectural Club organized and advertised a lecture series on early American architects. Included among the speakers were some of the city's leading architects.

cles on delineators and their techniques, sketches submitted by the readers, notices of open competitions, and a wealth of similar information filled the pages of *Pencil Points*. The contents were made even more challenging by including in every issue a photograph and a brief biographical account of a young drafter who had won a scholarship or award.

Early issues of *Pencil Points* printed the reports it received about the activities of the architectural clubs across the country, and this was no small audience. Philadelphia's T-Square Club had about 350 members, a fifth of whom were employers; the St. Louis Architectural Club had 175 members, half of them drafters; and about 75 members usually attended the monthly dinners of the Los Angeles Architectural Club. The lecture series presented by architectural clubs included topics ranging from "The Cloisters of France" to "Einstein's Theory of Relativity," and many clubs organized lectures and exhibitions that provided effective public relations for the local professionals. The schedules of activities that were most often reported by clubs included lectures on engineering topics, weekly life-drawing classes, field trips for sketching, and *ateliers* in which drafters could participate in the competitions of the BAID. As late as 1940 the Chicago Architectural Club announced that it was active "along the Beaux-Arts line," although Mies van der Rohe had arrived at Armour Institute of Technology two years before.[41]

Government Relations

At the AIA's 1923 convention in Washington, Henry Bacon, architect of the Lincoln Memorial, was awarded the Institute's Gold Medal. The ceremony in many ways epitomized the spirit of the Institute in boom times. After about five hundred guests had banqueted in marquees at the east end of the reflecting pool in front of the Memorial, Bacon and his collaborators, sculptor Daniel Chester French and muralist Jules Guerin, were led aboard a decorated barge that

> … simulated a Roman galley, with a huge red sail displaying the Institute seal, and on its deck a pedestal [which] held burning green fire. To the slow cadence of ceremonial music by the Marine Band on the deck, the barge was drawn the length of the great lagoon, and there followed on either bank the robed guests with a [state chapter's] brilliant banner marking every 20 feet or so … the figures of President Harding and Chief Justice Taft appeared between two of the columns as they started down the steps to meet the approaching barge. The majesty of the setting and the beauty of the brilliant, radiant colors against the deep shadows of the evening can best be conveyed by likening them to … ancient Roman festivities.[42]

Participation of the President and other governmental officials in these impressive ceremonies did not indicate an end to the years of hostility between the AIA and the federal government.

The Tarsney Act, which had authorized the federal government's employing private architects for public buildings, had been repealed in 1912, an action that was principally due to Congress's being unwilling to pay private architects the same fees that were customary for private clients. The Chairman of the House of Representatives' Public Buildings Committee, which favored assigning all government buildings to the Treasury Department's Supervising Architect, claimed with appropriate political hyperbole that:

> The Supervising Architect's office has not for years constructed one of these large buildings in the great cities or in the city of Washington. It has always been farmed out to the American Institute of Architects or their mem-

This dramatic climax of the 1923 convention of the American Institute of Architects honored Henry Bacon, the architect of the Lincoln Memorial. Delegates, dressed in colorful robes and carrying banners prepared by the state chapters, witnessed the ceremony at the steps of the Memorial. (*Journal of the American Institute of Architects*, June 1923.)

bers.... I am here to say I believe ... that the United States Government ought to have men competent to do that work in their own public-building office without going outside to hire these people to do it.

But three years earlier the Public-Buildings Commission, a different agency, had reported to Congress:

It is found that the cost of preparing plans and placing work under contract in the Supervising Architect's office is approximately 4 percent. Three percent additional is required to supervise and complete the work.[43]

Data show that through the period between 1817 and 1921 post offices had made up around 30 percent of the federal government's expenditures for building construction under the jurisdiction of the Office of the Supervising Architect, and post offices that were combined with other federal functions had been an additional 42 percent. (The Supervising Architect's responsibilities did not include military construction and some other categories.) Obviously, post offices were a favorite

"pork-barrel" legislation by which congressmen could demonstrate their ability to "bring home the bacon" for their constituents. Whenever a congressman spoke of "the gimcracks and curlicues of architecture," architects responded with comments about being "handed the order to design a $50,000 building ... when the most elementary knowledge of architecture tells them that a $20,000 building would serve every purpose...."[44]

When private architects obtained federal commissions, completion of the work might be extremely difficult. It took about a decade for the site of the Lincoln Memorial to be determined. The Washington offices of three governmental departments (Commerce and Labor, State, and Justice) were the subjects of competitions, contracts for architectural services were signed, and the architects pursued work on the projects, although appropriations for actual construction had not yet been made. Two of the architects, Arnold Brunner and Donn Barber, died during the long period of delay, and when the government approached the Allied Architects of Washington to continue the work,

a difficult problem arose regarding the claims of the architects' heirs and the ethics of a new architectural firm assuming the project. In 1931 it was claimed that the only practical way for a private architect working on a government project to get timely decisions from the office of the Supervising Architect was to employ a Washington architect, Jules Henri de Sibour, as a consultant on the work. By 1932 the personnel of the Supervising Architect's Office numbered 784 employees, not including drafters paid from the appropriations made for some projects, and required an appropriation of almost two million dollars.[45]

The first Keyes-Elliot Act, proposed by the chairs of both the Senate and House Committees on Public Buildings and Grounds and passed in 1926, permitted employment of private architects only for "floor plans and designs of buildings developed sufficiently to serve as guides for the preparation of working drawings and specifications" by the office of the Supervising Architect. It was followed four years later with a second Keyes-Elliot Act that allowed privately contracting for complete architectural services. But it was reported in 1931 that only 40 of the 378 government buildings being erected outside Washington had been assigned to private architects. A bill introduced that year by Robert A. Green, congressman from Florida, allowed officials "to employ by contract, and at the established rates of compensation, outside professionals ... the employment of outside architects or engineers may be omitted in connection with public buildings of a total cost for building and site of not more than $50,000." In defense of his agency, a member of the Supervising Architect's staff published an article charging that Louis La Beaume, chairman of the AIA committee on such matters, had "been refused a Federal contract, saw fit to vent his injured spleen ... and dug up Rep. Green

from the Florida backwoods to champion his grudge."[46] Relations between the AIA and the federal government had not improved.

Efforts to gain increased professional participation in the beautification of the nation's capitol, a long-time issue of the AIA, meant less to architects west of the Appalachians than their own efforts to wrest design commissions for state buildings and schools from state architectural agencies and municipal building departments. Architects in many locales found themselves in a situation not unlike that in St. Louis, where the architectural services for the federal government were provided by the Supervising Architect of the Treasury Department, the local schools by the Commissioner of School Buildings, and city projects by the municipal Board of Public Services and its staff architects.

In the years preceding and following World War I many architects had questioned the usefulness of the AIA. Between the eastern half of the country and the Pacific coast there were fourteen states in which only fifty-seven architects were members of the AIA, twenty-three of these to be found in Texas and none in seven of the states. When the *American Architect* at the end of 1917 proposed what its editors called "A National Organization," it asserted that "the profession has lost prestige, not only in its relation to the Government, but, ... to the general public." (At that time the editor of the *American Architect* was James Knox Taylor, who eight years before had completed fifteen years of service as the Supervising Architect of the Treasury Department.) Some of the magazine's readers agreed: "As far as the Great West is concerned the American Institute has been a misnomer ... [and has] confined its energies to the confines of a few cities on the Atlantic seaboard, with an occasional recognition of Chicago as also being an American city."[47] But in

the face of the country's going to war, nothing came of the *American Architect*'s proposal.

Although the AIA assumed the role of representing the entire profession, its membership in 1920 was only 6.5 percent of the architects counted in that year's U.S. census, but census-takers counted anyone who claimed to be an architect and most states had not yet enacted licensing laws. In addition, 47 percent of AIA membership was in the states situated along the shores of the Atlantic from Massachusetts to the District of Columbia. A 1924 publication that listed eighty-seven "Leading St. Louis Architects" included only thirty-five who were members of the AIA. Thirty years after merging with the WAA, the AIA was still caught in the inherent contradiction of its role as the voice of the profession and an organizational structure that was inconsistent with that role.

Through the 1920s the office of the Treasury Department's Supervising Architect assumed responsibility for the design of all federal government construction of buildings, except for military installations and large projects for which the employment of architectural firms might be stipulated in the authorizing legislation. For lesser projects, such as small-town post offices, the Treasury during this period undertook the development of standardized designs for specific sizes and types of government buildings, although the variation of actual sites limited the savings that could be achieved in that way. There was little work for the Supervising Architect during World War I, and through the booming twenties the plentiful opportunities in private construction were so attractive that the office was forced to advertise vigorously for architects and engineers. Although during the Great Depression a fresh supply of workers found refuge in the Supervising Architect's office, its activities were eventually removed from

the Treasury Department and scattered among a variety of government agencies where the construction of buildings from private architects' drawings became the principal function.[48]

African-American Architects

In the 1970s when eight African-American architects had been selected as Fellows of the AIA, all but one of them had received some part of their professional education at Howard University in Washington, D.C. The Department of Architecture at Howard was created in 1921 with its chairman Albert Irvin Cassell, who after studying at Tuskegee Institute had graduated from Cornell University. Three years later the department broadened its program by employing two fresh graduates from major architecture schools: Howard Hamilton Mackey from the University of Pennsylvania and Hilyard R. Robinson from Columbia University. Robinson returned to Columbia for graduate work and traveled in Europe to study the modern housing schemes that were being built there. When he returned to Washington in 1932, Robinson's expertise in public housing led to the commission for Langston Terrace, a project executed through an association of Robinson with a white-operated Washington firm and Paul Williams, a Californian who was the only black architect whose firm met government qualifications. After architectural study at the Los Angeles Art School and the local Beaux-Arts *atelier*, Paul Williams had continued at the University of Southern California with courses in engineering and business. Williams had built his practice from small houses to the lavish mansions of the movie elite, although his work included many more usual commissions.

The first firm in Washington, D.C., to integrate racially employed one of Howard University's black graduates in 1947. He

was brought into all client conferences about projects on which he worked and "not one client objected." However, another Washington firm reported losing clients because of hiring black drafters. Some advances had been made in the architectural education available to young African-Americans, but their integration into the architectural profession was slower to come. Although Hilyard Robinson was refused when he previously applied for membership in the Washington Chapter of the AIA, the chapter in 1943 took the unusual step of inviting him to join. As more black architects became members, the Washington Chapter of the AIA was forced to choose its meeting places largely according to the policies of hotels and clubs in that Southern city regarding acceptance of the chapter's black members. In 1959 the Washington Chapter of the AIA boycotted the national organization's annual convention because of segregated facilities in the host city of New Orleans.[49]

Associated Architects

Associations of local architects provided a convenient method by which relatively small architectural firms might maintain their own individuality and yet prevent the larger buildings in their community always being designed by a few large local firms or firms from bigger cities. A combination of architectural firms, known as Associated Buffalo Architects, Inc., contracted in 1920 to provide professional services relating to the design and construction of eighteen buildings for the Buffalo Board of Education. There were a total of around fifty architects in the thirty-five architectural firms that were stockholders in the association, all of them continuing their independent practices. A central office coordinated all work of the association, and a board of directors as-

signed projects to one or more of the firms. The *Journal of the AIA* commented: "It will no doubt come as somewhat of a shock to some of our more conservative brethren to learn that fifty architects in the city of Buffalo consented to have seven of their number pass judgment upon their professional qualifications...."[50]

Thirty-nine architects in Denver formed the Allied Architects Association in 1924 to undertake the City and County Building there. In Los Angeles thirty-three architectural firms, including about seventy architects, were charter members of the Allied Architects' Association of Los Angeles. This organization undertook large projects of the city and county governments, while the member firms continued their independent practices on other projects. The Association approached its projects in a manner that was in many ways modeled on the *ateliers* of the *Beaux-Arts*, rather than the procedures that had been employed in Buffalo. An explanation of the requirements was prepared and circulated to members of the Association, and those who chose submitted sketches of their ideas. For the Los Angeles Hall of Justice, on which the Association began work at the end of 1922, twenty-seven of the thirty-three firms submitted sketches for the exterior of the building, the only part of the work that was entrusted to architects. The designs were discussed, a vote taken, and another meeting scheduled for discussion of further development of those schemes. At the second meeting twenty-four schemes were submitted and criticized, and eighteen reappeared with revisions at a third meeting. All of these procedures occupied a period of about seven weeks, which included the holidays of Christmas and New Year's.[51]

By 1926 associations by which firms could unite in pursuit of large projects had been adopted in about a dozen instances, sometimes for a single project and some-

Above and on next page: Early in the 20th century architectural journals began to feature articles on office management, such as "Economical Equipment and Management of the Drafting-Room," "Scientific Management of the Drafting-Room," and a series on "The Business Side of an Architect's Office." An article on the Detroit office of Albert Kahn drew special attention to the printed forms that were used to record office procedures. (*Architectural Forum*, November 1918.)

times on a more permanent basis. Vehement objections came from many quarters. According to one California architect the Allied Architects' Association of Los Angeles, "hunting in packs," had em-

ployed "a former city attorney as the head of its political department."[52] The AIA was strangely concerned that "the designer or designers of an architectural work should receive personal recognition and credit"

and that "personal responsibility for all professional services should be maintained as clearly as in individual practice." The Board of Directors of the AIA stated its opinion that

> … the formation of such associations for general practice is not in the best interests of the art of architecture and that therefore the definite establishment of an association bringing to-

gether a large percentage of the practitioners of a given section to practice architecture as such an association is to be discouraged."[53]

The Great Depression

With the collapse of the American economy in the 1930s more than 5,000 banks folded, 32,000 businesses failed, and the national income was cut in half. This

demanded major readjustments in those architectural firms that survived, and events gravely altered the lives of those who worked in the firms that did not survive. Through much of the 1920s unemployment in the United States had held steady at about 7 percent; but through most of the next decade unemployment hovered around 20 percent. Drastic declines in the production of capital goods, particularly in construction, were among the earliest results of the stock market crash and the bank failures that ushered in the Great Depression. *Dodge Reports*, which had become the standard data collector for the construction industry (in 1932 including only the thirty-seven states east of the Rocky Mountains) stated that the total value of construction contracts involving architects' services was less than a seventh of what it had been in 1928, and conditions in the states farther west were estimated as only slightly better.[54] The number of architectural firms in the United States dropped by 40 per cent, and those firms that remained active were forced to reduce drastically the number of their employees. By 1932 about one-quarter of all the nation's workers were unemployed, but six-sevenths of architects and architectural drafters were without jobs. Many state chapters of the AIA cancelled their state conventions or failed to have quorums in attendance. Most AIA chapters made concessions like those of the St. Louis chapter, which cancelled all unpaid dues, reduced dues for the year, and allowed quarterly payments of $2.50 toward the dues.[55]

A 1930 graduate recalled: "I had a hell of a time getting a job. After visiting sixty-one offices in Philadelphia, I got a job in the sixty-second office." Another young architect found intermittent work in the construction projects with which the New Deal stimulated the economy:

During this period of 1931-1934, different offices would get government

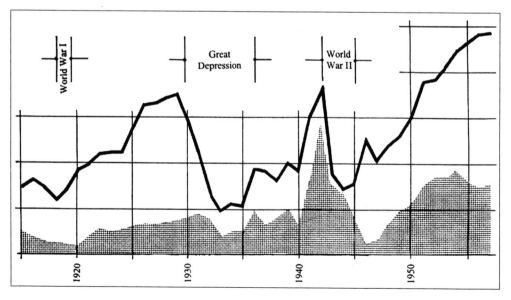

The value of new non-residential construction in the United States from 1915 to 1957 (converted to 1947-1949 prices). The shaded area represents that portion financed through public funds. These data do not include engineering or military projects, and consequently do not indicate the amount of wartime construction, which in 1942 and 1943 exceeded the total shown in the graph. (Data from U.S. Bureau of Census, *Historical Statistics of the United States. Colonial Times to 1957*, Series N 1-28.)

contracts in Philadelphia and I would work for them. Well, as soon as the job was put out for bids, everybody would be looking for a job.... I had a job about half of the time and spent the balance looking for work or doing Beaux-Arts problems at the T-Square Club.[56]

Because their overhead costs could be more quickly pared, small architectural offices often survived more easily than large firms.[57] At the same time almost 10,000 people entered practice, some having just finished their schooling and others deciding that, finding no employment as drafters, they might as well declare themselves architects.

Royal Barry Wills, who had started with an MIT degree in marine engineering and became the recognized master of the small Colonial residence, said: "I believe that in recent years fifty percent of those opening offices did so because they had been fired and could find no other employment." Setting up new practices was easier in the fifteen states that in 1932 had no registration laws, which included Connecticut, Massachusetts, and Texas. Many of the new firms economized by sharing a small office with others in the same predicament. When Stratton Hammon's employer in Louisville, Kentucky, closed his office, "only one desperate thing was open to me; I took the chance and opened my own office.... The three of us crowded into Redman's three-room office with no architectural commissions to distract us."[58]

If even the smallest firm were to survive the Great Depression, ingenuity was required. After two months of practice, Hammon won a local house-plan competition and decided to send "an illustrated article on houses" to *Ladies' Home Journal.* Surprised and pleased by the payment he received, Hammon weathered the Great Depression by augmenting a slender ar-

chitectural income by sending similar articles to *Good Housekeeping, House Beautiful, McCall's,* and other household magazines of the period. In Oklahoma City the firm of Sorey Hill & Sorey, a partnership formed in the inauspicious year 1931, survived by one partner taking a supervisory position with the Federal Housing Administration and another acting as a designer for the National Park Service. To pay the firm's office rent in a downtown office building the partners prepared layouts for the spaces that other tenants rented. Others followed their profession by working in their homes. (*Pencil Points,* the drafters' journal, published drawings in 1933 for a dining table that seated six and converted into a drafting table.) In Kansas City, where the number of architectural firms dropped by about a fourth between 1930 and 1933, Nelle Peters could find no new clients that wanted to build apartment buildings or hotels, and she worked for a while as a seamstress.[59]

In the face of adversity architects and their drafters tended to delay applying for government relief until their resources had been absolutely exhausted. Consequently, a significant amount of time passed before the drop in employment in the architectural segment of the construction industry was reflected in relief rolls. The Boston Society of Architects, in cooperation with an organization of engineers, was the first group to organize help for their unemployed colleagues. A small shop was opened by the Society where they sold the handiwork of architectural workers, from Christmas cards to birdhouses. Boston's efforts were followed in late 1930 by the Architects' Emergency Committee for the Region of New York, which included all communities within fifty miles of the city. A survey showed that at the end of 1932 relief efforts were underway by the Philadelphia and Cleveland Chapters of the AIA, the Michigan Society of Architects, and the

Chicago Architects' Relief Fund, and in several other areas emergency measures were getting underway. Most architectural organizations had begun operating employment bureaus. Funds were raised by raffles, auctions, tours of homes, and more unusual methods, which ranged from a "Latin Quarter Fête" in Chicago's Drake Hotel to a performance by Isadora Duncan's Dancers on the grounds of a Long Island estate.[60]

Florida reported relatively few problems because so many architects and drafters had returned to the North when the Florida building boom collapsed in 1925; about twenty-five firms represented in the Northern California AIA chapter arranged to shift employees among their drafting rooms in order to reduce the need for layoffs. The architectural offices in Kansas were so scattered that organized aid was impractical, and Montana glumly reported that: "There is not a single [project] in any office in the State and very little prospect of any." The Virginia Chapter of the AIA, perhaps not yet understanding the urgent needs of their former employees, reported that the chapter was concentrating on "efforts toward getting more work for the architects by endorsing the Institute's programs to have the Government employ private architects on Federal buildings" and by opposing "the activities of the Architects' Office of the State Board of Education."

The "job wanted" advertisements that were published free of charge in *Pencil Points* provide a poignant measure of the desperation among unemployed drafters. Most advertisements were at first persuasive but ended on a more plaintive note:

> Position Wanted: I am the man you want. You can now have a $60 a week architectural draftsman for only $15 per week. Grant me an interview and make me prove it. I am 27 years old. Have worked for important architects

in New York City on office buildings, industrial buildings, residences and alterations. I have always gained praise and promotion on my drafting and lettering ability. I am thoroughly familiar with building department work and the various procedures. If you have a position in your organization for me I will be grateful. Sanford S. Glyn, 2871 Ripple Street, Brooklyn, N.Y.

By the end of 1932 the New York Emergency Committee had received 2,551 applications for assistance from architects and architectural workers; employment was found for 1,068 of the applicants. Private jobs were arranged for about a third of that number, and the remainder were paid emergency wages by either the Emergency Work Bureau or the Emergency Relief Committee of New York architects. In its made-work projects the Philadelphia chapter of the AIA paid $4 a day and hired married men with children for five days, single men for one day per week, but after a year the chapter's funds were so low that the wages had to be reduced by one-fourth.[61]

By the middle of 1932 about half of the building activity in the United States was undertaken by public agencies ranging from municipalities to the federal government, and the following year's further drop in construction was almost entirely due to an economy-driven reduction in public-financed building. The Public Works Administration in 1933 began increasing the construction of government projects such as post offices, court buildings, and dams. In an effort to increase employment the National Recovery Act (NRA) in 1933 asked that industries and their workers collaborate in developing "codes," that would establish maximum hours per week and the minimum hourly wage to be paid workers, which supposedly would eliminate the use of low wages as a weapon in business competition. The

NRA code for architectural firms was pre-pared by a committee of the AIA, and it proposed a maximum workweek of forty hours for drafters and a minimum wage of fifty cents per hour for "an employee who has had at least two years' experi-ence." This was, to the horror of the very few union members in drafting rooms, only twenty dollars a week, just five dollars above the pay provided by emergency re-lief programs and the same as paid "a hod carrier employed on any public project."[62] Many drafters were indignant at the pro-posed code, but neither of the unions ac-tive at the time, the Architectural Guild of America or the Federation of Architects, Engineers, Chemists, and Technicians (FAECT), had been successful in attract-ing many members among architectural personnel. (In 1935 the NRA was declared unconstitutional.)

Prior hints at unionization among drafters had been detected in 1919, when a three-day meeting of the AIA Board of Di-rectors produced a predictable announce-ment that it "believes that, both for the ar-chitect and his assistant, a more adequate financial reward will come with the better quality of the service rendered."[63] The movement toward unionization was be-lieved to have originated in the west, mov-ing eastward "from San Francisco, from Chicago, from Indianapolis and other cities."

> A new kind of organization was an-nounced, having other purposes than those of the societies to which we have been referring. In general, these purposes were those of organized labor. In short, the draughtsmen had formed unions![64]

But architects and drafters, like most white-collar workers, were reluctant to take part in unions, which they considered blue-collar organizations. Most drafters hoped that their jobs would be a step to-ward their future as a partner in an archi-tectural firm, and workers who dreamed of soon advancing to management had little interest in unions.

After 1935 and the introduction of the Work Progress Administration (WPA), government-funded construction in-creased, largely through federal sponsor-ship of projects that would require a max-imum of labor be expended, quarrying stone, felling trees, or forming and mixing concrete. Under the aegis of the WPA over 110,000 public buildings were constructed or remodeled and over two million work-ers employed. By the spring of 1935 the data showed only 114 architects on relief in all New York State, but it is likely that many had by then despaired and shifted to other employment, no longer even bothering to list themselves as architects.

World War II

As the United States' full participa-tion in World War II began after Pearl Harbor, severe restrictions were placed on all construction that was not directly re-lated to the war effort. The "Stop Building Order" issued in April 1942 forbade resi-dential construction unrelated to the war and costing more than $500 and other construction costing more than $5,000. The heads of architectural firms scurried to obtain commissions for the govern-ment's military and industrial projects re-lated to the war. Although it was often said that opportunities for government com-missions might best be pursued near home in the district offices of government agen-cies, so many architects headed to Wash-ington that the *Architectural Record* pub-lished a list of the government agencies they might wish to visit and provided a map showing their locations in central Washington.

The search for war work was not easy. Large firms with experience on large pro-jects were sought by both the Army and

Navy, but in many cases these qualifications were satisfied by arranging an amalgamation of several small firms of architects and engineers, associations similar to those of the 1920s. In Chicago the combination of architectural and engineering activities had long been available, particularly among the firms with German backgrounds. In Detroit early in the 20th century Albert Kahn's brother Julius, a capable and inventive engineer, became a member of that firm, and Detroit architect Fred L. Smith had joined two engineers to form the precursor of Smith Hinchman & Grylls.

Typical of the architect-engineering (A&E) firms brought about by World War II were three architectural and two engineering firms in Oklahoma City that merged into "Associated Architects and Engineers" and soon began work on several naval training stations. A similar combination in Memphis produced "Allied Architects and Engineers," which also received naval commissions, and a Chicago combination secured government contracts with the disarming title, "Five Firms, Architects and Engineers." In North Carolina the Raleigh firm of William Henley Dietrich was part of an A&E firm for shipyard workers' housing, part of another firm for an Army quartermaster depot, and part of a still larger group for a Marine air base that at one point required a staff of 175 people. In Asheville firms united in Six Associates, and in Charlotte an engineering firm, J. Norman Pease & Associates, added an architectural segment to its staff. The availability of consultants of all sorts was an essential part of such combinations, and one well-known engineer was said to have connections of various kinds with some thirty-two A&E firms.[65]

In postwar architectural practice the increasing frequency of large-scale projects and urban settings encouraged many architects to acquire or hire skills in city-planning, balancing the detailed expertise implied by the inclusion of engineering with the broadening connotation of planning. On the typical firm's letterhead during the 1950s the partners' names were followed by the firm's identification as "Architects, Engineers and Planners." In a few decades the names of partners would be reduced to their initial letters, creating an impersonal corporate symbol that could continue after the original partners were long dead.

Registration and Reciprocity

By 1918 fifteen states, less than a third, had enacted laws regulating the practice of architecture. The AIA had prepared a model licensing law with which state chapters might approach their legislatures, although the national organization itself had never gone on record as either favoring or opposing such legislation.[66] Under architectural registration laws (1) the use of the title "architect" could be restricted to those who qualified according to the procedures and standards specified in the law or (2) the practice of architecture could be limited to those who qualified. The first of these methods was relatively simple, and violations could be clearly identified. But the most common complaint about the administration of registration laws was the fact that such legislation only restricted the use of the title "architect," instead of limiting the professional architectural services that were so difficult to define. As *Architectural Record* pointed out in 1918 the New York law that had been in effect for three years, "...aimed at large calibre results ... [but] the actual accomplishment has been chiefly in the form of a hair-splitting application of the title 'Architect'."[67] Caught up in an argument with the California registration board in 1954, John Lloyd Wright pointed out that the state's law "permits one with no more education

than is necessary to write the sentence 'I am not an architect' to practice architecture and enjoy the benefits from doing so to the same extent as if he were duly certified."[68]

The second form of limitation, prohibiting the "practice" of architecture, was usually subject to so many exceptions that it became almost meaningless. No legislature could bring itself to deny individuals the right to plan their own residences or to exclude all habitable structures from the work of engineers and builders. Frequently legislation stipulated a specific cost below which architectural services were not required, but it was difficult to control the range of exceptions to such legislation. By 1918 Illinois had altered its licensing law for engineers with phrasing that contradicted and virtually annulled key portions of the architectural licensing law. Legislation in New York at one point permitted engineers to assume complete responsibility for buildings so long as the term "architect" was not employed.[69]

Since licensing under U.S. law is a function of state governments, it provides a means by which the architects of one state might deter the territorial intrusion of architects from another state. Architects in some western states first began campaigning for registration laws after architects from older adjacent areas began to "poach," providing architectural services for the town's large buildings and leaving only the lesser projects for local architects. One Southern architect complained of architectural carpetbaggers, touring southern cities with their luggage crammed with drawings and photographs of their offices' work. Among the first fifteen states to enact licensing legislation, there were five western states (Colorado, Idaho, Montana, North Dakota, and Utah) and four southern states (Florida, Louisiana, and the Carolinas) where territorial protection may have been a motive. There were also

three states (Michigan, New Jersey, and Wisconsin) near powerful centers, but one must wonder about the motives that brought about licensing in the other three (Illinois, California, and New York).

The extent to which architects' competition with builders, engineers, and out-of-state architects may have encouraged commencing the long and arduous political battles required to obtain architectural registration laws can only be guessed. In 1956 eight states (including Kentucky, North Dakota, New Hampshire, and Wyoming) had licensed two or three times as many non-resident architects as resident. Fourteen states (including Illinois, Pennsylvania, and New York) had out-of-state registrations at a level between a quarter and a half of their in-state registrations.[70] Outside the pattern of all the other states was California, where there was only one non-resident license for each twenty resident licenses.

The laws enacted by most states included "grandfather clauses," admitting all who had acted as architects prior to passage of the law. Though legally and politically advantageous, such provisions were opposed by many because "it takes a generation to weed the rascals out." When the Illinois law was set in operation, the Board of Examiners of Architects received almost eight hundred applications and licensed about 90 percent of them. New York's law permitted the Board of Examiners to reject such applicants, and when the law first came into effect there were about 2,000 candidates of which some 500 were refused registration on the basis of the Board's interviews. Licenses were usually denied because the applicants had not actually been practicing as architects, but, according to one member of the New York board, many of those accepted "made us blush over the sorry credit of the profession."[71]

State chapters of the AIA were usually

closely connected to the boards that administered registration laws in their states. In most states the code of ethics adopted by the AIA—often a subject of quixotic alterations and heated debate within the organization—was employed by registration boards as the standard of professional behavior among licensed architects. A law proposed in Pennsylvania in 1917 even specified that the four architects on the state Board of Examiners should be architects with ten years of experience, "all members of the American Institute of Architects."[72]

In most states those applying for their first licenses were required to pass some form of examination, but during the early years of registration a diploma from an academic program would in many cases exempt an applicant from any examination. However, architects who had been admitted to practice without completing an examination could be rejected when they applied to another state for reciprocal licensing. As the *Architectural Record* expressed it: "Registration by exemption stops at the State line."[73] Until 1963 licensing examinations were written and scored by the members of each state's registration board, a practice that could result in extreme variation from year to year and state to state. In most states rumors periodically surfaced that extremely difficult questions and low marks on the tests resulted from the state board's desire to limit the number of architects in the state, thereby reducing competition, but there was always a possibility that such rumors were more signs of sour grapes than of official collusion.

In some cases drafters working in a state that passed few candidates found it expedient to take the licensing examination in an adjacent state where policies seemed more liberal and later apply for reciprocal licensing in the state where they resided. At one time when New Jersey

seemed unduly reluctant to grant reciprocal licenses to architects from the bordering states of Pennsylvania and New York, applicants from those states took the New Jersey test and then applied for reciprocal licensing in their home states. From the District of Columbia some went to Virginia to take the examination. There was controversy in 1951 when all twenty applicants in Georgia failed the state's licensing examination. The *Atlanta Journal* reported that "the examination included a key question calling for a design for a building and noted that contemporary or modern design would not be accepted," but it was generally conceded that the board had acted within its legal authority.[74]

The Board of Architect Examiners in Colorado was faced in 1952 with nine legal challenges. A suit brought by an engineer charged that the 1909 law under which the Board operated did not stipulate the qualifications required of applicants. Another suit resulted from the Colorado Board denying a reciprocal license to an applicant who had been licensed by examination in Illinois and accepted for reciprocity by three states. This suit charged that the Colorado Board "illegally, arbitrarily and unlawfully ... formulated a secret policy" of limiting the number who would be licensed. Seven other suits were brought, and in the end the court found Colorado's architectural licensing law to be unconstitutional.[75]

The National Council of Architectural Registration Boards (NCARB) had been established in 1920 to coordinate the work of state boards. Obviously this mission was closely tied to matters of reciprocal licensing and consequently to the standardization of criteria applied by the different states. Until the 1960s the NCARB concerned itself principally with certifying and maintaining the documents with which an architect licensed in one state could be reviewed for licensing in another

state, but the increasing distance within which an architectural firm might practice and the mobility of young architects increased the need for standardization.

Through the last half of the 20th century the NCARB, with the legal authority provided by the state boards that were its members, moved to the application of a standard examination for all states, highly systematized grading of even the building design sections of the examinations, and computerized administration of the examinations, contracting for most of the grading process to be done by a testing corporation. The simplification and unification brought about by the NCARB has resulted essentially in the installation of a national system of licensing, although the mandates of individual states provide some variation and much confusion. In 1995 only about 40 percent of the licensing boards required NCARB certification as the only acceptable method of obtaining reciprocal licenses. The AIA and NCARB have assumed competitive roles, debating which of them truly represents the future needs of the architectural profession, but since AIA membership is only about half of the architects in the United States and NCARB has its roots in the political appointment of state licensing boards, the question of representing the profession is certainly controversial and perhaps moot.[76]

New Influences on Practice

Changes in American society required the development of new specializations among architects, although schools and churches remained popular fields in which architects might concentrate their practices. In many cities the selection of a "Board of Education Architect" limited the opportunities for other architects, and the establishment around 1920 of "architectural bureaus" by religious organiza-

tions, from Methodists to Mormons, was indicative of the period's tendency to centralize such activities.[77]

After World War I the industrial construction that had been vital to the brief war effort continued in peacetime, and the development of 20th-century factory architecture in America was led by the automobile industry. The Ford plant at Highland Park, Michigan, where assembly line methods were tested before World War I, proved inadequate for production of the Model T in increasingly large numbers. As a part of the government's war effort in 1917, it was replaced by the River Rouge plant, which introduced a style of factory construction that was based on the purchase of large acreages of farmland and the construction of single-story skylighted factories that simplified expansion and changes in production layouts. The use of these large sites for factories encouraged the suburban spread of middle- and low-income housing, which in turn generated the construction of schools, churches, and other community functions in pastoral settings.

Most architects who had specialized in legitimate theaters and vaudeville houses quickly learned to apply that experience to the design of ornate "movie palaces," once the movies left store-front "nickelodeons." The largest motion-picture theaters were owned by the same firms that produced and distributed the films shown in them. Most of these companies had been previously engaged in booking vaudeville acts in the theaters that made up their "circuits." Rapp & Rapp, two brothers in Chicago, created movie-houses for the Balaban & Katz circuit; G. Albert Lansburgh designed for the Orpheum chain of which his brother was at first legal counsel and later president; Thomas Lamb designed for the Loew chain of theaters; and Marcus Priteca's classical style was sometimes called "Pantages Greek" after

the company that employed him. John Eberson introduced one of the most popular styles, a "magnificent amphitheater under a glorious moonlit sky" with wisps of clouds and twinkling stars overhead and "picturesque masses of buildings" around the walls, the techniques of stagecraft being extended to surround the audience.[78] But in 1948 the relationship of producers, distributors, and theaters was judged by the courts to be in violation of antitrust laws. Movie-house architects continued at work, but they no longer had such strong ties to the trusts that had produced and distributed early motion pictures.

The most powerful influences on the architectural profession were exerted even more directly by governmental actions. A change in laws could completely eliminate an entire field of architecture, bring one kind of building to the forefront of professional activity, or cause architectural firms to acquire or develop special knowledge and skills. Such changes in architecture and architectural practice were made by legislation, by the allocation of government funds at the federal, state, or local level, or by the reduction or elimination of certain taxes.

For instance, the Eighteenth Amendment to the U.S. Constitution abolished an entire field of industrial architecture, brewery design. A large number of architects (who were also engineers, as their advertisements invariably declared) specialized in breweries for German-style lager beer, which had been only a quarter of U.S. production in 1860 but later became more popular than English ales. There were at one time about 2,400 breweries in the United States, over half of them built from designs of Chicago's expert architects. As early as the 1870s hard times and the popularity of local-option liquor laws reduced the number of breweries, causing Michigan's 202 breweries to quickly drop to 68. Nevertheless, near the end of the

century *The Western Brewer* described August Mauritzen's practice as "eighteen draftsmen at work, and breweries in various stages of construction in Boston, Mexico, British Columbia and in more than half the States of the Union."[79]

The Eighteenth Amendment, in effect for thirteen years, prohibited the manufacture and sale of alcoholic beverages, and an entire building type was thereby abolished in 1920 and many of the architectural profession's most specialized practitioners were eliminated. Some breweries were converted to manufacturing soft drinks, but the complexity of the equipment inside breweries made conversion difficult. Conversely, the Detroit firm of Smith Hinchman & Grylls, which in the 1920s had a staff of 270 principally engaged in engineering projects, dropped in the early years of the Great Depression to an office boy, a secretary, and the four officers of the corporation. However, after the repeal of Prohibition the firm was quickly reactivated with the construction of distilleries, and by the start of World War II the firm had a staff of 700.[80]

The federal government found that nationwide improvements could be encouraged by its sharing their costs with states and cities. When there had been vast areas of federally-owned land, the states were granted land for purposes that Congress thought worthy. In that way the federal government had assisted states in establishing institutions of higher education through the Morrill Act, which contributed federal land that the states could sell. Cash grants served the same purpose in the 20th century. In 1920 there were eleven programs through which the federal government granted about $34 million to state and local governments; by 1964 some fifty-one programs granted almost $10 billion.[81] After World War II the condition of American cities and the low-

income housing in them brought grants-in-aid for "urban renewal" and the construction of publicly financed housing projects. The influence of federal grants-in-aid was so great that in 1979 the state and local governments' expenditures on urban renewal and housing projects were nine times as great as they had been a decade before. When it became apparent that the nation's hospitals were sadly inadequate, passage of the Hospital Survey and Construction Act of 1946 (more commonly known as the Hill-Burton program) made it possible for communities to build hospitals and receive grants-in-aid from the federal government for that purpose. (The extent of support varied according the need of the community and its own resources.) By 1970 Hill-Burton projects had totaled almost $13 billion of which federal grants had provided about 29 percent.[82]

Construction was also affected by changes in taxation that encouraged owners to build by significantly altering the financial viability of certain types of structures. Projects that converted, restored, and preserved buildings of historic significance were given financial advantages, and housing for elderly or handicapped tenants was assisted through several programs. Cities, anxious to attract industries, frequently offered exemptions from local taxes for extended periods. By exempting the interest on municipal bonds from income taxes it became easier for cities to increase their facilities and school districts to pursue their programs of improvement. This was particularly useful when the U.S. birth rate, which had declined between World War I and the depths of the Great Depression, began a sharp climb immediately after World War II. The birth rate continued at a high level until its decline began in 1968, ending a demographic phenomenon called the "Baby Boom," that strongly influenced American customs and na-

tional policies for a half-century. Suddenly many more elementary schools were needed in the suburban communities where so many children now lived. Next came new junior high schools, and high schools soon afterward. Universities had already experienced rapid growth caused by the G.I. Bill that supported the education of World War II veterans, but a new form of educational institution, the community college, appeared.

Changes in the calculation of the depreciation of buildings encouraged construction by speculators and businesses, small or large. For tax purposes buildings had previously been depreciated by a "straight-line" method, the same amount being deducted from profits each year of a building's predicted period of useful life. Through a comprehensive revision of federal tax laws in 1954—the first since 1876—this method was abandoned for methods that increased the allowable depreciation during the early years, making it possible for the owner to deduct two-thirds of a new building's value during the first half of its period of depreciation and in many cases doubling the amount that could be deducted during the first year.[83] Changes in the laws during the 1980s drastically shortened the estimated life of buildings, making it possible for an owner to make still greater deductions over a shorter period. In many cases the construction of factories, apartment buildings, and corporate office buildings became financially advantageous.

After World War II the conditions of international politics required additional technical knowledge of many architectural firms. During the years of "Cold War" between the USSR and the United States, involving a number of mutual defense pacts between nations and a confrontational policy that was called "brinksmanship," the American government judged its most economical tactic to be investment in

nuclear weapons. After tests of hydrogen bombs in 1952 the American public was terrified by the perceived danger of nuclear attack, and many families built bomb shelters in their basements. The federal government funded instruction of architects and engineers in the current theories about construction that might offer some degree of protection from atomic weapons.

An additional impact of international affairs came in the 1970s, when the Yom Kippur War in Israel caused the Organization of Petroleum Exporting Countries (OPEC), a bargaining agent for the oil-producing countries, to react dramatically. In political terms OPEC announced that it would no longer sell oil to countries supporting Israel; and in economic terms OPEC set the price of their oil at a level five times as high. These actions were major contributors to the staggering inflation of the period, and for the architectural profession they meant that technical requirements and the operating costs of buildings became design factors of unprecedented importance. The mechanical systems of buildings, the heating, lighting, and other systems that regulated the environment within a building, became an increasingly large part of the cost of constructing buildings and operating them.

From foreign affairs to city property taxes, governmental actions and decisions were increasingly decisive factors in the initiation of projects coming to architectural firms. Large firms with narrow specialties appeared, flourished, and sometimes faded according to the funding available, directly or indirectly, as a result of legislation. One firm in the 1970s noticed a court decision regarding conditions in prisons and quickly set about becoming prison specialists; school architects converted to shopping center specialists; and all wise firms kept their eyes on public interests and the government's responses to them.

Deprofessionalization

In the last half of the 19th century the status of professions had recovered from the Jacksonian era when they had lost public respect, and the change was accomplished largely through the activities of professional organizations. The advantages of unified action had been clearly demonstrated by large manufacturing trusts that had been able to regularize their production, dictate quality, and establish prices to the satisfaction of all but populists and political radicals. The controls and standards that could be imposed through professional self-regulation depended on the existence of a unified group that dominated the profession. The AIA, like other professional societies, exerted its leadership principally through maintaining fee schedules and the ethical standards it advocated.

At the start of the 20th century members of the AIA were only about a twentieth of the architects counted in that year's census. Among its members not all charged a fee of 5 percent (a standard that in 1908 was raised to 6 percent) and some did not always obey the organization's ethical preferences. The 1909 *Canon of Ethics* of the AIA, the organization's first fully-developed code, is typical and later versions varied little from it. Of the twelve canons spelling out the things that were to be considered "unprofessional for an architect," four stipulated conduct with regard to professional competitions, a matter of decreasing importance. Three of the canons dealt with the architect's relationship to his clients, declaring it "unprofessional":

1. To engage … in any of the building trades.
2. To guarantee an estimate or contract….
3. To accept any commission … [from an] interested party other than the owner.

Canon 1, coming from the early 19th-cen-

tury campaign to distinguish between builders and architects, has now been largely nullified by the development of "design-build" firms and the addition of "construction management" services in architectural firms. Canon 3 acknowledged and prohibited the acceptance of kickbacks by architects, which had been a problem in the 19th century.[84]

The remaining five canons dealt with the behavior of architects in the rivalry among members of the profession. These declared it "unprofessional:"

> 4. To pay for advertising.
> 9. To injure falsely or maliciously ... the professional reputation, prospects or business of a fellow architect.
> 10. To undertake a commission while the just claim of another architect who has previously undertaken it, remains unsatisfied....
> 11. To attempt to supplant a fellow architect after definite steps have been taken toward his employment.
> 12. To compete knowingly ... for employment on the basis of professional charges.[85]

A later phrasing of the Canon 12 said: "An architect shall not enter into competitive bidding against another architect on the basis of compensation." In 1970 a new form, much more cautious and somewhat vague, was adopted: "After being selected for his professional qualifications, an architect shall reach an agreement with his client or employer as to the nature and extent of the services he will provide and his compensation." Nevertheless, four of these five restraints on members of the AIA (the exception, Canon 9, relates to injury of "professional reputation") would be involved in legal actions dealing with the architectural profession.

The Department of Justice in 1972 charged that in opposing competitive bidding on fees the AIA had acted in violation of the Sherman Antitrust Law. When Congress passed the antitrust law in 1890 there had been few dissenting votes in either house of Congress, because the act was assumed to be largely symbolic in nature. For its first decade antitrust litigation was principally conducted against labor unions, and seldom against manufacturers, bankers, or railroads, since courts considered that monopolistic activities were simply the way business was done and did not involve "interstate commerce." The law itself was vague, leaving most details of its application to be determined by court decisions and additional legislation that might define the scope of the law and stipulate exemptions. (The best known of these peculiarities is the immunity from anti-trust law granted by courts to professional baseball, saying "personal effort, not related to production, is not a subject of commerce."[86])

The Antitrust Division of the Department of Justice accused the AIA of prohibiting its members from "submitting price quotations for architectural services," a policy that banned competitive bidding among architectural firms. The government's charges were part of a broad campaign by Nixon's Department of Justice, and early in 1973 an Assistant Attorney General publicly stated that the Antitrust Division intended to devote much of its resources to attacking "restraint of trade" in the professions. The AIA was not alone in attracting attention. Through several years the Department of Justice made charges against other professional groups: bar associations, engineering societies, and organizations of accountants for the fee schedules they distributed; medical and dental associations for their influence on licensing and admission to professional schools; and bar associations and pharmacists' organizations for bans on advertising. Because the activities of the professional organizations were so similar, each charge made by the Department of Justice served as a warning

to other groups. The message was unmistakable: the "learned professions" were now considered businesses, and providing "professional services" was trade.[87]

Legal counsel advised the AIA that battling the Department of Justice would be costly and fruitless, and a decision was made to negotiate a consent decree by which the AIA would agree to no longer have any rules or standards stating that the "submission of price quotations for architectural services ... is unethical, unprofessional, or contrary to any policy" of the AIA.[88] Under the consent decree the AIA agreed to eliminate all statements against competitive bidding on fees and to inform its members of that change in policy.

Just four months after the consent decree was filed for *U.S. v. The American Institute of Architects*, Congress enacted a bill that established for federal government projects a system for selecting architects that had long been used by governmental groups and some businesses. A qualitative review of applicants would produce three ranked selections, with whom contract negotiations would be conducted in the order in which they were ranked. Although it might seem to contradict the antitrust proceedings, the Congressional committee spoke of this system as a "highly acceptable form of cost competition."[89]

The situation was exacerbated in 1977 when the AIA was sued by a member for the disciplinary action imposed on him. Expulsion or suspension of members was the only authority that the AIA had, and that was challenged in the case, *Aram H. Mardirosian v. American Institute of Architects & Seymour Auerbach*. The subject of the case was the clumsy handling of arrangements for the remodeling and restoration of Union Station in Washington, D.C. and construction of a Visitor Center within the station. Auerbach, the initial architect on the project, had complained to the Washington Chapter of the

AIA that Mardirosian, his successor on parts of the project, had sought the job when Auerbach had already been selected as architect. On the basis of his firm's violation of the AIA's Canons of Ethics, Mardirosian was suspended from AIA membership for one year. But the U.S. District Court's decision found that the requirement of the Canons of Ethics that prohibited "supplanting" another architect was an unlawful restraint of trade and the AIA's suspension of one of its members was unlawful. In 1990, responding to the AIA's Chicago chapter circulating information that "was an agreement among members not to compete on the basis of price" and not to discount fees or provide free services, the Department of Justice again obtained a consent decree requiring that the AIA monitor its chapters and conduct an "antitrust educational program" for its members.[90]

By the end of the 20th century the architectural profession—and all the other professions—were engaged in redefining the nature of professionalism in America. (Today changes in the practice of medicine are the most obvious evidence of deprofessionalization.) The 19th-century model of professionalism was clearly unacceptable, and the mystique of specialized and esoteric professional knowledge had little meaning for the 21st century. It has been suggested that architecture and some other professions will become stratified, with different firms concentrating on separate aspects of the profession as it used to be, and others have predicted large and comprehensive organizations that would be prepared, through a phalanx of consultants and a variety of personnel, to undertake any professional problems imaginable.

The Present

In 1903 J. S. Gibson. writing in the journal *Architecture*, advised young archi-

tects regarding some of the choices to be made upon entering practice:

> Some rely on the artistic blindness of the general public and run lucrative drawing manufactories on business-like lines. These are the shrewd and practical ones. Some have relatives who are something big in the city of finance or society, and these push their architectural appendages in the same manner as they do shares.... Some drift into that refuge of mediocrity, an official appointment in a Government office, and in the Office of Works, or such-like departments, do what they can to spread the commonplace over the land.... Some enter into partnerships with clever men of business, who "manage" the clients while they manage the office. These are the timid ones, likeable fellows who think the chief end of life is to get a cornice perfectly proportioned.... Some attach themselves to the land, and, backed by financiers, erect enormous piles of vulgarly commonplace type, whose chief quality is bulk, ... these are the wily ones.... Some determine to live for art's sake, and usually die for it instead; these are the foolish and artistic ones. These are but a few of the thousand and one ways of practicing our profession, and each of you must one day settle this great question for yourself.[91]

But at the start of the 20th century there were already so many salesmen-architects, engineer-architects, artist-architects, businessman-architects, and other mutations and deviations of professional activities that few laymen still believed the Beaux-Arts image of the architect who "should be very temperamental, work in a studio not an office, and all the prerogatives of the Greenwich Village Artist should be his."[92]

The public on the whole thought well of architects. In a 1947 study of occupational prestige in the eyes of the public (90 categories from "Supreme Court justice" to "garbage collector") architects were ranked eighteenth at the same level as lawyers and dentists. A 1963 repeat of the same survey elevated architects to the fourteenth level, alongside dentists and county judges but below lawyers, however in reality this advancement of architects may have been due to a decline in the prestige of county judges, clergymen, and the mayors of large cities.[93] The average licensed architect at the middle of the century was a "forty-three year-old male with 2.2 children and 5.1 years of educational work beyond high school," son of a white collar worker, member of the Republican party and a conservative Protestant church, according to a sociological study. He was convinced that architecture should be ranked second only to medicine but also believed that the public ranked it below lawyers and business executives.[94] (But the study was limited to architects licensed in California, and the national average architect may have been somewhat different.)

The most extensive changes in the everyday routines of architectural practice and production came with the introduction of computers into the drafting room. In 1955 Ellerbe Architects, a Minneapolis firm specializing in hospital projects, pioneered by buying computer time from the University of Minnesota. When the firm bought its own hardware, the principal uses were engineering calculations, management of its projects in forty different states, and programming space requirements, the last taking advantage of the firm's immense store of information regarding hospital planning.

Almost thirty years later a former "systems director" from Ellerbe acclaimed the "potential of increased production" to be also found in the use of computer graphics, although he expressed his fears that computer programs were being used for "providing our services on more pro-

jects rather than using Computer Graphics and other computerized methods to provide better products through additional analysis."[95] Software for computer-aided design improved and soon the computer became a standard tool of architectural practice. The roles of intern architect and drafter are being altered as a result of computer applications. The organizational changes that will result from the adoption of the computer may depend principally on the size of architectural offices and the variety of their projects. Occasionally articles are published detailing leading high-style designers' dependence on pencil sketches and predicting a future generation of designers without pencils. In the meantime the management and informational advantages offered by computer systems have been especially useful to the large international firms that have developed.

The "big time" in architecture was characterized somewhat in 1967 when the business magazine *Fortune* pointed out that the Becket firm in Los Angeles, "puts $100 million worth of buildings a year into the U.S. skyline."[96] At that time Welton Becket & Associates, which had begun as a partnership in 1930, had a "staff of 355, including more than seventy-five registered architects and twenty registered engineers."[97] Becket in 1949 had bought out his partner's heirs, becoming the sole owner of the firm in order to pass it on to a son and a nephew, an intention typical of architects in the late 19th century. Seven years after Becket's death in 1969 his firm was sold to Ellerbe Associates, a Minnesota firm that then had almost 350 architects on its staff. Near the end of the century Ellerbe Becket Inc. would rank as the sixth largest architectural firm in North America and eleventh in the world.[98]

In many ways the court decisions of the 1970s have proved to be prophetic. The practice of architecture had been declared a business, and the largest firms began to engage in the mergers, buyouts, and other maneuvers that were typical of corporations of the period, although in 1996 it was reported that even in good times about 70 percent of the mergers arranged between architectural firms failed.[99] The firm of Caudill Rowlett Scott (CRS) started in Texas after World War II as a firm of school architects that were to trail the generation of Baby Boomers from elementary school to graduate school. In 1983 CRS bought an engineering firm; and in little more than a decade the firm went public, selling its stock to investors. After its engineering components were sold off; the four offices of CRS and their 225 employees were purchased by Hellmuth Obata Kassabaum (HOK). With the additional purchase of a British firm, HOK was ranked for a time as the largest architectural firm in the world, having around 2,000 employees in some twenty-five offices around the world.[100] In a 1998 international ranking of architectural firms according to the number of qualified architects on their staffs, forty-five of the top hundred were American firms, followed by seventeen firms in Japan.[101] American architectural firms having more than twenty employees are only about 5 percent of the total number of firms in the country. Still, this segment of the profession probably collects about half the total amount paid for architectural services and employs almost half of American architects.

But there have always been some architects who preferred to practice independently with a small staff, although few intentionally maintained professional activity as simple as that described by a District of Columbia architect in 1987:

Never had a partner, never had a secretary. I've done everything. I have been a one-man operation.... Having a one-man practice gives one a cer-

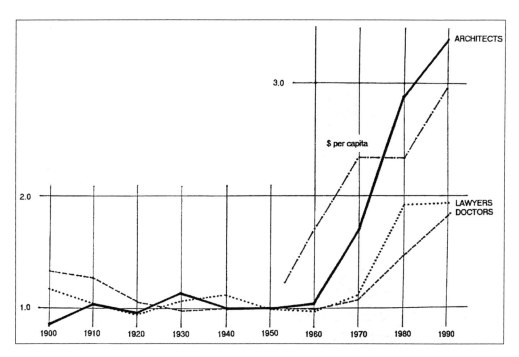

Changes in the supply of professionals in terms of the number per million of population (1950 = 1.0). Also shown is the per capita expenditure on non-residential, non-military building construction, adjusted for inflation. (Data are from U. S. Census and Department of Commerce reports.)

tain degree of independence. You don't have to take jobs to keep a staff busy.[102]

In the 1990s the small firm was still significant. Data indicate that in well over half of American architectural firms the only licensed architect is the owner, assisted by drafters and other non-professional personnel.[103] Almost half of American architects practice their profession in firms with fewer than ten employees.

As the 20th century ended there was no shortage of architects to serve the "Golden Age" in America. Through the first half of the 20th century each national census showed that there were about 160 architects for each million of total population in the United States (or an architect for every 6,000 people). The number of architects (related to the general population) began to increase in the 1960s, perhaps due

to the crowds of veterans who had studied architecture under the G.I. Bill. The number increased more sharply through the two decades that followed, as Baby Boomers finished college and entered the profession. In the 1990 census there were around 550 architects for each million people (or an architect for every 1,800), bringing the supply of architects in the United States to a level three times that of earlier times. But the need and desire for buildings increased similarly during these years, and now the average American uses and is responsible for the construction of a much greater volume of building construction than fifty years ago. In the United States between 1950 and 1990 the money spent per capita on building construction almost tripled. Obviously, a major transformation of the architectural profession's role is in the making.

Notes

Abbreviations have been used to designate the periodicals most often cited. Citations are not provided for information available in Henry F. Withey and Elsie Ratburn Withey, *Biographical Dictionary of American Architects (Deceased)* (1956; reprint, Detroit, 1996); *Macmillan Encyclopedia of Architects* (New York, 1982); and *Dictionary of American Biography* (New York, 1946–1958).

AA—*American Architect*
(Including *American Architect & Building News*, 1876–1908; *American Architect*, 1909–1921; *American Architect & the Architectural Review*, 1921–1925; and *American Architect*, 1925–1936.)

AR-*Architectural Record*, 1891 to present.

JAIA—*Journal of the American Institute of Architects*
(Including runs 1913–1928, 1944–1983.)

JSAH—*Journal of the Society of Architectural Historians*
(Including *Journal of the American Society of Architectural Historians*, 1941–1944, and *Journal of the Society of Architectural Historians*, 1945 to present.

Part I: Before 1800

1. Lee Soltow, *Distribution of Wealth and Income in the United States in 1798* (Pittsburgh, 1989), Table 29, 92.

2. Henry Wansey, quoted in Soltow, *Distribution of Wealth and Income*, 21, 17.

3. Carl Bridenbaugh, *Early Americans*, (New York, 1981), 113–14. "Boston Building Ordinances, 1631–1714," *JSAH*, May 1961, 91.

4. *Bradford's "History Of Plymouth Plantation*," quoted in Louise Hall, *Artificer to Architect in America: A Preliminary Report* (Durham, NC, 1954), 15.

5. R. W. G. Vail, "The Beginnings of Manhattan," *JSAH*, May 1952, 19.

6. Quoted in Bridenbaugh, *Early Americans*, 97.

7. Quoted in Bridenbaugh, *Early Americans*, 113.

8. Quoted in Mills Lane, *Architecture of the Old South: Colonial & Federal* (Savannah, 1996), 33.

9. Harold Donaldson Eberlein, *The Architecture of Colonial America*, (Boston, 1915), 83. Rhys Isaac, *The Transformation of Virginia, 1740–1790* (Chapel Hill, 1982), 33.

10. "Boston Building Ordinances," 90. Joseph Jackson, *American Colonial Architecture* (1924; reprint, New York, 1969), 88.

11. Quoted in Hall, *Artificer to Architect*, 21.

12. *Architects and Builders in North Carolina*, Catherine W. Bishir, J. Marshall Bullock, and William Bushong, eds. (Chapel Hill, 1990), 24, 99.

13. Bruce A. Kimball, *The "True Professional Ideal" in America* (Cambridge, 1992), 55.

14. *Maine Catalog, Historic American Buildings Survey*, Denys Peter Myers, compiler, (Augusta, ME, 1974), 31. Bridenbaugh, *Early Americans*, 95.

15. *Maine Catalog, HABS*, 31.

16. Hall, *Artificer to Architect*, 23. Darrett B. Rutman, *Winthrop's Boston* (Chapel Hill, 1965), 52.

17. Beatrice St. Julien Ravenel, *Architects of Charleston* (Charleston, 1945), 27.

18. *Columbian Centinel*, 1818, quoted in Jack Quinan, "Some Aspects of the Development of the Architectural Profession in Boston between 1800 and 1830," *Old Time New England*, Summer/Fall 1977, 35.

19. Hall, *Artificer to Architect*, 65.

20. Quoted in Lane, *Old South: Colonial & Federal*, 172.

21. Frederic C. Detwiller, "Thomas Dawes: Boston's Patriot Architect," *Old-Time New England*, Summer-Fall 1977, 5–6.

22. Lane, *Old South: Colonial & Federal*, 136. Joseph Jackson, *Early Philadelphia Architects and Engineers*, (Philadelphia, 1923), 38–40. Eberlein, *Colonial America*, 266–67. Roger G. Kennedy, *Architecture, Men, Women and Money, 1600–1860* (New York, 1985), 98.

23. Quoted in Bridenbaugh, *Early Americans*, 103.

24. The Carpenters' Company of the City and County of Philadelphia, *The Rules of Work of the Carpenters' Company of the City and County of Philadelphia*, (1786; reprint, Princeton, 1971), 1.

25. Rawson W. Haddon, "The First Architectural Society in American," *AR*, August 1915, 287.

26. Quoted in Lane, *Old South: Colonial & Federal*, 45.

27. Carl Bridenbaugh, "Peter Harrison Addendum," *JSAH*, December 1959, 159.

28. Quoted in *Architects and Builders in North Carolina*, 123.

29. Ravenel, *Architects of Charleston*, 67–68.

30. Ravenel, *Architects of Charleston*, 49.

31. Louise Hall, "First Architectural School? No! But ... ," *JAIA*, August 1950, 80. "Our First Architectural School?" *JAIA*, March 1950, 139.

32. Daniel J. Boorstin, *The Americans: The Colonial Experience* (New York, 1958), 297.

33. Carl Bridenbaugh, *Peter Harrison, First American Architect* (Chapel Hill, 1949), Appendix C.

34. John Summerson, *Architecture in Britain, 1530 to 1830* (Baltimore, 1954), 214.

Part II: 1800 to the Civil War

1. Jeffrey G. Williamson and Peter H. Lindert, *American Inequality* (New York, 1980), 36.

2. Alonzo Thomas Dill, *Governor Tryon and His Palace* (Chapel Hill, 1955), 2, 253.

3. Letter to John Ewing Colhoun, 17 April 1802, *The Correspondence and Miscellaneous Papers of Benjamin Henry Latrobe*, (New Haven, 1984), 1:203.

4. Damie Stillman, "New York City Hall: Competition and Execution," *JSAH*, October 1964, 129.

5. Louise Hall, *Artificer to Architect in American: A Preliminary Report* (Durham, NC, 1954), 5. William T. Ham, "Associations of Employers in the Construction Industry of Boston," *Journal of Economic and Business History*, 1930, 60.

6. John S. Sledge, "An Ornament to the City: Mobile's Government Street Presbyterian Church," *Gulf Coast Historical Review*, Spring 1993, 41–42.

7. Quoted in Harold Kirker, *The Architecture of Charles Bulfinch* (Cambridge, 1969), 6.

8. "Appeal to A Generous Public," *Columbian Centinel*, 27 January 1796, quoted in Harold and James Kirker, "Charles Bulfinch: Architect as Administrator," *JSAH*, March 1963, 29.

9. Kirker, *Architecture of Charles Bulfinch*, 14.

10. Walter Muir Whitehill, "A Centennial Sketch," in *Boston Society of Architects: The First Hundred Years, 1867–1967*, Marvin E. Goody and Robert P. Walsh, eds. (Boston, 1967), 18–19.

11. Whitehill, "A Centennial Sketch," 17.

12. James Gallier, *Autobiography of James Gallier, Architect* (Paris, 1864), 18.

13. Mills Lane, *Architecture in the Old South: Greek Revival and Romantic* (Savannah, 1996), 101, 170. Dell Upton, "The Traditional House and its Enemies," *Traditional Dwellings and Settlements Review*, Fall 1989, 81.

14. Walter H. Kilham, *Boston after Bulfinch* (Cambridge, 1946), 53. James F. O'Gorman, "H. and J. E. Billings of Boston: from Classicism to the Picturesque," *JSAH*, March 1983, 60.

15. J. Meredith Neil, "The Precarious Professionalism of Latrobe," *JAIA*, May 1970, 67.

16. Agnes Addison Gilchrist, *William Strickland, Architect and Engineer* (1950; reprint, New York, 1969), 12.

17. Lawrence Wodehouse, "Ammi Burnham Young, 1798–1874," *JSAH*, December 1966, 277.

18. Katherine M. Long, "Style and Choice in Mid-19th-Century Church Architecture" in *Thomas Alexander Tefft: American Architecture in Transition, 1845–1860* (Providence, 1988), 84.

19. Everard M. Upjohn, *Richard Upjohn, Architect and Churchman* (New York, 1939), 83–86.

20. *Christian Register* (Boston), 28 November 1846, as quoted in Upjohn, *Richard Upjohn*, 84.

21. Constance M. Greiff, *John Notman, Architect, 1810–1865* (Philadelphia, 1979), 30, 177.

22. John A. Bryan, "Outstanding Architects in St. Louis between 1804 and 1904," *Missouri Historical Review*, October 1933–July 1934, 84. Francis W. W. Kervick, *Architects in America of Catholic Tradition*, (Rutland, VT, 1962).

23. Hall, *Artificer to Architect*, B-112. Joseph Jackson, *American Colonial Architecture* (1924; reprint, New York, 1969), 199. Gallier, *Autobiography*, 20.

24. Quoted in Lane, *Old South: Colonial and Federal*, 233–34.

25. Asher Benjamin, *American Builder's Companion* (Boston, 1806), v-vi, viii.

26. Alexander J. Wall, "Books on Architecture Printed In America, 1775–1830," in *Bibliographical Essays: A Tribute to Wilberforce Eames*

(1924; reprint, Freeport, NY, 1967), 308. Lane, *Old South: Greek Revival & Romantic*, 170.

27. Lane, *Old South: Greek Revival & Romantic*, 46, 198.

28. Jack Quinan, "Some Aspects of the Development of the Architectural Profession in Boston between 1800 and 1830," *Old Time New England*, Summer-Fall 1977, 33–35.

29. Charles B. Wood, III, "A Survey and Bibliography of Writings on English and American Architectural Books Published before 1895," *Winterthur Portfolio*, 1965, 129.

30. Kirker, *Architecture of Charles Bulfinch*, 387.

31. Roger Hale Newton, *Town & Davis, Architects* (New York, 1942), 67.

32. George Templeton Strong, *Diary*, Allan Nevins and Milton Halsey Thomas, eds. (New York, 1952), 1:292.

33. Quinan, "Development of the Architectural Profession," 34. Hanna Hryniewiecka Lerski, *William Jay: Itinerant English Architect 1792–1837* (Lanham, MD, 1983), 231. Gallier, *Autobiography*, 21. Carolyn Hewes Toft, Esley Hamilton, and Mary Henderson Gass, *The Way We Came. A Century of the AIA in St. Louis* (St. Louis: 1991), 2.

34. David T. Van Zanten, "Jacob Wrey Mould: Echoes of Owen Jones and the High Victorian Styles in New York, 1853–1865," *JSAH*, March 1969, 41.

35. Roy Eugene Graham, "Joseph Jacques Ramée and the French Emigré Architects in America," (master's thesis, University of Virginia, 1968), 3. Quoted in Talbot Hamlin, *Benjamin Henry Latrobe* (New York, 1955), 130.

36. Carolina V. Davison, "Maxmilian and Eliza Godefroy," *Maryland Historical Magazine*, March 1934, 8.

37. Graham, "Joseph Jacques Ramée," 4, (Appendix C) 78.

38. Graham, "Joseph Jacques Ramée," 86.

39. Jean Garrigoux, *Un Aventurier Visionnaire, Arsène Lacarrière Latour 1778–1837* (Aurillac, 1997), 94–97.

40. Hamlin, *Latrobe*, 214. Beatrice St. Julien Ravenel, *Architects of Charleston* (Charleston, 1945), 94–97. Bryan, "Outstanding Architects," 83.

41. Lillian M. Snyder, "The Contribution of Icarian Alfred Piquenard, to Architecture in Iowa and Illinois," *Communal Societies*, 1986, 163–165.

42. Ellen W. Kramer, "Detlef Leinau, An Architect of the Brown Decades," *JSAH*, March 1955, 19. Lane, *Old South: Greek Revival & Romantic*, 253.

43. Ravenel, *Architects of Charleston*, 147. Hilary S. Irvin, "The Impact of German Immigration on New Orleans Architecture," *Louisiana History*, Fall 1986, 180.

44. Quoted in William Howard Adams, *Jefferson's Monticello* (New York, 1983), 34.

45. Richard Dozier, "The Black Architectural Experience in America," *JAIA*, July 1976, 163. Gallier, *Autobiography*, 23.

46. Lane, *Old South: Greek Revival and Romantic*, 304. Donna C. Hole, "Daniel Pratt and Barachias Holt: Architects of the Alabama State Capitol," *Alabama Review*, April 1984, 86. *Architects and Builders in North Carolina*, Catherine W. Bishir, J. Marshall Bullock, and William Bushong, eds. (Chapel Hill, 1990), 279.

47. Milly McGehee, "Auburn in Natchez," *Antiques*, March 1977, 546.

48. C. Ford Peatross, *William Nichols, Architect* (University, AL, 1979), 1.

49. Kenneth Hafertepe, *Abner Cook. Master Builder on the Texas* (Austin, 1992), 43.

50. Spencer Bidwell King, Jr., "A Yankee Who Served the South," *Atlanta Historical Bulletin*,

51. Rawson W. Haddon, "The First Architectural Society in America," *AR*, August 1915, 287.

52. Haddon, "First Architectural Society," 288.

53. George Champlin Mason, "Professional Ancestry of the Philadelphia Chapter," *JAIA*, September 1913, 373.

54. Nancy J. Brcak, "Country Carpenters, Federal Buildings: An Early Architectural Tradition in Ohio's Western Reserve," *Ohio History*, Summer-Autumn 1989, 133. Bruce A. Kimball, *The "True Professional Ideal" in America* (Cambridge: Blackwell, 1992), 167.

55. Samuel Haber, *The Quest for Authority and Honor in the American Professions, 1750–1900* (Chicago, 1991), 9.

56. Vincent Clark, "A Struggle for Existence: The Professionalization of German Architects," in *German Professions 1880–1950*, Geoffrey Cocks and Konrad H. Farausch, eds., (New York, 1990), 148. Henry Saylor, "The AIA's First Hundred Years," *JAIA*, May 1957, 6.

57. Mason, "Professional Ancestry," 371.

58. Hobart B. Upjohn, "An Early Chapter in Institute History," *JAIA*, July 1925, 265.

59. Hamlin, *Latrobe*, 148, 149, 586.

60. Letter to Robert Mills, 12 July 1806, *Correspondence of … Latrobe*, 2:240.

61. Quoted in "Latrobe on Architects' Fees, 1798," *JSAH*, October 1960, 116.

62. Neil, "Precarious Professionalism," 69.

63. Talbot Hamlin, *Greek Revival Architecture in America* (London, 1954), 143–44.

64. Jenny Anger, "The Rise of the Professional Architect" in *Thomas Alexander Tefft*, 14.

65. "American Institute of Architects," *Crayon*, December 1857, 372.

66. Whitehill, "A Centennial Sketch," 25.

67. "An Important Trial. Compensation of Architects," *Architects' & Mechanics' Journal*, 6 April 1861, 9.

68. "An Important Trial," *Architects' & Mechanics' Journal*, 16 March 1861, 231.

69. Henry Ericsson, *Sixty Years a Builder* (Chicago, 1942) 125.

70. Cecil D. Elliott, "The North Carolina State Capitol, Section II—The Architects," *Southern Architect*, June 1958, 26.

71. J. Frederick Kelly, "A Forgotten Incident in the Life of Ithiel Town," *Old Time New England*, January 1941, 66.

72. Lane, *Old South: Colonial & Federal*, 232–33.

73. Lane, *Old South: Greek Revival & Romantic*, 45, 193.

74. Greiff, *John Notman*, 18.

75. Wilbur H. Hunter, Jr., "Robert Cary Long, Jr., and the Battle of Styles," *JSAH*, March 1957, 29.

76. Quoted in Anger, "Rise of the Professional Architect," 12.

77. Omar N. Fawzy, "The Development of the Architectural Working Drawing from the Descriptive to the Proscriptive: A Study in Architectural Communication" (Ph.D. diss., University of Pennsylvania, 1991), 144–45.

78. Samuel Lapham, Jr., "Architectural Specifications of a Century Ago," *AR*, March 1923, 239. Marian Card, "A. J. Davis and the Printed Specification," *College Art Journal*, Summer 1953, 355.

79. Lisa B. Lubow, *From Carpenter to Capitalist: The Business of Building in Postrevolutionary Boston* (Boston, 1997), 187.

80. Gallier, *Autobiography*, 18.

81. Newton, *Town & Davis*, 38–39.

82. *Evening Post*, 19 July 1879.

83. Thomas Rothrock, "The University of Arkansas's 'Old Main'," *Arkansas Historical Quarterly*, Spring 1971, 6, 7.

84. "An Important Trial," 16 March 1861, 232. *The Architect's Handbook of Professional Practice* (Washington, 1927), 15.

85. Mary Greene Nye, *Vermont's State House* (Montpelier, 1931), 1.

86. Henry Russell Hitchcock, *Temples of Democracy* (New York, 1976), 111.

87. Letter to Robert Mills, 12 July 1806, *Correspondence of … Latrobe*, 2:243.

88. John W. Carpenter, *John W. Carpenter's Tennessee Courthouses* (London, KY, 1996), x.

89. Carpenter, *Tennessee Courthouses*, xii. Lee Burns, *Early Architects and Builders of Indiana*, (Indianapolis, 1935), 198–99.

90. Burns, *Early Architects*, 197. Sarah E. Rusk "Hezekiah Eldredge, Architect-Builder of St. John's Church, Cleveland, Ohio," *JSAH*, March 1966, 50.

91. Burns, *Early Architects*, 193, 199. Anton Scherrer, "Notes on Costigan," *JSAH*, March 1985, 32. George Ehrlich and Peggy E. Schrock, "The A. B. Cross Lumber Company 1858–1871," *Missouri Historical Review*, October 1985, 14–15.

92. Alexander Carl Guth, "Early Day Architects in Milwaukee," *Wisconsin Magazine of History*, September 1926, 18, 21.

93. *JSAH*, January 1947, Edward R. DeZurko, "Early Kansas Churches," 26.

94. Harold Kirker, "Eldorado Gothic. Gold Rush Architects and Architecture," *California Historical Society Quarterly*, March 1959, 31.

95. Kirker, "Eldorado Gothic," 31, 32.

96. Kirker, "Eldorado Gothic," 31. Lyle F. Perusse, "The Gothic Revival in California 1850–1890," *JSAH*, October 1955, 15

Part III: The Civil War to World War I

1. Allan Nevins and Henry Steele Commager, *A Pocket History of the United States* (New York, 1970), 270.

2. Alan Brinkley, *The Unfinished Nation* (New York, 1993), 471.

3. Toni M. Prawl, *E. J. Eckel (1845–1934), The Education of a Beaux-Arts Architect and His Practice in Missouri* (Ph.D. diss., University of Missouri-Columbia, 1994), 134.

4. *Long Island Country Houses and Their Architects*, Robert B. Mackay, Anthony K. Baker, and Carol A. Traynor, eds., (New York, 1997), 140, 152, 440. Philippe Oszuscik, "Vernacular Architecture of Davenport, Iowa," *Pioneer America Society Transactions*, Annual Meeting for 1986, 17. John S. Sledge, "Rudolph Benz: Mobile's Gilded Age Architect," *Gulf Coast Historical Review*, Fall 1994, 152.

5. Dankmar Adler, "Some Notes on the Earlier Chicago Architects," *Inland Architect*, May 1892, 47.

6. Selected from "General Notes," *AA*, 11 August 1877, 13 October 1877, v, vi.

7. Charles. P. Dyer, *The Immigrant Builder* (Philadelphia, 1872).

8. "The Architect's Side of It," *AR*, February 1905, 39. *Sweet's Catalogue*, (1906, reprint), vii, xii.

9. Henry Van Brunt, "Richard Morris Hunt, A Memorial Address," *Proceedings of the 29th Annual Convention of the American Institute of Architects*, 1895, 78. A. O. Elzner, "A Reminiscence of Richardson," *Inland Architect*, September 1892, 15. James F. O'Gorman, "An 1886

Inventory of H. H. Richardson's Library and Other Gleanings from Probate," *JSAH*, May 1982, 150.

10. Leland M. Roth, *McKim Mead & White, Architects* (New York, 1983), 63. Philip Sawyer, "Early Days of York & Sawyer," *JAIA*, November 1951, 198. Keith N. Morgan, *Charles A. Platt: The Artist as Architect* (New York, 1985), 204. H. Van Buren Magonigle, "A Half Century of Architecture," *Pencil Points*, November 1933, March 1934, 480, 116.

11. Vincent Clark, "A Struggle for Existence: The Professionalization of German Architects," in *German Professions, 1800–1950*, Geoffrey Cocks and Konrad H. Jarausch, eds. (New York, 1990), 145. Herbert M. Baer, "The Course in Architecture at a German 'Technische Hochschule'," *AA*, 16 March 1901, 83.

12. William Adams Delano, "Memoirs of Centurian Architects," *JAIA*, July 1948, 4. Walter H. Kilham, Jr., *Raymond Hood, Architect. Form through Function in the American Skyscraper* (New York, 1973), 32.

13. Huger Elliott, "Examinations in Paris," *JAIA*, November 1946, 204.

14. Quoted in James Philip Noffsinger, *The Influence of the Ecole des Beaux-Arts on the Architects of the United States* (Washington, 1955), 33.

15. Calculated from data in Henry F. Withey and Elsie Rathburn Withey, *Biographical Dictionary of American Architects* (1956; reprint, Los Angeles, 1970). Mardges Bacon, "Ernest Flagg: Beaux-Arts Architect and Reformer" (Ph. D. diss., Brown University, 1978), 22–23.

16. Charles Collens, "The Beaux-Arts in 1900," *JAIA*, February 1947, 82–83.

17. Thomas J. Noel and Barbara S. Norgren, *Denver: The City Beautiful and its Architects, 1893–1941* (Denver, 1987), 188.

18. A remark made to Claude Bragdon, quoted in Willard Connely, "New Chapters in the Life of Louis Sullivan," *JAIA*, September 1953, 107–08.

19. Ralph Adams Cram, *The Gothic Quest* (New York, 1907), 302. Kenneth H. Cardwell, *Bernard Maybeck: Artisan, Architect, Artist* (Santa Monica, 1996), 43. Theodore W. Pietsch, "The Superiority of the French-Trained Architect," *AR*, February 1909, 110. Paul Cret, "The Ecole des Beaux Arts: What Its Architectural Teaching Means," *AR*, April 1908, 369.

20. Jeffrey A. Cohen, "Building a Discipline: Early Institutional Settings for Architectural Education in Philadelphia, 1804–1890," *JSAH*, June 1994, 175.

21. "Convention of the American Institute of Architects," *New York Daily Tribune*, 23 October 1867, quoted in E. James Gambaro, "Early Days of the Institute," *JAIA*, April 1952, 166. "Report of the Committee on Permanent Organization," quoted in Bacon, "Ernest Flagg," 88.

22. William R. Ware, "Architecture at Columbia College," *AA*, 6 August 1881, 61.

23. A.D.F. Hamlin, "The School of Architecture," *Columbia University Quarterly*, June 1906, 212.

24. William R. Ware, "Professional Draughtsmen as Special Students in the School of Architecture," *School of Mines Quarterly*, July 1897, 423–424.

25. Charles H. Moore, "Training for the Practice of Architecture," *AR*, January 1921, 58. Richard Plunz, "Reflections on Ware, Hamlin, McKim, and the Politics of History on the Cusp of Historicism," *The History of History in American Schools of Architecture, 1865–1975*, Gwendolyn Wright and Janet Parks, eds., (New York, 1990), 61–62.

26. *The Making of an Architect, 1881–1981. Columbia University in the City of New York*, Richard Oliver, ed. (New York, 1981), 18.

27. Michael Pause, "Teaching the Design Studio, A Case Study: MIT's Department of Architecture 1865–1974," (Ph.D. diss., MIT, 1976), 68b. Noffsinger, *Influence of the Ecole*, 92.

28. Everett Waid, "The Architectural Incompetence Revealed by Some Registration Laws," *JAIA*, May 1918, 254.

29. Peter L. Goss, "William Allen, Architect-Builder, and His Contribution to the Built Environment of Davis County," *Utah Historical Quarterly*, Winter 1986, 54. Jeannette Kinyon, *Prairie Architect, F.C.W. Kuehn: His Life and Work* (Sioux Falls, 1984), 2, 8. Harrison Mosley Ethridge, "The Black Architects of Washington, D. C., 1900–Present" (Ph.D. diss., Catholic University, 1979), 4.

30. Mary Carolyn Hollers George, *O'Neil Ford, Architect* (College Station, 1992), 15–16.

31. George N. Lamphere, *The United States Government; Its Organization and Practical Workings ...* (Philadelphia, 1880), 93

32. *Secretary of the Treasury, Annual Report, 1853*, quoted in Darrell Hevenor Smith, *The Office of the Supervising Architect of the Treasury* (Baltimore, 1923), 4.

33. Douglas L. Stern, "Government Architecture in the Gilded Age: The Office of Alfred Mullett" (master's thesis, University of Virginia, 1981), 4.

34. Lawrence Wodehouse, "John McArthur, Jr. (1823–1890)," *JSAH*, December 1969, 281.

35. "The Architects and the New Post Office," *New York Times*, 6 February 1867, 2.

36. 40th Cong., 2nd Sess. (1868), H. Ex. Doc 316, quoted in Jennifer Laurie Ossman, "Recon-

structing a National Image: The State, War and
Navy Building and the Politics of Federal Design
1866-1890," (Ph. D. diss., University of Virginia,
1996), 107.

37. *New York Sun*, 27–28 May 1874, 1.

38. "American Architects in Congress," *Architect* (London), 29 January 1886, 56.

39. George Champlin Mason, "Professional Ancestry of the Philadelphia Chapter, *JAIA*, September 1913, 381. *Boston Society of Architects. The First Hundred Years, 1867–1967*, Marvin E. Goody and Robert P. Walsh, eds. (Boston, 1967), 28. Henry H. Saylor, *The AIA's First Hundred Years* (Washington, 1957), 14.

40. Samuel Haber, *The Quest for Authority and Honor in the American Professions, 1750–1900* (Chicago, 1991), 198, 208.

41. William Fogerty, "On Some Differences between British and American Architectural Practice," *Irish Builder*, 1 March 1875, 68. Deborah S. Gardner, "The Architecture of Commercial Capitalism: John Kellum and the Development of New York, 1840–1875," (Ph. D. diss., Columbia University, 1979), 325.

42. Quoted in Hank Todd Smith, *Since 1886: A History of the Texas Society of Architects* (Austin, 1983), 7–9.

43. C. H. Blackall, "Fifty Years Ago," *AA*, 5 January 1926, 7. William Bushong, *The Centennial History of the Washington Chapter AIA, 1887–1987* (Washington, 1987), 9.

44. Quoted in "Architectural Federation in the States," *British Architect*, 21 December 1888, 433.

45. "Constitution of the Western Association of Architects," quoted in Saylor, *First Hundred Years*, 16.

46. "Fellows and Fellowship," *JAIA*, January 1919, 52.

47. American Institute of Architects, *Proceedings 1889*, 75.

48. Report of Western Association of Architects convention, *Inland Architect*, November 1885, 69. Louise Bethune, "Women and Architecture," *Inland Architect*, March 1891, 20–21.

49. George Champlin Mason, *Architects and Their Environment, 1850–1907* (Ardmore, PA, 1987), 54. Bethune, "Women and Architecture," 20. Antoinette J. Lee, *Architects to the Nation: The Rise and Decline of the Supervising Architect's Office* (New York, 2000), 161. David Gebhard, "William Gray Purcell and George Grant Elmslie and the Early Progressive Movement in American Architecture from 1900 to 1920," (Ph.D. diss., University of Minnesota, 1957), 50.

50. Judith Paine, "Pioneer Women Architects," in *Women in American Architecture*, Susana Torre, ed. (New York, 1977), 63–64.

51. Judith Paine, *Theodate Pope Riddle. Her Life and Work*, (New York, 1979), 4, 6.

52. *AA*, 10 December 1892, 158, 170.

53. *Inland Architect*, May 1889, 64.

54. Bruce A. Kimball, *The "True Professional Ideal" in America* (Cambridge, 1992), 299.

55. Paul Kruty, "A New Look at the Beginnings of the Illinois Architects Licensing Law," *Illinois Historical Journal*, Autumn 1997, 158. "The Report of the Committee on the Registration of Architects," *Journal of the Proceedings of the American Institute of Architects*, 1907, 70.

56. Richard Michael Levy, "The Professionalization of American Architects and Civil Engineers, 1865–1917" (Ph.D. diss., University of California Berkeley, 1980), 138.

57. Waid, "Architectural Incompetence," 254–55.

58. Peter B. Wight, "A Recent New Jersey Decision and the Illinois Licensing Board," *AA*, 16 July 1904, 23. "The Registration Tangle," *AR*, December 1923, 587.

59. "Registration in America," *Architect* (London), 22 July 1892, 52. *AA*, 24 November 1900, 58. *AA*, 31 March 1900, 101. Samuel Hannaford, "Licensing Architects," *AA*, 4 February 1899, 39.

60. Leslie Childs, "The Architect and the Law," *Architectural Forum*, July 1924, 19.

61. Goss, "William Allen," 55.

62. Thomas Crane Young, "Two Opinions on Architectural Advertising," *AA*, 1 January 1919, 26.

63. Fogerty, "Some Differences," 68.

64. Sharon Lee Irish, "Cass Gilbert's Career in New York 1899–1905," (Ph.D. diss., Northwestern University, 1985), 80.

65. Sharon Irish, *Cass Gilbert, Architect. Modern Traditionalist* (New York, 1999), 61.

66. Roth, *McKim, Mead & White*, 241, 337.

67. Joseph Hudnut, "Confessions of an Architect," *JAIA*, September 1950, 109. "In Appreciation of Arnold W. Brunner," *AR*, May 1925, 461.

68. Thomas Hastings, *Thomas Hastings, Architect. Collected Writings*, David Gray, ed. (Boston, 1933), 148.

69. *Inland Architect*, November 1885, 69.

70. *Inland Architect*, November 1885, 70.

71. *Daily Statesman*, 7 September 1879, as quoted in William Elton Green, "'A Question of Great Delicacy': The Texas Capitol Competition, 1881," *Southwestern Historical Quarterly*, October 1988, 255.

72. George R. Mann, "George R. Mann's Comments on George W. Donaghey's *Building a State Capitol*," *Arkansas Historical Quarterly*, Summer 1972, 136.

73. John M. Carrère, "Architectural Competitions," *Engineering Magazine*, May 1893.

74. Robert Bruegmann, *The Architects and the City. Holabird & Roche of Chicago, 1880–1918* (Chicago, 1997), 343.

75. *Texas Republican* (Marshall) 17 April 1852, quoted in Green, "Question of Great Delicacy," 247.

76. David F. Ransom, "James G. Batterson and the New State House," *Connecticut Historical Society Bulletin*, January 1980, 8.

77. Henry-Russell Hitchcock and William Seale, *Temples of Democracy*, (New York, 1976), 181.

78. "A Gentleman's Agreement," *AA*, 15 May 1897, 51.

79. Elizabeth G. Grossman, "Two Postwar Competitions: The Nebraska State Capitol and the Kansas City Liberty Memorial," *JSAH*, September 1986, 245. "Shadows and Straws," *JAIA*, August 1916, 322.

80. Theodore Minot Clark, *The Architect, Owner and Builder before the Law* (Boston, 1894), 25.

81. Editors' note to W. M. Aiken, "Competitions under the Tarsney Act and Others," *AA*, 30 November 1901, 72.

82. John Y. Cole, "Smithmeyer & Pelz, Embattled Architects of the Library of Congress," *Quarterly Journal of the Library of Congress*, October 1972, 283.

83. *John L. Smithmeyer et al., Appts., v. United States*, 147 U.S., 197, 1893.

84. Cole, "Smithmeyer & Pelz," 304.

85. Quoted in Cecil R. Roseberry, *Capitol Story* (Albany, 1964), 33.

86. Roseberry, *Capitol Story*, 41, 63, 72–75.

87. Hitchcock and Seale, *Temples of Democracy*, 249. "The Report on the Pennsylvania Capitol Investigation," *Outlook*, 31 August 1907, 934–35. Suzanne McInerney, "A Capital Idea! A Brief and Bumpy History of Pennsylvania's Capitols," *Pennsylvania Heritage*, Winter 1944, 30.

88. Leopold Eidlitz, "The Architect of Fashion," *AR*, April-June 1894, 351.

89. James Gallier, *Autobiography of James Gallier* (Paris, 1864), 18–19, 20.

90. John V. Van Pelt, "Architectural Training in America," *AR*, May 1928, 447.

91. Henry Matthews, *Kirtland Cutter, Architect in the Land of Promise* (Seattle, 1998), 63. Morgan, *Charles A. Platt*, 74. Robert A. M. Stern, *George Howe. Toward a Modern American Architecture* (New Haven, 1975), 30.

92. Jean Ames Follett-Thompson, "The Business of Architecture: William Gibbons Preston and Architectural Professionalism in Boston during the Second Half of the Nineteenth Century" (Ph.D. diss., Boston University, 1986), 18.

93. Prawl, "E. J. Eckel," 215.

94. Richard Longstreth, *On the Edge of the World* (New York, 1983), 91.

95. Charles C. Savage, *Architecture of the Private Streets of St. Louis: The Architects and the Houses They Designed* (Columbia, MO, 1987), 154.

96. Paul R. Baker, *Stanny. The Gilded Life of Stanford White* (New York, 1989), 152. Christopher Alexander Thomas, "The Lincoln Memorial and its Architect, Henry Bacon (1866–1924)" (Ph.D. diss., Yale University, 1990), 100.

97. J. D. Forbes, "Shepley, Bulfinch, Richardson & Abbott, Architects: An Introduction," *JSAH*, Fall 1958, 19–20.

98. Thomas Hastings, "A Letter from Thomas Hastings FAIA Reminiscent of the Early Work of Messrs. Carrère & Hastings, Architects," *AA*, 7 July 1909, 3. Thomas Hastings and others, "John Merven Carrère," *New York Architect*, May 1941, 65. Magonigle, "Half Century," 563.

99. Sawyer, "Early Days," 195.

100. Theodore Starrett, "John Wellborn Root," *Architecture & Building*, 11 November 1912, 431.

101. Hilary S. Irvin, "New Orleans," *Louisiana History*, Fall 1986, 396–97. Margaret Henderson Floyd, "A Terra-Cotta Cornerstone for Copley Square: Museum of Fine Arts, Boston, 1870–1876," *JSAH*, May 1973, 87.

102. Lawrence White quoted in Roth, *McKim, Mead & White*, 58.

103. Quoted in Richard Oliver, *Bertram Grosvenor Goodhue* (Cambridge, 1983), 121.

104. Louis H. Sullivan, *The Autobiography of an Idea* (New York, 1926), 202.

105. Diana Balmori, "George B. Post: The Process of Design and the New American Architectural Office (1868–1913)," *JSAH*, December 1987, 351.

106. Lloyd C. Engelbrecht and June-Marie F. Engelbrecht, *Henry C. Trost, Architect of the Southwest* (El Paso, 1981), 3–9. Longstreth, *On the Edge of the World*, 54. Bruce Hooper, "Samuel Eason Patton, Opera House Architect of the Southwest," *Journal of Arizona History*, Spring 1997, 60–66.

107. Letter to Isaac Hazelhurst, 19 July 1806, from *Correspondence and Miscellaneous Papers of Benjamin Henry Latrobe*, vol. 2 (New Haven, 1984), 248. Derived from Appendix A in Thomas S. Hines, *Burnham of Chicago* (New York, 1974), 371–82.

108. Fogerty, "Some Differences,", 68.

109. Glenn Brown, *Memories, 1860–1930* (Washington, 1931), 24–25.

110. C. David Jackson and Charlotte V. Brown, *History of the North Carolina Chapter of*

the American Institute of Architects, 1913–1998 (Raleigh, 1998), 9. Gebhard, "William Gray Purcell and George Grant Elmslie," 101. Carolyn Hewes Toft, Esley Hamilton, and Mary Henderson Case, *The Way We Came. A Century of the AIA in St. Louis*, George McCue, ed. (St. Louis, 1991), 45.

111. Charles Allerton Coolidge," *American Society of the French Legion of Honor*, Summer 1951, 107.

112. Forbes, "Shepley, Bulfinch, Richardson & Abbott," 25. Toft, Hamilton, and Gass, *The Way We Came*, 14.

113. Maya Hambly, *Drawing Instruments 1580–1980* (London, 1984), 65.

114. AA, 25 January 1890, 50.

115. William Gray Purcell, "First 'Skyscraper'," *Northwest Architect*, January-February 1953, 5.

116. Ernst Lietze, *Modern Heliographic Processes: Manual of Instruction* (New York, 1888), 53.

117. B. J. Hall, *Blue Printing and Modern Plan Copying* (London, 1921), 9.

118. Magonigle, "Half Century," 477. Kinyon, *F. C. W. Kuehn*, 16.

119. Omar N. Fawzy, "The Development of the Architectural Working Drawing from the Descriptive to the Prescriptive: A Study in Architectural Communication" (Ph.D. diss., University of Pennsylvania, 1991), 144. Eugene Clute, *Drafting Room Practice* (New York, 1928), 155.

120. "The Organization of an Architect's Office, No. VII. Office of George B. Post, New York," *Engineering Record*, November 1891, 362. George C. Baldwin, "The Offices of Albert Kahn, Architect, Detroit, Michigan," *Architectural Forum*, 1918, 125–30.

121. Magonigle, "A Half Century," 477.

122. Baker, *Stanny*, 200.

123. Sturgis, "Some Recollections," 267. "The International Conference in London," *JAIA*, September 1924, 413. Thomas H. Morgan, "Reminiscences of the Architecture and Architects of Atlanta," *Atlanta Historical Bulletin*, June 1937, 8.

124. Balmori, "George B. Post," 351. Aaron Betsky, *James Gamble Rogers and the Architecture of Pragmatism*, (Cambridge, 1994), 12.

125. George E. Thomas, Michael J. Lewis, and Jeffrey A. Cohen, *Frank Furness: The Complete Works* (New York, 1991), 41. Oliver, *Bertram Grosvenor Goodhue*, 6. Everard M. Upjohn, *Richard Upjohn, Architect and Churchman* (1939; reprint New York, 1968), 154.

126. Hudnut, "Confessions of an Architect," 70–71. Thomas, Lewis, and Cohen, *Frank Furness*, 83.

127. Elzner, "Reminiscence," 15.

128. *AA*, 25 January 1890, 50.

129. Paul R. Baker, *Richard Morris Hunt* (Cambridge, 1980), 493. Thomas, Lewis, and Cohen, *Frank Furness*, 360.

130. Roth, *McKim, Mead & White*, 57, 115. Goldwin Goldsmith, "I Remember McKim, Mead & White," *JAIA*, April 1950, 172. Samuel Huiet Graybill, Jr., "Bruce Price, American Architect, 1845–1903," (Ph.D. diss., Yale University, 1957), 145–46. Karen Sawislak, *Smoldering City. Chicagoans and the Great Fire, 1871–1874* (Chicago, 1989), 137.

131. William Gray Purcell, "This Too, Might be History," *JSAH*, October 1943, 17.

132. Balmori, "George B. Post," 351. John Taylor Boyd, Jr., "Otto R. Eggers, Architectural Renderer & Designer," *AR*, May 1913, 422. Purcell, "This Too," 19.

133. F. W. Fitzpatrick, "Ramblings. A Chat with the Young Draftsman," *Pencil Points*, August 1927, 462. Prawl, "E. J. Eckel, " 217, 224. "Oscar Enders 1865–1926," *Pencil Points*, August 1927, 506. Eileen Manning Michels, "A Developmental Study of the Drawings Published in 'American Architect' and in 'Inland Architect' through 1895" (Ph.D. diss., University of Minnesota, 1971), 31.

134. Steven McLeod Bedford, *John Russell Pope, Architect of Empire* (New York, 1998), 29.

135. Harry W. Desmond and Herbert Croly, *Stately Homes in America* (New York, 1903), 362.

136. Graybill, "Bruce Price," 190.

137. Engelbrecht and Engelbrecht, *Henry C. Trost*, 64–67.

138. Levy, "Professionalization," 171–72.

139. *Letters of Brigham Young to His Sons*, Dean C. Jessee, ed. (Salt Lake City, 1974), 264.

140. Paul Starrett, *Changing the Skyline* (New York, 1938), 38. Reginald Pelham Bolton, "The Engineer, the Architect and the General Construction Company," *Brickbuilder*, October 1904, 215.

141. R. Clipston Sturgis, "The Profession and the Institute Fifty Years Ago," *JAIA*, July 1945, 16.

142. Edgar V. Seeler, "The Relations of Specialists to Architects," *Proceedings of the 38th Annual Convention of the AIA* (Washington: Gibson Brothers, 1905), 133.

143. Sturgis, "Some Recollections," 267. "General Contracts versus Individual Contracts," *AR*, September 1908, 231.

144. Robert D. Andrews, "Conditions of Architectural Practice Thirty Years and More Ago," *Architectural Review* (Boston), November 1917, 237. *The History of Real Estate, Building and Architecture in New York City during the Last Quarter of a Century* (1898; reprint New York, 1967), 583. Oliver, *Bertram Grosvenor Goodhue*, 196.

145. Bruegmann, *Architects and the City*, 81.

146. "General Contracts versus Individual Contracts," 233. *Journal of the Proceedings of the 40th Annual Convention of the AIA*, 1907, 89–90.

147. Ethridge, "Black Architects," 14, 30. Louis R. Harlan, *Booker T. Washington, The Wizard of Tuskegee, 1901–1915* (New York, 1986), 119.

148. Ethridge, "Black Architects," 14–35. Richard Dozier, "The Black Architectural Experience," *JAIA*, July 1976, 164, 166.

149. Michael T. Klare, "The Architecture of Imperial America," *Science & Society*, Fall 1969, 277.

150. George Ehrlich, "Partnership Practice and the Professionalization of Architecture in Kansas City, Missouri," *Missouri Historical Review*, July 1980, 464. Wilda Sandy and Larry K. Hancks, *Stalking Louis Curtiss* (Kansas City, 1991). Virginia L. Grattin, *Mary Colter, Builder upon the Red Earth* (Flagstaff, 1980).

151. Kathryn Eckert, "Midwestern Resort Architecture: Earl H. Mead in Harbor Springs," *Michigan History*, January-February 1979, 11.

152. Cynthia Barwick Malinick, "The Lives and Works of the Reid Brothers, Architects, 1852–1943" (Master's thesis, University of San Diego, 1992), 35–36.

153. Elizabeth Hawes, *New York, New York. How the Apartment House Transformed the Life of the City (1869–1930)*, (New York, 1993), 65.

154. Quoted in Hawes, *New York*, 48.

155. Aline Lewis Goldstone and Harmon H. Goldstone, *Lafayette A. Goldstone. A Career in Architecture* (New York, 1964), 50–51, 75. Hawes, *New York*, 48, 53, 96.

156. Letter of F. A. Schermerhorn, 3 April 1883, quoted in *Making of an Architect*, 7. Sarah Bradford Landau, *Edward T. and William A. Potter, American Victorian Architects* (New York, 1979), 8, 409–10. Roy Lubove, "I. N. Phelps Stokes: Tenement Architect, Economist, Planner," *JSAH*, May 1964, 75.

157. "Dwight H. Perkins," *Architectural Forum*, October 1952, 122–23. Guy Szuberla, "Irving Kane Pond: A Michigan Architect in Chicago," *Old Northwest*, Summer 1979, 116. From an unpublished manuscript by Flagg, quoted in Bacon, "Ernest Flagg", 328.

158. Edward R. Kantowicz, "To Build the Catholic City," *Chicago History*, Fall 1985, 4. Geoffrey M. Gyrisco, "Victor Cordella and the Architecture of Polish and East-Slavic Identity in America," *Polish American Studies*, Spring 1997, 38–40.

159. Landau, *Edward T. and William A. Potter*, 15.

160. Thomas J. Schlereth, "Solon Spencer Beman, 1863–1914," *Chicago Architectural Journal*, 1985, 26.

161. Citizens Research Council of Michigan, *Report on the Method of Securing Architectural Service in Eight Cities* (Detroit, 1919), Chart B. Toft, Hamilton, and Gass, *The Way We Came*, 16–17.

162. Dwight H. Perkins, Father of Today's 'New' School Ideas," *Architectural Forum*, October 1952, 125.

163. Peter B. Wight, "Public School Architecture at Chicago. The Work of Dwight H. Perkins," *AR*, June 1910, 495. "Dwight H. Perkins, Father of Today's 'New' School Ideas," 123.

164. Daniel H. Burnham, "Lessons of the Chicago World's Fair," *AR*, January 1913, 38.

165. John R. Riggleman, "Building Cycles in the United States, 1875–1932," *American Statistical Association. Journal*, June 1933, Chart I, 178. Francine Haber, Kenneth R. Fuller, and David N. Wetzel, *Robert S. Roeschlaub, Architect of the Emerging West, 1843–1923* (Denver, 1988), 31.

166. Charles Moore, *Daniel H. Burnham. Architect, Planner of Cities* (Boston, 1921), 99.

167. Moore, *Burnham*, 103–4.

168. *Inland Architect*, November 1897, 36.

169. Irish, "Cass Gilbert's Career," 266. Glenn Brown, "The Tarsney Act. Historical Review," *Brickbuilder*, May 1906, 95.

170. Ernest Eberhard, "Fifty Years of Agitation … for Better Design of Government Buildings and Government Employment of Private Architects," *AA*, June 1931, 82.

171. William A. Boring, quoted in Eberhard, "Fifty Years," 82.

172. *The Tarsney Act. Letters of the Secretary of the Treasury*. 62nd Congress, 2nd Session, Senate Document No. 916 (Washington, 1912), 4.

173. Eberhard, "Fifty Years," 86. R. H. Thayer, *History, Organization and Functions of the Office of the Supervising Architect of the Treasury Department* (Washington, 1886), 35. Frank Miles Day, "Report of Standing Committee on Competitions," *Proceedings of the Forty Sixth Annual Convention of the AIA*, 1913, 53.

Part IV: World War I to the Present

1. "Editorial Comment," *Architectural Forum*, January 1918, 29.

2. Caroline Hewes Toft, Esley Hamilton, and Mary Henderson Gass, *The Way We Came*, George McCue, ed. (St. Louis, 1991), 38.

3. Carl F. Pilat, "Camp Lewis, American Lake, Wash." *AR*, January 1918, 52–53.

4. "War Demonstration Hospital of the Rockefeller Institute," *Science*, 31 August 1917,

206. Edward F. Stevens, "Our War Hospitals in France," *AR*, March 1918, 8.

5. Bruce Barton, *This Is the Hut the "Y" Built* (New York, 1918), 3.

6. Theodore Wesley Koch, *Books in the War* (Boston, 1919), 8. Sara Holmes Boutelle, *Julia Morgan, Architect* (New York, 1988), 88. *Long Island Country Houses and Their Architects, 1860–1940*, Robert B. Mackay, Anthony K. Baker, and Carol A. Traynore, eds. (New York, 1997), 86. David Lee Shillinglaw, *An American in the Army and YMCA, 1917–1920*, Glen E. Holt, ed. (New York, 1931), 34, 38.

7. "Shadows and Straws," *JAIA*, January 1918, 3. "Latest Developments in Housing at Washington," *JAIA*, January 1918, 36. Richard Spencer Childs, "First War Emergency Government Towns, IV. Groton, Connecticut," *JAIA*, November 1918, 510.

8. U.S. Department of Labor, *Report of the United States Housing Corporation* (Washington: GPO, 1919), 65. Nicholas Adams, "The United States Housing Corporation's Munitions Worker Suburb in Bethlehem, Pennsylvania (1918) and its Architectural Context." *Pennsylvania Magazine of History and Biography*, January 1984, 76, 82.

9. T. William Booth, "Design for a Lumber Town by Bebb and Gould, Architects," *Pacific Northwest Quarterly*, October 1991, 134–38.

10. Willford I. King, "The Building Prospect, Part I. Building Costs," *AR* April 1921, 340. "Building Operations Subject to Promotion at This Time," *Architectural Forum*, June 1919, 183. "1924—Another $5,000,000,000 Building Year," *Architectural Forum*, January 1924, 8. John R. Riggleman, "Building Cycles in the United States, 1875–1932," *American Statistical Association, Journal*, June 1933, Chart II, 181.

11. Robert T. Jones, "The Architects' Small House Service Bureau," *Architectural Forum*, March 1926, 201.

12. *Scrapbook of Homes* (Minneapolis, ASHSB, 1928).

13. Jeffrey Karl Ochsner, ed., *Shaping Seattle Architecture*, (Seattle: University of Washington Press, 1994), 68. *AA*, 17 September 1892, 174.

14. Quoted in Catharine W. Bishir, J. Marshall Bullock, and William Bushong, *Architects and Builders in North Carolina. A History of the Practice of Building* (Chapel Hill, 1990), 277.

15. Katharine Cole Stevenson and H. Ward Jandl, *Houses by Mail* (Washington, 1986), 16, 21.

16. Donald O. Weese, "The Architects' Small House Service Bureau," *AR*, January 1923, 89–90. Lisa Diane Schrenk, *The Impact of the Architects' Small House Service Bureau on Early Twentieth Century Domestic Architecture*, (Mas-

ter's thesis, University of Virginia, 1988), Appendix V, p 80.

17. Lancelot Sukert, "As I Saw It," *Octagon*, June 1932, 5. "A Protest to the AIA from the Architects' League of Northern New Jersey," *PP*, June 1929, 413.

18. "Architects Combine for House Planning," *New York Times*, 11 March 1936. Eugene J. Johnson and Robert D. Russell, Jr., *Memphis, An Architectural Guide* (Knoxville, 1990), F-25.

19. "S.R.I.," "Houses for the Well-to-Do," *JAIA*, April 1925, 147. *The Movement to Improve Small House Architecture* (Minneapolis, 1930).

20. *Long Island Country Houses*, 129, 87–88.

21. Thomas J. Noel and Barbara S. Norgren, *Denver. The City Beautiful and Its Architects, 1893–1941* (Denver, 1987), 188. Keith N. Morgan, *Charles A. Platt, The Artist as Architect* (New York, 1986), 206.

22. Letter, 27 December 1919, in *San Simeon Revisited*, Nancy E. Loe, ed. (San Luis Obispo, 1987), 21.

23. John E. Aldred, interviewed by the *World Telegram*, as quoted in *Long Island Country Houses*, 27.

24. Ross Miller, *Here's the Deal* (New York, 1996), 52. *Long Island Country Houses*, 215.

25. Elizabeth Hawes, *New York, New York. How the Apartment House Transformed the Life of the City (1869–1930)* (New York, 1993), 225, 230. Steven Ruttenbaum, *Mansions in the Clouds. The Skyscraper Palazzi of Emery Roth* (New York, 1986), 65, 67, 123.

26. Bradley Skelcher, "Achieving the American Dream: The Career of John Augustus Nyden, 1895–1932," *Swedish-American Historical Quarterly*, July 1994, 143.

27. Barbara D. Hoffstot, *Landmark Architecture of Palm Beach* (Pittsburgh: Ober Park Associates, 1974), 92. Donald Curl, "Joseph Urban's Palm Beach Architecture," *Florida Historical Quarterly*, April 1993. Alexander O. Boulton, "The Tropical Twenties," *American Heritage*, May-June 1990, 93.

28. Dorothy May Anderson, *Women, Design and the Cambridge School* (West Lafayette, IN, 1980), 91.

29. Toft, Hamilton, and Gass, *The Way We Came*, 28.

30. Judith Paine, "Pioneer Women Architects," in *Women in American Architecture*, 66. George Ehrlich and Sherry Piland, "The Architectural Career of Nelle Peters," *Missouri Historical Review*, January 1989, 164.

31. "First Jewish Lady Architect of the West," *Western States Jewish History*, October 1984, 19. Lucinda Liggett Eddy, "Lilian Jenette Rice: Search for a Regional Ideal. The Develop-

ment of Rancho Santa Fe," *Journal of San Diego History*, Fall 1983, 262. "Women Architects Few but Versatile," *New York Times*, 11 April 1937.

32. Nathaniel Alexander Owings, *The Spaces in Between. An Architect's Journey* (Boston:, 1973), 264. Anne Patterson, "Women Architects: Why So Few of Them?" *Inland Architect*, December 1971, 18.

33. Report of the Committee on Permanent Organization, quoted in Mardges Bacon, "Ernest Flagg: Beaux-Arts Architect and Reformer," (Ph.D. diss., Brown University, 1978), 88.

34. Arthur Clason Weatherhead, "The History of Collegiate Education in Architecture in the United States" (Los Angeles, 1941), 77.

35. F. H. Bosworth, Jr. and Roy Childs Jones, *A Study of Architectural Schools* (New York, 1932), 8. Otto J. Teegen, "The B.A.I.D.—Its Past and Future," *JAIA*, October 1953, 184. Data developed from periodic reports in *JAIA* and *Bulletin of the Beaux-Arts Institute of Design*.

36. Bosworth and Jones, *Architectural Schools*, 8. John V. Van Pelt, "Architectural Training in America," *AR*, May 1928, 449.

37. Stratton Hammon, "Architects of Louisville," *Filson Club History Quarterly*, October 1987, 419.

38. Bosworth and Jones, *Study of Architectural Schools*, 61.

39. Toft, Hamilton, and Gass, *The Way We Came*, 54.

40. *AR*, March 1923, 283.

41. John Zukowsky, "The Chicago Architectural Club, 1895–1940," *Chicago Architectural Journal*, 1987, 19.

42. "The Fifty-Sixth Convention of the AIA," *AR*, June 1923, 312.

43. "Shadows and Straws," *JAIA*, February 1917, 53.

44. Darrell Hevenor Smith, *The Office of the Supervising Architect of the Treasury*, Service Monographs of the United States Government, No. 23 (Baltimore, 1923), Table: "Expenditures," 132. Charles Harris Whitaker, "Our Stupid and Blundering National Policy of Providing Public Buildings, Part II, Post Office Buildings," *JAIA*, March 1916, 99.

45. "The Secretary's Page," *JAIA*, May 1926, 228. Ernest Eberhard, "Fifty Years of Agitation for Better Design," *AA*, June 1931, 86. A. L. Brockway, "The Story of the Office of the Supervising Architect," *AA*, June 1932, 80.

46. Louis La Beaume, "The Federal Building Program," *Octagon*, April 1931, 14. H. R. 6187, quoted in "Federal Employment of Private Architects," *Octagon*, December 1931, 4. H. H. Harriss, "Provincialism vs. H. R. 6187," *PP*, March 1932, 188.

47. F. E. Davidson, "The Question of State Societies," *JAIA*, April 1920, Figure 1, 188. "A National Organization," *AA*, 9 January 1918, 39. Robert Willison, "A National Organization," *AA*, 6 February 1918, 155.

48. Antoinette J. Lee, *Architects to the Nation: The Rise and Decline of the Supervising Architect's Office* (New York, 2000), 247–48, 279.

49. William B. Bushong, *Centennial History, Washington Chapter the American Institute 1887–1987* (Washington, 1987), 70, 77, 78, 86.

50. "The Cooperative Plan of Buffalo Architects," *JAIA*, April 1920, 166.

51. Noel and Norgren, *Denver*, 189. "The Allied Architects' Association of Los Angeles." *JAIA*, August, September, October 1924, 376, 417–18, 456.

52. Albert C. Martin, "Letters to the Editor. Allied Architects' Associations," *JAIA*, April 1926, 189–90.

53. D. Everett Waid, "Allied Architects Associations," *JAIA*, January 1926, 84.

54. Talbot Faulkner Hamlin, "The Architect and the Depression," *Nation*, 9 August 1933, 152.

55. Toft, Hamilton, and Gass, *The Way We Came*, 53.

56. Bushong, *Centennial History*, 63–64, 76.

57. Christine Brendel Scriabine, "The Frayed White Collar: Professional Unemployment in the Early Depression," *Pennsylvania History*, January 1982, 9.

58. Royal Barry Wills, *This Business of Architecture* (New York, 1941), 11. Hammon, "Architects of Louisville," 430.

59. Tom Sorey, Jr., "Sorey Hill & Sorey: Architects with a Civic Conscience," *Chronicles of Oklahoma*, Winter 1993–1994, 358. Joseph B. Wertz, "Dining Room Architecture," *PP*, January 1933, 34. Ehrlich and Piland, "Nelle Peters," 173.

60. "Unemployment Relief Measures," *AR*, December 1932, 354–359, 360.

61. "Unemployment Relief Measures," 354–59.

62. L. Seth Schnitman, "Building Trends and Outlook," *AR*, July 1932, 72 and August 1933, 90. Henry Sasch, "The Draftsmen Organize!," *PP*, October 1933, 429.

63. *JAIA*, December 1919, 510.

64. George Bain Cummings, "The Progress of the Draughtsman's Union Idea, with Particular Reference to the Situation in New York City," *JAIA*, April 1920, 158.

65. "Technical Teams with War Work," *AR*, June 1942, 36–37. C. David Jackson and Charlotte V. Brown, *History of the North Carolina Chapter of the AIA 1913–1998* (Raleigh, 1998), 30–31.

66. "Editorial Comment," *AR*, May 1918, 195.

67. "State Registration of Architects and Columbia University," *AR*, August 1918, 182.

68. *Architectural Forum*, August 1954, 51.

69. D. Everett Waid, "The Architectural Incompetence Revealed by Some Registration Laws," *JAIA*, May 1918, 255.

70. "Distribution of Architects and Engineers in the United States," Joseph E. Smay, compiler, *JAIA*, September 1956, 110–111.

71. W. W. Beach, "National Certification of Architects," *Architectural Forum*, October 1920, 150. Paul Kruty, "A New Look at the Beginnings of the Illinois Architects Licensing Law," *Illinois Historical Journal*, Autumn 1997, 161. Waid, "Architectural Incompetence," 254.

72. D. Everett Waid, "Idaho's New Registration Law and the Proposed Law for Pennsylvania," *JAIA*, May 1917, 239.

73. "The Registration Tangle," *AR*, December 1923, 587.

74. Jesse Weinstein, referring to Joseph Abel in Bushong, *Centennial History*, 87. *Atlanta Journal*, 6 September 1951, as quoted in Herbert C. Millkey, "Georgia License Controversy," *JAIA*, February 1952, 67.

75. "Colorado Architect Examiners under Fire on Licensing," *Architectural Forum*, January 1953, 49. "New Architect Licensing Law in Colorado Faces Test," *Architectural Forum*, September 1953, 45.

76. Michael J. Crosbie, "Family Feud," *Progressive Architecture*, November 1995, 71.

77. Allen D. Roberts, "Religious Architecture of the LDS Church: Influences and Changes since 1847," *Utah Historical Quarterly*, Summer 1975, 326. "The Bureau of Architecture of the Methodist Episcopal Church," *AR*, January 1921, 95.

78. Maggie Valentine, *The Show Starts on the Sidewalk* (New Haven, 1994), 38. E. C. Murphy, "A Special Type of Motion Picture Theatre," *PP*, November 1928, 705.

79. Chris Hanlin, "The Architectural Development of Breweries in Michigan, 1860–Prohibition," *Chronicle: Quarterly Magazine of the Historical Society of Michigan*, Spring 1990, 3. Susan K. Appel, "Chicago and the Rise of Brewery Architecture," *Chicago History*, Spring 1995, 11–13.

80. Malcolm Collins, "Smith, Hinchman and Grylls: Architects from Detroit," *Michigan History*, September-October 1978, 50. Thomas J. Holleman and James P. Gallagher, *Smith, Hinchman & Grylls, 125 Years of Architecture and Engineering, 1835–1978* (Detroit, 1978), 137, 214–15.

81. Daniel Elazar, "The Shaping of Intergovernmental Relations in the Twentieth Century," in *The Politics of American Federalism*, Daniel Elazar, ed., (Lexington, MA, 1969), Table 2, 26.

82. Judith R. Lave and Lester B. Lave, *The Hospital Construction Act, An Evaluation of the Hill-Burton Program, 1948–1973*, (Washington, 1974), 13. Daniel J. Elazar, *American Federalism: A View from the States*, 3rd edition (New York, 1984), Table 3.6, 73.

83. "New Tax Bill to Benefit Industry," *Architectural Forum*, September 1954, 128–29.

84. "Principles of Professional Practice and the Canons of Ethics," *Journal of Proceedings AIA 1909 Convention*, 110.

85. "Principles of Professional Practice and The Canons of Ethics," 110.

86. Supreme Court: *Federal Baseball Clubs of Baltimore, Inc. v. National League of Professional Baseball Clubs*.

87. "Final Judgement, *United States of America v. The American Institute of Architects*," 19 June 1972, included in "The Justice Department Matter," *JAIA*, July 1972, 39. Thomas E. Kauper speaking to the New York State Bar Association, as quoted in Kenneth C. Ellis, "Antitrust Law: An Application of the Sherman Act to the Professions," *University of Florida Law Review*, Summer 1973, 741. John F. Gaither, Jr., "The Antitrust Division v. The Professions—'No Bidding' Clauses and Fee Schedules," *Notre Dame Lawyer*, April 1973, 966.

88. "Final Judgement," 40.

89. H.R. Rep. No. 1188, 92nd Cong., 2d Sess. 6 (1972) as quoted in Gaither, "Antitrust Division v. The Professions," 975.

90. "AIA Resolves Antitrust Allegations by Justice Department," *Building Design & Construction*, September 1990, 17.

91. J. S. Gibson, "Architectural Practice, Real and Ideal," *Architecture*, February 1903, 24.

92. Raymond Yates, "Succeeding in Architecture," *Scientific American*, 23 July 1921, quoted in Levy, "Professionalization," 282.

93. Robert W. Hodges and others, "Occupational Prestige," *American Journal of Sociology*, November 1964, Table I.

94. Carleton Monroe Winslow and Edward C. McDonagh, "The Architect Looks at Himself," *JAIA*, December 1961, 34.

95. G. Anthony DesRosier, "Computer Graphics Design and Drafting in A/E Firms," *North Carolina Architect*, January-February 1982, 7.

96. Robert Sheehan, "Portrait of the Artist as a Businessman," *Fortune*, March 1967, 144.

97. Sheehan, "Portrait of the Artist," 147.

98. "1998 World Survey," *World Architecture*, December 1997–January 1998, 146, 150.

99. Bradford McKee, "Merger Mania," *Architecture*, June 1996, 151.

100. Martin Pawley, "HOK's Ultimate Ac-

colade," *World Architecture*, December 1997–January 1998, 130.

101. "The Top 500 League Table," *World Architecture*, December 1997–January 1998, 134–35.

102. Harry W. Ormston, quoted in Bushong, *Centennial History*, 64.

103. *Architecture Factbook, 1992 Edition* (Washington: AIA, 1992), 22.

Bibliography

Adler, Dankmar. "Some Notes upon the Earlier Chicago Architects." *Inland Architect and News Record* (May 1892): 47–48.

Anderson, Dorothy May. *Women, Design, and the Cambridge School.* West Lafayette, IN: PDA, 1960.

Andrews, Robert C. "Conditions of Architectural Practice Thirty Years and More Ago." *Architectural Review* (U.S.) (November 1917): 237–238.

Bacon, Henry. "Charles Follen McKim, A Character Sketch." *Brickbuilder* (February 1910): 38–47.

Bacon, Mardges. "Ernest Flagg, Beaux-Arts Architect and Reformer." Ph.D. dissertation, Brown University, 1978.

Baer, Herbert M. "The Course in Architecture at a German 'Technische Hochschule'." *American Architect & Building News* (16 March 1901): 83–85.

Baker, Paul R. *Stanny. The Gilded Life of Stanford White.* New York: Free Press, 1989.

Balmori, Diana. "George B. Post: The Process of Design and the New American Architectural Office (1868–1913)." *Journal of the Society of Architectural Historians* (December 1987): 342–355.

Barnett, Tom. "George I. Barnett: Pioneer Architect of the West." *Western Architect* (February 1912): 13–14, 23.

Beauchamp, Tanya Edwards. "Adolph Cluss: An Architect in Washington during Civil War and Reconstruction." Master's thesis, University of Virginia, 1972.

Bishir, Cathrine W., J. Marshall Bullock, and William Bushong. *Architects and Builders in North Carolina: A History of the Practice of Building.* Chapel Hill: University of North Carolina Press, 1990.

Blackall, C. H. "Fifty Years Ago." *American Architect* (5 January 1926): 7–9.

Bledstein, Burton J. *The Culture of Professionalism: The Middle Class and the Development of Higher Education in America.* Boston: Norton, 1976.

Bosworth, F. H., and Roy Childs Jones. *A Study of Architectural Schools.* New York: C. Scribner's Sons, 1932.

Bosworth, Welles. "I Knew H. H. Richardson." *Journal of the American Institute of Architects* (September 1951): 115–126.

Boutelle, Sara Holmes. *Julia Morgan, Architect.* New York: Abbeville, 1995.

Brcak, Nancy J. "Country Carpenters, Federal Buildings: An Early Architectural Tradition in Ohio's Western Reserve." *Ohio History* (Summer-Autumn 1989): 131–146.

Bridenbaugh, Carl. *Early Americans.* New York: Oxford University Press, 1981.

_____. "Peter Harrison Addendum." *Journal of the Society of Architectural Historians* (December 1959): 158–159.

_____. *Peter Harrison, First American Architect.* Chapel Hill: University of North Carolina Press, 1949.

Brooks, H. Allen. "Steinway Hall, Architects and Dreams." *Journal of the Society of Architectural Historians* (October 1963): 171–175.

Brown, Glenn. *Memories, 1860–1930.* Washington: W.F. Roberts, 1931.

_____. "Personal Reminiscences of Charles Follen McKim." Parts 1–4. *Architectural Record* (November, December 1915): 575–582, 681–689, (January, February 1916):84–88, 178–185.

_____. "The Tarsney Act. Historical Review." *Brickbuilder* (May 1906): 95.

Bruegmann, Robert. *The Architects and the City: Holabird & Roche of Chicago, 1880–1918.* Chicago: University of Chicago Press, 1997.

Bryan, John A. "Architects in St. Louis between 1804 and 1904." *Missouri Historical Review* (October 1933): 83–90.

Bushong, William B., Judith Helm Robinson, and Julie Mueller. *Centennial History. Washington Chapter of the American Institute 1887–1987.* Washington: Washington Architectural Foundation Press, 1987.

Card, Marian. "A. F. Davis and the Printed Speci-

fication." *College Art Journal* (Summer 1953): 354–359.

Clark, Clifford E., Jr. "Domestic Architecture as an Index to Social History: The Romantic Revival and the Cult of Domesticity in America, 1840–1878." *Journal of Interdisciplinary History* (Summer 1976): 33–56.

Clark, Theodore Minot. *The Architect, Owner and Builder before the Law*. London: Macmillan, 1894.

Clarke, Vincent. "A Struggle for Existence: The Professionalization of German Architects." In *German Professions 1800–1950*, edited by Geoffrey Cocks and Konrad H. Jarausch. New York: Oxford University Press, 1990.

Cohen, Jeffrey A. "Building a Discipline: Early Institutional Settings for Architectural Education in Philadelphia, 1804–1890." *Journal of the Society of Architectural Historians* (June 1994): 139–182.

Cole, John Y. "Smithmeyer & Pelz: Embattled Architects of the Library of Congress." *Quarterly Journal of the Library of Congress* (October 1972): 282–306.

Collins, Malcolm. "Smith Hinchman & Grylls: Architects from Detroit." *Michigan History* (September-October 1978): 45–52.

Connely, Willard. *Louis Sullivan as He Lived*. New York: Horizon, 1960.

Cooledge, Harold N. *Samuel Sloan, Architect of Philadelphia 1815–1884*. Philadelphia: University of Pennsylvania Press, 1986.

Curl, Donald. *Mizner's Florida, American Resort Architecture*. Cambridge: MIT Press, 1999.

Delaire, E., David de Penanrun, and Louis François Roux. *Les Architectes Elèves de l'Ecole des Beaux-Arts, 1793–1907*. Paris: Librairie de la Construction Moderne, 1907.

Delano, William Adams. "Memoirs of Centurion Architects [Century Club]." *Journal of the American Institute of Architects* (July, August, September, October 1948): 3–9, 81–87, 130–136, 180–184.

Dill, Alonzo Thomas. *Governor Tryon and His Palace*. (Chapel Hill: University of North Carolina Press, 1955.

Dostoglu, Sibel Bozdogan. "Towards Professional Legitimacy and Power. An Inquiry into the Struggle, Achievements and Dilemmas of the Architectural Profession through an Analysis of Chicago 1871–1909." Ph.D. thesis, University of Pennsylvania, 1982.

Dozier, Richard. "The Black Architectural Experience in America." *Journal of the American Institute of Architects* (July 1976): 162–163, 166, 168.

Edwards, Alba M. *The Sixteenth Census of the United States: 1940. Population, Comparative*

Occupation Statistics for the United States, 1870 to 1940. Washington: GPO, 1943.

Ehrlich, George. "Partnership Practice and the Professionalization of Architecture in Kansas City, Missouri." *Missouri Historical Review* (July 1988): 458–480.

Eidlitz, Leopold. "The Vicissitudes of Architecture." *Architectural Record* (April-June 1891): 471–484.

_____. "The Architect of Fashion." *Architectural Record* (April-June 1894): 347–353.

Elzner, A. O. "A Reminiscence of Richardson." *Inland Architect and News Record* (September 1892): 15.

Engelbrecht, Lloyd C., and June-Marie F. Engelbrecht. *Henry C. Trost, Architect of the Southwest*. El Paso: El Paso Library Association, 1981.

Ericsson, Henry. *Sixty Years A Builder*. Chicago: A. Kroch, 1942.

Ethridge, Harrison Mosley. "The Black Architects of Washington D.C., 1900–Present." D.Arch. dissertation, Catholic University of America, 1979.

Fawzy, Omar H. *The Development of the Architectural Working Drawing from the Descriptive to the Prescriptive: A Study in Architectural Communication*. Ph.D. dissertation, University of Pennsylvania, 1991.

Fitzpatrick, F. W. "Ramblings. A Chat with the Young Draftsman." *Pencil Points* (August 1927): 461–462, 500.

Flagg, Ernest. "The Ecole des Beaux-Arts." *Architectural Record* (January-March, April-June, July-September 1894): 302–313, 419–428, 38–43.

_____. "A Fish Story. An Autobiographical Sketch of the Education of an Architect." *Journal of the American Institute of Architects* (May 1945): 182–188.

Floyd, Margaret Henderson. *Architectural Education and Boston. Centennial Publication of the Boston Architectural Center, 1889–1989*. Boston: The Center, 1989.

Follett-Thompson, Jean Ames. "The Business of Architecture: William Gibbons Preston and Architecture Professionalism in Boston during the Second Half of the Nineteenth Century." Ph.D. dissertation, Boston University, 1986.

Gallier, James. *Autobiography of James Gallier*. Paris: E. Briere, 1864.

Gambaro, E. James. "Early Days of the Institute." *Journal of the American Institute of Architects* (April 1952): 161–167.

Gardner, Deborah S. "The Architecture of Commercial Capitalism: John Kellum and the Development of New York." Ph.D. dissertation, Columbia University, 1979.

Geraniotis, Roula Mouroudellis. "German Architects in Nineteenth-Century Chicago." Ph.D. dissertation, University of Illinois, 1985.

Gilchrist, Agnes Addison. *William Strickland, Architect and Engineer, 1788–1854.* 1950; reprint, DaCapo, 1969.

Goldsmith, Goldwin. "I Remember McKim Mead & White." *Journal of the American Institute of Architects.* (April 1950): 168–172.

Goodman, Paul, and Percival Goodman. "Jews in Modern Architecture." *Commentary* (July 1957): 28–35.

Goody, Marvin E., and Robert P. Walsh. *The Boston Society of Architects. The First Hundred Years 1867–1967.* Boston: Boston Society of Architects, 1967.

Graham, Roy Eugene. "Joseph Jacques Ramée and the French Emigré Architects in America." M.Arch. thesis, University of Virginia, 1968.

Gray, David. *Thomas Hastings, Architect. Collected Writings with a Memoir.* Boston: Houghton Mifflin, 1933.

Gray, Lee. "Addendum: Mies van der Rohe and Walter Gropius in the FBI Files." In *Mies van der Rohe: Critical Essays,* edited by Franz Schulze. New York: Museum of Modern Art, 1989.

Graybill, Samuel Huiet, Jr. "Bruce Price, American Architect, 1845–1903." Ph.D. dissertation, Yale University, 1957.

Green, William Elton. "A Question of Great Delicacy: The Texas Capitol Competition, 1881." *Southwestern Historical Quarterly* (October 1988): 247–270.

Greiff, Constance J. *John Notman, Architect 1810–1865.* Philadelphia: Athenaeum, 1979.

Haber, Samuel. *The Quest for Authority and Honor in the American Professions, 1750–1900.* Chicago: University of Chicago Press, 1991.

Hall, Louise. "Artificer to Architect in America." Ph.D. dissertation, Harvard University, 1954.

Hambly, Maya. *Drawing Instruments 1580–1980.* London: Sotheby's, 1988.

Hamlin, A. D. F. "The Battle of Styles." *Architectural Record* (March 1892): 265–275.

Hamlin, Talbot. "The Architect and the Depression." *Nation* (9 August 1933): 152–154.

_____. *Benjamin Henry Latrobe.* New York: Oxford University Press, 1955.

_____. *Greek Revival Architecture in America.* London: Oxford University Press, 1944.

Hammon, Stratton. "Architects of Louisville: From the 1920s through World War II." *Filson Club History Quarterly* (October 1987): 419–443.

_____. "School of Architecture, 1914 to 1926, University of Louisville." *Filson Club History Quarterly* (April 1968): 125–131.

Harbeson, John F. *The Study of Architectural Design.* New York: Pencil Points Press, 1926.

Hardin, Bayless E. "The Capitols of Kentucky." *Register of the Kentucky State Historical Society* (July 1945): 173–200.

Hartmann, Sadakichi. "A Conversation with Henry Janeway Hardenbergh." *Architectural Record* (May 1906): 377–380.

Hastings, Thomas. "A Letter from Thomas Hastings FAIA Reminiscent of the Early Work of Messrs. Carrere & Hastings." *American Architect* (July 1909): 3–4.

Hauck, Eldon. *American Capitals.* Jefferson NC: McFarland, 1991.

Hays, William Charles. "The 'T-Square Club' of Philadelphia. Two Decades of Club History." *Current Literature* (May 1904): 515–20.

Hitchcock, Henry-Russell, and William Seale. *Temples of Democracy: The State Capitals of the U.S.A.* New York: Harcourt Brace Jovanivich, 1972.

Holleman, Thomas J., and James P. Gallagher. *Smith, Hinchman & Grylls: 125 Years of Architecture and Engineering, 1835–1978.* Detroit: Wayne State University Press, 1978.

Hooper, Bruce. "Samuel Eason Patton, Opera House Architect of the Southwest." *Journal of Arizona History* (Spring 1997): 57–70.

Hoskins, George Gordon. *The Clerk of Works. A Vade Mecum for All Engaged in the Superintendence of Building Operations.* London: Spon, 1878.

Irish, Sharon. *Cass Gilbert, Architect. Modern Traditionalist.* New York: Monacelli Press, 1999.

Irvin, Hilary S. "The Impact of German Immigration on New Orleans Architecture." *Louisiana History* (Fall 1986): 375–406.

Jenney, William LeBaron. "Autobiography of William LeBaron Jenney, Architect." *Western Architect* (June 1907): 59–66.

_____. "An Old Atelier in Chicago in the Seventies." *Western Architect* (July 1907): 72–75.

Kahn, Albert. "Thirty Minutes with American Architects. High Spots in Half Century of Building." *Architect & Engineer* (April 1937): 21–26, 47–48.

Kahn, Edgar. "Albert Kahn: His Son Remembers." *Michigan History* (July-August 1985): 24–31.

Kelly, J. Frederick. "A Forgotten Incident in the Life of Ithiel Town." *Old Time New England* (January 1941): 62–69.

Kennedy, Roger G. *Architecture, Men, Women, and Money.* New York: Random House, 1985.

Kilham, Walter H., Jr. *Raymond Hood, Architect. Form through Function in the American Skyscraper.* New York: Architectural Book Publishing, 1973.

Kimball, Bruce A. *The 'True Professional Ideal' in America: A History.* Cambridge: Blackwell, 1992.

Kinyon, Jeannette. *Prairie Architect. F. C. W. Kuehn: His Life and Work.* Sioux Falls SD: Center for Western Studies, 1985.

Kocher, A. Lawrence. "The American Country House." *Architectural Record* (November 1925): 401–512.

Kruty, Paul. "A New Look at the Beginnings of the Illinois Architects Licensing Law." *Illinois Historical Journal* (Autumn 1997): 154–172.

Laing, Alan K. *Nathan Clifford Ricker 1843–1924. Pioneer in American Architectural Education.* Urbana-Champaign: University of Illinois, 1973.

Landau, Sarah Bradford. *Edward T. and William A. Potter, American Victorian Architects.* New York: Garland, 1979.

Landy, Jacob. *The Architecture of Minard Lafever.* New York: Columbia University Press, 1970.

Lane, Mills. *Architecture of the Old South.* 2 vol. Savannah: Beehive Press, 1996.

Lapham, Samuel, Jr. "Architectural Specifications of a Century Ago." *Architectural Record* (March 1923): 239–244.

Lee, Antoinette J. *Architects to the Nation. The Rise and Decline of the Supervising Architect's Office.* New York: Oxford University Press, 2000.

Leonard, Glen M. "William Allen's Clients: A Socio-economic Inquiry." *Utah Historical Quarterly* (winter 1986): 74–87.

Levy, Richard Michael. "The Professionalization of American Architects and Civil Engineers, 1865–1917." Ph.D. dissertation, University of California Berkeley, 1980.

Liscombe, Rhodri Windsor. *Altogether American: Robert Mills, Architect and Engineer, 1781–1855.* New York: Oxford University Press, 1994.

Lloyd, A. Perlett. *A Treatise on the Law of Building and Buildings.* Boston: Houghton Mifflin, 1888.

Longstreth, Richard. *On the Edge of the World. Four Architects in San Francisco at the Turn of the Century.* Cambridge: MIT Press, 1989.

Loring, Sanford E., and W. L. B. Jenney. *Principles and Practice of Architecture.* Chicago: Cobb Pritchard, 1869.

Lubov, Lisa B. "From Carpenter to Capitalist: The Business of Building in Postrevolutionary Boston." In *Entrepreneurs: The Boston Business Community 1770–1850*, edited by Conrad Edick Wright and Katheryn P. Viens, 181–209. Boston: Massachusetts Historical Society, 1997.

MacKay, Robert B., Anthony K. Baker, and Carol A. Traynor, eds. *Long Island Country Houses and Their Architects, 1860–1940.* New York: Norton, 1997.

Magonigle, H. Van Buren. "A Half Century of Architecture." *Pencil Points.* (November 1933): 477–480; (January, March, May, July, September, November 1934): 9–12, 115–118, 223–226, 357–359, 464–466, 563–565.

_____. "Some Suggestions as to the Making of Working Drawings." *Brickbuilder* (May, July, August 1913): 99–103, 147–153, 174–178.

Magruder, Charles. "The White Pine Monograph Series." *Journal of the Society of Architectural Historians* (March 1963): 39–41.

Malinick, Cynthia Barwick. "The Lives and Works of the Reid Brothers, Architects 1852–1943." M.A. thesis, University of San Diego, 1992.

Mason, George Champlin. *Architects and their Environment 1850–1907.* Ardmore PA: Rubblestone, 1907.

_____. "Professional Ancestry of the Philadelphia Chapter." *Journal of the American Institute of Architects* (September 1913): 371–386.

McFarland, Dennis P. *Montgomery C. Meigs: Engineer, Builder, Quartermaster General of the Union Army.* Thesis, University of Virginia, 1994.

Michels, Eileen. "Late Nineteenth-Century Published American Perspective Drawings." *Journal of the Society of Architectural Historians* (December 1971): 291–308.

Morgan, Keith N. *Charles A. Platt: The Artist as Architect.* New York: Architectural History Foundation, 1985.

National Council of Architectural Registration Boards. *The History of the NCARB.* Washington: NCARB, 1994.

Neil, J. Meredith. "The Precarious Professionalism of Latrobe." *Journal of the American Institute of Architects* (May 1970): 67–71.

Newton, Roger Hale. *Town & Davis, Architects.* New York: Columbia University Press, 1942.

Noel, Thomas J., and Barbara S. Norgren. *Denver. The City Beautiful and its Architects, 1893–1941.* Denver: Historic Denver Inc., 1987.

Noffsinger, James Philip. *The Influence of the Ecole des Beaux-Arts on the Architects of the United States.* Washington: Catholic University Press, 1955.

O'Gorman, James F. "H. and J.E. Billings of Boston: from Classicism to the Picturesque." *Journal of the Society of Architectural Historians* (March 1983): 54–65.

_____. *H. H. Richardson. Architectural Forms for an American Society.* Chicago: University of Chicago Press, 1987.

Oliver, Richard, ed. *Bertram Grosvenor Goodhue.* New York: Architectural History Foundation, 1983.

_____. *The Making of an Architect, 1881–1981. Columbia University in the City of New York.* New York: Rizzoli, 1981.

Ossman, Jennifer Laurie. "Reconstructing a Na-

tional Image: The State, War, and Navy Building and the Politics of Federal Design, 1866–1890." Ph.D. dissertation, University of Virginia, 1996.

Overmire, E. P. "A Draftsman's Recollection of Boston." *Western Architect* (February 1904): 18–20.

Peatross, C. Ford. *William Nichols, Architect*. University AL: University of Alabama, 1979.

Peck, Amelia, ed. *Alexander Jackson Davis, American Architect 1803–1892*. New York: Rizzoli, 1992.

Prawl, Toni M. "E. J. Eckel (1845–1934): The Education of a Beaux-Arts Architect and His Practice in Missouri." Ph.D. dissertation, University of Missouri-Columbia, 1994.

Purcell, William Gray. "Forgotten Builders." *Northwest Architect* (November-December 1944): 3–7, 13.

_____. "This Too, Might Be History." *Journal of the Society of Architectural Historians* (October 1943): 16–24.

Quinan, Jack. "Some Aspects of the Development of the Architectural Profession in Boston between 1800 and 1830." *Old Time New England* (Summer-Fall 1977): 32–37.

Ranlett, William G. *The Architect*. New York: Dewitt & Davenport, 1849; reprint, DeCapo, 1976.

Ransom, David F. "James G. Batterson and the New State House." *Connecticut Historical Society Bulletin* (January 1980): 1–15.

Ravenel, Beatrice St. Julien. *Architects of Charleston*. Charleston: University of South Carolina Press, 1992.

Riggleman, John R. "Building Cycles in the United States, 1875–1932." *American Statistical Association. Journal* (June 1933): 174–183.

Roseberry, Cecil R. *Capital Story*. Albany: New York State Office of General Services, 1964.

Roth, Leland. *McKim Mead and White, Architects*. New York: Harper & Row, 1985.

Ruttenbaum, Steven. *Mansions in the Clouds. The Skyscraper Palazzi of Emery Roth*. New York: Balsam, 1986.

Saint, Andrew. *The Image of the Architect*. New Haven: Yale University Press, 1983.

Saylor, Henry. "The AIA's First 100 Years." *Journal of the American Institute of Architects* (May 1957): 109–180.

Schachtman, Tom. *Skyscraper Dreams: The Great Real Estate Dynasties of New York*. Boston: Little Brown, 1991.

Schweinfurth, J. A. "Great Builders I Have Known." *American Architect* (November 1931): 48–49, 92, 94, 96.

Sheehan, Robert. "Portrait of the Artist as a Businessman." *Fortune* (March 1967): 114–118, 178, 183–184.

Shillaber, Caroline. *1861–1961: Massachusetts Institute of Technology School of Architecture and Planning. A Hundred Year Chronicle*. Cambridge: MIT, 1963.

Smith, Darrell Hevenor. *The Office of the Supervising Architect of the Treasury. Its History, Activities and Organization*. Baltimore: John Hopkins University Press, 1923.

Smith, Hank Todd. *Since 1886: A History of the Texas Society of Architects*. Austin: Texas Society of Architects, 1983.

Snyder, Lillian M. "The Contribution of Icarian, Alfred Piquenard, to Architecture in Iowa and Illinois." *Communal Societies* (June 1986): 163–171.

Starrett, Paul. *Changing the Skyline: An Autobiography*. New York: McGraw-Hill, 1938.

Stein, Susan R., ed. *The Architecture of Richard Morris Hunt*. Chicago: University of Chicago Press, 1986.

Stern, Douglas L. "*Government Architecture in the Gilded Age: The Office of Alfred Mullett.*" M.Arch.Hist. thesis, University of Virginia, 1981.

Stern, Robert A. M. *George Howe: Toward a Modern American Architecture*. New Haven: Yale University Press, 1975.

Storrer, Bradley R. "The Schindler Licensing Letters. Schindler-Wright Exchange." *Journal of the Taliesin Fellows* (1992): 14–19.

Sturgis, R. Clipston. "Practice of Fifty Years Ago." *Journal of the American Institute of Architects* (September 1947): 138–139.

_____. "The Profession and the Institute Fifty Years Ago." *Journal of the American Institute of Architects* (July 1945): 15–19.

_____. "Some Recollections." *Journal of the American Institute of Architects* (July, August, September 1926): 266–268, 294–296, 357–358.

Sullivan, Louis. *The Autobiography of an Idea*. New York: American Institute of Architects, 1926.

Szuberla, Guy. "Irving Kane Pond: A Michigan Architect in Chicago." *The Old Northwest* (Summer 1979): 109–140.

Thayer, R. H. *History, Organization and Functions of the Office of the Supervising Architect of the Treasury Department with Copies of Reports, Recommendations, etc.* Washington: GPO, 1886.

Thomas, Christopher Alexander. "The Lincoln Memorial and Its Architect, Henry Bacon (1866–1924)." Ph.D. dissertation, Yale University, 1990.

Thomas, George E., Michael J. Lewis, and Jeffrey A. Cohen. *Frank Furness: The Complete Works*. New York: Princeton Architectural Press, 1991.

Toft, Carolyn Hewes, Esley Hamilton, and Mary Henderson Gass. *The Way We Came. A Century*

of the AIA in St. Louis. St. Louis: Patrice Press, 1991.

Torre, Susana, ed. *Women in Architecture: A Historic and Contemporary Perspective.* New York: Whitney Library of Design, 1977.

Turak, Theodore. *William LeBaron Jenney, a Pioneer of Modern Architecture.* Ann Arbor: UMI Research Press, 1986.

Tuthill, William B. *Practical Lessons in Architectural Drawing.* New York: Comstock, 1881.

Upjohn, Everard. *Richard Upjohn, Architect and Churchman.* 1939; reprint, DaCapo, 1968.

Upjohn, Hobart. "An Early Chapter in Institute History." *Journal of the American Institute of Architects* (July 1925): 264–266.

_____. "Architect and Client a Century Ago." *Architectural Record* (November 1933): 377–382.

Upton, Dell. "Pattern Books and Professionalism." *Winterthur Portfolio* (summer-autumn 1984): 107–150.

Van Brunt, Henry. "Richard Morris Hunt 1828–1895." *Journal of the American Institute of Architects* (October 1947): 180–187.

Van Horne, John C., ed. *The Correspondence and Miscellaneous Papers of Benjamin Henry Latrobe 1805–1810.* New Haven: Yale University Press, 1986.

_____, and Lee W. Formwalt, eds. *The Correspondence and Miscellaneous Papers of Benjamin Henry Latrobe 1784–1804.*

Wall, Alexander J. "Books on Architecture Printed in American, 1775–1830." In *Bibliographical Essays. A Tribute to Wilberforce Eames,* 299–310. Cambridge: Harvard University Press, 1924.

Ware, W. R. "Architecture at Columbia College." *American Architect and Building News* (6 August 1881): 61–62.

Wallis, Frank E. "Richard M. Hunt, Master Architect and Man. Some Personal Reminis-
cences." *Architectural Review* [U.S.]. (November 1917): 239–240.

Weatherhead, Arthur Clason. *The History of Collegiate Education in Architecture in the United States.* Los Angeles: 1941.

Whyte, James H. *The Uncivil War. Washington during the Reconstruction, 1865–1878.* New York: Twayne, 1958.

Wight, Peter B. "Reminiscences of Russell Sturgis." *Architectural Record* (August 1909): 123–131.

Wills, Royal Barry. *This Business of Architecture.* New York: Reinhold, 1941.

Wilson, Charles C., Samuel Lapham, and Walter F. Petty. *Architectural Practice in South Carolina.* South Carolina Chapter, AIA, 1963.

Winslow, Carleton Monroe, and Edward C. McDonagh. "The Architect Looks at Himself." *Journal of the American Institute of Architects* (December 1961): 32–35.

Wister, Owen. "The Keystone Crime. Pennsylvania's Graft-Cankered Capitol." *Everybody's Magazine* (October 1907): 435–448.

Wodehouse, Lawrence. "Ammi Burnham Young, 1798–1874." *Journal of the Society of Architectural Historians* (December 1966): 268–280.

Wood, Charles B., III. "A Survey and Bibliography of Writings on English and American Architectural Books Published before 1895." *Winterthur Portfolio* (1965): 127–137.

Woods, Mary N. "The 'American Architect and Building News' 1876–1907." Ph.D. dissertation, Columbia University, 1983.

_____. *From Craft to Profession. The Practice of Architecture in Nineteenth-Century America.* Berkeley: University of California Press, 1999.

Zukowsky, John. "The Chicago Architectural Club, 1895–1940." *Chicago Architectural Journal* (1982): 170–174.

Index

Number in *italics* indicate photographs or drawings.